G000125375

FREDRIKSON STALLARD

FREDRIKSON STALLARD

WORKS

SKIRA

Art Director
Marcello Francone

Design
Luigi Fiore

Editorial Coordination
Vincenza Russo

Editing
Marco Abate

Layout
Paola Ranzini Pallavicini

First published in Italy in 2019 by
Skira Editore S.p.A.
Palazzo Casati Stampa
via Torino 61
20123 Milano
Italy
www.skira.net

Printed and bound in Italy.
First edition

ISBN: 978-88-572-3522-6

Distributed in USA, Canada, Central & South
America by ARTBOOK | D.A.P. 75 Broad
Street Suite 630, New York, NY 10004, USA.
Distributed elsewhere in the world
by Thames and Hudson Ltd.,
181A High Holborn, London
WC1V 7QX, United Kingdom.

Special thanks to
David Gill
Francis Sultana
Nadja Swarovski
Daniel Malarkey
Caroline Roux
Deyan Sudjic
Glenn Adamson
Gareth Williams
Keith Bolderson
Suzanne Trocmé
Katie Richardson
Sophie Davies
Michael Hardy
Sweetu Patel
Philip Wood
Jason Basmajian
Ben Evans
Sarah Douglas
Tony Chambers
Nick Compton
Malcolm Young
Haruki Ara
Toby Starr
William Govoni
Emily Lean
Angel Monzon
Inger Fredrikson
Anders Fredrikson
Jackie

Contents

Foreword

Deyan Sudjic

What makes looking at (and trying to understand) design, so constantly fascinating and enlightening, is the way that the subject appears to constantly change shape. The discussion moves back and forth, up and down, on a scale of relative preoccupations with recurring issues. It goes from the social to the aesthetic, from the commercial to the cultural, from analogue to the digital and the specific to the generic. And yet at the same time it is also in some sense always about the same things. Design is about our relationship with the material world, about the meanings of things, about the pleasure that we take in imagination and form, and material qualities. At heart it is about the significance that those things have for us.

Glenn Adamson's exploration of the work of Patrik Fredrikson and Ian Stallard in this book is more than a conventional monograph. It offers an insight into their work, and the extent to which it is a highly contemporary version of what design can be. He finds them rooted in the recent past of design, and its traditions beyond it. They learned from Memphis and Ingo Maurer and Droog, Ron Arad and Zaha Hadid, but importantly also blend high art and popular culture.

In the past decade, the Design Museum has shown their work in three very different installations. In the most recent, their piece *Species II* was featured as a contender for the 2016 Beazley Design of the Year award in our new building in Kensington. The exhibition was an engaging exploration that inevitably poses the same question each year: how do you measure social purpose against formal invention, an all-terrain wheel chair against a website, a magazine against a rehydration kit. And the answer each year is that the point is not to say that one is a more appropriate definition of design than another. The intention is to show that design is a complicated landscape full of ideas and insights and potential.

Among the polemics and the commitment to a social mission, *Species II* had a very different quality. It was not a representation of something else, nor was it a solution to anything. Carved from polyurethane, glass fibre and polyester, and

with the colour of dried blood, it had the presence of a giant piece of moon rock, which its form somewhat resembled. It has a kind of autonomy that does not really need to be explained. It has a tactile material quality and a sense of shape and surface that imposes itself on any space in which it stands, even a museum gallery in which few of its neighbours share its assumptions. And, outside the context of the museum, you could sit on it.

Fredrikson Stallard's *Pandora* chandelier was one of the highlights of *Digital Crystal* four years previously, an exhibition that the museum organized in its original home at Shad Thames with Swarovski. *Digital Crystal* showed a mixture of newly commissioned work and existing pieces from the company's long running collection of chandeliers designed by a range of architects and designers including Zaha Hadid and Ron Arad. Pandora, designed in 2007 was one of the earlier examples in the series. It is made up from almost 2000 individual pieces of crystal each of them suspended from a cascade of threads that have been meticulously organized to connect with an electric powered motor pre-programmed to adjust the height and relative position of the individual crystals. The result is impressive.

It creates a kind of kinetic chandelier. In one position it takes on a form approximating to a kind of deconstructed baroque chandelier.

In others it appears to explode and gradually reconfigure itself as the unseen motor moves a crystal constellation into different positions.

In one way it demonstrates a very different sensibility to that of *Species II*. *Pandora* is a work of design in that it is the realization of the designers' ideas which is based on the precision with which their intentions have been carried out by others. And it suggests the language of industrial production. Unlike *Species* which reflects the marks of the makers tools and hands, *Pandora* is polished and precise. Its designers knew exactly what they wanted before manufacture began. *Species II* depended on a certain sense of discovery in the process of making. But at the same time there is a connection in the thinking behind both pieces. They have their roots in reinterpretations

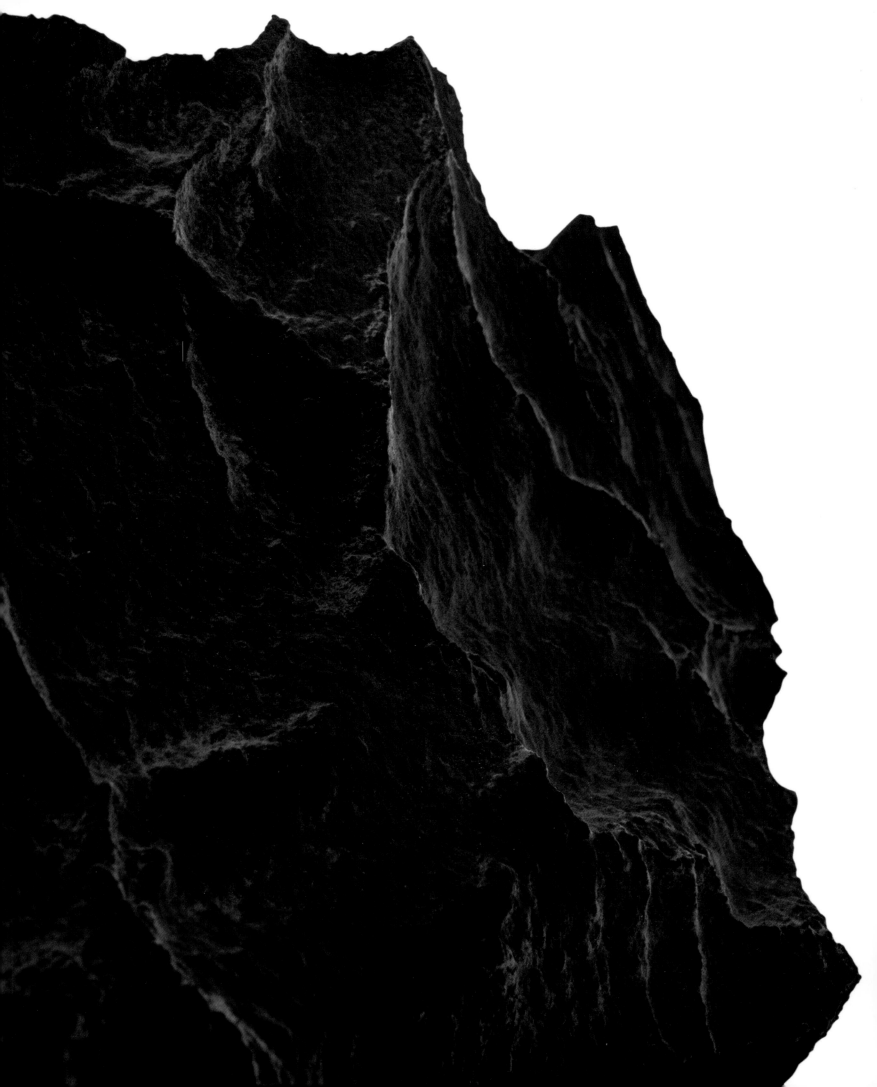

of the archetypes of interior decoration: a chandelier and a chaise longue.

And that sense of how to look at and how to understand Fredrikson Stallard's work is underscored by their first appearance at the Design Museum in 2007. A pair of their *Bergère* chairs were displayed rotating on plinths inside a glass and steel tank positioned on the Thames front outside the museum. The chairs, one high back, one low, were made from hand beaten polished stainless steel, and shocking pink rubber.

The original *Bergère* was in its time – the early 18th century – an innovation in furniture design. The word means 'shepherdess', and it was devised as an armchair that could be moved around an interior, rather than fixed in position as part of an architectural backdrop. It was based on an upholstered back and arms, from which the wooden framing emerged.

Fredrikson Stallard's updated versions used bolder forms, and played off metal against rubber, rather than wood and fabric. And the pink suggested a more overt erotic connotation than the flirtatiousness of the first *Bergère*.

Fredrikson Stallard have roots in cultural history, at the same time, they explore new materials and contexts. They seek to continue to meet the very human need for the tactile, material objects that we use to define ourselves.

In this book, Glenn Adamson produces a strikingly original recapitulation of where what we see as contemporary design comes from. He has moved beyond a long, and now no longer entirely relevant conflict between hand making, craft skill, industrial design and decorative art. The distinctions between them, and the very concept of function and utility have been swept aside by the digital revolution. Adamson draws a convincing parallel between the impact of the arrival of recording technology on music, and that of mass production on design. Just as couture fashion suffered a near death experience in the social revolution of the 1960s before being reborn for a new audience, so design in a world defined by Ikea at one end, and the limited edition at the other has been used to find new ways of meeting old impulses.

There have been changes in speed and form, and the incorporation of new elements, but some fundamentals have remained.

He takes Fredrikson Stallard's work as the starting point for a revaluation of the meaning of objects, making, and understanding them.

He traces the routes they took to working together, and the different experiences that they have brought to the partnership. He sees their work as exploring the limits of consistency, or perfection in making. He traces the inspirations that they have taken from their predecessors, and the ways in which they have built on them. And he has looked at the impact of the pragmatism that came from making their way in the commercial world, before they reached a gallery audience. He offers a compelling insight into the relevance of their work, and the context of which it forms a part.

Fredrikson Stallard

Glenn Adamson

Here's a little noted but striking fact: modern design originated about the same time as recorded music. The end of the nineteenth century saw the establishment of a new profession, the industrial designer, who was not principally a mechanic or artisan, but a form-giver and idea-generator. It was at this moment that design began to disengage from trade practice, and became redefined as a future-oriented discipline.

Also toward the end of the nineteenth century, people were able to listen to the past for the very first time. Thomas Edison pioneered the technology, etching the sound waves of music or recorded speech into wax-coated cardboard cylinders. Not quite a designer, Edison was more an engineer and inventor. Yet his way of working was comparable. He innovated constantly, so that his own products almost immediately became obsolete. His recordings, first made available commercially in 1889, were quickly displaced by better solutions, such as hard rubber and shellac disks. The improvement was steady and dramatic; "comparison with the living artist reveals no difference," Edison's advertisements claimed in 1909. That was an exaggeration, but it would be realized in time, as other recording technologies arrived in swift succession, right down to the 8-track tapes, cassettes, CDs, and digital downloads of our own lifetimes.

Just as Edison was releasing his ghostly sounds into the world, the first genuine design reform movements were gaining ground. These too were based on a new relationship to the past. Previously, design had been a matter of gradual change. Tastes shifted constantly, but for the most part incrementally. Craft guilds and trade unions enforced existing patterns of work, and consumers were similarly subject to path dependency. Even during the so-called "consumer revolution" of the eighteenth century, new forms and fashions took years to proliferate. This slow rhythm of change could survive even dramatic disruptions: long after the *ancien régime* was overthrown in France, the Rococo – the ultimate style of autocratic luxury – remained viable in democratic nations.

Over the course of the nineteenth century, however, the pace of design change started to accelerate. There were many factors in play, among them photographic reproduction, the decline of the guilds, and the rise of technologies such as mass production and rapid transport. Already in the 1860s, Christopher Dresser was able to make a living offering his services as an "ornamentist" to all comers, whether they made cast iron furniture, electroplated metal, or slipcast ceramic.[1] Though he drew on the eternal verities of nature, Dresser's business model was premised on his ability to continually generate new and striking forms. By the turn of the century, as the term *Art Nouveau* suggests, novelty in design was at a premium to an extent it had never been before. It was spurred on by the advent of galleries, promotion, and the press. Manufacturers staged high-profile unveilings at international expositions. Even the Arts and Crafts Movement, though backward-looking in its veneration of medieval artisanship, was in many respects a modern fashion, self-conscious in its use of the past.[2] It was, to use an anachronistic term from the music industry, a "remix" of what had come before. From this point onwards, designers, like musicians, would need to change their tune constantly. Such are the dictates of the volatile modern market.

Somewhat counter-intuitively, the ability to preserve music – making it a permanent art form, as well as a performative one – increased the rate of change. When songs had only existed in the moment, there was comparatively less incentive to write new ones. But when last year's hit record could be played at will, and sales had already tailed off, novelty suddenly was at a premium. Already by the 1950s, no teenager would be caught dead listening to their parents' music; today, the popularity of a song is measured in days, not decades. For recording artists, the challenge is to produce enduring value in the face of this rapid churn.

The story of modern design is not an exact comparison with this system, because chairs and tables hang around in a way that songs don't.

Yet the parallels are numerous. In both fields, style and technique are always on the move. The precession of new ideas is constant. A few become classics; most don't, fading quickly after their introduction. The classics tend to inspire imitations, which are usually far inferior. It has taken designers a long time to come to terms with this state of affairs. Unlike their colleagues in music, they long denied the influence of changing tastes. William Morris's emphasis on a primary "joy in labour," or the Bauhaus principle of "truth to materials," are well-known principles of this kind; Charles Eames once advised, "innovate as a last resort – more horrors are done in the name of innovation than any other." Of course, Charles and Ray Eames are celebrated as among the greatest design innovators of all time. In practice, modern design has been constantly subsumed within the imperative toward the new, on the assumption that the market will quickly burn through even the best ideas. Even the present-day emphasis on sustainability obeys this rule. The reduction of carbon footprint is an area of intense competition, and "green" materials like raw, untreated wood and salvaged concrete are dominant aesthetic cues – at least for the moment. The question is how to achieve objects of inherent value against this backdrop. Once we all accept the fact that design operates (for all practical purposes) like the music industry, oriented to rapid change for its own sake within an insatiable market, how is it possible to produce ideas of transcendent grace?

Here is where Fredrikson Stallard come in. Hopefully the reader will forgive the somewhat protracted exposition provided up to this point, but to understand what they do, it is crucial to have in mind the larger pattern. Look at any of their work, and you will immediately notice a certain quality of speed – not in a visual sense, as in 1930s streamlining, but perceptually. Their objects deliver right up front. To look at their work is already to feel that your attention has been rewarded, though invariably there is much more to discover. Indeed, there is typically a dramatic tension in their work between the flickering, seductive surface and a seriousness of intent that lies within. At their best, Fredrikson Stallard's objects are brilliant in just the same way that a great pop song is. There's a depth to the feeling and thinking, but also a killer hook.

This set of aesthetic tendencies bespeaks a philosophy – one that is absolutely in tune with the nature of contemporary design. Fredrikson Stallard make no claims concerning the modernist high ground, in which objects are conceived as optimal, efficient solutions, end points of rigorous analysis. Nor are they critical utopians, creating provocative objects whose propositions are destined to remain unfulfilled. They are, rather, intuitive makers, happy to accept the condition of constant flux – the reality that they are only as relevant as their last idea. They see that the values of their discipline are contingent, not timeless. They suspect orthodoxy, and prize instinct. Hence the energies of the work: the quick crush, the sudden splash, the grab and bind. Hence the way that Fredrikson Stallard move effortlessly through drastically different, even oppositional production scenarios. Hence, too, their knowing feints toward other works of fine art and historical design, both canonical and kitsch. All of these tactics are ways of acknowledging the contemporary territory, and their place within it.

The new millennium has brought other leading figures in design to the fore, of course. Many of them find a place in this book; Fredrikson Stallard are highly attuned to their colleagues' contributions, and see them as part of the context for their own work. But look where you will, you will not find any designers who feel the pulse of the times more keenly than they do. We live in a moment when attention is one of our dearest commodities; when the digital is remaking the domains of production and consumption; when "new materiality" is a field of intensive research; when the essential need for human contact remains pervasive, yet is frequently unmet. If you want to understand these complex parameters for design in our times, and how they can be resolved one object at a time, look at Fredrikson Stallard.

1. Beginnings

Ian Stallard and Patrik Fredrikson arrived at art school in the mid-1990s. It would be a decade before they were working together as a team, at least on an official basis. There were constant financial pressures on them, both during their student days and in their first years as aspiring independent designers. Ian worked first as a waiter and then at the interiors store Habitat, which was founded by Terence Conran; Patrik in a Björn Borg underwear store. They were also (we'll come back to this) partying hard. In this period, however – the ten years leading up to 2005 – they not only produced one of their most iconic designs, and developed a workable collaborative design vocabulary; they also acquired the business skills requisite to their later success, including a knack for getting things done under pressure.

They met at the bar, in 1995. Both were students enrolled at Central St. Martins. Ian was in his third year; Patrik, though he is five years older, had just arrived. They had come from very different places, each of which embodied a certain cultural template within late capitalism. Ian is originally from suburban Essex, and had spent his growing-up years sampling the various idioms of rebellion that seemed open to him. He liked kitsch. He liked Jeff Koons. He liked Pierre et Gilles. He wore a white suit covered with badges, and nasty narrow ties. He was a gay boy struggling to come out.

Patrik, meanwhile, was living in a Swedish town called Hofterup, a place he describes as "like J.G. Ballard's *High Rise*, but horizontal." In classic Scandinavian style, it had been laid out by an architect who had a vision of how people should live. This architect had constructed the largest house in the town for his own use; others came in three sizes, but were otherwise identical modules. The sea was nearby, as was the forest; there was a petrol station; and that was about it. "It was interesting," says Patrik. "There was nothing to do."

He actually means this: Hofterup was a very creative environment, because he and his friends had to invent everything. The experience paved the way for him to take up a career in design.

Perhaps encouraged by his parents, who were style-conscious in a way that is virtually unknown

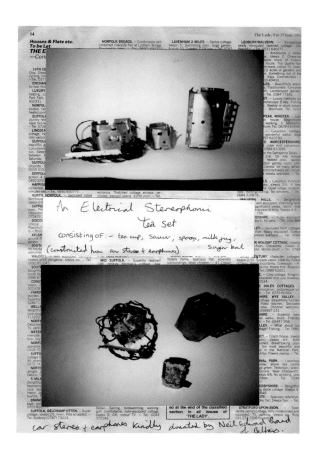

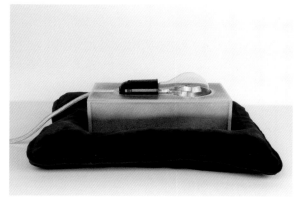

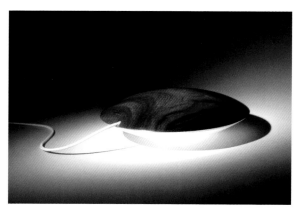

Car Stereo Tea Set, 1992
car stereo, headphones

Sleeping Beauty, 1997
silk velvet, aluminium

Luna, 1998
walnut, glass

13

in Britain but commonplace in Scandinavia (they wanted Poul Henningsen PH lamps for their kitchen so badly that they left the bulbs bare until they could afford the purchase), Patrik went to college to study graphics, and then began work in the nearby city of Malmö, as an art director in the advertising business. For someone of tender age, he was doing very well. Yet Sweden's design culture felt stifling to him – a whole industry thinking inside the box. While visiting a friend in London, Patrik wandered through some of the city's art school degree shows. He immediately realized there was an energy there, a freedom that he had been missing. He resolved to come to London himself, and so, in 1995, enrolled at Central St. Martins.

By that time, Ian had already established himself as a potter. Though initially attracted to film during his foundation year, he'd ended up in ceramics – "I love making things and I'm a bit of a pyromaniac," he says, "and it brought those two things together." His early works in clay drew on the enthusiasms, and the up-yours attitude, of his youth. He made a giant cock that disassembled into individual bowls, each one inscribed with ABBA lyrics. He created a mad hatter's tea party (sadly not extant, even photographically), and for the centerpiece, asked his friends to write the most obscene thing they could think of on a giant teapot. He met Grayson Perry, who was not yet famous, when Perry came to St. Martins as a visiting tutor. Ian recognized him as a kindred spirit – two unconventional Essex boys with devilish streaks. At the time, both were making little ceramic shrines – Ian's were based on gay icons taken from *Attitude* magazine, such as Take That, Michael Portillo, Holly Johnson.

Ian was also working in the art department for a television show called the *Big Breakfast*. Mention this program to Britons of a certain age, and you'll be rewarded with a big goofy smile. It ran on Channel Four, then the wayward child of British broadcasting, and presented its viewers with a maximalist combination of vivid colour, slapstick comedy, and celebrity guest stars. Ian had landed a job there thanks to, of all people, Patrick Swayze. This was a few years after *Ghost*

was in the cinemas – a film well remembered by ceramics enthusiasts, because of a gauzy sex scene set in a potshop. Swayze was booked on to the show, and the producers at the *Big Breakfast* duly came calling to St. Martin's to get hold of a potter's wheel. Yes, they could take one, they were told, but only if Ian came along to oversee its use. He was soon hired, and spent the next year making props and sets for the *Big Breakfast*, typically working with cut vinyl on foamboard. It was a helpful experience for a young artist, as it required him to work quickly and at large scale.

Meanwhile, Patrik was developing his work in a completely different vein. The word "poetic" is overused in design discussions, but it's hard to avoid when looking at his early student works. A single bulb embedded into a solid block of aluminium, lying prone on a velvet pillow; a lampshade bisected by a piece of laminated wall; a beautifully turned wooden disc, glowing softly beneath. All are nominally designs for lighting, and it would be easy to assume that Patrik wanted to establish himself as a specialist in that field. Certainly it was an interest for him, and in particular, he notes the importance of Ingo Maurer on his work at this time. But his intentions had more to do with narrative than lighting *per se*. It is helpful here to remember that Patrik was, only months before, a commercial art director in Sweden. While he wanted to break out of the Scandinavian box, his skill set was still grounded in that discipline. This explains the importance of titling in these student works – a holdover from years spent working with copy-writers – and also the atmospheric way that he often photographed his work, such as the homoerotic backdrop of his early piece *Love Box*.

To understand where both Ian and Patrik were coming from at this time, it is helpful to take a further step back and consider the state of design as it existed in the mid-1990s, when they arrived at art school. Like most students, they were consciously reacting to precedent. For them, this meant the paroxysm of postmodernism, which had just come to an end. That movement had been theoretically-inflected and subcultural,

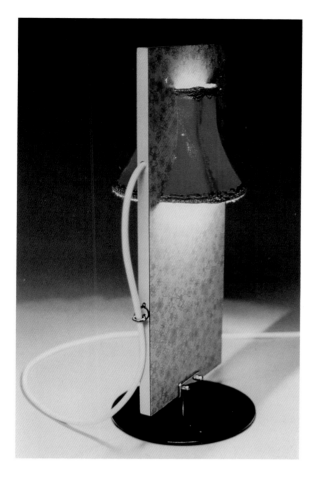

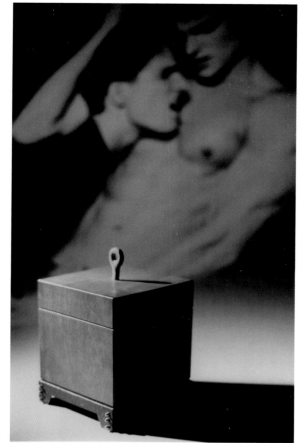

but its energies had become dissipated in a wave of corporatization. What had begun as disruption eventually became standard business procedure. Viewed in hindsight, Ian's earliest work, especially, must be seen in relation to postmodernism, particularly the colourful and exaggerated strain typified by the Milanese collective Memphis.

Formed back in 1981, Memphis had confronted the commercial nature of design like never before. They addressed the mediation of objects, through various strategies including photogenic surfaces and distinct "collections" released annually, as at a couture house. The experiment ran its course quickly. Its leader, Ettore Sottsass, predicted that it would not last long even when it was just getting going, and he was right. But Memphis certainly left its mark. From high street shops to music videos, their outrageous, late-night-party aesthetic became a transiently popular "look." This was right in line with the presumption of throwaway fashionability that had animated the group in the first place. For many established designers, the spectacle was both sobering and infuriating.

It is easy to draw the line from Memphis to Ian Stallard, particularly when taking his work as a prop maker on the *Big Breakfast* into account. The objects that Sottsass et al. made actually looked far better on TV, or in magazines, than they did in person; they were essentially made to be photographed. Memphis products were sheathed in patterned plastic laminates, partly because one of their key funders was Abet Laminati (Memphis was, among other things, a product placement scheme for the company). This affinity to mediation was a key insight – if that's the right word – offered by postmodern design. The shifting sands of the marketplace were revealed to be the only foundation going. Successful design was not a matter of resisting commercial forces, or pretending they didn't exist, but understanding them, and working both through and around them. This lesson would go on to be intrinsic to Fredrikson Stallard's work.

If the legacy of Memphis was a significant context for Ian's initial forays, then Patrik's lighting was even more directly influenced by the more recent rise of Dutch design. Around the time

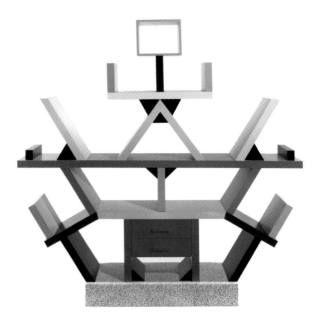

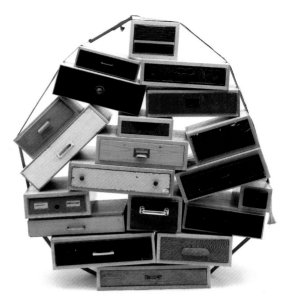

Ettore Sottsass, *Carlton Room Divider*, 1981
wood and colored plastic laminate

Tejo Remy, *You Can't Lay Down Your Memory Chest of Drawers*, 1991
metal, paper, plastic, burlap, contact paper and paint

that he arrived at St. Martin's, the phenomenon was in full swing, having been primed by the Design Academy Eindhoven, which graduated a series of "star" designers including Jurgen Bey (1990), Tord Boontje (1991), Richard Hutten (1991), Hella Jongerius (1993), and Maarten Baas (2002). (They also expelled Marcel Wanders, in 1988.) The Eindhoven model, equal parts Bauhaus and Motown, would be perfected toward the end of the decade, when the DAE was under the leadership of genius fashion trend forecaster Lidewij Edelkoort. But already by that time, the Dutch had achieved tremendous international influence, particularly via Droog Design.

Though often described as a design collective along the lines of Memphis, Droog was more of a curated collection, put together by the designer Gijs Bakker and the impresario Renny Ramakers. The objects that they chose did share certain characteristics: a dry wit (Droog in fact means "dry"); narrative implication; an interest in craftsmanship, which contrasted with the use of found objects; and a teasing relationship to functionality, which was neither entirely absent in Droog products, nor in any sense efficient. Again, all these principles would eventually take their place in Fredrikson Stallard's own work, minus the somewhat jokey comedy that typified some Droog products.

One can see clear parallels between Patrik's early work and specific objects in the Droog collection – *Sleeping Beauty* calls to mind Tejo Remy's milk bottle lamps, while his later conception for *Table #1* (AKA the "log table") would borrow the tension belt from Remy's iconic *You Can't Lay Down Your Memory* chest of drawers. Ian, too, produced objects that could easily have fitted into the Droog catalogue, notably a series of lights cast from standard industrial fixtures – ingeniously using the translucency of porcelain to transform a quotidian object into a ghostly phantasm. But, as with Memphis, the real importance of Droog had to do with attitude rather than specific imagery. As Patrik puts it, these precedents gave a "go ahead to a whole path of work." Droog were working from their own point of view, not that of a corporate client. And whilst the consumer was acknowledged in their objects, this was done in a sophisticated way, a wink between consenting adults. Ian and Patrik were just setting out, but they already began to frame their ambition: to be independent and unconventional in character, pitched somewhere in the vast and then largely unmapped territory that lay between fine art and industrial design.

This was indeed a joint project. Though they would not formally become a team for some time, Ian and Patrik became partners both personally and creatively almost immediately upon meeting one another. In many art schools

Down Light, 2003
porcelain

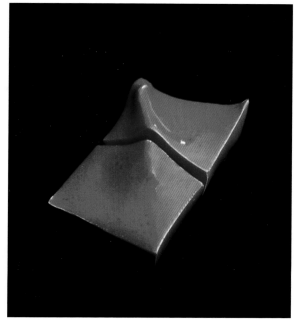

of the time, their instinct to collaborate might have been frustrated by institutional divisions. Ian was in ceramics and Patrik in product design, after all. But St. Martin's was fully committed to interdisciplinarity. There was no sense that the "crafts" were a world apart, or indeed, that a product designer should stay within the lines of finely engineered functionality. One telling anecdote: Patrik and his fellow students were assigned to design something that would reduce handbag theft. Most of his colleagues came up with clips that would fasten to the underside of café tables; Patrik proposed a 100' high sculpture in Leicester Square, a gigantic *aide memoire* for Londoners to hold on to their purses.

Thanks to the fluidity at St. Martin's, Patrik was able to drop in on the ceramics studio occasionally, while Ian became aware of the larger field of design in a way that aspiring potters in other schools would not have. Even so, they pursued separate paths for a while. The first to graduate was Ian. He set up his own ceramics studio with the support of Cockpit Arts, which offered below-market rents to young creatives. His was a typical giftware operation in many ways, operating at a scale that might be described as "limited mass production." Sales came through trade shows like *Top Drawer* and at direct sales (two annually, one at the holidays) that brought in the majority of the income. Ian was working

on his own, so the hours were long, and it was important to devise expedient methods. One was to buy in whiteware blanks and print on to them – working more in the manner of a graphic designer than a potter. Another, more predictive of later work, was to roll out a large slab of clay and press it with their hands, then slice it into squares. The shapes of each unit thus formed bore the contours of their fingers. The very first collaboration that Ian and Patrik undertook was a large run of cufflinks made in this way. Each

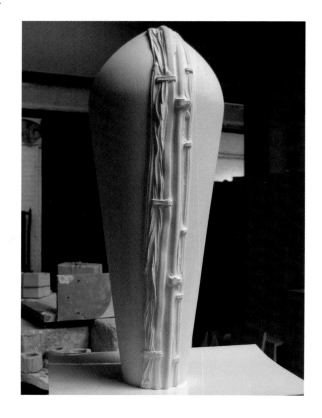

pair was different, a straight-sided unit with an amorphous, curved top. This admittedly modest project not only inaugurated their way of working together in the studio, but also anticipated the combination of geometry and free composition seen in so many later Fredrikson Stallard works.

While Ian was making a go of it as an independent designer-maker, Patrik found paid work as a designer's assistant. The opportunity had come through a summer internship between his second and third year at St. Martin's – a placement with Michael Young, who was then working as part of the production company TYMC (his partners were Theo Theodorou and Yoichi Nakamuta, thus the acronym). This put him at the heart of a busy commercial design operation. He was only given rote jobs at first, such as sanding down prototypes, but he began to see how prominent designers conducted themselves: how to organize up-front investment for ambitious projects, how to work with clients, how the business was organized. The placement also gave him an instant network. TYMC were headquartered in the same space as Rolf Sachs's studio; Patrik met luminaries like Ron Arad and Zaha Hadid, and the gallerist David Gill, who represents Fredrikson Stallard today. Again, the most important impact was conceptual; as Patrik says, "all I knew to that point was shops and stores, and all of a sudden the gateway opened to a world I hadn't known existed." These connections also became Ian's, and the horizons of the young couple expanded together.

Of the professional designers that Patrik met at TYMC, the most immediately significant would prove to be Michael Wolfson. At that time, he was running his own design business out of his South Kensington apartment, and also working as a senior architect for Zaha Hadid. Wolfson happened to have a job vacancy in his own studio at this time and hired Patrik, initially only one day a week but eventually fulltime. His jobs were once again primarily technical in nature, and included drafting architectural drawings by hand – this was in the days before computer rendering was commonplace, so the tools were the old fashioned ones of pens and scalpel. The digital was right on the horizon, though, and Hadid was leading the way. For designers in London, it was as if she had occupied that entire territory; Patrik recalls that when other people did begin using CAD, their work invariably looked "Zahaesque." Wolfson was strongly affected by this futuristic aesthetic, but his personal taste tended more to the mid-century era. This became an important if temporary influence on both Ian and Patrik – they adopted the look for their own shared apartment. It also showed up in Ian's ceramics, as he shed the British whimsy of his college work and began using a monochromatic palette (lots of blacks and reds) and sharply defined silhouettes.

Throughout his time with Wolfson, Patrik had continued to make his own independent design projects, often fabricating them with Ian's help. When it came time to break out on his own, he had his network readymade; he set up

Early studio at Cockpit Arts, London, 2002

Exhibition at 100% Design, London, 2003

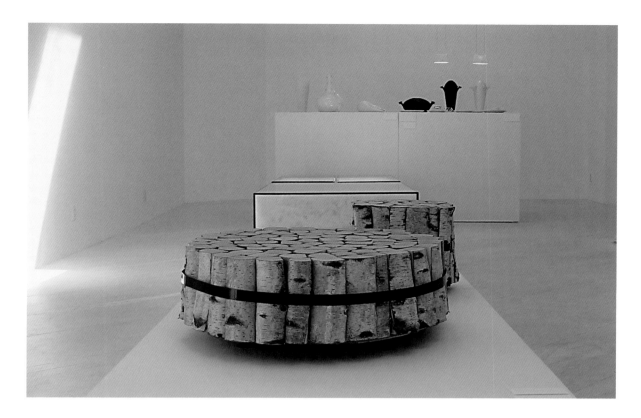

his own company (initially called FRDRKSN, no vowels) and found some success in selling products to The Conran Shop and other stores. Then came a big moment, thanks to Suzanne Trocmé, an editor at *Wallpaper** whom Patrik and Ian had met through Michael Wolfson. She had befriended them and was keeping a close eye on their work; so she was in the perfect position to help when Patrik came up with the idea for *Table #1*, in 2001. As she immediately saw, the piece captured the craft-friendly, sustainability-oriented spirit of the millennial moment. Trocmé featured the table in the magazine, and it proved decisive. The coverage coincided with other high-profile exposure – *Table #1* was also picked up in other high-style publications like *Scene*. Ian's ceramic giftware, meanwhile, was being featured "in *Prima* next to a pullout knitting pattern," as well as in mainstream papers like the *Sun* and the *Daily Mail*. It suddenly seemed self-evident to him that he should abandon the limited-run mass production strategy he had been pursuing, with its abundant workload, small margins, and lack of realistic expansion strategy. Instead he would join Patrik in the making of more creatively designed and intensely crafted objects.

2. On the Make

Right at this time, Ian secured a booth at the 100% Design Fair, an event that was much higher-toned than the trade fairs where he had previously shown his ceramics. Participation represented a real financial risk, though, particularly as a hoped-for subvention from the Crafts Council did not come through. Ian proceeded anyway, and to fill out the booth, Patrik contributed some of his own recent designs. It was all done rather quickly and intuitively, certainly without an overall curatorial intent. Yet the booth sang. The colour scheme, black and white with just a few splashes of intense red, was possessed of a gothic glamour totally unique in the fair. The dramatic effect resulted partly from serendipity, but it also attested to a real commonality in their work. Ian's earlier Mad Hatter aesthetic had deepened and darkened, and its fairytale notes (dragon's heads and wax candlesticks) seemed entirely of a piece with the hewn birch of *Table #1*.

Here is a good moment to mention the fact that, in addition to putting in the hours in their respective studios, Ian and Patrik were also devoting serious time to London nightlife. For both of them, the city's gay scene had been a revelation

19

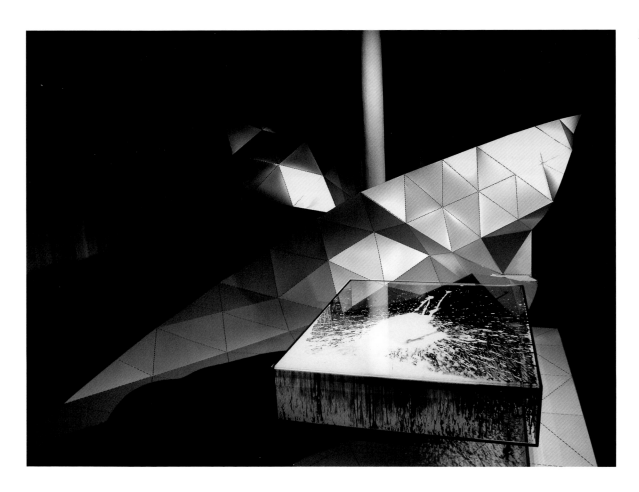

when they first encountered it; Ian remembers being "swallowed up by it entirely" in his second year at St. Martin's, and one can only imagine what it felt like for Patrik, given his upbringing in a quiet Swedish village. They were fixtures in Shoreditch's electro music nights, and at a venue called the Ghetto in Soho which featured music nights called Nag Nag Nag (on Wednesday) and The Cock (on Sunday). "We were at our poorest financially," they say, "but having the most fun."

Alongside the dancing, drugs and sex, there was a not inconsiderable professional angle to this intense social life. The mix included key players in London's fashion, fine art, and design industries; it was an inheritance from the heady days of the New Romantics, which had similarly functioned as a seedbed for cross-disciplinary creativity in the 1980s. Among other habitués of the scene were Johnny Woo, Princess Julia, the curator Michael Hardy, and the extraordinary leather gear artisan Ilya Fleet. The all-wax candles that premiered at the 100% Design booth were produced by Fitzrovia retailer Thorsten van Elten; that deal was literally swung on the dancefloor at The Cock.

Nightlife was also a connective tissue for Ian and Patrik's first gallery representation, which (somewhat surprisingly) was in New York City rather than London. The venue, in Williamsburg, Brooklyn, was a brand new gallery called Citizen Citizen – the name was intended to communicate the idea of exchange between designers in Britain and America. Its proprietor, Sweetu Patel, had approached Ian and Patrik at the 100% Design booth and invited them to show; it was a persuasive offer, partly because at the time Williamsburg had a similar energy to that in Shoreditch, a vital music scene nestled alongside fashion, art, and start-up companies. Initially the plan was for Citizen Citizen to open with a group show, but in the end Ian and Patrik inaugurated the space with a solo presentation, in 2004. The selection overlapped with the monochromatic, gothic works shown at 100% Design – the candles were there in force, as were angular coathooks evocative of Patrik's earlier lighting experiments. There were several ambitious additions, the most important of which were based around the new idea of a table-like glass container on legs, the so-called *Unit*. These

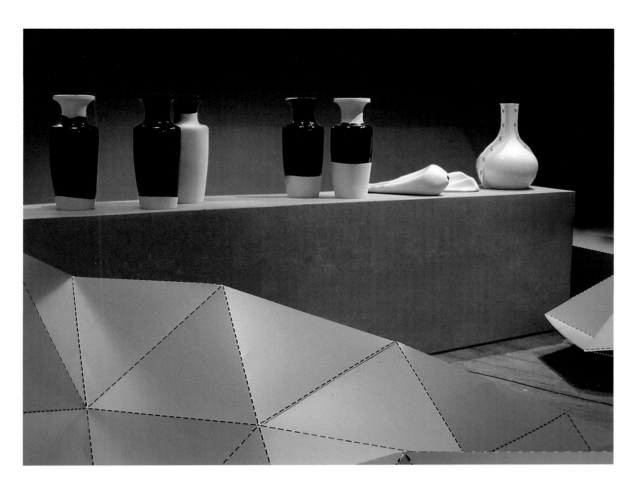

transparent boxes can be considered the first important Fredrikson Stallard collaborations.

Also included in the Citizen Citizen show was *Brush #1* (2002), in which the central icon of Christian faith is turned into a floor scrubber. This object exemplifies the aggressive side of Fredrikson Stallard in their early days. The clear meaning of the piece is that nothing is sacred. Certainly the provocation did not go unnoticed. They say that they received actual death threats; conversely, some visitors dared them to use religious emblems from other faiths in a comparable way (they demurred, feeling that as their own upbringings had been Christian, it would not be appropriate for them to use symbols from other religions). Today, they look back on this work's energy as somewhat adolescent: "anyone can stand up in a church, and yell 'fuck!' But once you have everyone's attention, then what do you do?"

They would have opportunity to answer that question, for another show followed quickly thereafter, back in London. Entitled *Factio*, it was the brainchild of Michael Hardy, a young, underground entrepreneur who wanted to channel the cross-disciplinary energy of nightlife into a more formal mode of presentation. He had recently moved from New York City, where he had been working in fine art galleries and just started to work with Louisa Guinness Gallery in London, staging shows with artists and designers such as Donald Judd and Ron Arad. Hardy had become an important presence in Ian and Patrik's life since they had met at 100% Design; all three shared creative ambition and similar taste when it came to the club scene. Indeed, the most memorable thing for attendees of *Factio*, held during the 2004 London Design Festival, may well have been the *mise en scène*. The display space was lit in dramatic chiaroscuro, like a club. The all-night soundtrack for the opening event, DJ'd by Matthew Glamorre (best known for his collaboration with Leigh Bowery in the art-rock band Minty), began with baroque opera and gradually descending into electro beats. The personnel of the exhibitors included fashion designer Shelley Fox, the architecture firm Plasma Studio (Eva Castro and Holger Kehne), Sonic Artist Tom Richards and fine artist Ross Tibbles. The message was that all

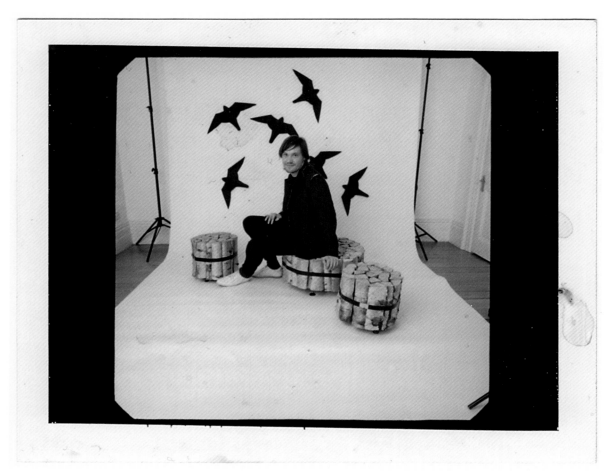

Photoshoot for *Elle Decoration*, 2004

Opposite page
Sketches for the Tribeca Grand
exhibition, *Gloves for an Armless
Venus*, New York, 2005

disciplines are interconnected under the heading
of creative production; *factio* is the Latin word for
"making."

Fredrikson Stallard's own contributions
perfectly communicated this fluidity. *Factio*
included one of the *Units*, with spatters of
milky white and black paint inside it; a series
of ceramics with overall profiles based on Ming
vases, sheathed in heat-shrunk, industrial PVC
in the place of traditional glaze; and a series of
other experiments, including one vase with
Frankensteinian bolts and another that seemed
to have given up the ghost, lying exhausted and
post-priapic in a puddle of its own materiality.
It was a strong selection, aesthetically well-
coordinated. But particularly in the company of
so many other artists' works, the diversity perhaps
raised as many questions as it answered. Were
Fredrikson Stallard to be sculptors or product
designers? Were they primarily interested in form
or function, style or statement? Outside the free-
spirited, multidisciplinary mash-up of a show like
Factio, where would their work sit? Answers to
these questions would be forthcoming, and soon.

3. Objects, Suggestions and Consequences

2004 had been an auspicious year for Fredrikson
Stallard. Newly minted as a design partnership,
they had staged their first gallery exhibitions
together, and had attracted considerable attention
for their work in the press. A promo shot taken for
Elle Decoration captures the moment. Patrik sits
amidst iterations of *Table #1* on a white backdrop;
a group of black kites they had designed in the shape
of falcons wheel behind him. Patrik had taken the
fierce and fast-flighted bird of prey as a personal
emblem; an actual Peregrine falcon, perched on
one of Ian's *Dragon* vases, was used as the lead
promotional image for their first show at Citizen
Citizen. The shot for *Elle* was taken early one
morning, following a late night out partying with
Jake Shears and Ana Matronic, and their band the
Scissor Sisters. In its basic conception, the image
is a run-of-the-mill professional design photo –
portrait and products on a seamless backdrop – but
it communicates a sense of subcultural abandon,
and a desire to fly free of the moment.

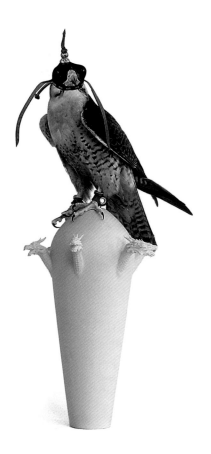

Dragon Vase with Falcon, 2003
porcelain

23

The promising but inchoate energy of that moment would soon coalesce in an exhibition called *Gloves for an Armless Venus*. The fabulous title of this show was proposed by Marc Kroop, another friend from the London gay club scene. Poetic as it is, the phrase pins down the character of Fredrikson Stallard's work better than any other: notionally functional, yet not strictly necessary; highly aesthetic; connected to a deep, even archaic wellspring of sensuality. (Ian jokes, "Like my Latin teacher used to say, Venus was not the goddess of love, she was the goddess of sex. They're quite different things.") To an art world audience, the phrase also immediately connotes a relation to Dada and Surrealism, particularly the work of Salvador Dalí.

All of these qualities were borne out in the *Armless Venus* exhibition. Right from the moment when people received their invite – white text printed on a rubbery black paper material called Plike – they were given to understand that they would be attending something more than a design show. The exhibition (perhaps a better word would be "happening") was presented during the run of the furniture trade fair ICFF, but it was conceived almost as an antidote to the vibe of that event. The venue was the TriBeCa Grand, normally used for music and fashion promotions, and the opening party was held from 9pm to 2am. At this midnight hour, the gothic, fetishistic objects in the show felt just right. As at *Factio*, electro music blasted in the venue (the DJ was Richard Fearless). One wall was used to project a film at large scale: the falcon on the vase again, but this time in motion, its hooded head swivelling. In effect, it was a design event with the machinery and ambition of a highly anticipated album launch.

The dark glamour of the objects on view were equal to the staging. Fredrikson Stallard's new "rugs" in poured urethane formed a centerpiece for the display space-cum-dancefloor. Illumination was provided by a skyline-like arrangement of the designers' all-in-one candles, burning together in a single conflagration. (This was a serendipitous, last-minute idea; quite a

few of the fragile pieces had broken in transit, and Ian and Patrik decided they might as well get some use out of them.) A row of the Ming vases, half-sheathed in their black PVC, and a *Unit* filled with white feathers offered further seductive materiality. On the sidewalk outside the venue, there was a table made of solid ice, melting inexorably away under a single spotlight.

Gloves for an Armless Venus was subtitled "a montage of objects, suggestions and consequences." Here too the project delivered, capturing a new set of tantalizing possibilities not only for Fredrikson Stallard as a studio, but also for the field as a whole. For many years, ambitious designers had tried to break out of the context of industrial products by presenting their work as sculpture. This meant showing in white-walled galleries and museums, and often selling to collectors. Ian and Patrik were by no means averse to this type of presentation – as we will see, gallery settings have been an important part of their overall approach – but if *Gloves for an Armless Venus* was a "suggestion" leading down the road to certain "consequences," that had to do not with adopting the standard format of art, but instead the sort of stagecraft that one normally encounters in other cultural industries.

A couple of years previously, back in 2003, Ian and Patrik had sat down to write a business plan that could pass muster with their bank manager. Already at that time they had imagined their enterprise as akin to that of a fashion atelier. They thought that they would produce objects at the low end in terms of price point – production work, like the candles and vases – and also at the high end, rather as a fashion house would make socks and underwear alongside fabulous gowns. By 2005, it was already becoming clear to them that they had been only half right: they would indeed approach things as a fashion atelier might, but would be concentrating almost entirely on haute couture.

Their timing could not have been better. They had intuited that a shift in the design field was underway, presaged by a handful of figures

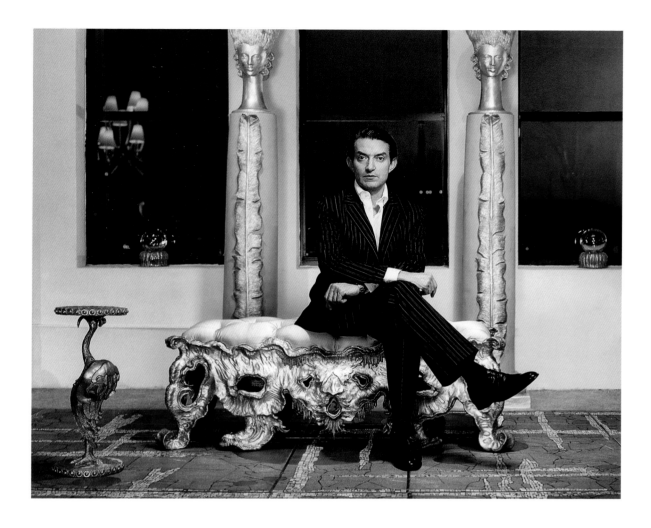

like Ron Arad. In this paradigm, designers would create one-off or limited-edition pieces, with the intention of selling to collectors and museums through galleries. Somewhat unfortunately, this orientation toward the high end came to be described as "design art," a term initially proposed by the auctioneer Alexander Payne, who used it in relation to a show at Phillips de Pury in 1999. From the get-go it was one of those odd pieces of language that is used almost entirely in scare quotes. Few designers accepted it as a satisfactory account of what they were trying to achieve, and the motivations behind its adoption (that is, chasing the higher prices that prevail in the art world) was too transparent to be convincing. Less than ten years after coining the phrase, even Payne himself distanced himself from its use, even as the prices for singular design works like Marc Newson's *Lockheed Lounge* were topping out.[3]

More problematically, the use of the phrase "design art" tendentiously suggested affinities among a diverse range of studio practices, which did not really exist; and it implied that the primary concern of the designers concerned was to be accepted as akin to fine artists, and that the key intellectual orientation within the field was to contemporary sculpture. This was extremely misleading, for while there are certainly connections between designers like Fredrikson Stallard and some fine artists – more on this below – the business model for high-end design is just as similar to contemporary fashion or music, with their cycles of product launches, heavy use of professional PR, and overall stylistic orientation. Tellingly, acute observers like the critic Henrietta Thompson not only noted Fredrikson Stallard's "cross-fertilization" with the art world, but also the way they fit into a broader stylistic register: "if the combination of rock'n'roll bad and innocent integrity works for some of the biggest brands and celebrities in the world, from Virgin to Kate Moss, it can work for these guys, too."[4]

4. A New Platform

Whatever problems the new nomenclature may have had, the game it sought to describe was definitely on. Shortly after the presentation of *Gloves for an Armless Venus*, Ian and Patrik were bemused to see the new furniture production company Established & Sons (founded by Alasdhair Willis, husband to fashion designer Stella McCartney) execute a lavish show for its inaugural presentation at the Salone del Mobile in Milan, essentially using the playbook that they had used at the TriBeCa Grand: dance music, theatrical lighting, a guest list heavy on fashion people and celebs, even a similar use of crates as display plinths. Within a short space of time, there would be a small ecosystem of galleries fostering design talent, and devoting their resources to the demanding fabrication of objects. The first to specialize in the field, arguably, was Galerie Kréo, founded in 1999 in the 13th Arondissement of Paris. In 2005 came Established & Sons, and the following year Carpenters Workshop, founded in Paris by Julien Lombrail and Loic Le Gaillard. In 2008, the storied London antiques firm Mallett launched a contemporary collection called Meta, headlined by two ambitious cabinets by the Dutch designer Tord Boontje.[5] America gained a new flagship in the field when Marc Benda, originally from Switzerland, went into partnership with Barry Friedman, the long-established fine and decorative art dealer, in New York City. (It is indicative of the strength of European design that Friedman Benda has focused primarily on international figures, with the exception of a few Americans such as Wendell Castle.) This initial burst of energy would be cut short by the recession of 2008, but the basic workability of the model was sound. Though Established & Sons was forced to close its limited edition showroom in St. James's, they and all the other galleries mentioned above did survive the downturn, and today are as active and ambitious as ever.

What the new galleries tagged with the "design art" label had in common was not a conceptual orientation to fine art, but rather an

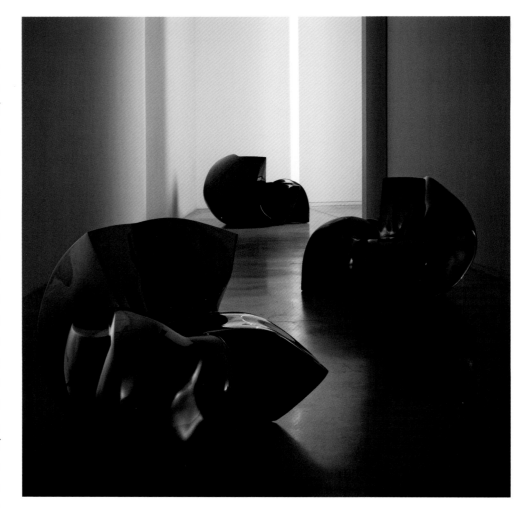

adoption of certain internal operating mechanisms and financial arrangements. There had of course been many ambitious design stores before, like Murray Moss in New York; and back in the 1980s, during the heyday of postmodernism, there had been galleries that showed furniture and other design, like Art et Industrie, again in New York, and En Attendant les Barbares in Paris.[6] There had also been an important role for limited editions in the design world, most famously those produced by Italian luxury companies like Alessi and Cleto Munari.[7] What the new crop of galleries did differently was to combine three strategies typical of the commercial contemporary art world: presenting work in curated one-person or group shows; representing designers on exclusive basis; and investing money in the production of limited edition works by specialist fabricators.

There was just one gallery that had been doing business like this in the 1990s, and that was David Gill in London. When he opened his gallery on Fulham Road, way back in 1987, Gill first

showed fine artists like Giacometti and Matisse, consistent with his background in the Modern and Old Masters department at Christie's. But he saw an opportunity to do something different: to present works of design within a broader intellectual framework than commercial venues typically allowed. He says that his training as an art historian was important in framing this intention: "when I work with an artist, I look at history. I look at the piece and ask whether it is contemporary. Is it derivative? Is it strong enough, as a new idea for the future? I always look at it from that point of view."[8] This set of criteria was quite unlike that of a high-end furniture store. Gill also had the perfect man to help him launch the new initiative: Donald Judd. The great minimalist artist had produced furniture since the 1970s, originally for his own use and subsequently as a design practice alongside his sculptures, employing some of the same principles but keeping the two rigorously separate.

Judd had shown his furniture at Max Protetch Gallery in New York, but had never exhibited the pieces in Europe. For Gill, Judd's work was the ideal way to begin: "it's plain furniture, but it merits more than one day of relevance. It becomes historical." Soon, reasoning that Paris was more a centre for design than London, he was working with the French partnership of Élisabeth Garouste

and Mattia Bonetti. They would become regular collaborators (and he has continued to work closely with Bonetti, who parted company with Garouste in 2002). Throughout the succeeding decade, Gill became increasingly involved in design, showing both contemporary work and historic pieces by figures such as Line Vautrin and Jean Cocteau. (He was also crucial in launching the career of the hard-to-place Grayson Perry.) In 1999 Gill moved to an expanded space in a Vauxhall warehouse, giving him the scale to show monumental work for the first time, including works by Zaha Hadid, who had been such an inspiration to Ian and Patrik earlier in their careers. In 2012, he opened a third space in the St. James area of London.

When it came time for Fredrikson Stallard to be represented by a gallery, David Gill was instinctively the right fit. The relationship with Citizen Citizen had fizzled quickly – though spirited and enterprising, it was a start-up and lacked the kind of network necessary to support ambitious design production and sales. Ian and Patrik also briefly showed work in the Marais district of Paris at a little gallery called Tools, run by Loïc Bigot. But following the positive impression from their participation in *Factio*, and the dramatic impact of *Gloves for an Armless Venus*, their scope of possibility rapidly expanded. Given the timing,

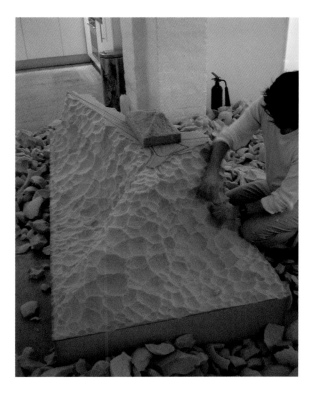

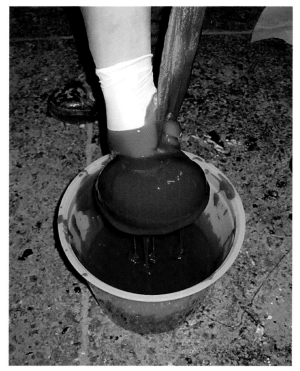

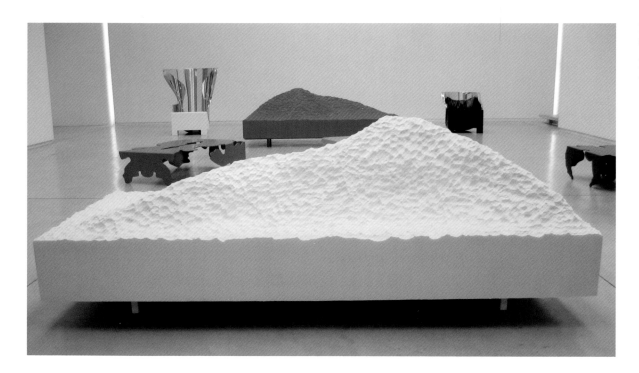

one might have assumed they would sign with the new and exciting Established & Sons, but they preferred the program at David Gill, and also were impressed by his initial response to their work. On one occasion shortly after they met, he plucked a twist of dipped foam off a shelf in their studio and inquired about it. Told that it was the model for a chair – a reply that would likely have puzzled most people – he admired it, and encouraged them to pursue the design. Thus *King Bonk* was born, with its accompanying ottoman.

King Bonk would be the focus of Fredrikson Stallard's second show at the gallery, in September 2008; by then, they had already scored a great success in their inaugural presentation in the spring of 2007 simply entitled *Furniture*, with a presentation anchored by the brilliantly conceived *Pyrenees* couch. The show also included the *Bergère* chair, the *Rubber Table*, examples from the *Unit* family, the poured urethane pieces *The Lovers* and *Rug #1*, and the *Aluminium Series*, tables made of 9mm thick folded metal based on Rorschach ink blots – a motif they have long favoured for its randomness, abstraction, and reference to psychological suggestion. Gill, for his part, had first been intrigued by the ice table that Ian and Patrik stationed outside of *Gloves for an Armless Venus*; he remembers asking himself how such a gesture could be rendered into permanent form

– a question that would eventually be answered in works like *Gravity* and *Antartica*, but was at that time an open-ended speculation. He was also struck by the working partnership between Ian and Patrik, the way that they were blending their different skill sets and backgrounds into a single unified approach.

Gill would go on to have a great influence on their career, not by micro-managing their creative work – they say that he only offers general suggestions, not narrow stipulations, "encouraging us to grow without telling us how" – but by offering a platform, and establishing certain parameters. A consistent aspect of his advice is that they should remain firmly grounded in the language of design, holding to functionality as if it were the gravitational field for their imaginative flights of

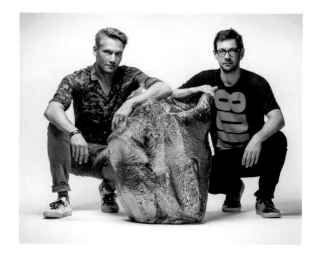

Consequences, 2015
bronze, concrete, various dimensions

Billboard, 2010
ceramic, paint, ink

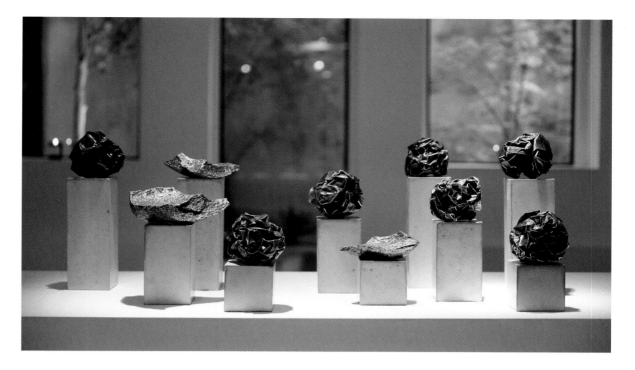

fancy. Yet he also supports their desire to indulge in speculative material experimentation, and to more or less ignore any preconceived sense of what a buyer might want to put in their home. In describing his role in their practice, he puts it very simply: "they get excited about a material, generate an idea, and begin working against boundaries to make it happen. I facilitate."

Gill's consistent practical support has doubtless been extremely important to Fredrikson Stallard. But so too has the overall creative ecosystem of the gallery. They have been more affected by his ongoing involvement in fine art than by the other designers he represents. One might not expect that Paul McCarthy would be a significant figure for them, for example – the L.A. artist's bawdy, image-rich narratives are a far cry from Fredrikson

Stallard's focused finesse. Yet McCarthy's work, which they first encountered through Gill in 2007, has influenced them in several respects. A small detail, which would likely escape many people's attention, is that before McCarthy casts an object he tends not to clean up the original. Detritus and other marks of making are often preserved – the "chaos of the process," as they put it. Particularly if the model is scaled up in size, these incidental elements can have an important presence in the final sculpture. A similar approach can be seen in Fredrikson Stallard's recent series *Hybrideae*, for example, in which the quick imprint of the hand is monumentalized in bronze. For them, this embrace of the happenstance speaks to McCarthy's general *modus operandi*, one that they increasingly have adopted, in which the object has the quickness and

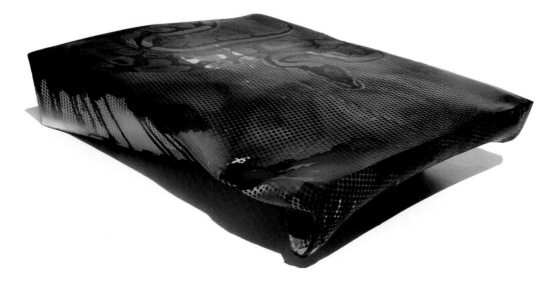

authenticity of a studio snapshot. Though it may be the outcome of long consideration, each work retains an instinctive urgency, edging up to the possibility of collapse. Many of their inspirations share this quality: the painter and sculptor Georg Baselitz, the choreographer Hofesh Shechter, or the writer J. G. Ballard.

Another lesson that Ian and Patrik have drawn from observing McCarthy and other fine artists has to do with the philosophy that underpins their studio practice. Back in 2007, when they first joined Gill, they noted in an interview, "our work is sculptural, but it's not purely fine art. We do have a love affair with art – especially with certain artists, such as Richard Wilson, and Andres Serrano – but we're more inspired by the way they think, the way they work, than the work itself."[9] Today, a decade later, they are not so inclined to make such a clear distinction. They do not declare themselves to be sculptors, being just as wary of that oversimplification as they are of being considered product designers. Like so many other practitioners in the twenty-first century, they have a post-disciplinary stance, in which those categories seem more like historical points of reference than stable identities.

In purely pragmatic terms, when it comes to the rhythm of the studio, their working habits do closely resemble those of a fine artist. These days, it can be difficult to tell exactly where each Fredrikson Stallard project ends and the next

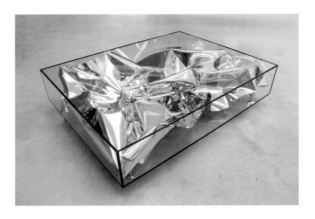

Silver Crush, 2011
glass, aluminium, steel

Momentum exhibition, London, 2015

begins; any one encounter with the work feels like a cross-section of ongoing concerns. This methodology contrasts with that of most designers – including Ian and Patrik themselves, in their early days – in which each undertaking is considered a distinct enterprise. "You're encouraged to dip in and out, and approach a new project with a clear head," Patrik notes. This is partly a practical matter. For most designers, an object is signed off when it goes "into production," that is, when it is handed over to a fabricator or a factory.

The iterative, circling experimentation employed in the typical fine art studio is quite different from this goal-oriented approach, and for Fredrikson Stallard it feels like a better fit. Rather than start from scratch on each project, they have built up a vocabulary of forms that they can deploy at will across various contexts. Sometimes this process yields curiosities like the knurled metal spheres they call *Consequences*, small abstract forms that seemed to them to possess their own

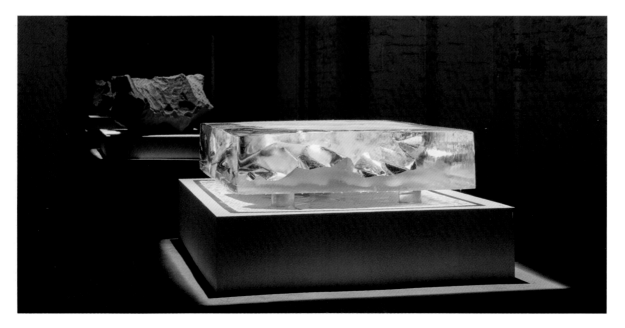

value, as traces of the making process. Sometimes the same open-ended process results in an entirely comfortable sofa. The continuity throughout is that they are continually revisiting their own repertoire, considering it from new angles and putting related solutions to different ends.

This constant reinterpretation sits somewhat uneasily with the conventional practice of limited editions, which guides the production and sale of most contemporary high-end design. In principle, the logic of editioning is straightforward enough. Given that a product requires a long period of development and investment, it certainly makes sense to create more than one, so that these costs can be recouped. On the other hand, making too many of a particular object would flood the market, and depending on the making process involved, might also stretch quality control. The solution, originally adapted from historic practices of printmaking and photography, is to establish a limited run of identical pieces. Typically the size of the edition is stipulated in advance so that buyers are informed as to the rarity (or lack thereof) of their purchase. A well-known example in the domain of fine art is the work of Jeff Koons, who is famous for his perfectionism and ambition. In most cases, it has been impossible for him to realize his work without editioning. Thus there are five of the iconic *Balloon Dog* sculptures, each in a different color; as the curator Scott Rothkopf remarks, "the break-even point on fewer examples would have been impossibly high. There couldn't have been one without the whole litter."[10]

The limited edition practices in contemporary design are fairly standardized. Each piece is usually produced in a batch of one dozen on an "8 + 2 + 2" formula, that is, eight works for sale, two prototypes, and two artists' proofs. The prototypes may have some variance, and allow leeway while the form is being developed to its final state, while the proofs are retained by the studio and gallery for use in exhibitions, or as reference for subsequent projects. In theory, this has always been the standard arrangement between Fredrikson Stallard and David Gill Gallery, but in truth they often depart from it. The *Crush* tables, which

premiered at Design Miami/Basel in 2011 and were featured in a show with Gill the following year, follow the usual rule. There are three versions of the design in silver, gold and black, which have very different affects – industrial, luxurious, and saturnine, respectively – but are made in more or less the same way. Each was made in the standard edition run of 8 + 2 + 2, so there are 36 in total. The later design *Species*, however, was approached in a totally different way. It was initially made in a group of three handmade prototypes in varying shades of deep, Rothko reds. ("We use the same colour pigments for all the *Species*," they note, "but in different ratios to achieve the different reds, from a bright red to saturated dark burgundy and plum tones.") This trio of objects was shown in a presentation entitled *Momentum* held at the designers' studio rather than with David Gill. The gallery did, however, take on the management of *Species II*, which are scanned from an original and then CNC-carved, to produce an edition of twelve. Recently, Ian and Patrik created a version in a new silhouette, entitled *Species III*, which only exists as a single prototype – so far.

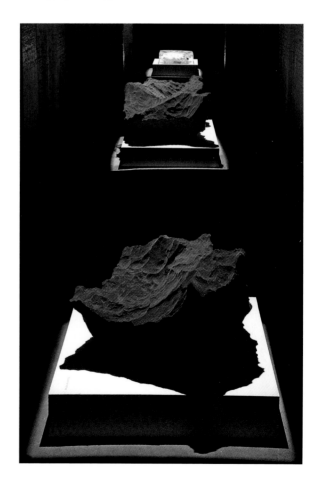

5. Aiming High

How are these decisions made? Partly it is a matter of the specific production techniques involved. While each *Crush* table is made by hand, the process is not so laborious that an edition of twelve is out of the question, nor is the variation such that the edition seems at odds with itself; each work is in fact unique, but the parameters for variation are fairly tight. In the case of *Species*, the hand-picked foam is both more labour-intensive and more variable, making an edition of handmade pieces seem inappropriate. They would simply be too different from one another. The use of CNC yields consistency, but also a noticeably different, softer effect in the form. So the distinctions between the prototypes and the edition are substantial.

However, this issue of physical manufacture is only one of the factors that Fredrikson Stallard must take into account when deciding how many of a piece to make, and how to calibrate its offer to the market. They are constantly considering questions of functionality – pieces that are less well-adapted to everyday domestic use are more likely to remain prototypes – and also their own willingness to adapt certain ideas to suit a client's wishes. For example, they may ask themselves of a given design: would they be happy to make it in a different color? To set the tabletop one inch higher off the ground? These are questions, which fine artists do not usually face, that can be very important in defining the identity of a given design.

Matters are further complicated by the fact that when Ian and Patrik are developing a work, they are not necessarily clear on what its eventual status will be. Will it remain a one-off, or be produced as a limited edition? Will it be the basis for a whole collection? An experiment that will never see the light of day, but may influence other projects? The final decision is made only once the work is approaching resolution, and in consultation with the gallery. Over time these innumerable choices, in which pragmatic and artistic issues are resolved one by one, have accumulated into a position: one in which quality of execution is the highest priority.

Here we touch on a thorny issue, and one hardly unique to Fredrikson Stallard. There's no way around it; their work is expensive. They have on occasion been accused of elitism – of making objects only for the wealthy – or simply asked whether they would consider creating objects for

Species I, 2015
detail, polyurethane, glass fibre, polyester

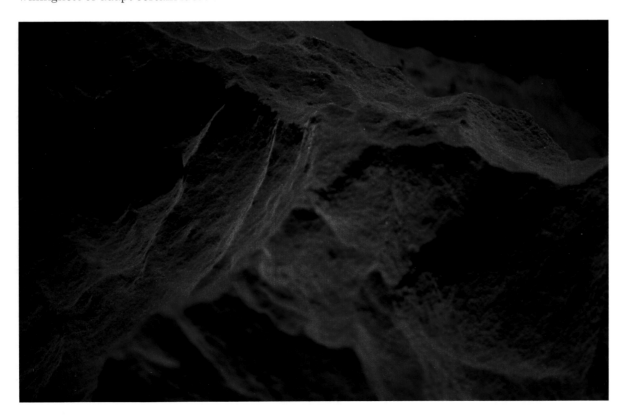

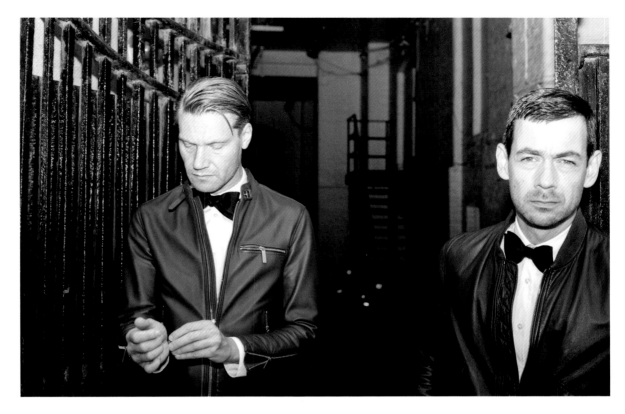

a mass market, alongside their limited edition and one-off objects. It might seem easy enough to increase the accessibility of their work by this means. But it would hardly be straightforward to adapt their approach to mass production. Even if they could persuade a manufacturer to create a run of (say) ten thousand *Species* sofas and sell them at competitive prices – which seems unlikely – how many people would buy such an unusual object? And what sacrifices in quality would have to be made in the process? It is true that their work is costly, but as William Morris knew well, that has always been the unavoidable implication of fine craftsmanship. Fredrikson Stallard have occasionally made successful designs for mass production – their *Hyde* chair for Bernhardt (2009), for example, won the Red Dot Award for its combination of sleekness and broad proportions, and they have done some effective design work for the Italian furniture company Driade. But this is clearly not where their primary interests, lie.

It is also worth noting that, in the years since Ian and Patrik began working together, the middle tier of the design market has weakened considerably. Long-established companies aiming at middle-class consumers, like Heal's and Habitat, do still exist. But the more successful strategies seem to be those on the margins: galleries on the one hand, Ikea on the other. The efficiencies of mass production and distribution – both of which have been much accelerated by digital technologies – have intensified price competition. Increasing income inequality doubtless contributes to the divergence as well. For designers, the impact has been considerable. No matter what the level of quality, the royalties offered for contract design are vanishingly small, certainly not enough to support many successful independent studios. Those furniture companies that do aim for the middle market, like Cappellini, Knoll and Herman Miller, rely heavily on their extensive back catalogue of midcentury modern masterpieces, further reducing investment in new design.

Against this backdrop, and given their proclivities for intensive material investigation, it is hardly surprising that Fredrikson Stallard have aimed high rather than seeking out the mass market. But of course this strategy is itself not always an easy one; it requires constant attention not only to objects themselves, but also to the public profile of the studio. Like most artists and designers, Ian and Patrik's relationship to the

second-order phenomenon of PR is complex. On the one hand, they see how the promotional vehicles for design tend to flatten out its programmatic aspects; when their objects appear online and in magazines, they do so primarily as images with little intellectual armature. At its worst, design promotion can be an echo chamber, particularly with the advent of social media and clickbait-driven websites.

On the other hand, Fredrikson Stallard have a sophisticated understanding of this process of mediation, and have been more successful than most in managing it as a platform. With the experience of *Gloves for an Armless Venus*, they had an early taste of successful promotion, and they have remained adept at it since. Their general policy is to eschew framing their work in terms of stereotypical lifestyle – attractive models lounging on the furniture in posh flats. Sometimes their work is shot in an isolated manner, on a white seamless backdrop, which is of course its own stereotype. But ideally, resources permitting, they try to secure photographs that are not just neutral records, but creative works in their own right. Of late they have tended to commission extreme close-ups of their work,

which simultaneously emphasize the play of scale in their work (faced with a shot of *Species*, one might wonder, is this a mountain or a molecule?) and quality of execution. On occasion they have abstracted photographs of objects to the extent that they afford only a tantalizingly incomplete impression of an object – it can only be fully appreciated in person.

Ian and Patrik are also called to pose for portraits very frequently. Again they resist stereotype, the classic shot of the designer, poised in the act of creation, pencil in hand. They almost invariably appear together, a couple and a partnership, dressing the part of the urbane gents that they are – "calm, grownup and proper," as Patrik laughingly puts it. They are aware that any representation in the media is going to be partly spin, and are not so naïve as to believe that there is a way to avoid it. ("The fine art world does plenty of PR," as they point out, "it's just better disguised.") To the extent that they can, however, they aim high in the realm of representations, just as they do in the work itself. Their overriding goal in generating secondary images is to pave a path back to the work itself, and its ineffable physicality.

Patrik Fredrikson, Nadja Swarovski & Ian Stallard with *Prologue* at the Belvedere Museum, Vienna 2016

Opposite page
Eden, 2014
brass, Swarovski crystal
Swarovski Kristallwelten

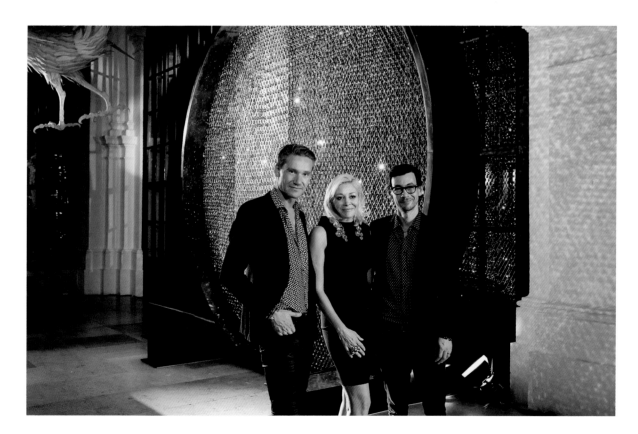

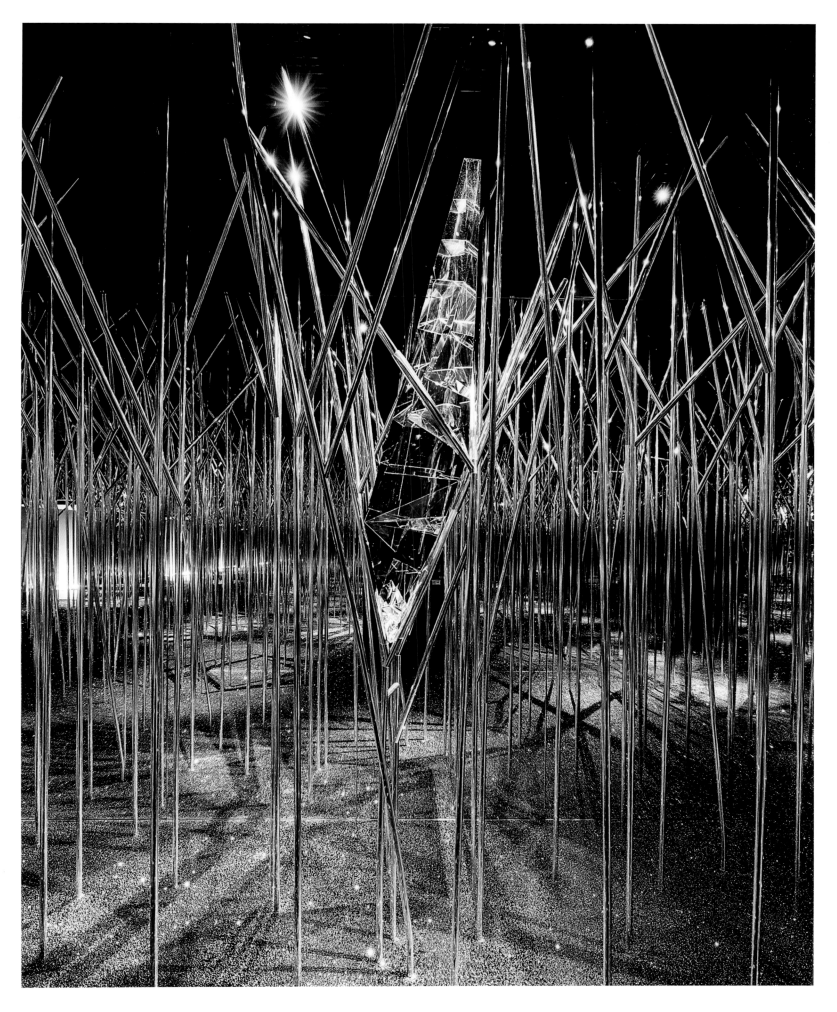

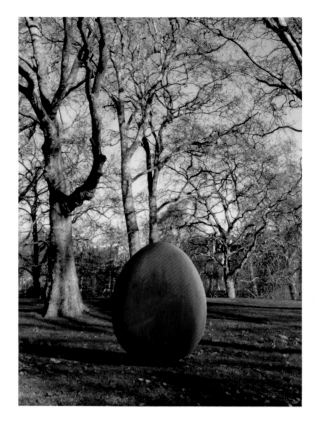

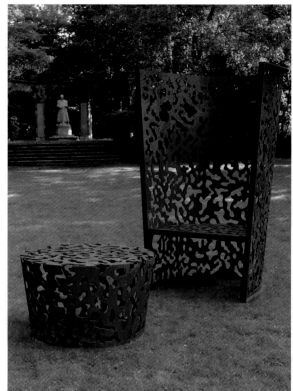

6. The Public Eye

Just as things were starting to get rolling with David Gill, another important person came into Fredrikson Stallard's orbit: Nadja Swarovski. She is an unusual figure within the corporate world – indeed, within any world – having joined her family company's executive board (the first woman to do so) at the age of 25. She immediately infused the brand with a new level of fashion-forward relevance. From the outset, Nadja was determined to enhance the awareness of Swarovski crystals in the domains of high design and fashion, and she had the instincts to do that well. In 2002 she initiated the Crystal Palace showcase at the Salone del Mobile in Milan, and under her creative leadership the company has maintained a strong program of art fair and museum presentations.[11]

With the possible exception of Tord Boontje, there has been no collaborator more significant to Swarovski's design profile than Fredrikson Stallard. Nadja says that she was initially attracted to the pair at this emergent stage in their career because they were young and cutting-edge: "their work is not sarcastic or ironic, but always has a twist, always allows a different point of view. And because of

the camaraderie within the design field, we felt comfortable mixing people at different career levels."[12] The instinct paid off. Beginning with the kinetic chandelier *Pandora*, presented at the 2007 Crystal Palace, they have completed a great range of projects with Swarovski: further one-off public sculptures (*Cavern*, 2008; *Iris*, 2011; *Prologue*, 2014; and *Eden*, 2014); two jewellery collections (*Space Flowers*, 2013, and *Armory*, 2015); a collection of fixtures incorporating custom-fabricated crystal components (*Glaciarium*, 2016). Ian and Patrik regard Nadja Swarovski as an immensely important patron, their Medici: "rather than having to depict religion, we get to use crystal." She in turn regards them as ideal collaborators, "investing so much thought in everything they do, and not working in one specific style. Each project is different, but they always strike a chord."

Clearly, Fredrikson Stallard's relationship to Swarovski is exceptional, but they are only one of several steady corporate clients. Working in this arena, they have come to prize consistency and duration in their relationships above all. While they have achieved satisfying results in one-off commissioning situations , they prefer to be able to contribute to the company's overall

Fabergé Egg, 2012
Cor-Ten steel

Camouflage, 2016
powder coated aluminium
Driade

Portrait, 2008
Cor-Ten steel

brand profile, sustaining a narrative across multiple projects. Often, the key is one decision-maker in the corporate structure who will back the partnership. Another example of this in Fredrikson Stallard's portfolio is their work for Driade, which was developed with the support of the company's founding director Enrico Astori (the connection came through Marva Griffin Wilshire, creator of Salone Satellite, a showcase for younger designers in Milan.)

The mirror and table forms they created for the Italian furniture company Driade in 2014 clearly derive from the concerns of the studio at that time – similarly craggy, rock-like forms appear in the *Species* works, as well as the *Glaciarium* collection for Swarovski. One of the Driade pieces, *Sereno*, is particularly memorable, with the sculptural elements penetrating the taut tabletop. It was inspired by the experience of swimming in a Swedish lake and seeing rocks poking out of the water, the asymmetrical forms reflected perfectly in the mirror-like water. More recently, Fredrikson Stallard have completed a range of outdoor furniture, *Camouflage*, which continues the organic theme. The openwork pattern laser-cut into the aluminium does evoke military camouflage, but also dappled light falling through a forest canopy.

Another arena in which Fredrikson Stallard have excelled is public art, typically in commissions that arose through their company patrons. The first such project they completed, under the auspices of champagne house Veuve Clicquot, was *Portrait*, and in addition to their public works for Swarovski, they have also completed projects in association with Fabergé and Jaguar. As anyone who has ventured into the domain of public art knows well, it is a fraught undertaking with numerous stakeholders, and it is not surprising that some of Fredrikson Stallard's best work in this vein has gone unrealized. In 2012, for example, they developed a project for the Church of St. John, a parish church in Hackney. That year, London had experienced its first mass uprising in many years, the Tottenham riots, which were touched off by an episode of police violence. Religious organizations

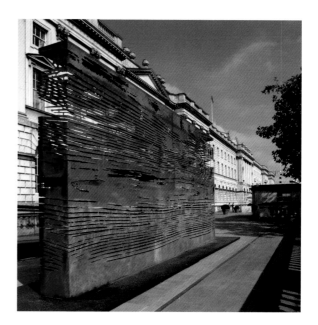

were on the frontline, offering both literal and figurative sanctuary. They were spaces in which the community could come together to heal following the unrest, but also targets: St. John's had a brick thrown through one of its windows.

With these events in mind, Fredrikson Stallard proposed a breathtakingly beautiful composition in stained glass, a pattern of radiating cracks in varied tints of blue. Formally, the work relates to their longstanding interest in reflection, plays of light, and disruption. Clearly, against the backdrop of urban violence, the design was provocative, and the congregation ultimately did not approve it. This is a shame, for the works formal and narrative simplicity belies its potential for multiple readings – for example, it could be understood to depict not an act of vandalism, but the dramatic entry of God's spiritually enlightening presence. The piece finally satisfies the question raised earlier, in relation to the designers' early avant garde gesture *Brush #1* (2002; see p. 75); say you've yelled "fuck" in a church. What do you do next? The Hackney window lives up to this challenge. As a contemporary religious icon, it strikes at the heart of the matter of spirituality, perhaps uncomfortably; had it been realized, however, it might well have provided parishioners with a powerful emotional anchor.

Another public artwork that has gone unrealized to date, entitled *Ferrum*, is perhaps their most ambitious project. It was originally

Space Flowers cuff, 2013
gold plated brass, Swarovski crystal

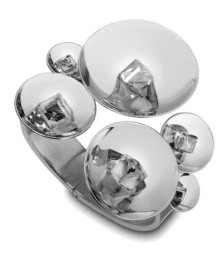

conceived to be set within an office tower in D3, the new Dubai Design District. Typically for the city's architecture, the building has a soaring atrium surrounded by tiered balconies. Fredrikson Stallard were intrigued by the unusual configuration of the vast interior. Working from their longstanding interest in lens technologies, such as telescopes, they conceived a giant tube, some eight meters in length, which would slowly rotate in the space. The tube was to be fabricated from Cor-Ten steel, their preferred material for public artworks, but here with an additional resonance given the constant presence of construction cranes and suspended pipes and girders in the Dubai cityscape. The interior of *Ferrum* was to be lined with Swarovski crystals, like a *pavé*-jewelled cuff turned inside out. As the sculpture swivelled on its mounted cables, at a hypnotically deliberate pace, it would periodically align with a bystander's position. Suddenly, the rusted matte exterior of the tube would give way to an interior view, fiery with refracted light. The sculpture would have provided a dynamic visual connector for the tower atrium, and for those familiar with the studio's work for Swarovski, would have recalled the graceful movement of *Pandora*, their first commission for the company.

7. Why (and How) It Matters

The high-contrast experience of *Ferrum*, in which heavy metal unexpectedly yields to optical spectacle, is one of the most dramatic examples of Fredrikson Stallard's theatrical way with materials. That approach is, however, pervasive in their practice. Where many designers begin from a function, or an image, or a particular cutting-edge device, Ian and Patrik almost always generate their ideas through engagement with actual substances, often with their bare hands. The production of their work, too, tends to be thoroughly artisanal: they have become connoisseurs of processes such as metal-forming, gem-cutting, and lost-wax casting, and have invented a few processes their own, such as the patient folding required to make the *Crush* series and its variants. We have already seen how intrinsic this materially intensive way of working is to their creative vision; but it is also worth considering how it positions them within the firmament, not only among designers, but in the still larger context of early 21st century cultural production.

Initially, one might assume that Fredrikson Stallard's dedication to solid craftsmanship would render their work anachronistic. It seems almost

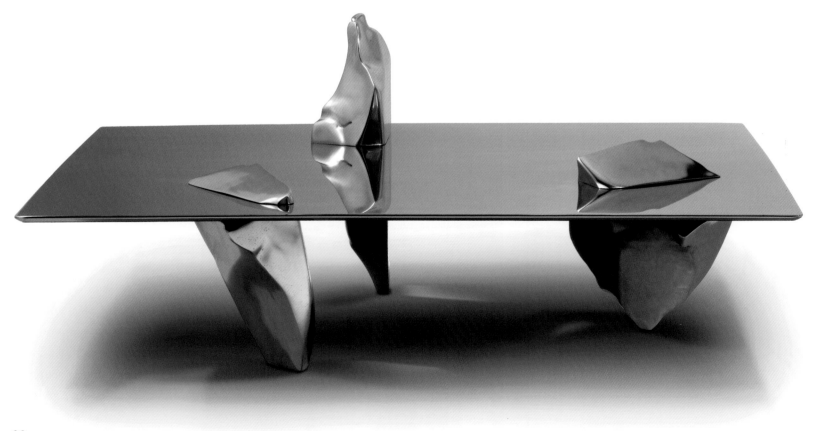

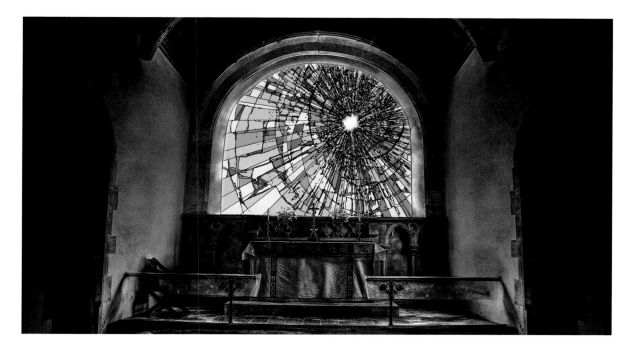

too obvious to mention, but it is important to remember that the biggest story in 21st century design has been the rise of the digital. Armed with our devices, we are connecting to each other in all sorts of unprecedented ways; this in turn has wrought effects in the technological, financial and political sectors that range from the thrilling to the dismaying. Design has been the midwife of these dramatic transformations, giving smooth shape to our expensive digital products so that the disruption and upheaval they portend will be more easily digested. The inoffensive, proficiently crafted curves of an iPhone make it a cultural suppository. It goes down easy – so easy in fact that we may not stop to wonder what is happening until it is too late. Credit, or blame, for this masterful blend of bling and bland is usually given to Jonathan Ive at Apple, as if he had invented it all by himself (or worked it out over lattes with Steve Jobs). In fact, he is only the best known of a legion of designers working in similar idioms and to the same purpose, in many branches of product design. The smoothed-out smartphone look, and a concomitant degree of digital augmentation, can now be found in everything from refrigerators to toasters. It may all seem quite futuristic – though as we know from looking back at the 1950s, nothing dates quite as hard, or as fast, as a confident gesture to tomorrow.

In any case, Fredrikson Stallard quite clearly could not be more different to this approach.

The care that they take in fashioning their objects is a thoughtful response to the wave of dematerialization that the digital has brought. That does not make them rear guard partisans (and it is important to say this right away). In many of their projects, computer-based techniques are exploited to brilliant effect – quite literally so in the case of the *Glaciarium* crystals, for example, which appear to have been mined from deep within the earth but were actually delicately contoured on screens in the studio, and then fabricated by Swarovski using the latest in digitally-driven cutting tools. So clearly, Ian and Patrik are no Luddites. They do, however, avoid gimmickry of any kind – you will never find a Fredrikson Stallard object that is "enabled" to perform some service or other, or "networked" to a system beyond itself. Immediacy is, for them, a guiding principle.

Consider the difference between their show-stopping chandelier *Pandora* and the equally spectacular centerpiece of the previous Swarovski Crystal Palace, Ron Arad's *Lolita* (2004). Nadja Swarovski remarks, "we're all asking ourselves whether digital technology will humanize us or dehumanize us; and it's counterintuitive, but every time we've introduced technology to a chandelier, it has become more human – it's exactly the opposite of what you might expect. Both Ron Arad and Fredrikson Stallard achieved that, but in different ways." Arad's design stunned

audiences with its interactive capabilities. It was lined with over 1000 LEDs, which could display text messages sent to the chandelier by visitors from their devices. The text messages – a novelty at the time in their own right – flowed along its graceful spiral form, the illuminated data points flickering in compelling juxtaposition to the sparkling crystals. If Arad's chandelier wears its technology on its sleeve, then the arcane workings of Fredrikson Stallard's *Pandora*, by contrast, are entirely hidden from sight. Indeed, the whole point of the piece is that its gliding motion feels magical, as if the chandelier were a fixture purloined from an enchanted fairytale castle. It is not a showpiece for the power of the digital, like *Lolita*, but a subtle application of digital techniques to produce a real-world effect. *Pandora* is a quintessentially twenty-first century design, yet it speaks to age-old human imaginings.

The approach taken to the digital in *Pandora* typifies a key dynamic in Fredrikson Stallard's work. While there is often great complexity underlying their work, they always want to stage a direct, sensuous encounter with the physical realm. This establishes them as leading exemplars of a trend in recent design, which is sometimes described as the "new materialism." Like most catchphrases, this one can be confusing: it was originally coined by theorists Manuel DeLanda and Rosi Braidotti (independently of one another) in the late 1990s. In the thought of both writers, idealist models of history (most notably, those derived from Hegelian dialectics) were rejected, in favor of a more diverse set of materially-based explanations. Instead of understanding historical change in terms of big abstractions, like capitalism, linear progress, or the "information age," they argued that we should see society as being shaped by specific material conditions, like economies of scale, technological infrastructure, the gendering of space, and impending ecological crisis. They called for precise analyses of such material phenomena, without presuming that a single synthetic model would account for them (this is the point at which they differed with Marxism, which had previously dominated materialist accounts of history).

They further argued that society is shaped by the multiple complex interactions within the material register: change happens within and arises from these material configurations, it is not imposed on matter from above. DeLanda in particular has remained a prominent voice in recent years, and his approach has been influential among political theorists, sociologists, architects, and physicalist philosophers.[13]

If this all sounds somewhat complicated, it is; and certainly, it would be incorrect to make a direct analogy between the work of thinkers like DeLanda and designers operating under the banner of "new materialism." Generally, in the design field, the term is not used to describe a philosophical position, but a pragmatic method. Neo-materialist designers begin with the formation of matter itself. So, instead of buying an existing set of materials off the shelf (plywood, tubular steel, whatever), they intervene at an earlier stage in the production cycle, giving shape to the stuff that the object will eventually be made from. Often, this methodology does incorporate new technology, as in the field of "smart textiles," in which fabrics are embedded with remarkable new properties through the engineering of their fibers or structure.[14] The phrase "new materialism" has also been used to describe the beguiling practice of Neri Oxman, whose objects – furniture, body ornament and architectural panels – are developed according to the logic of genetics.[15] Oxman is based at the MIT Media Lab, a headquarters for this kind of research. Another is the Eindhoven Design Academy in the Netherlands, where another neo-materialist wunderkind, Joris Laarman, trained, graduating in 2003. In the years since, Laarman has created what is arguably the most impressive single oeuvre in technologically-driven design. Sometimes he draws on biomechanics as Oxman does, as in his *Bone Chair* (2006); more often he follows the logic of digital tools themselves, as in his *Dragon Bench* (2014), which is drawn in space with a customized metal printer maneuvered on a robotic arm.

Not all new materialist designers employ advanced technology. Indeed, for most working in this field, the appeal of developing substances

Glaciarium component, 2017
Swarovski crystal

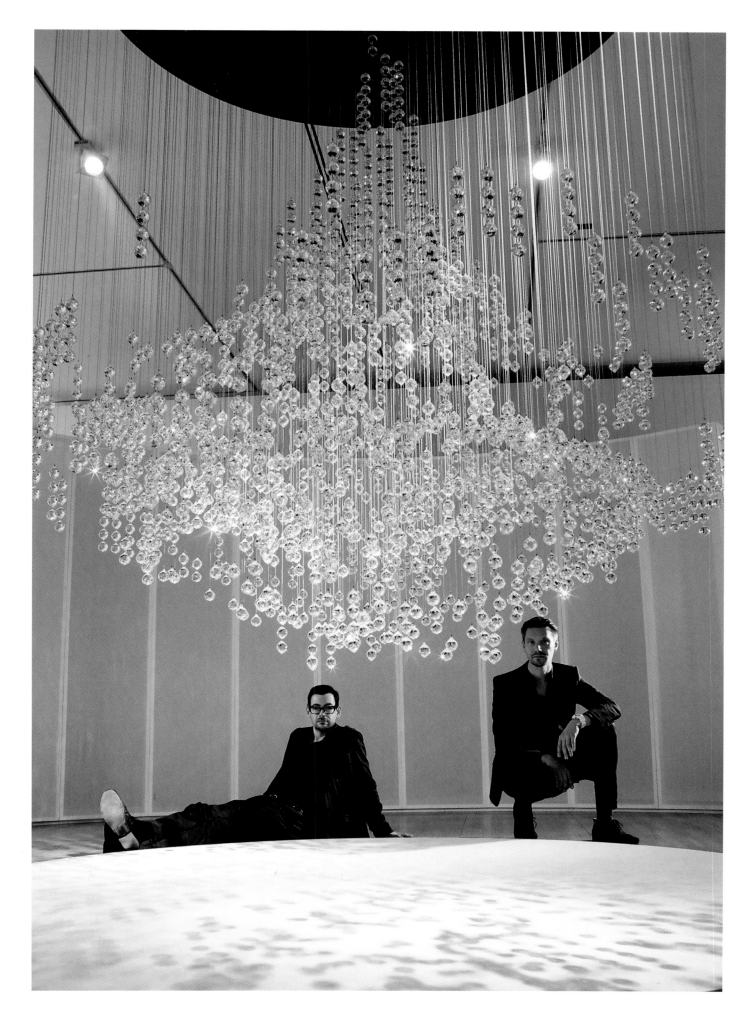

"from scratch" is that it affords autonomy from the commodity chain, and permits the designer to completely control the aesthetics and ethics (such as ecological footprint) of their work. Avoiding advanced technology helps to preserve this autonomy. Often, a material will be developed prior to determining a specific use, keeping parameters open as long as possible so as to encourage creative breakthrough. Leading examples of studio-based practices in this vein include: FormaFantasma (Andrea Trimarchi and Simone Farresin), who have made objects out of mouth-blown and cast lava, naturally occurring polymers or "proto-plastics," and a casting material composed principally of sorghum flour; Marlène Huissoud and Tomáš Libertíny, both of whom have made objects using the natural deposits of insects; Julia Lohmann, who has conducted a long-term research project on the potential of ecologically plentiful kelp and other seaweeds; Hella Jongerius, who has experimented with a natural latex called chicle; and Max Lamb, who creatively adapts primordial forming techniques like chisel-carving and sand-casting. (Lamb has also partnered with the entrepreneur Brent Dzekciorius to create a commercially viable marble replacement called *Marmoreal*, composed of reclaimed waste like dust and chips.) One must also mention here the singular figure of Gaetano Pesce, the Italian maverick designer whose experiments with rubber, fabric and other materials, beginning in the 1970s, anticipated many of the concerns of this current generation.

Again, it is not straightforward to draw a direct line between designers like these and philosophers of "new materialism" like DeLanda. However, it is certainly possible to see these two practical and intellectual currents as allied to one another. Both emphasize materiality as an autonomous domain of effect. The commonality is the thought that, by focusing on matter *per se*, we can find a secure and stable framework of reference. Materials stand obdurately outside the "spin" of mediation, distorting ideological narratives, and the fragmentary distractions of online experience.

On a basic emotional level, then, "new materiality" offers respite. On a practical level, it is a way to generate authentic new forms. On a theoretical plane, it can be viewed as a possible means to claim a place for individual subjectivity. In the political register, finally, the emphasis on materiality channels age-old conceptions self-reliance as a necessary basis for critique, and also connects to a more recent sense that "the people" need to take matters back into their own hands (a feeling shared on both the left and right ends of the spectrum, by the way). As Adam Szymczyk, curator of *Documenta 14*, has put it: "we were told for so many years that physical presence was no longer important in politics, that the body had been subsumed by social media. But suddenly, it has become important to put your body forward."[16]

Fredrikson Stallard occupy a distinctive position within this diverse field of thinking and making. With a few exceptions – such as the early work *The Lovers*, a passionate emblem of gay identity, or their proposed window for St. John's in Hackney – their work is not overtly political. Also, unlike most of the neo-materialist designers mentioned above, they do not tend to construct their narrative around making processes. When Libertíny conceived his *Honeycomb Vase* in 2005, he framed the conversation around the piece in relation to a single fact: it was an object made entirely by bees. Critical reception to the work followed suit, with journalists and curators invariably focusing attention on this novel method of fabrication. There is certainly nothing wrong with this approach. The design was a great success, acquired by MoMA, shown at the V&A, and widely covered in the design press. But it meant that the object operated at the level of anecdote, like an exotic item in a cabinet of curiosities. Nowhere in public discussion of the *Honeycomb Vase* (including Libertíny's own comments) does the actual form of the object – roughly similar to a Chinese urn, with a globular body and conical neck – seem to register as being important. Equally indicative, over several editions of the piece, Libertíny has allowed its shape to wander into various amorphous variations, sometimes with polyp-like "handles," sometimes lurching to one side, sometimes with vertical fins. His allows the bees to have their way.

It is impossible to imagine Fredrikson Stallard adopting such a laissez-faire attitude, or allowing a storyline like "made by bees" to take precedence. Instead, their emphasis is on an ongoing campaign of aesthetic accomplishment. They are as prolific as any designers working today, and increasingly, it is clear that they generate meaning at the level of the practice as a whole, rather than through the accumulation of one-off projects. In this respect, they differ somewhat from even their closest peers, like FormaFantasma, Joris Laarman and Max Lamb. All of these designers are certainly involved in ongoing developmental research, but their initiatives tend to be relatively discrete, and when presented to the world, are framed (like the *Honeycomb Vase*) in terms of a specific generative process. For Fredrikson Stallard, materiality is conceived more as a continuous, shifting terrain of exploration. Works arise within this holistic process, and are perfected, but the onward journey is the ultimate priority.

In some ways, this book – with its focused discussions on individual pieces, including descriptions of manufacture – exists in tension with Fredrikson Stallard's overall philosophy. They make no secret of the fact that the *Species* seats are fabricated in polyurethane, the *Tokyo* table of stainless steel, *Gravity* in acrylic. It's all public. And they are certainly interested in the way that these various materials inflect the meaning of the works in question. But they also prefer to preserve a degree of mystery around the techniques they employ, not for proprietary reasons, but because they do not want to fetishize their own procedures. It is telling that FormaFantasma, Laarman, and Lamb make beautifully produced how-was-it-done videos, shot in their own studios. Again, it is hard to imagine Fredrikson Stallard ever doing this (though Swarovski has occasionally released "behind the scenes" footage relating to their designs). What they are after are affective forms, not demonstration pieces.

And so, while you will find accounts in these pages of how Fredrikson Stallard's works were realized, this should not be taken as implying that their work is about process in any narrow

sense. In conversation, Ian and Patrik often adopt the metaphor of painting to describe their compositional approach. They are as apt to make the comparison when speaking of the *Crush* tables, with their folded aluminium sheets, *Avalanche*, made with fragments of glass, or the recent body of works *Reformation*, bronzes cast from cardboard. None of these works is painted in any literal sense, obviously, but from the designers' point of view, it still makes sense to speak in this way. Like painters, they are always thinking about the disposition of form – how they can combine multiple incidents within a total effect. Each fold, break, or tear is like a single brushstroke. To get to the point of engaging with their objects in this way, they must undertake extensive experiments; but these investigations are not an end in themselves.

Among neo-materialist designers, Fredrikson Stallard's reluctance to stake their claims on material innovation makes them anomalous. Laarman's *Dragon Bench* is a beautiful object, to be sure, but it is primarily motivated by the formative potential of instrument used to make it. The studio website notes that this mobile metal printer, which Laarman calls MX3D, has "the capacity to 3D print smart, functional objects composed of sustainable materials in virtually any shape."[17] (He has since used the tool to make a footbridge.) This is amazing, no doubt. But Fredrikson Stallard aren't interested in "virtually any shape." They strive for particular aesthetic results, and are happy to let the processes involved remain in the background.

It does still make sense to speak of their practice within the overall rubric of "new materialism." They are no less concerned than Laarman, or any of their other peers in this arena, to establish a deep, nuanced relationship with physicality. And this posture has a clear philosophy behind it. They see their work as existing in counterpoint to prevailing trends of digitization, and as making a quiet case for the satisfactions of considered craftsmanship. These are socially-aware positions, with their own complex history. At the end of the day, though, they are primarily oriented to the ends, not the means. The path they use to get to where they are going may have its fascinations, but it is never the center of attention.

8. Past and Presence

Having now situated Fredrikson Stallard more clearly within the present-day context, we can move on to show how they work in the reflected light of the past. Ian and Patrik are by no means old-fashioned connoisseurs (they do not collect antiques, for example) but they do have great visual literacy in the decorative arts. Elsewhere in these pages, I refer to their overall style as "baroque minimalism", a phrase that is compounded of two specific historic idioms, which they have managed to unify despite their seemingly antithetical character. The baroque, here, is not meant just as a superficial stylistic signifier. They are keen observers of this historical idiom, which initially developed in Catholic Europe in the era of the counter reformation, and gradually proliferated from there, as far as Latin America and India. It has been called the first global style.[18]

The hallmarks of the baroque, all of which find correspondence in Fredrikson Stallard's work, are several. First and foremost, it is a theatrical mode, in which effects like high-contrast lighting and monumental scale are employed to awe and inspire. Second, it is frankly emotional in affect, operating at a high pitch of intensity. This relates to a third and final quality, that of constant motion. From the drapery of a Bernini sculpture to the swirling composition of a Rubens painting to the vaulting architecture of Borromini, the baroque takes us on a thrill ride of internal movement, which is often keyed into an iconographical program of dramatic story-telling. Yet it is, at the end of the day, a classical style. Baroque composition is not just a free-for-all. Its unruly energies are controlled through compositional intelligence, formal systems (such as the classical orders), and exquisite craftsmanship.

Fredrikson Stallard's most important aesthetic breakthrough has been their substitution of Minimalist principles for these classical constraints. They have borrowed extensively from the work of 1960s industrial sculpture, that of Donald Judd particularly, as a way to impose order on the more chaotic elements in their work. Among the lessons they have applied from Minimalism are a propensity for geometric regulation – which accounts for the rectilinear profiles of many of their works, and their extensive use of straight cross-sections – and the idea of the 'Gestalt,' that is, a strong overall shape that cannot be easily broken down into parts.[19] They also have adapted Judd's approach to colour, which is highly specific and always bound up inextricably with material expression; and of course, they are deeply invested in industrial materiality, which imposes its own rigours. All of these aspects of Minimalism serve, like the classical elevation of a baroque church, to unify what would otherwise amount to an uncontrolled material expressionism.

Fredrikson Stallard's engagement with the baroque, and their instinct to replace its classicizing elements with modern traits, was present in their work right from the beginning. Early in their career, they occasionally made explicit copies of historical objects, with a Minimalist twist – the one-piece monochrome *Candle #1*, and several takes on traditional Ming vases. Another early work, the *Bergère* chair, has lines that closely echo a high-backed Chesterfield or other curvilinear baroque seat, but is rendered in an *echt* Minimalist palette of stainless steel and rubber. In more recent years, their glosses on traditional form have been more abstruse, but they are definitely still present, and still inflected by industrial aesthetics. When two gold *Hurricane* mirrors were set into niches in the Great Marble Hall of the Belvedere Museum in Vienna, it was suddenly obvious that their DNA lay in a baroque form called the pier mirror, which was designed primarily to reflect light back into a chamber, adding to interior illumination in a time before electricity. That function is no longer relevant, but the conception of the form – a large, shining surface that activates a larger space – was powerfully attractive to them.

Such specific historical types give Fredrikson Stallard a helpful jumping-off point, a framework

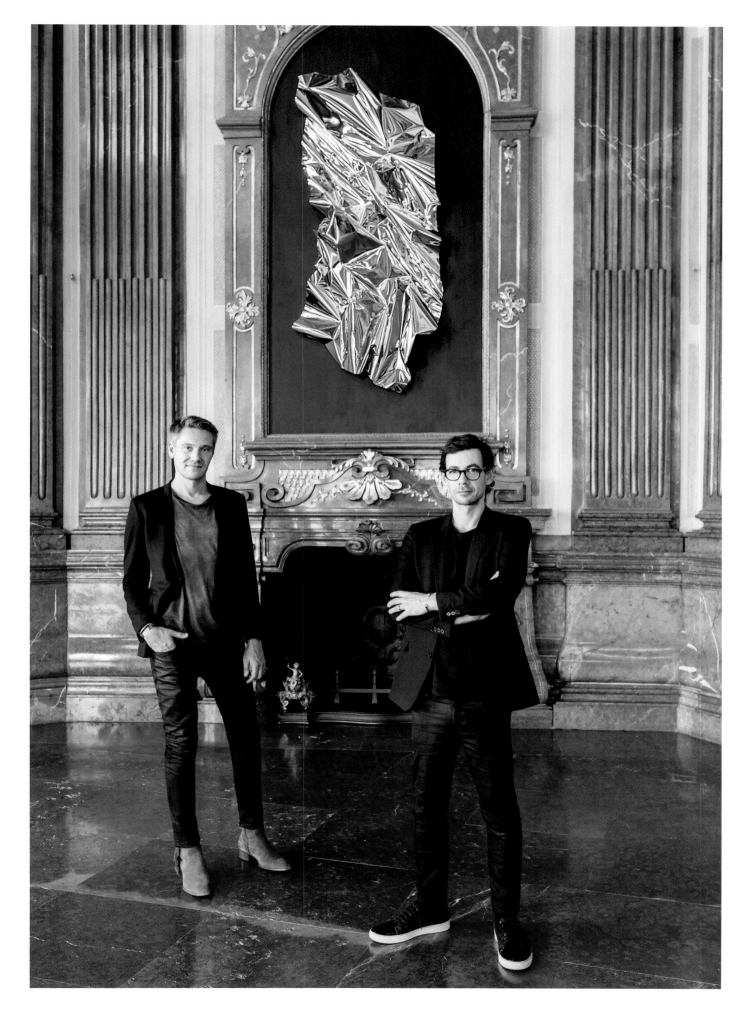

in which to operate, even though the result is invariably quite free of the original referent. They have explored the format of the double console, for example, an eighteenth-century furnishing form in which sculptural tables are paired off to establish balance and visual interest in an interior. Their updates on the console are quintessential "baroque minimal" objects: *Hurricane*, 2015, and *Hudson*, 2016, both part of the *Crush* series. These had an immediate precursor in a piece called *Landscape – Diptych II* (2013), made on commission from Jaguar for an exhibition curated by *Wallpaper** magazine. In this early iteration of the work, they were inspired (as well they might have been) by a trip round Europe in a Jaguar F-Type lent to them by the company. On this latter-day grand tour, they thought a good deal about the contours of the passing landscape as well as those of the automobile; they had been surprised to learn that modern engines are so powerful that the aerodynamic curves of the body are essentially cosmetic, and have little real impact on performance. When it came time to produce the design, they in essence staged a collision between the two topologies that had interested them, and created one of their few pure sculptures in the process. The upper surface was in super-polished aluminium – its topology recalling a mountain landscape – while the "body" appeared to have been vertically extruded from that irregular shape.

The Jaguar commission was a great example of free material and formal experimentation; it might have gone nowhere, had they not thought to flip the design over ninety degrees and make it functional. The split between the two elements, which had originally been intended simply to reveal the cross-section, now performed a functional service, dividing the objects into a matched pair reminiscent of the console tables often placed in the chambers of great houses in the eighteenth century. Those objects were specimens of high craft, with elaborate marquetry, lacquer, or carved ornament, often set in ormolu (gilt bronze) mounts. By recalling such forms, Fredrikson Stallard bestow a pedigree on their

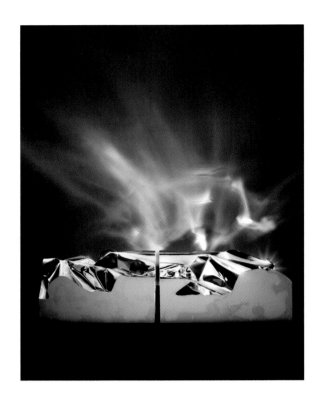

Diptych: Landscape II, 2013
aluminium, wood, polyurethane, polyester

crumpled metal objects. They almost literally depict a collision between the contemporary and the historical.

Like pier mirrors, eighteenth-century consoles were only nominally utilitarian. Their primary role was simply to be looked at, and to act as framing elements within an orchestrated decorative scheme. In discussions of the distinction between fine and decorative arts, which tend to be replicated in juxtapositions between contemporary art and design, this point is often forgotten. We pretend that furniture serves a specific purpose, while paintings do not. In fact, this easy dichotomy does not reflect historical patterns of use. Picture a Georgian country house: sculpture, cabinets, tapestries and framed portraits, as well as architectural ornamentation, all combine to communicate prestige and refinement. It is true that some furnishings found daily use; indeed, in the most elite cases, such as French courts, functionality was turned into a diverting game in its own right through the incorporation of secret drawers, movable work surfaces, and other kinetic elements. But sensibility, fine and decorative art were by no means sharply separated; that is a prejudice we impose on the period in retrospect.

This backdrop helps to inform Fredrikson Stallard's attitude to utility. When pressed to

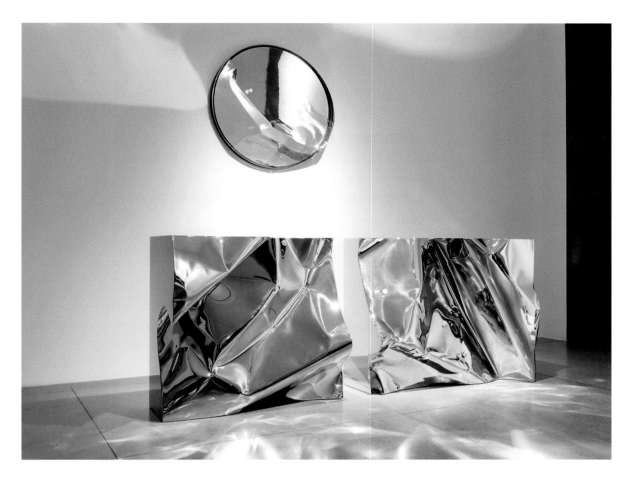

say whether their work is functional or not (the implication being that this would somehow determine its status on art / design spectrum), they invariably deflect the question, pointing to the variability within their studio practice. Certainly, use plays an important compositional role for them; even the provision of a surface at a certain height is a significant parameter, and in pieces like *Pyrenees* and *Species*, the overall form is generated in relation to the hollowed-out seats. But considering this to be a defining characteristic is rather like saying that a painting is defined by its four edges. That's certainly true, but it doesn't tell you much about the artist's vision: one could move a *Species* chaise from the floor to the wall, and still enjoy its presence. In practice, there is a wide continuum of degrees of usefulness in Fredrikson Stallard's oeuvre. It is not a dictating consideration, just another variable in the creative formula.

Thus, a pair of *Hudson* consoles are intended to sit in a contemporary interior much as their antecedents sat in panelled parlours; and, to draw an analogy to another historic moment

that informs their work, a piece like *Detroit* or *Polaris* anchors a room much as a sculptural coffee table served as the sculptural centrepiece of an Art Deco salon. Such correspondences are helpful in understanding Fredrikson Stallard's particular brand of historicism. Just as their use of technology is more internalized and tacit than that of other contemporary designers, their references from the past tend to be more thoroughly digested. Compare their work, for example, to Jurgen Bey's *Tree-Trunk Bench* (1999), Maarten Baas's *Smoke* series (2002), or Sebastian Brajkovic's *Lathe* chair (2008), all works which operate through the ingenious transformation of antique furniture. In all of these pieces, the historical form remains present as a symbolic element; the energy of the designs comes from the theatrical juxtaposition of old and new. By contrast, Fredrikson Stallard tend to integrate the historical and the contemporary more fully, operation on a principle of fusion rather than fission. The past is always present in their work, but it is thoroughly absorbed into the spatial conception of the work.

9. Private Life

Here's something that many creative people have in common: their most ambitious ongoing work is the place where they live. From Frank Lloyd Wright to Donald Judd to Karl Lagerfeld, "home" has been an ongoing aesthetic concern, a space where artistic impulses are concentrated. Such domestic interiors are interesting for their temporal quality; passing interests of various moments, various projects, gradually accumulate in them. Over time, such places eventually become physical biographies, palimpsest-portraits of their creators.

Fredrikson Stallard fit right into this pattern. Ian and Patrik are now on their third apartment together – they first moved in together in 1997, furnishing the place in a mid-century look influenced by Michael Wolfson's taste. In 2005 they moved to Haggerston in an effort to simplify their lives, fusing their living area, design office and workshop all together in one domicile. Previously, they said, they had felt like "everything was always in the wrong place, including us." The newly integrated set-up, by contrast, drastically increased their productivity: "when everything is a mere few steps from your bed it leads to a whole kind of energetic explosion of creativity."[20]

In 2012 they moved into their present headquarters in Holborn, and it seems quite likely they are there to stay. The space was astounding even before they arrived, a conversion of a three-story print shop accessed via an imposingly cavernous freight tunnel. This is Dickensian territory – the Charles Dickens Museum is just a few blocks away, and some of the most dramatically gothic scenes in the novelist's early masterpiece *Oliver Twist* were set in the streets and river nearby. Once inside Fredrikson Stallard HQ, however, the visitor feels in the presence not of the past, but the future. Ian and Patrik have spoken of their love of another writer, J. G. Ballard, and his darkly imaginative science fiction narratives that are at once "chaotic" but also "interesting and passionate and exciting," urban landscapes in which "everything is crumbling,

but still standing."[21] The space where they live and work has precisely this kind of energy. The industrial shell of the original building is still evident, but it is filled with the apparatus of a cutting-edge studio – banks of computers, small handmade and printed models, and full-scale plaster prototypes limned with patina.

On several occasions, Fredrikson Stallard have used their home and studio as a gallery. The first major instance of this was the 2015 exhibition *Momentum*, which served as the launch for the *Species* collection and other pieces from the more speculative side of their practice. In the same year, they used the tunnel for the launch of their very Ballardian jewellery collection for Swarovski, *Armory*; and in 2017, they used the space once again to present the white bronze vessels entitled *Hybrideae*, accompanied by music that was itself a hybrid of classical and contemporary electronica, a live duet between the cellist Gerald Peregrine improvising on Bach with contemporary electronic composer Rosey Chan. On one level, these events are further evidence of their adeptness in the art of presentation: there is something undeniably convincing about seeing design in the very space where it was conceived, particularly when the space is so consonant with the work. Yet in a deeper sense, these events represent the fullest realization of the instincts that animated Fredrikson Stallard right at the beginning of their careers, in exhibitions like *Gloves for an Armless Venus* and *Factio*. They have so completely internalized the cross-platform approach that they now literally inhabit a multidisciplinary creative space, in which the usual divide between private and public has become permeable.

And so, while attending one of the staged events at Fredrikson Stallard HQ is certainly memorable, a visit to the studio on any weekday morning will leave something of the same impression. Ian and Patrik live with many of their own pieces, and have said that ideally, with the exception of a few artworks by others that they own and admire, they would like to personally shape every element of their space. They plan to collaborate with a kitchen company, for

Armory show, London, 2015

example, making a space in which "ingredients on the countertop would already look like a sculpture." They also have a roof garden, which was a significant inspiration for the perforated aluminium furniture collection *Camouflage* they recently realised for Driade. The choice of finishes (a clean white or rusted metal), as well as their concern for how the pieces would look mid-winter without their removable cushions, were informed by their own rooftop experience of the year-round London climate.

One of Ian and Patrik's current projects is a dining chair – a form that one might have thought they'd have taken on long ago. The architect Mario Bellini once remarked that while many architects had made many great buildings, hardly any had ever designed more than one great chair. Fredrikson Stallard are acutely aware of the difficulty of the form. An obsessive focus of collectors, curators, and designers themselves, it is by now very difficult to achieve anything original, and that may be one reason that have largely steered clear of it; the more decisive factor is that their sculptural inclination leads more naturally to expansive forms – sofas, wall mirrors, tables – that do not need to fit precisely to the body.

In any case, for some years they have been using old bent-metal and plywood chairs reminiscent of Jean Prouvé around their dining table, but now have determined to make their own. The current vision for the chair (which relates to a group of stools and lamps) is that of a slender tripod, draftsmanly in its attenuated and linear form. They plan to call it *Untitled*, with delicious irony, since that is a conceit normally employed by fine artists, and this is the most purposively functional, understated thing they have made for a long time. If they can pull it off, though, it will add yet another element to the part-elegant, part-rough-and-tumble *Gesamtkunstwerk* that is their home.

To be sure, not everyone can expect to live like Patrik and Ian do. They have enjoyed success in their careers, and have had the opportunity to relentlessly pursue their own aesthetic interests. Yet there is a broader lesson to be learned from their example. They are fully aware of the advantages of Ikea furniture – its cheapness and neutrality make it so easy to buy, and live with. But it is equally easy to throw away. Isn't it better to have fewer, better things, each of which may last a lifetime or longer, and represent a depth of private concern?

10. Conclusion

What will be next for Fredrikson Stallard? That is hard to predict, for as with any sophisticated artists, their working process is complex and multivariable, responsive not only to ongoing research but also external opportunity and influence. It seems safe to say that their highly productive relationships with David Gill Gallery and Swarovski will continue to be major platforms; they have also, just recently, undertaken their first presentation at Machado-Muñoz gallery in Madrid. The exhibition, entitled *Fluido*, included classics like the *Rubber Table* and *Pyrenees*, as well as newer pieces like *Species*, the hydraulically-formed steel tables *Tokyo* and *Detroit*, and the acrylic mirror *Metamorphosis*, with its mysterious visual depth and dynamism. They continue to develop corporate and public commissions; and to judge from projects like *Ferrum*, they are likely to be increasingly ambitious in these arenas.

The best indication of what is to come, however, is the existence of the volume you now hold in your hands. When Fredrikson Stallard staged *Momentum* in 2015, they were firm in saying that it was not a retrospective. "Although we're not new kids, we're still beginning," Ian commented. "We're still in the early stages." To which Patrik added, somewhat pointedly, "I never feel entirely comfortable with what we do."[22] These statements were not to be taken as false modesty, or genuine dissatisfaction, but rather as expressions of an ongoing restlessness. Now, two years later, that spirit is certainly still with them. The current work of the studio evinces just as much desire for novel material experimentation as ever; the ambitious cardboard-based group entitled *Reformation*, with its Rauschenberg-like alchemical transformation of detritus into resolved compositions, could almost have been devised as a demonstration of the pair's ongoing curiosity, their openness to whatever comes their way.

Roof terrace at Fredrikson Stallard HQ showing *Camouflage Daybed* and *Portrait Light*, London, 2017

Yet there is now, perhaps for the first time, a willingness to look back and take the measure of what they have done; and also to look forward, to ever more ambitious possibilities. They have reached a tipping point. Practical and financial considerations are no longer so constraining for them as they once were, and they have achieved confidence and mastery across a diverse material repertoire. Their collaboration with David Gill goes from strength to strength, and their own studio has also grown, so they have sufficient staff to manage the logistics of production and other practicalities that would once have taken up much of their time and attention. Add all this together, and you have the recipe for creative freedom. Their intertwined strands of DNA – that of a trained product designer and a skilled ceramist – are still present, but they feel more able than ever before to follow their artistic inclinations.

Arriving at such a moment, this book does more than offer a retrospective view of Fredrikson Stallard's achievements so far. It also marks an inflection point in the narrative arc of the studio, a further increase in momentum. By setting out their work so far in print, between covers, they have rendered their *oeuvre* in the form of a single object: a volume you could put on a coffee table, perhaps even one of their own devising. These pages will hopefully be of interest to all who leaf through them. But in a sense, the book is best considered a tool, and its ideal readers will be artists & designers – from students just starting out, to Ian and Patrik themselves. When they pull the plastic wrapper off the first edition and sit down together to take a look, you can be sure they'll think right away of something else they want to do. You can be equally sure it will be something materially inventive, aesthetically resolved, and technically challenging; something that is understandable as furniture, yet not wholly contained within that category; something sculptural, even if it happens to be subject to domestic use; something immediately pleasing, though it stands just a little outside of the comfort zone. Best of all, it will be yet another new beginning.

[1] Michael Whiteway, ed., *Shock of the Old: Christopher Dresser's Design Revolution* (London: V&A Publications, 2004).

[2] See Tom Crook, "Craft and the Diologics of Modernity," *Journal of Modern Craft* 2 (1) (March 2009).

[3] "Auctioneer ditches Design Art," *Icon* (8 February, 2008). See also Alice Rawthorn, *Hello World* (New York: Overlook Press, 2013).

[4] Henrietta Thompson, "Profile: Fredrikson Stallard," *Design Week* 23/26 (26 June, 2008), p. 13.

[5] On the "Design Art" boom of the early 2000s, see Alex Coles, *Design Art* (London: Tate, 2005); Gareth Williams, *The Furniture Machine: Furniture Since 1990* (London: V&A Publications, 2006); and Gareth Williams, *Telling Tales: Fantasy and Fear in Contemporary Design* (London: V&A Publications, 2009).

[6] Art et Industrie, founded in 1977 by Rick Kaufmann, played an important role in introducing Italian radical design to America, as well as fostering local makers like Howard Meister and Forrest Myers. See *Art et Industrie: A New York Movement* (New York: Magen H, 2015).

[7] See Glenn Adamson and Jane Pavitt, eds, *Postmodernism: Style and Subversion, 1970 to 1990* (London: V&A Publications, 2011).

[8] Quotes from David Gill are taken from an interview conducted on 10 April 2017.

[9] "Fredrikson Stallard on Forty Naked Johnny Depps," *Crafts* 205 (March/April 2007), p. 92. The original source incorrectly has Richard Wilson's name as Rebecca (perhaps confusing him with the sculptor Rebecca Warren).

[10] Scott Rothkopf, "No Limits," in Rothkopf, ed., *Jeff Koons: A Retrospective* (New York: Whitney Museum of American Art, 2014), p. 28.

[11] *Swarovski: Crystal Palace* (Kempen, Germany: teNeues, 2010).

[12] All quotes from Nadja Swarovski are taken from a phone interview conducted on 5 April, 2017.

[13] DeLanda's most well-known book on these themes is *A Thousand Years of Non-Linear History* (New York: Zone Books/Swerve Editions, 1997). Rosi Braidotti independently argued a similar case from a feminist perspective. For an overview, see Rick Dolphijn and Iris van der Tuin, eds, *New Materialism: Interviews and Cartographies* (London: Open Humanities Press, 2012).

[14] The exhibition *Extreme Textiles: Designing for High Performance* (2005) at the Cooper-Hewitt, National Museum of Design, was a prominent showcase for this material.

[15] Bruce Sterling, "The New Materialism: Nature's Logic and Design," *Abitare* 482 (May 2008). See also Oxman's website *materialecology.com*.

[16] Adam Szymczyk interviewed by Michelle Kuo, *Artforum* 55/8 (April 2017), p. 72.

[17] http://www.jorislaarman.com/work/mx3d-bridge/ [accessed 5 April, 2017]

[18] Michael Snodin and Nigel Llewellyn, *Baroque: Style in the Age of Magnificence 1620-1800* (London: V&A Publications, 2009).

[19] Donald Judd's classic statement on Minimalist composition is his essay "Specific Objects," *Arts Yearbook* 8 (1965).

[20] Fredrikson Stallard interviewed by Caroline Roux, *Pin Up* 7 (Fall/Winter 2009/10), p. 62.

[21] Fredrikson Stallard interviewed by Oli Stratford, *Disegno* 14 (1 October 2015).

[22] *Ibidem.*

Fredrikson Stallard
Beyond Design: Outside of Art

Richard Dyer

Patrik Fredrikson and Ian Stallard's practice takes place in a territory outside of conventional categorisations of design and fine art. While they explicitly fabricate objects for the domestic environment, and encompass many of the parameters of "interior design" in the objects they conceive and fabricate, their working practice and creative trajectory is far closer to that of contemporary artists. While not suggesting this work be designated "art" and not "design", thereby occupying a more elevated position in a notional hierarchy of aesthetic production, I would suggest that the distinction between the two categories is unnecessary, and in fact redundant; the truth is that fine art and design not only lie on a continuum, but also occupy shared territories and frequently borrow from each other's methodologies and strategies.

Let us examine an iconic series of work: the *Species* sofas, originally carved – literally with the artists' hands – from polyurethane foam, the UV protected material is then covered with fibres whose colour looks like it is derived from the paintings of Mark Rothko. Because the fibre "paint" is made up of three distinct colours the surface is chromatically articulated as the viewer moves around the work, and with subtle variations in the ratio of the three colours each sofa can take on a different hue. These works can of course be sat on, however, that is not their primary signification. For decades the design of a sofa has been dominated by a proto-modernist ideal of utility and ergonomic

functionality; the Bauhaus aesthetic has dominated design to such an extent that nearly all sofas in the twenty-first century look very similar, varying only in price and material. Fredrikson Stallard's *Species*, however, evoke not so much a sofa, a machine for sitting, as a quasi-geological mass, a paradigm shift in how the notion of a sofa can act as an emotional and poetic touchstone for the imagination – a contemporary sculpture. The true affinity is with the work of such artists as Andrea Zittel; I am thinking here particularly of her 1998 sculptural installation *Raugh Furniture: Lucinda*, the artist's constructed "environmental furniture" which challenged the body to adapt to its pre-existing dimensions, fabricated without regard to the demands of ergonomics, design conventions or domestic constraints.

In Fredrikson Stallard's shelve series, *Bibliothèque*, patinated steel, nano-waxed to a seductive sheen, holds a lineage not to conventional shelving design but rather to Carl Andre's hot-rolled steel floor sculptures such as *5 x 20 Altstadt Rectangle* (1967) or *144 Steel Square* (1967). The artists deploy the aesthetics of high minimalism to encode a renegade reading of their interior pieces into the work; the varying thickness of the shelves, and their meandering and expressive lines, are derived from free-form marks drawn by the artists, mapped onto the unyielding rigidity of the steel. Although the artists are fascinated by "usage", utility and the deployment of objects in the domestic environment, their bookshelves *are* actually meant to house books; however, there is also a keen awareness of the inherent sculptural aspects of an object that must also fulfil its function – to hold books – but at the same time account for itself as an aesthetic object in the world.

The series of cast bronze *Antarctica* guéridon (seventeenth-century French occasional tables), has a striking "family resemblance" to Anish Kapoor's *Void Field* (1989) (installed at the British Pavilion at the 44th Venice Biennale in 1990) where the artist arranged twenty pieces of flat-topped sandstone to fill the space. Although Fredrikson Stallard's rocky monoliths *are* occasional tables – collectors *might* place objects

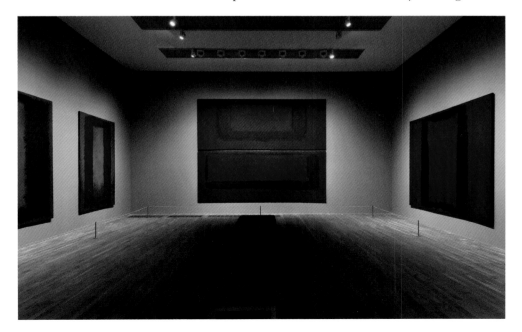

on them – they also function as pure sculpture, especially when clustered in a group, evoking the now classical tropes of "installation" art. Their natural affinities are with other works of contemporary art which deploy natural stones as a central element in their installations, such as that of Cai Guo-Qiang's *Cultural Melting Bath* (1997), where the artist transported thirty tons of naturally shaped "Taihushi" (scholars') rock from Diangsu in China to New York, and, from a very different aesthetic register, Elmgreen & Dragset's interventionist installation, *Taking Place* (2001–2002), where the large, irregular chunks of the gallery wall the artists had destroyed were piled in the centre of the space.

The desk and table vitrines, such as *Crush: Silver*, where a pristine glass rectangular prism houses a dynamically and carefully buckled polished steel sheet, function perfectly as a desk, and yet recall the crushed metal works of artists such as John Chamberlain, or Richard Wentworth's children's toy tools in a horizontal vitrine *Thinking Aloud* (1999), and could as easily be hung on the wall as mounted on the four legs which demarcate them as "table". The artists have frequently deployed the vitrine as a means to present anarchic and unexpected materials such as the crazy crumpled topography of a Kelvalite emergency blanket, down feathers, usually more at home hidden in a duvet, or wildly splashed Cryla paint. In the clean cuboid space of a vitrine the materials are allowed to connect with the viewer on an emotional and imaginative level while at the same time the piece is able to serve a utilitarian purpose.

The genesis of a Fredrikson Stallard object is most often a gesture, sometimes violent, sometimes delicate and nuanced, by one of the artists; whether it is the fine calligraphy which formed the basis of the *Bibliothèque* shelves, or their counterpoint in the *Scriptus* mirrors – which were developed from initial free-hand clustered scribbles executed on a small scale – the violent chiselling of blocks of ice to be computer scanned and minimally manipulated for the *Antarctica* dining and coffee table or guéridon, or the very physical gouging out of the giant blocks of polyurethane foam for the originals of the *Species* series. This marked trace of the body, frozen in time, then expressed in two dimensions or three, is captured and inflected forward in space and time to form the core dynamic element of the work, its "structural DNA". The movement of the body – so well expressed in the work of their favourite choreographer, Hofesh Shechter – and its trace, introduces a strongly performative element in Fredrikson Stallard's practice. Even in its completed form the works still seem to be "performing" for the viewer; either through their dynamic capture and reflection of light, articulating the surrounding environment, or by the way the highly reflective surfaces steal the viewers image, distort it, transform it and cause it to become an active aspect of the work.

Modernism completely elided the emotional aspect of the utilitarian object, one which had been ramped up to maximum in the Baroque, Rococo, Gothic and Romantic movements, but which was suddenly absent, with the functional aspect of the object given primacy. At the heart of this functionality was the ever-receding notion of perfection, form in perfect harmony with function; the object stripped of all unnecessary ornament and decoration, texture and distracting detail. Unfortunately, modernism, and its later expression in minimalism, missed an essential truth. We love the people we love, and the things we love, not because of their conformity to the ideal, but because of the way they deviate from it, they appeal both emotionally and physically because they are not "perfect", it is the uniqueness, the deviation from the standard, which draws our eye, the notion of perfection being, paradoxically, one of the most flawed in the lexicon of the aesthetic alphabet. Modernism's obsession with the utilitarian led to a pared-down minimalist aesthetic – or anti-aesthetic – which reduced architecture and objects in the domestic environment to their basic functionality, their primary objective being to fulfil their function, as opposed to being vehicles of the imagination.

Just as Fredrikson Stallard's practice as "designers" is fully imbricated with the approach of contemporary artists, so too do artists frequently

Anish Kapoor, *Void Field*, 1989
cumbrian sandstone and pigment,
work consisting of six element

Donald Judd, *Untitled*, 1965
galvanized steel

draw on the methodologies and iconographies of design. Donald Judd, the central minimalist artist of the twentieth century, also designed and produced his own furniture. This fact has not yet entered the serious critical and theoretical debates about his work, and the nature of design and art. However, his furniture design's formal resonance with his minimal sculptures – such as the signature *Untitled* (1990 – first type 1965), the classic anodised aluminium, bronze and Plexiglas vertical shelf stack – is undeniable, despite the artist's efforts to keep the two practices absolutely separate. The list of artists alluding to furniture in their practice is extensive, from Mark Camille Chaimowitcz's untitled installation (1984) of optically distorted hybrids of desks/stairs and geometrically skewered televisions and side tables, to Richard Artschwager's "furniture art", clad in its characteristically kitsch Formica fake woodgrain finishes.

An exciting recent development in Fredrikson Stallard's practice is the 2017 *Reformation* series. The artists perform an alchemical transformation, from "base metal" to "gold", beginning with the lowliest of discarded materials – corrugated cardboard – and transforming it into a gilded bronze cavern of iridescent luxury. The cabinets are dark and encrusted on the outside, like some ancient chrysalis; but when the cabinet doors are opened the room is flooded with golden light from the gilded interior. When closed, these cabinets, especially in a series of two or more, read as contemporary sculptural installation, in the same way as the artists' 2016 console *Hudson*, its function as a pair of side tables long forgotten. It is this carefully orchestrated amnesia as to the "real" purpose and function of their work which allows Fredrikson Stallard to move beyond the constraints of design, and outside those of fine art.

Works

Text by Glenn Adamson

Patrik Fredrikson
2-Light and *4-Light*, 1998

Though he never intended to become a lighting designer, Patrik was deeply interested in illumination and reflection during his studentship at Central St. Martin's. His first works at the college had been lamps investigating the conditions of still life, in which found objects were incorporated for their symbolic potential. For his thesis show, he opted for a more formal approach. Angled planes, fabricated in steel and acrylic, were mounted on a ball-bearing swivel joint. This allowed for variation both in the silhouette of the fixture and the illumination it cast. The conception has a vaguely Cubist character, the physicality of the fixture exploded through overlaid reflections; it also recalls Art Deco lighting by the likes of Pierre Chareau. At the time, the design had little impact – Patrik's display was lost in the throng of the degree show, and he threw himself into work at Michael Wolfson's studio upon graduating, so did not immediately pursue the ideas. In retrospect, however, the lights seem to anticipate later Fredrikson Stallard concerns, particularly the refractory qualities of their work with crushed metal and with Swarovski crystals.

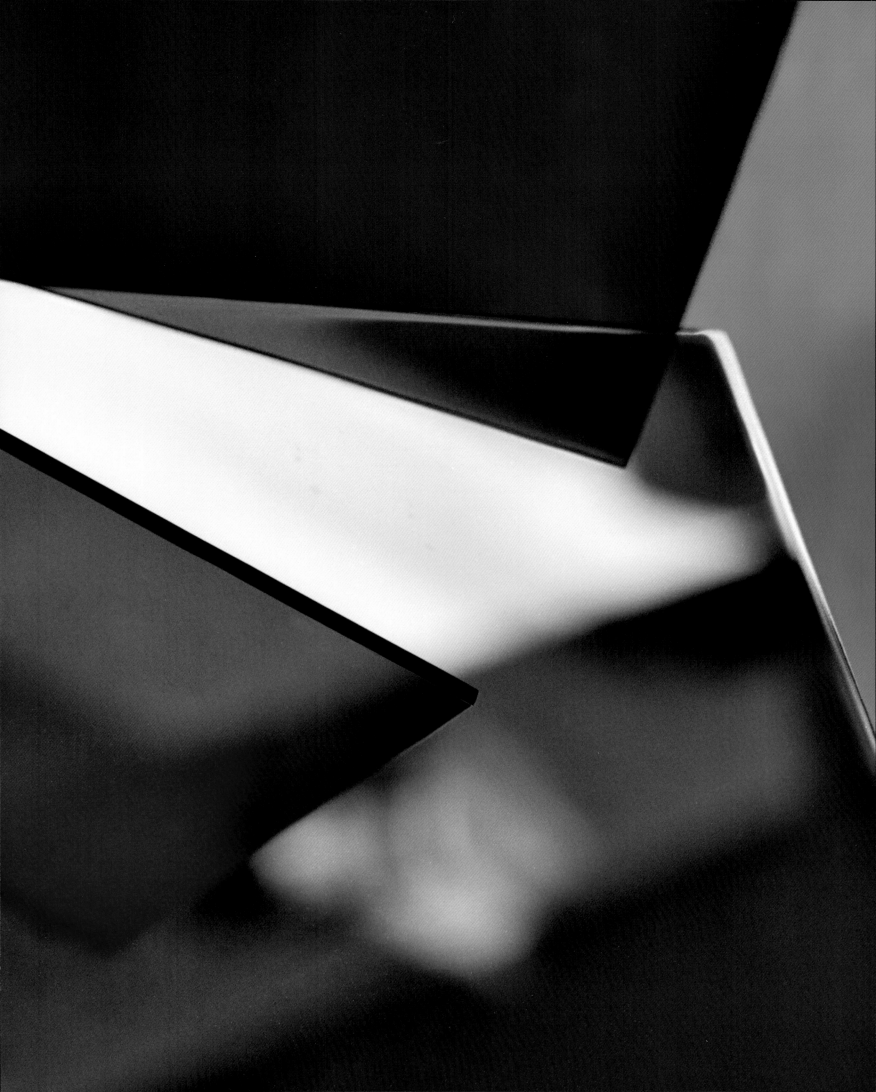

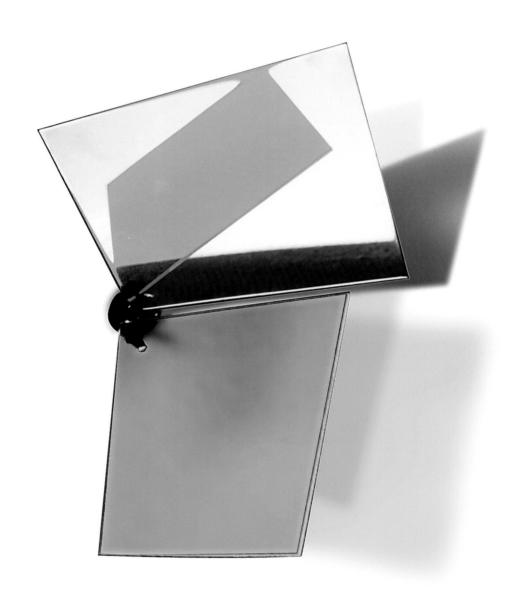

2-Light, 1998

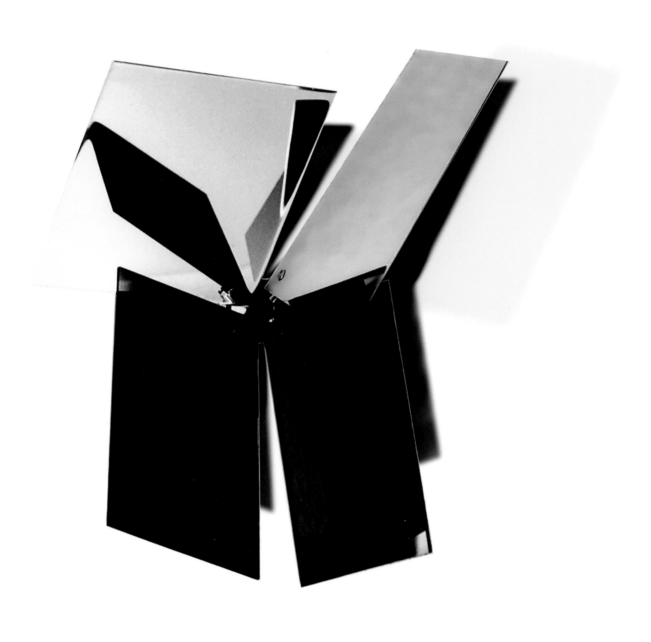

4-Light, 1998

Keyring, 2001

Coat Hook #1, 2001

Ian Stallard
Urban, Hofterup and *Scaffold Tableware*, 2002

After graduating from Central St. Martin's, Ian set up a ceramic studio and began making things at a furious rate. Much of his production was handmade using moulds, and then glazed. These pieces were successful, selling well at the regular sales he staged in his studio, but laborious to produce, so he sought more efficient processes. One of these was to buy in blanks that he could then decorate. He selected high-quality porcelains manufactured by the Swedish company Rorstrand and then printed them, either using traditional black and platinum inks, or with a then-novel photo transfer process. One of the patterns produced in the latter technique, entitled *Urban*, spoke clearly of the city life that Ian and Patrik were living at the time, with a bold image depicting a road penetrated by a drain (one thinks of Robert Gober's contemporaneous sculptures, with their veiled allusions to gay identity). Another pattern, *Scaffold*, also conjured the cityscape, and wittily connoted historical Constructivist wares. *Hofterup* served as a dark pastoral pendant, the print based on photos taken near Patrik's hometown in Sweden. Ian's intention was to place his dinnerwares into department stores, which went largely unrealized, but they were an important element in the exhibitions he and Patrik organized together in 2003 and 2004. In this sense they helped pave the way to the formation of Fredrikson Stallard.

Urban Tableware, 2002

Scaffold Tableware, 2002

Hofterup Tableware, 2002

Table #1, 2001

This breakthrough work, conceived by Patrik and executed in close collaboration with Ian, played a significant role in establishing the couple's profile as independent designers. Deceptively simple, it consists of a quantity of axe-cut birch logs, such as one would use for firewood in rural Sweden, bound tightly by a steel shipping belt. Though it seems impromptu, a quick Duchampian exercise in found object arrangement, the execution of the work was extremely demanding. To begin with, it rapidly became clear that wood of sufficient quality – white-barked, straight-grained, without knots, discolouration or wounds – would be all but impossible to get in Britain. So the pair sourced logs from northern Sweden, imported them in one big batch, and dried them next to Ian's ceramic kiln. Specialized equipment was also required to tighten the strap around the logs. After laying out each tabletop – a jigsaw puzzle in its own right, worked out by starting from the outer edge and then gradually filling in to the center – they bound the construction and then brought it to an industrial shipper who cinched the belts tight using a power winch. The tops were sanded to create a precisely level, smooth surface. Later, when the edition was taken over by David Gill Gallery, a platform was set under the logs to make construction easier; but in the earliest versions the legs were joined directly into the birch logs, another delicate operation as even a small difference in height would make the table wobble.

Patrik's original idea for the table had derived from his lifetime of experience with Scandinavian design. It was a wry joke to make a table out of firewood, given the longstanding regional love of shaped timber – and perhaps also a reaction against the slick, computer-driven work he was doing for Michael Wolfson at the time. These personal associations apart, the piece fitted neatly into the design Zeitgeist at the turn of the millennium. In addition to its echoes of iconic postmodern designs – Danny Lane's *Woodcutter's Table* (1989) and Tejo Remy's *You Can't Lay Down Your Memory* (1993) – the table resonated with a broader current of craft-intensive "authentic" designs, often made from natural materials. Made in two sizes, an occasional table and a coffee table, the piece was immediately successful, garnering press coverage and initial sales. (The Stockholm collector Mia Wrigley purchased three.) It was a strong encouragement to the pair to trust their instincts: "It taught us to be brave, to jump off the cliff."

Table #1 was included in Gareth Williams exhibition *Telling Tales* at the Victoria & Albert Museum, London in 2009 and was subsequently acquired by the museum for its permanent collection.

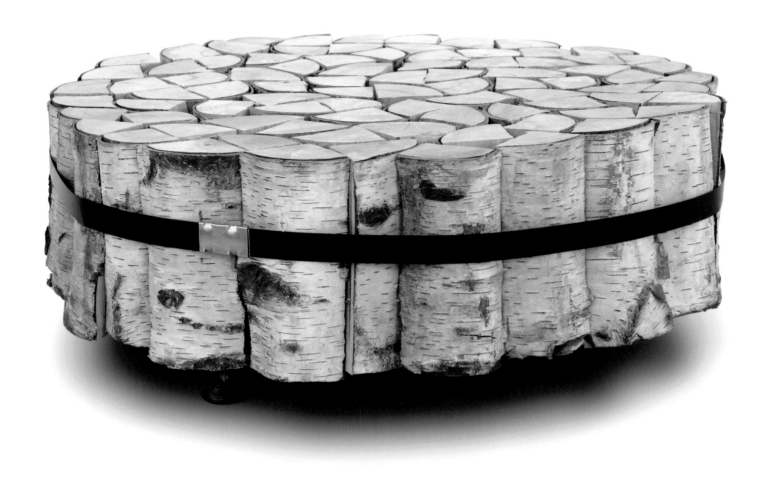

Table #1, 2001

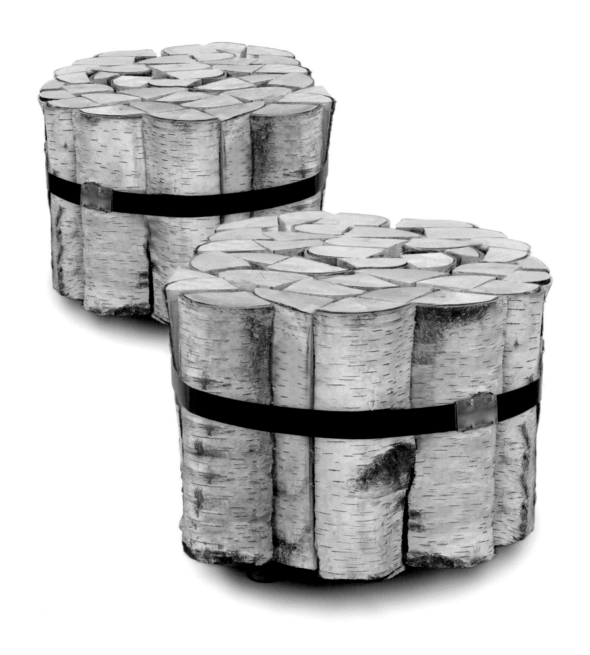

Table #2, 2001

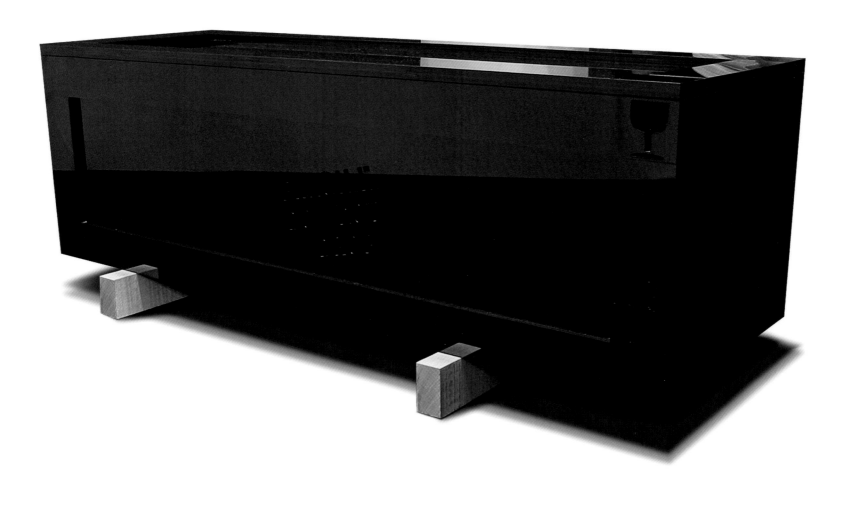

Table #5, 2003

Candle #1, 2002

Ian and Patrik learned a great deal from this design, and they did so the hard way. It began as a simple enough idea: to make a candle entirely from wax, including the base. They purchased an antique candlestick at a Swedish flea market, brought it back to London, put a shaped length of broomstick in the top, and set to work moulding and casting it – only to discover that it was quite difficult to create a clean wax cast of such an elaborate object. After many trials they managed to fabricate a pair (one black, one white) just in time for the 100% Design show in 2003. Naturally, they received an order for 500 of them, which they boldly accepted. After a bit of scrambling they managed to find manufacturers to take it on, based in Latvia; but it was an expensive process, and to pay its way the candle had to retail at £40. Their friend, the Fitzrovia design retailer Thorsten van Elten, sold the candles for a time but the price point was too high for an ephemeral object. And so, although the design brought in some much-needed income,

and contributed to the overall atmosphere of their early shows, it did not quite take off.

To Ian and Patrik's chagrin, the idea was soon knocked off by other producers without their approval, more than once, and at ever descending levels of quality and price. Eventually, a version popped up at the mass supermarket Sainsbury's, selling for £1.99. Telling the story now, they recall the advice of Winfried Scheuer, one of Patrik's instructors in product design at St. Martin's. As an independent designer, it is impossible to protect yourself from copying, he said; the costs of legal enforcement are prohibitive. Better to go through ideas as quickly as possible, showing in as many places as possible, and move on; or even better, make something that can't be copied, because no one would know how. In time, Fredrikson Stallard would exemplify this principle, making objects of such sheer, intensive physicality that they constituted their own intellectual property protection.

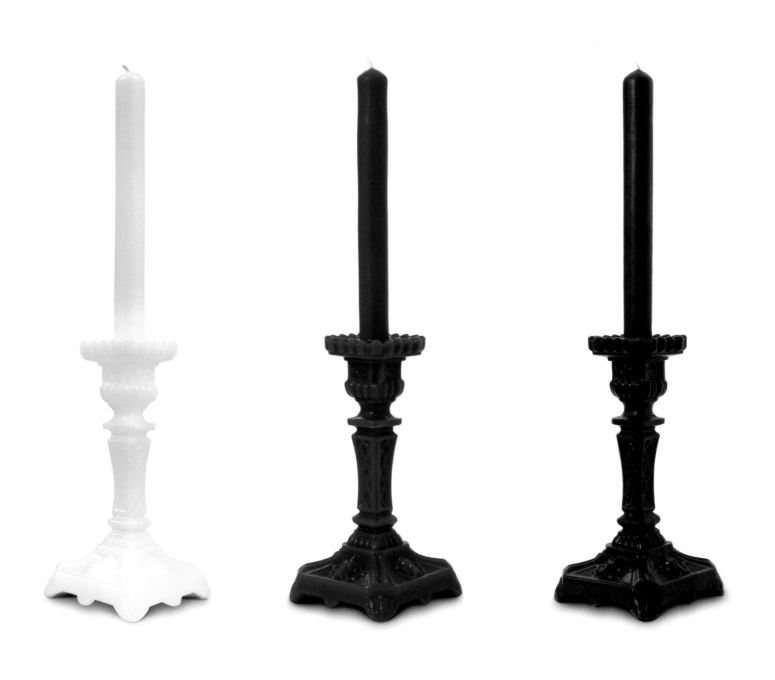

Candle #1, 2002

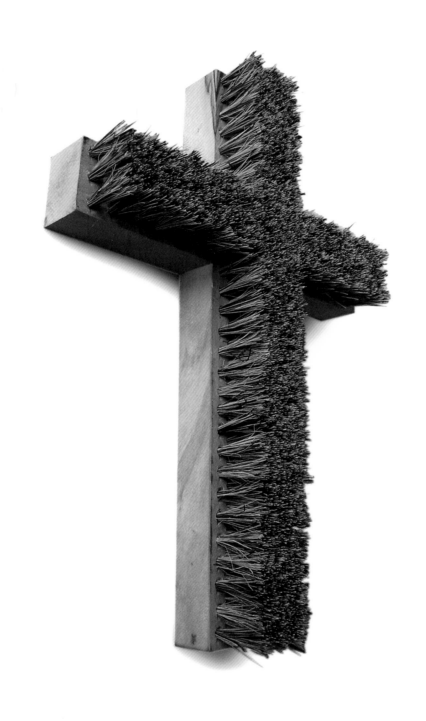

Brush #1, 2002

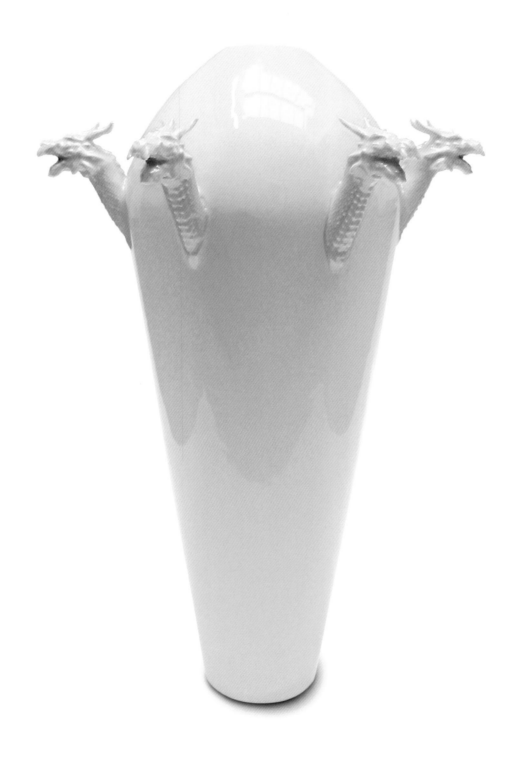

Dragon Vase, 2003

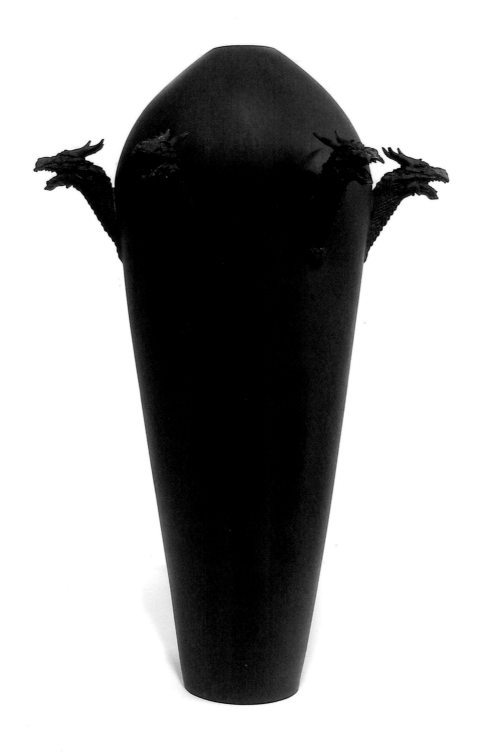

Dragon Vase, 2003

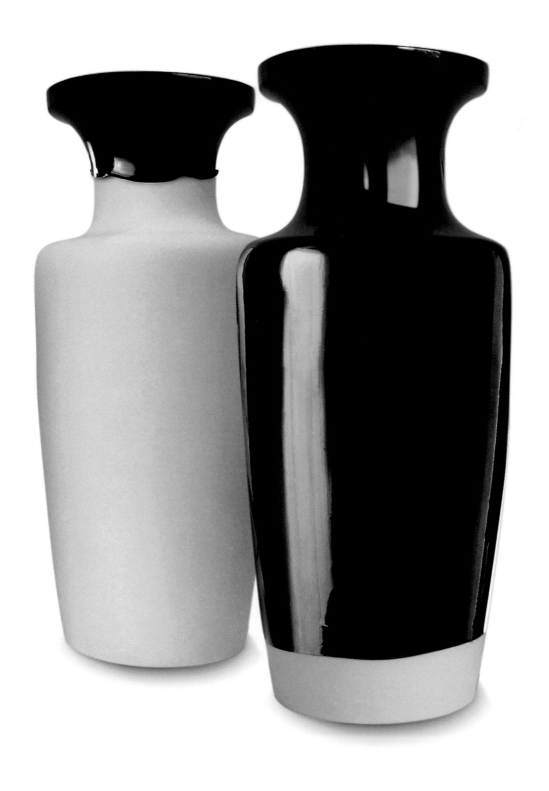

Ming #1, 2004

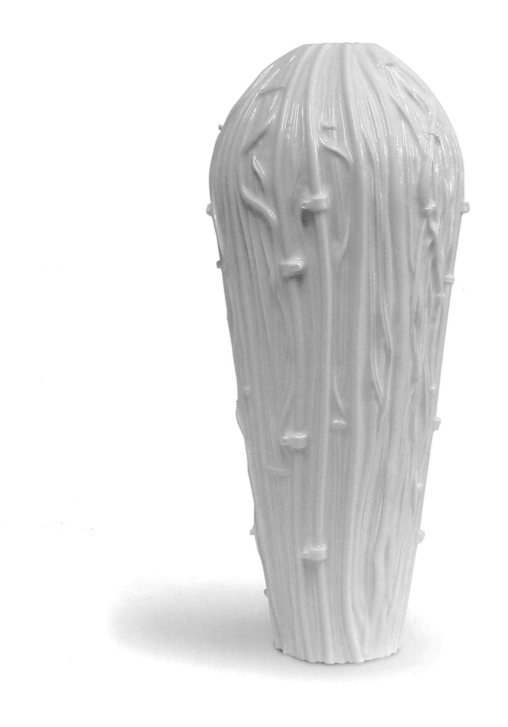

Cable Vase, 2003

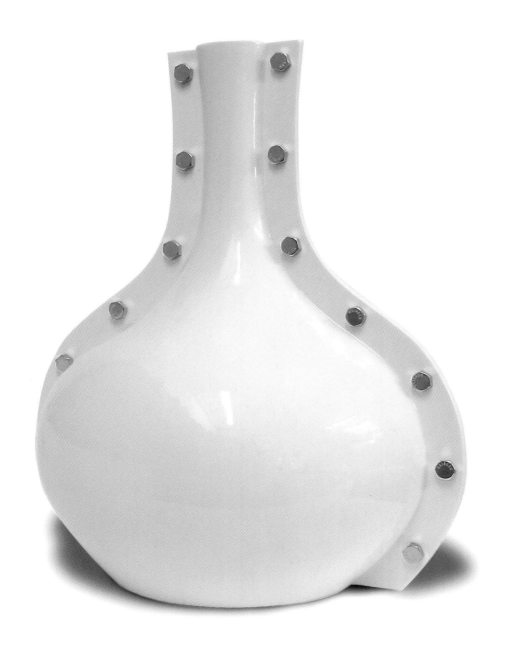

Bolt Vase, 2004

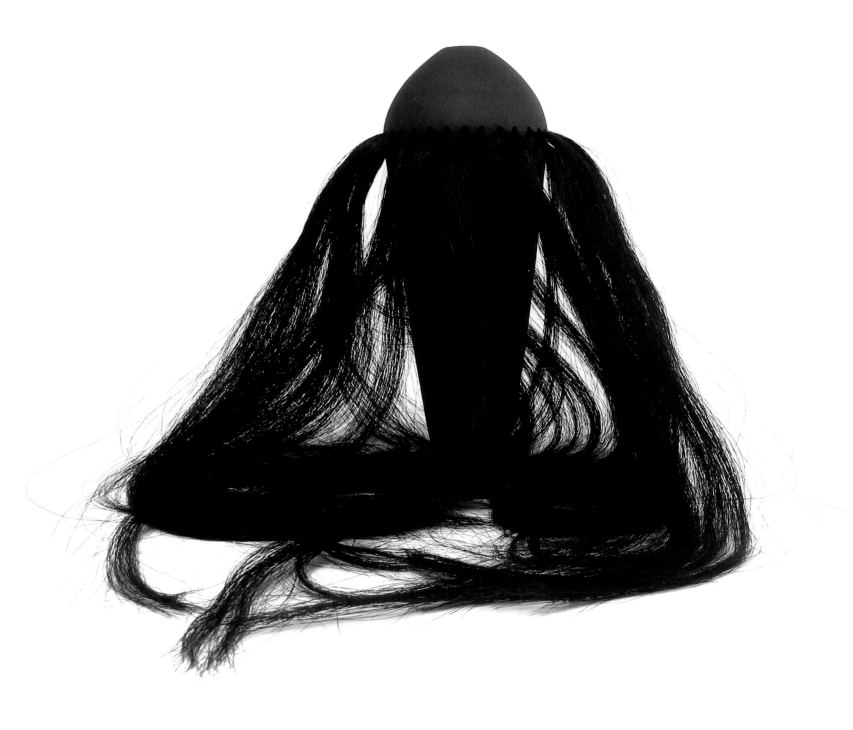

Villosus, 2004

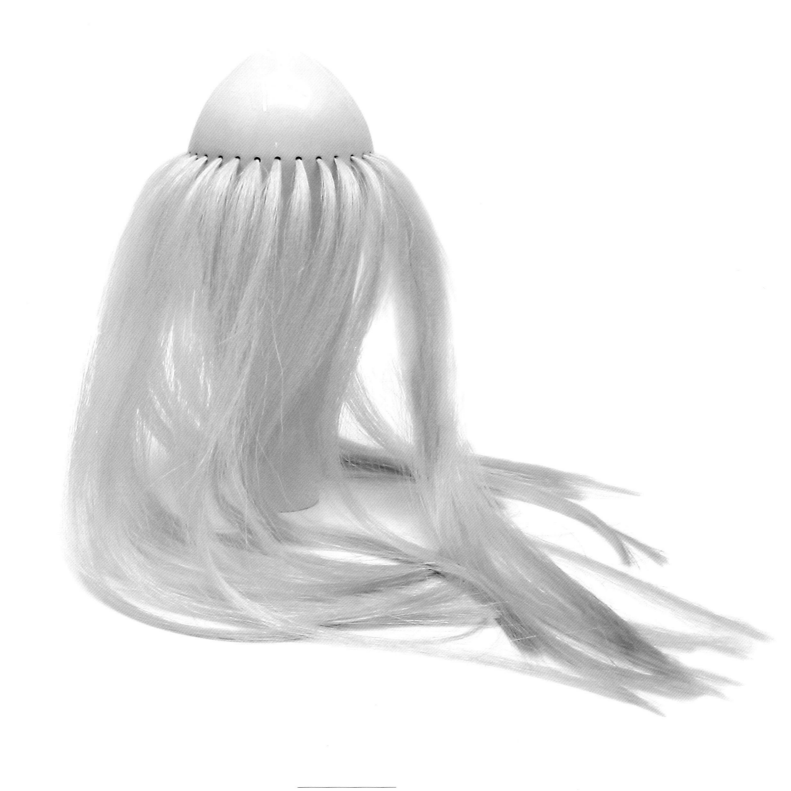

Villosus, 2004

Dead Vase, 2004

Units, 2004

Right at the outset of their career, Fredrikson Stallard developed a knack for appropriating existing design vocabularies and turning them to newly expressive ends. This is nowhere more evident than in the series of table-like objects they simply describe as *Units*. These orthogonal forms are filled with various substances – paint, feathers, or acrylic – and set on short metal legs, sourced from an industrial machinery supplier. The precedents for the series are clear enough – Donald Judd's Minimalist furniture, the sculptures of Yves Klein, or for that matter, any museum vitrine. The *Units* represent an occupation of this established visual language. The neutral box is treated as a window: inside each one, a material experiment unfolds, a specimen under glass.

Ian and Patrik were still climbing the learning curve when they first made the *Units* for their inaugural show at Citizen Citizen in Brooklyn. They experienced a couple of setbacks. Originally, the two parts of *Unit: Diptych* were meant to be filled with down feathers and crude oil, but the weight of the latter proved impossible to support. For the *Diptych* they substituted sheets of white and black acrylic, and realized the feather version as a separate piece. More disappointingly, the first version of *Unit: Monochrome* broke in transit, and so was not included in the Citizen Citizen show. (They realized belatedly that the sealed glass box had shattered due to the pressure differential during the flight.) This was a shame, as it was arguably the most memorable design of the group – and they did go on to produce a successful edition based on the idea. Rather like a Jackson Pollock (which is of course another conscious reference), the paint seems to be chaotic, perhaps the result of an explosion, but is actually painstakingly applied by hand in an ingenious contemporary take on the traditional technique of *verre eglomisé*. It takes about a month to dry, at which point the box is hermetically sealed, trapping the fragile composition within. The painting was done by Patrik and Ian personally, on site at the glass manufactory that fabricated the *Units*. Throughout the series, they were interested in a play of opposites – black/white, soft/hard, light/heavy, opaque/transparent. In *Unit: Monochrome*, this duality does not resolve into stasis, but retains the liquid potentiality that was present at the moment of creation.

Perhaps appropriately, given its modular neutrality, the *Unit* is the only typology that Fredrikson Stallard have retained throughout their career. While the container has always been more or less the same, made in the same Swedish glass factory, they have rethought the contents again and again. Sometimes, as with *Silver Crush*, the reinvention of the *Unit* eventually led to whole new series of works liberated from the rectilinear format. The see-through glass box has been something like a portal, which they have passed through repeatedly in the creative process – or like an abstract model of the imagination at work, constantly refilled with new possibilities.

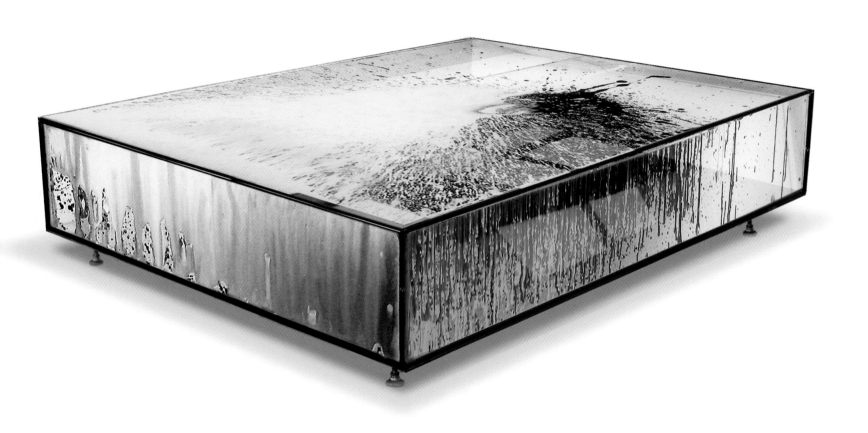

Monochrome, 2004

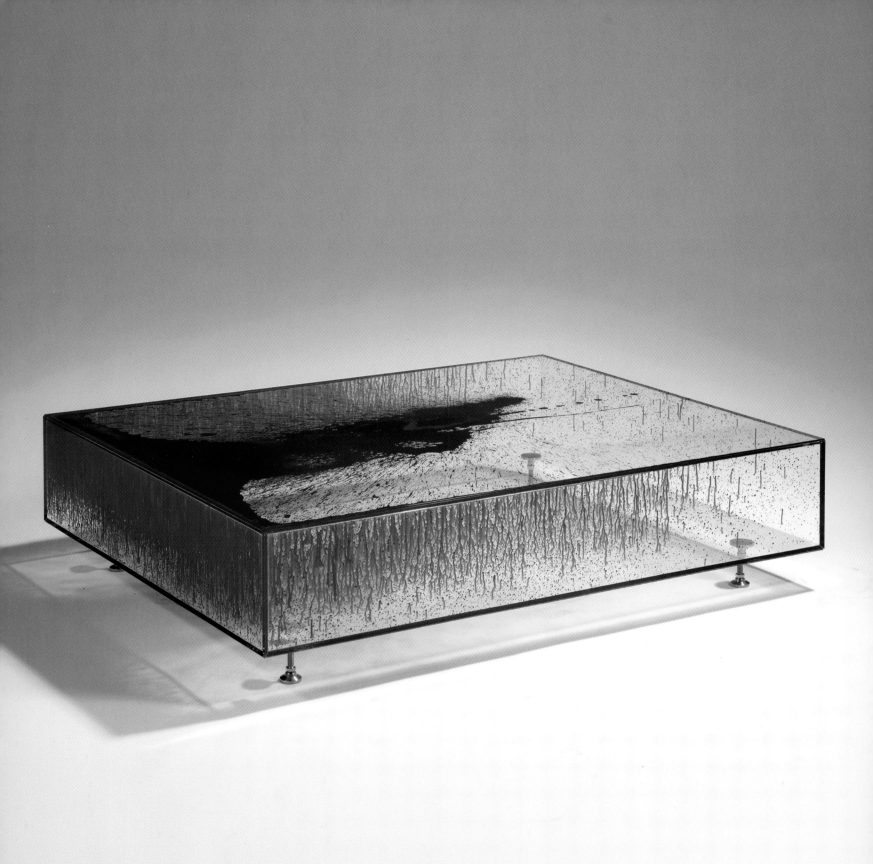

Monochrome Blue, 2009

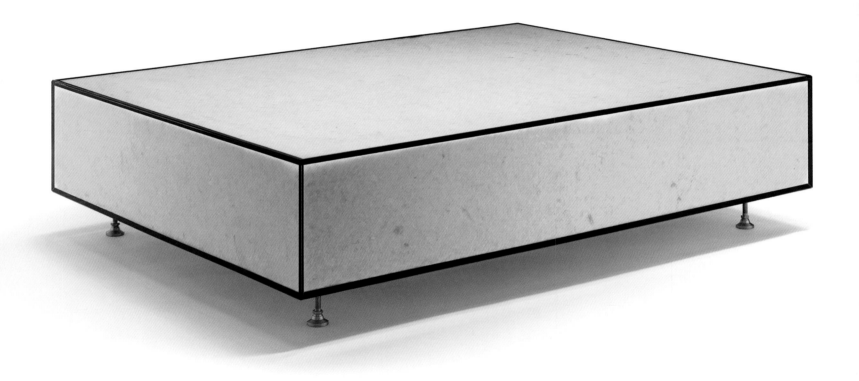

White Feather, 2004

White Feather, 2011, Side Table

Pink Feather, 2009

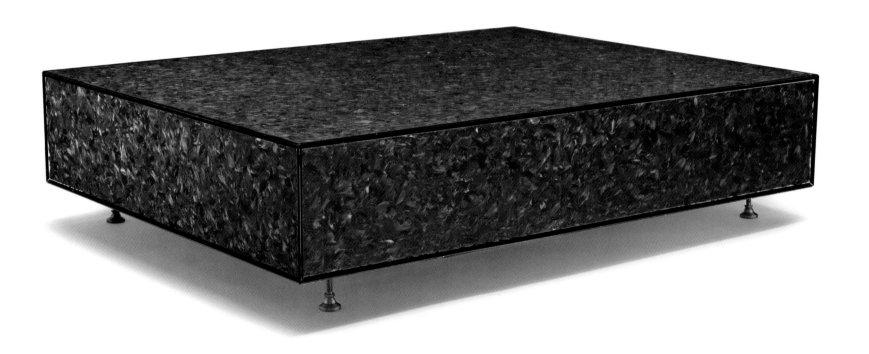

Blue Feather, 2009

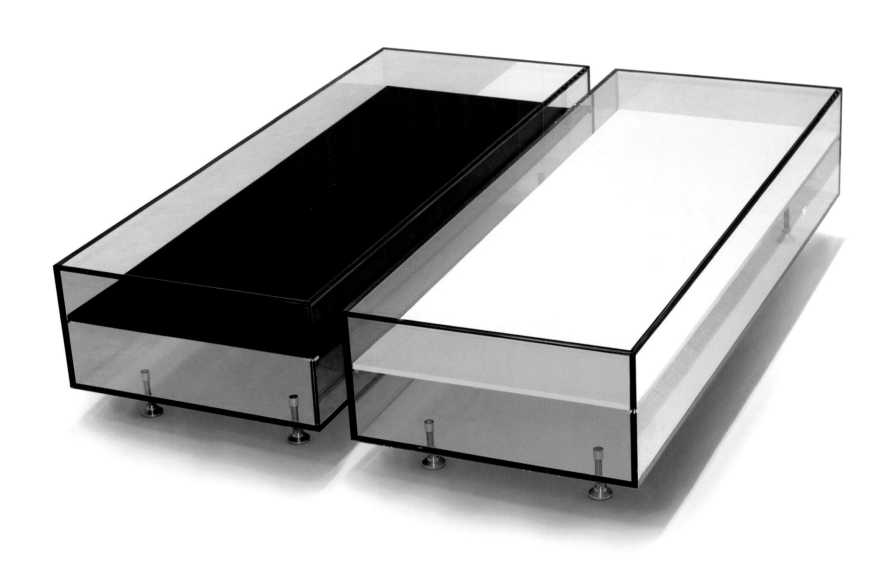

Diptych, 2004

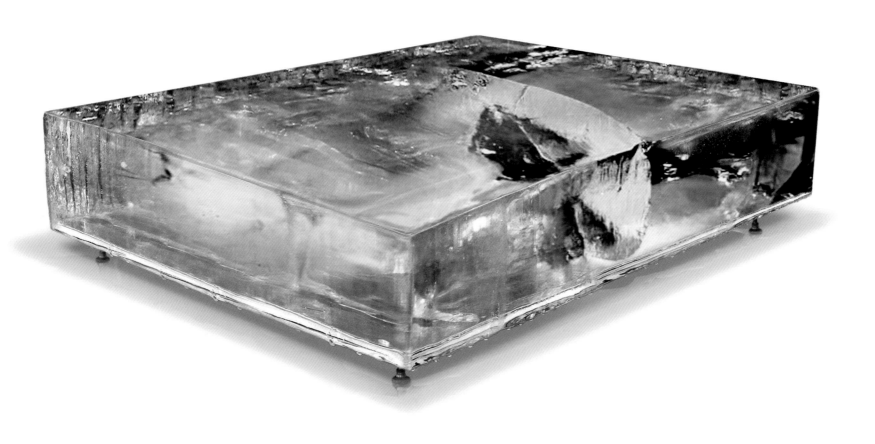

Unit #4 Ice, 2005

Rug #1, 2004, and The lovers, 2005

"The idea was, what is the last thing you would want to have on your floor?" This was the original premise behind two objects that Fredrikson Stallard first exhibited at their breakthrough exhibition, *Gloves for an Armless Venus*. First came black, then red; an oil spill, then a double pool of blood. Both are made of urethane, poured out in one go on a plastic sheet in Patrik's studio. The flow of the liquid material, slowed to a stop by portable heaters placed around its perimeter, resulted in a slightly tapered pool, perhaps ten millimeters thick in the middle and thinning toward the edges. The works are gothic in their imagery, kinky in their materiality. They bespeak the young designers' frustration with the "niceness and perfection" of normative modernism, and their desire to establish an unmistakably independent voice.

Fredrikson Stallard were at pains to make their pools functional; the urethane is tough stuff, sufficiently scratch-proof to stand up to stiletto heels. As Patrik puts it, a fine artist might have simply poured a quantity of oil or blood on the floor and called it a carpet; they took the same idea and subjected it to many materials tests, a process that anticipated many later research projects of the studio. Yet there is no mistaking the conceptual resonance of the gesture. *Rug #1*, in particular, relates closely to earlier artworks: Richard Wilson's well-known 1987 installation, in which a room was lined with steel and filled with used sump oil; the heavy gestural paintings of Joyce Pensato; or the poured floor works of American sculptor Lynda Benglis.

The lovers floats free from these sources – it ranks as Fredrikson Stallard's first poetic masterpiece. They certainly realized that it might be controversial – this was, after all, the same time that they were putting out works like the intentionally provocative *Brush #1*. A gentler and ultimately more satisfying interpretation of *The lovers*, however, is suggested by the title: it symbolizes two kindred passions, intermingled. In 2005 Fredrikson Stallard was just starting out as an official concern. Ian and Patrik's artistic identities were merging into one. It seems appropriate that they should have made *The lovers* just at this moment. It is a deeply romantic work, the only one in their oeuvre that can be understood as a double self-portrait.

Rug #1, 2004

The Lovers, 2005

Pyrenees, 2007

Consider how difficult it is to design a really great sofa. While history abounds with iconic chairs, the horizontality and frontality of the couch tend to limit its expressive possibilities; it usually gets pushed up against a wall, most likely under a painting.

Fredrikson Stallard's *Pyrenees* sofa departs boldly from that dynamic through the device of a central, meandering ridge. A typical straight-backed settee of the same dimensions would normally seat three; *Pyrenees*, which is intended to be set in the middle of a room, can seat five comfortably. Each seating position is different in its contours, creating an interactive social situation when the object is in use.

The piece had an unusually long gestation period, beginning with a deceptively simple design study in which a length of cloth was thrown over a rectilinear form. It may look like a scene from a painter's studio – the model just departed – but what the study reflects is Fredrikson Stallard's desire to deconstruct the constituent elements of upholstered furniture. (The couch that John Chamberlain made in 1970-71, with its oversized proportions and silk parachute lining, was also in their minds.) Most modern, mass-produced seating is composed of dense foam cushions, set into a frame. Shape, tactility and durability are provided by textile covers. In *Pyrenees*, this whole system is literally picked apart. A single foam block is carved by hand, scallops of the material pared away one at a time. This subtractive technique resulted naturally in a complex topology – a mountain range at domestic scale – which prompted the work's title straightaway.

Initially, Ian and Patrik tried to simplify the form they had achieved so that it could be traditionally upholstered, but they quickly realized this would obscure the object's special qualities. So they instead invented a process which could create a thin and fibrous surface – effectively, a way to provide the softness and warmth of textile without having to stretch a fabric over the form. Further testing with the support of some friendly chemical engineers (who had also assisted in formulating the urethane for *Rug #1* and *The Lovers*) helped them to achieve a relatively hard-wearing surface. They initially executed the piece in black and forest green – their usual penchant for subdued monochrome – but when their new gallerist David Gill suggested that they consider a bolder colour, they returned the idea with topspin: an intensely shocking pink. Ian later described it as the "most colourful, the colour-est, the colourest-est colour that there is," and indeed it marked a shift in their work from a thoroughly restrained palette to much more adventurous hues. Finally, the piece was set on slim metal legs, reminiscent of the elements of a museum display mount.

This base seems appropriate, given that *Pyrenees* has the feeling of a large-scale mineral specimen, abruptly sectioned at its flat sides. It could almost have wandered loose from a minerals gallery – a thought that might strike you if you were to encounter the work at the V&A, which acquired one of the edition, and is located across the street from the Museum of Natural History. Ian and Patrik chose colours that, especially, in person, enhance this geological quality: the green version is a mixture of short black and long yellow fibres, creating an iridescent effect, appearing almost gold in places. Despite the long and involved design process, *Pyrenees* seems almost to have been found rather than made. Fredrikson Stallard often seek this property in their work; if the finished object is not possessed of immediacy, even a feeling of inevitability, it's back to the drawing board.

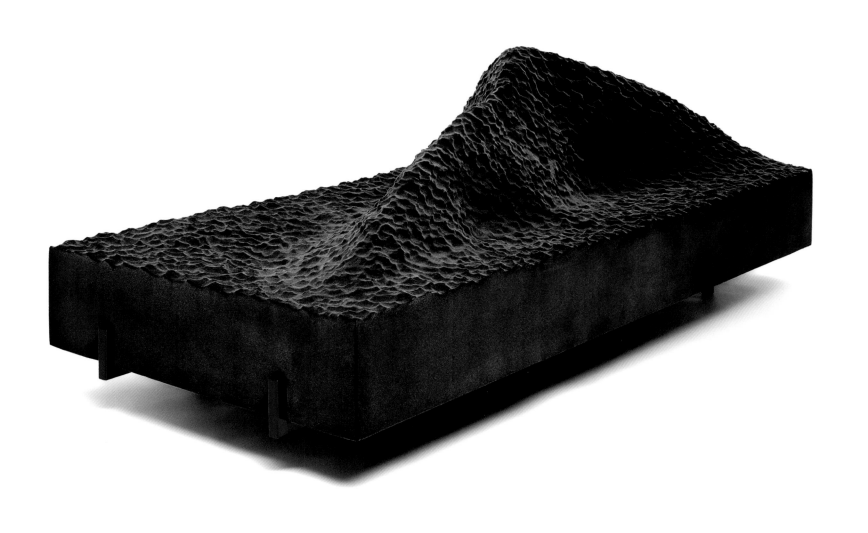

Pyrenees, 2007

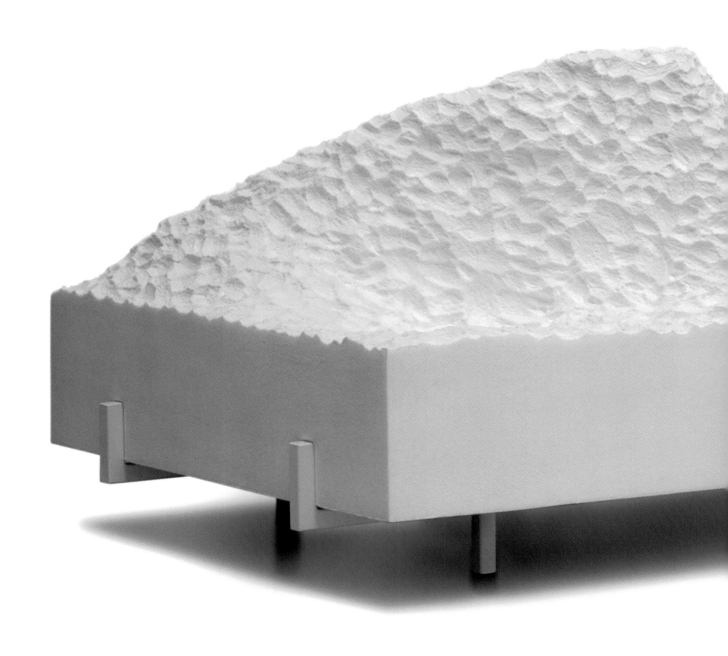

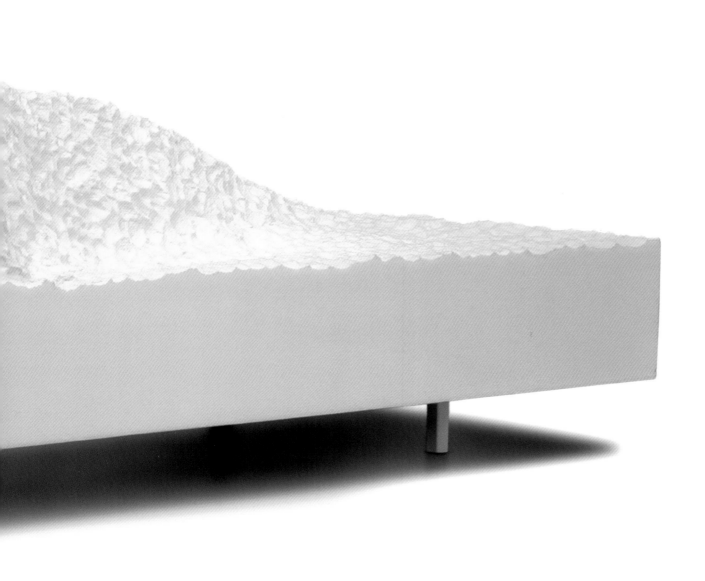

Pyrenees, 2007

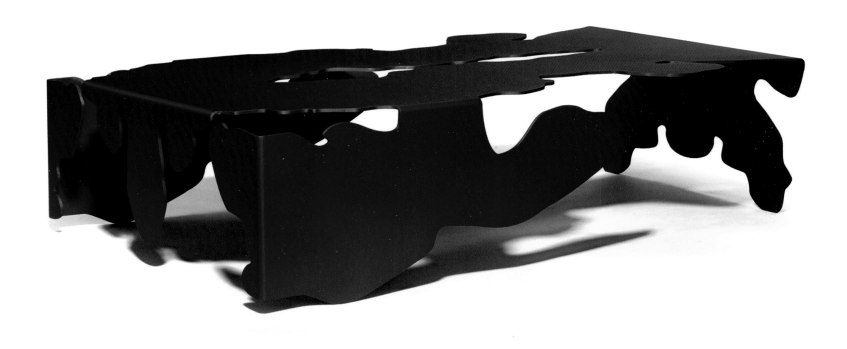

Aluminium, 2007, Table

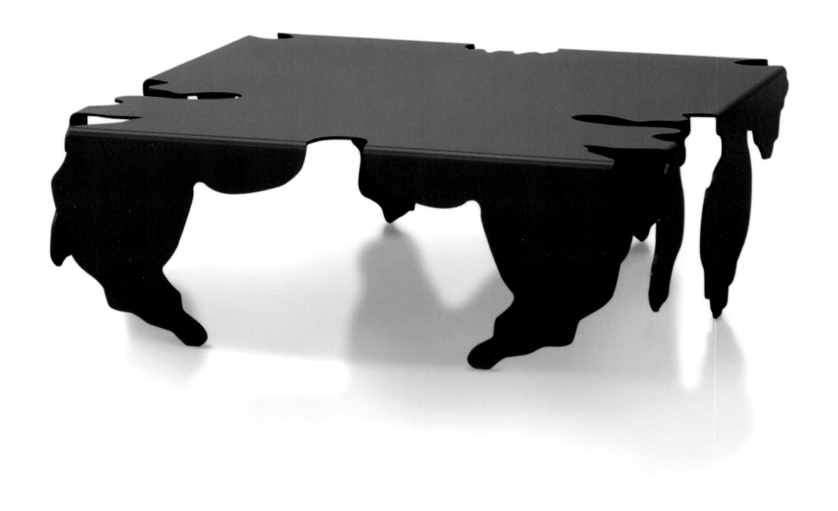

Aluminium, 2007, Square Table

Tarkett Case Eminent, 2007

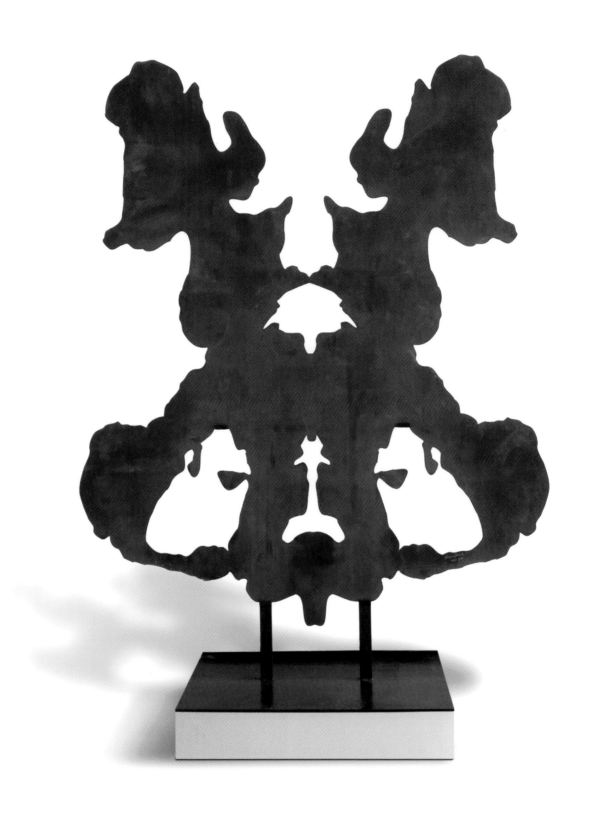

Orchideae CorTen, 2010

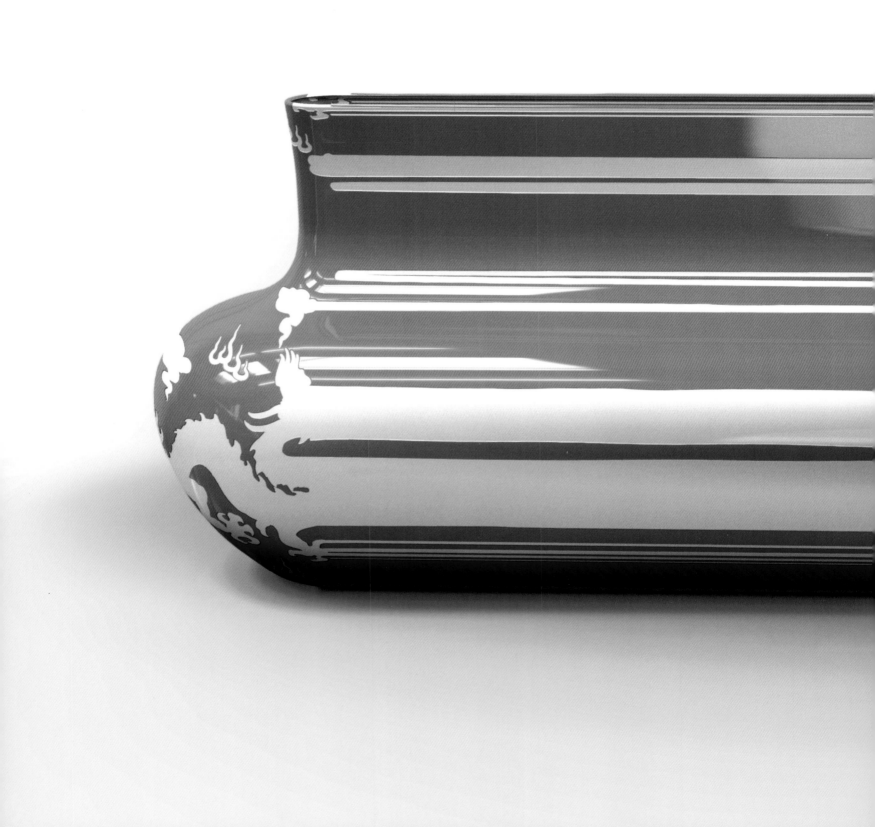

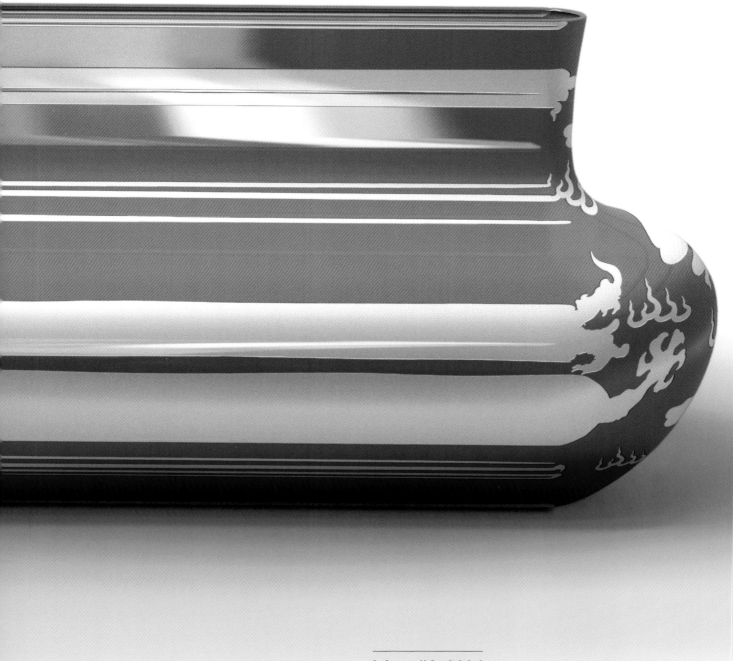

Ming #2, 2006

Rubber Table, 2007

There has long been a free flow between Fredrikson Stallard's domestic life and their professional design work; they say that they are gradually working towards a living space which is completely designed and made by them, a process that is taking many years and proceeds incrementally alongside their professional practice. Along the way, this ambition has yielded ideas that they have deployed elsewhere in their work.

The pattern is illustrated well in the case of the *Rubber Table*, which was presented in their inaugural exhibition at David Gill Gallery in 2007. Its genesis occurred when Ian and Patrik bought an orchid at the Columbia Road Flower Market. They wanted to give it a good pot to live in, and so started to work, drawing on Ian's long experience with plaster (the material that potters typically use to make moulds for slipcasting). As he puts it, there is a "magical fifteen-to-twenty-second moment when the plaster is curing, when it is like lava." They exploited this evanescent quality by allowing the plaster to stiffen to just the right consistency, then pouring it over an inverted terracotta pot. Once the plaster dried fully, they were left with a chalky-white vase with a smooth, pot-shaped interior and a textured exterior, which preserved the motion of the pour used to create it.

Immediately Ian and Patrik realized that this idea was too good for just one plant pot, so they started working with the technique on larger scale, aiming to make a table. The first try was a pour of plaster over a polystyrene block. After the plaster dried, a process that took a whole month because of its thickness, they decided that the result was too homogenous. They retained this first prototype object, and now that it has become patinated with age say that they enjoy its surface character; but at the time they felt that a different material would work better. It happened that they were regularly visiting a film prop company in London where the cast rubber element of their *Bergère* chair was fabricated. The workshop was filled with urethane rubber limbs, including some for the 2007 production of *Sweeney Todd* (starring Johnny Depp). Seeing this flesh-like material in such surreal profusion, they realized it would make a perfect substitute.

Thus the *Rubber Table* was born. It was initially made in three colours: a skin tone matching a cosmetic foundation they picked out at Selfridges; a shocking pink, which they chose in a slightly teasing way to respond to David Gill's suggestion that they explore bolder colour; and a dense black, "like coal out of the ground," as Patrik puts it. These three were later supplemented with a malachite green version. They also produced a smaller occasional table using the same process. The design approach was predictive of much of their later work, in which a single material is combined with an innovative means of direct forming, which embraces a certain degree of chance. The result is a singular object that is at once complex and straightforward.

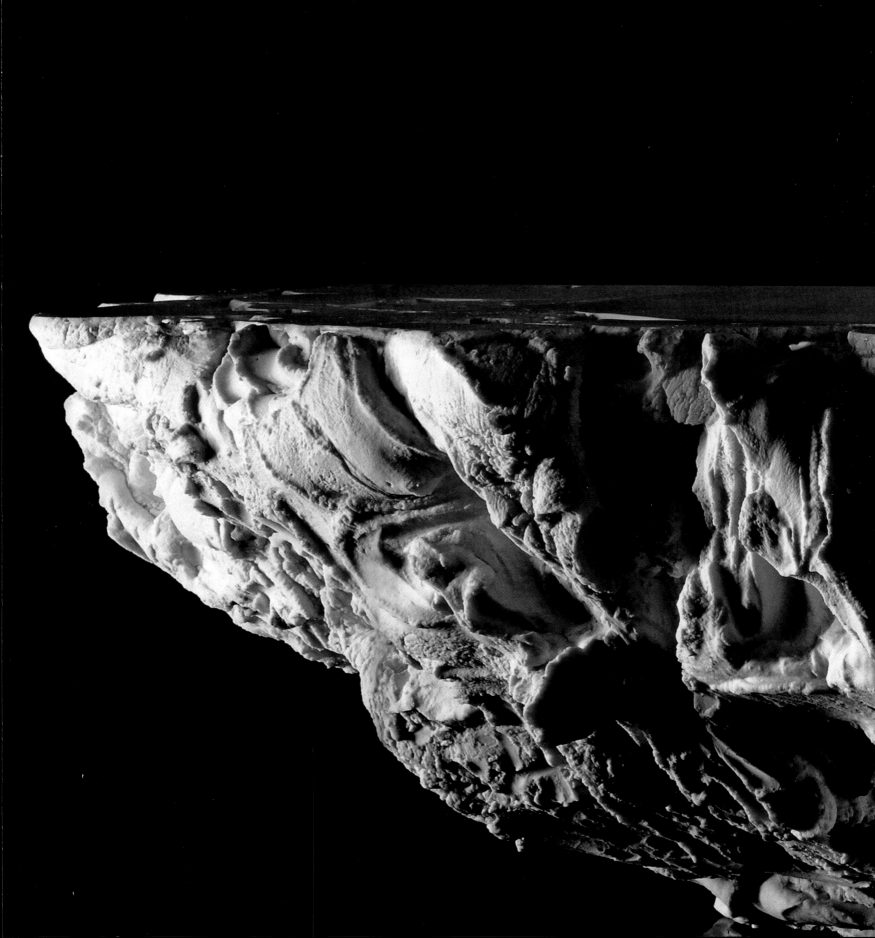

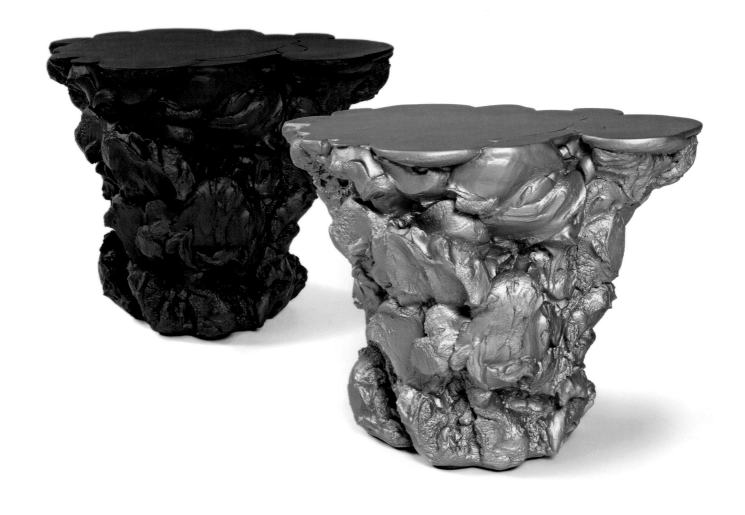

Rubber Side Table, 2007

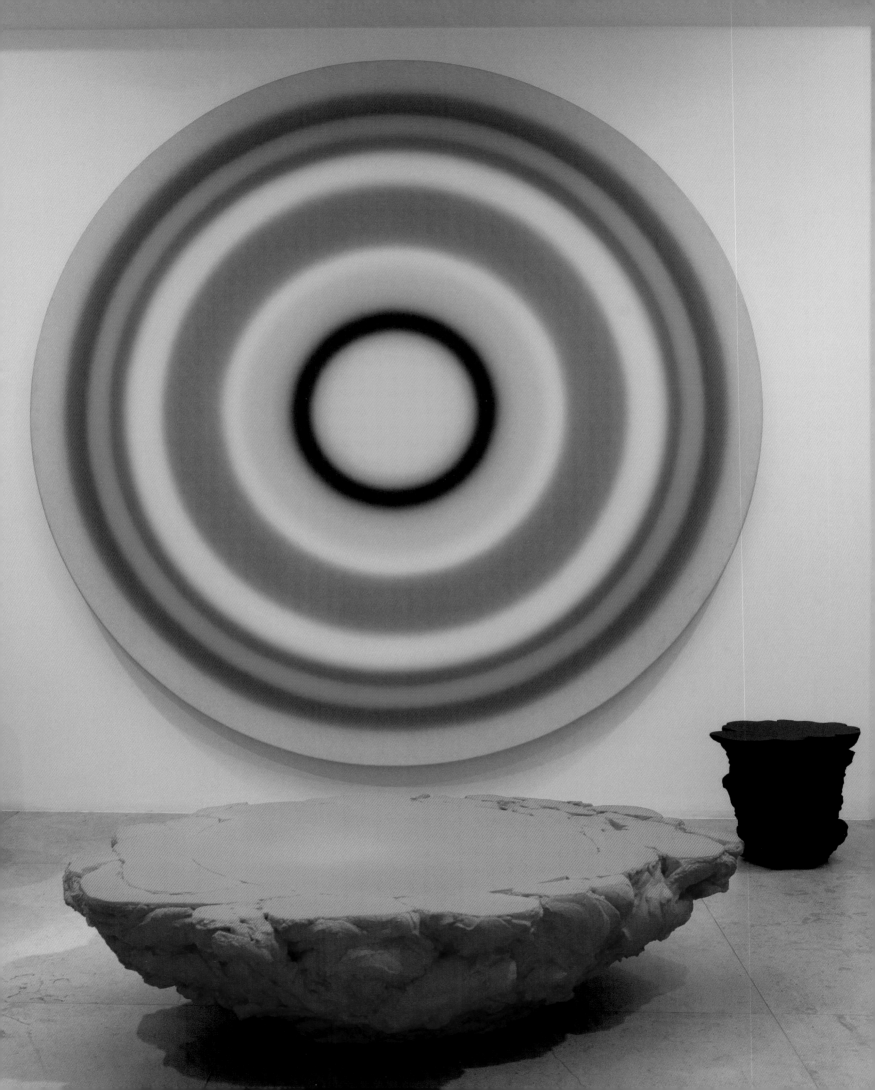

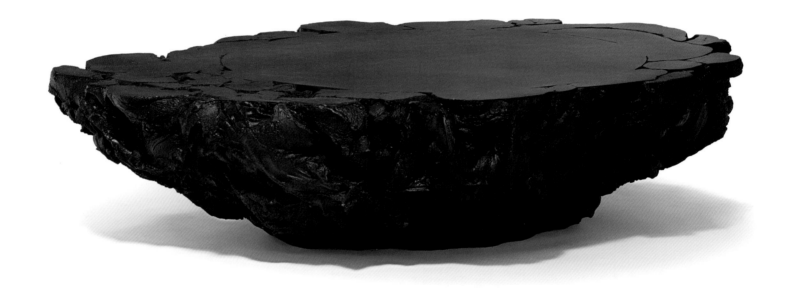

Rubber Table, 2007

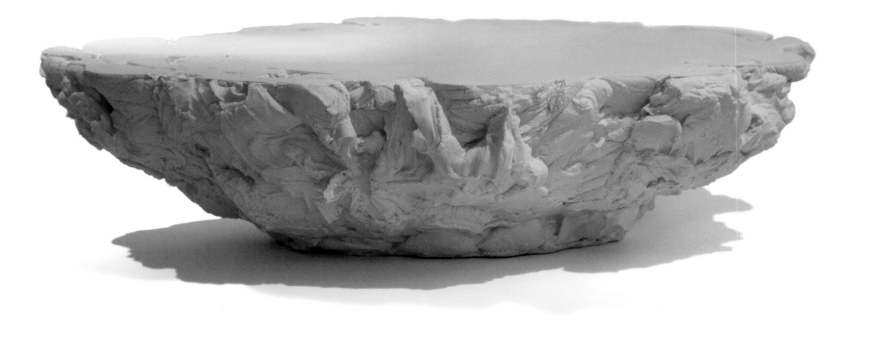

Rubber Table, 2007

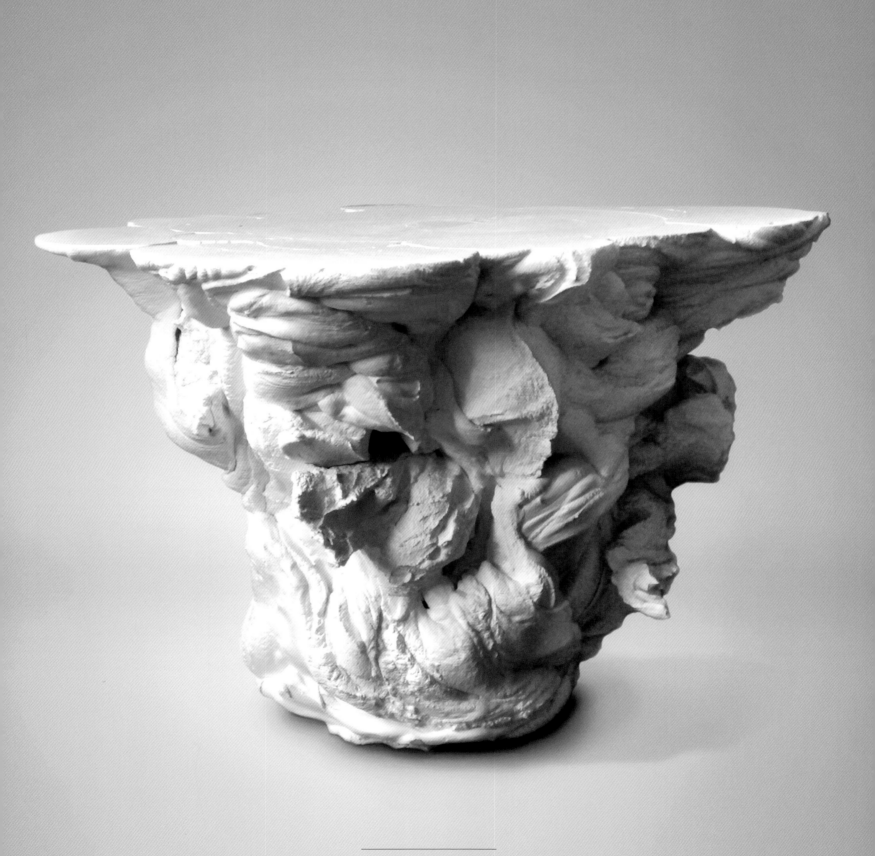

Plaster Table, 2007

King Bonk, 2008

The unusual title for this work derives from a childhood memory of Ian Stallard's. On the playgrounds of Essex, a "king bonk" was a type of marble, large in size and with a prominent coloured swirl in its interior. The slang phrase came to Ian when developing an early conception for this chair, rendered in clear acrylic with a melted, coloured form in its core. Though this treatment was not ultimately realized, the name stuck. Its semi-allusion to a certain large cinematic gorilla certainly feels appropriate to the design's generous proportions and tightly clenched, muscular form.

The design is atypical in Fredrikson Stallard's oeuvre in the sense that the original model had a totally different materiality from the final object. Usually, there is continuity between initial experimentation and the eventual forming process, albeit refined through multiple tests. In the case of *King Bonk*, however, this would not have been practical, because the first study was a small length of foam, quickly twisted and tied in the hands and then dipped in rubber.

3D scanning and fabrication were not yet sophisticated enough in 2007 to permit a digital scaling process, so Ian and Patrik resorted to direct methods. They got a big block of polystyrene and simply carved it with a chainsaw, using the model as a reference. The form was then patched and adjusted with automotive body filler. This "master" – which they still retain, an impressive relic in its own right – was then used to make a mould, in which the final fibreglass object was made. As the designers note, despite its translation into a solid, monolithic object, the chair still retains its kinetic energy, "as if by cutting a supporting string it all would unfold to the flat sheet it once was." David Gill pointed out to them that the powerful asymmetry of the object seemed to require an offsetting companion element, and so a matching footstool was designed to accompany it.

The full edition of eight *King Bonk* chairs were unveiled in grand style for Fredrikson Stallard's second exhibition at David Gill Gallery. The large industrial space in Vauxhall was turned into a theatre of sorts – windows blocked, the room filled with dry ice smoke, a single vertical spotlight trained on each chair. The drama was enhanced by the gleaming surfaces of the chairs, which recall Henry Ford's famous line about the Model T – "you can have any colour you like, as long as it's black." Gill had encouraged Fredrikson Stallard to explore brighter colours in their work, and to execute *King Bonk* in a range of hues; feeling that it would look best intense and dark, they were unsure of how to respond to this until they noticed a Bentley driving past them in London, which had an "interference" paint, black with rich chromatic undertones. They approached Bentley to apply a similar finish to all the chairs, in four different shades (violet, cobalt blue, silver and gold), lending them a saturnine and luxurious glamour.

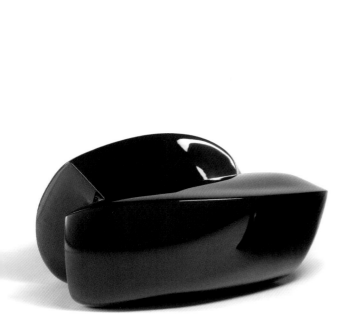
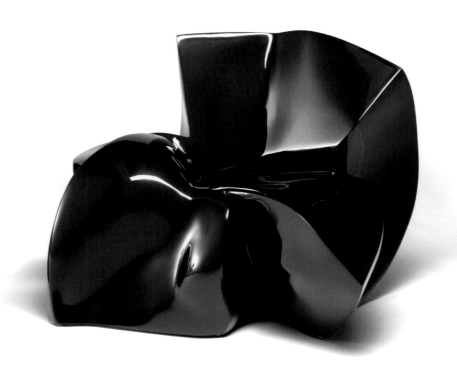

King Bonk, 2008

Pandora, 2007

"For us it was sort of a holy grail." That is how Fredrikson Stallard describe their first crack at the Crystal Palace, Swarovski's annual show space at the massively attended Salone del Mobile in Milan. It was indeed a big gig. 2007 was a breakthrough year for them in several respects, given the new association with David Gill, and the immediate success of the *Pyrenees* sofa. But it was their collaboration with Swarovski, at the heart of the world's biggest design event, that did most to put Fredrikson Stallard on the international map. Previous entrants in the series had set an impressive precedent. Tord Boontje's branchlike *Blossom* lighting fixture, a signature piece for the designer, had premiered at the first Crystal Palace in 2002. Since then other luminaries including Ron Arad, Hussein Chalayan, and Gaetano Pesce had also participated in the program.

One of the key challenges that Swarovski gave to designers in the Crystal Palace program was to reinterpret the chandelier. Nadja Swarovski, who initiated the series, says that she originally intended "to stimulate more creativity within the industry" – to encourage lighting manufacturers to make more interesting fixtures, and therefore new and different settings for the company's crystals.

Over time, Swarovski realized that they were having considerable success in actually selling the chandeliers, so the project continued and expanded, paving the way for projects like Fredrikson Stallard's *Glaciarium* collection.

A good chandelier is an architectural centrepiece, a complex construction, and of course an opportunity to show off the scintillation of faceted crystals. It is typically a rather traditional object, however – indeed, Nadja Swarovski's patronage of contemporary designers is motivated primarily by the desire to infuse familiar typologies with new ideas. This is exactly what Fredrikson Stallard did in *Pandora*. Observing that a standard chandelier is essentially a volume composed of many individual elements, they realized that by introducing movement, they could "explode" the object. Each of the crystals is individually hung on its own wire strand, which is engineered to rise and fall slowly within an orchestrated pattern. The crystals occasionally align into the silhouette of a conventional chandelier, only to slide again into apparent chaos.

The kinetic action of *Pandora* grounded it in the contemporary moment – the piece is digitally driven and its motion recalls the smooth operations of computer animation. It

also has the benefit of showing off Swarovski's crystals to dazzling effect, because of the constant shifting of light off their mobile, slightly trembling facets. As one might expect given its mesmerizing visuals, *Pandora* was rhapsodically received in Milan, and it stole the show again in 2012 when it was featured in *Digital Crystal*, a survey of Swarovski projects incorporating new technology at the Design Museum in London.

Yet, beyond the sheer optical splendour of *Pandora*, it also conveys a subtle philosophical message. One almost fails to notice that there is no source of light in the object itself – it illuminates only through reflection. Indeed, there is actually no chandelier there at all, only the outline of one, which itself appears transiently. The form exists only in our heads, as we imprint our memory of other chandeliers on to it. In this way, *Pandora* speaks to the very nature of tradition, which also accumulates in the domain of perception and over time. Of all the work that Fredrikson Stallard has made for Swarovski, this piece might be the one that best captures the nature of the company – their ongoing project to preserve an established image, while remaining constantly on the move.

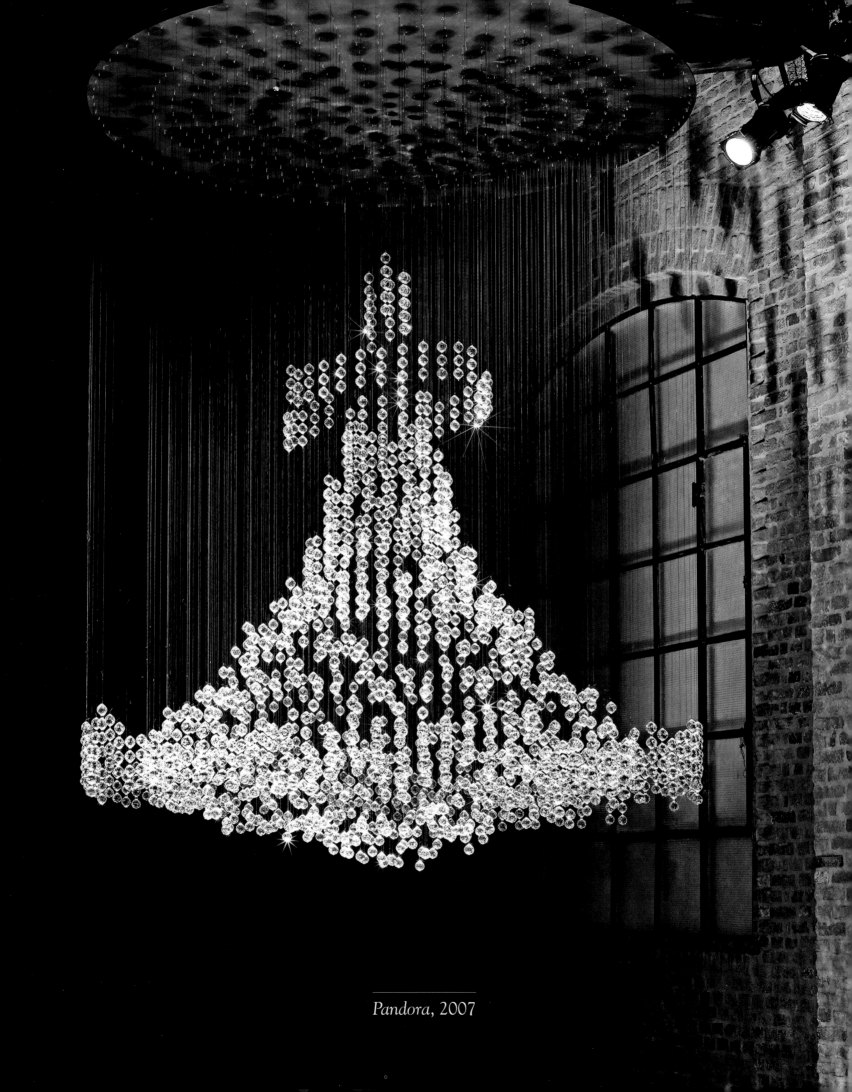

Pandora, 2007

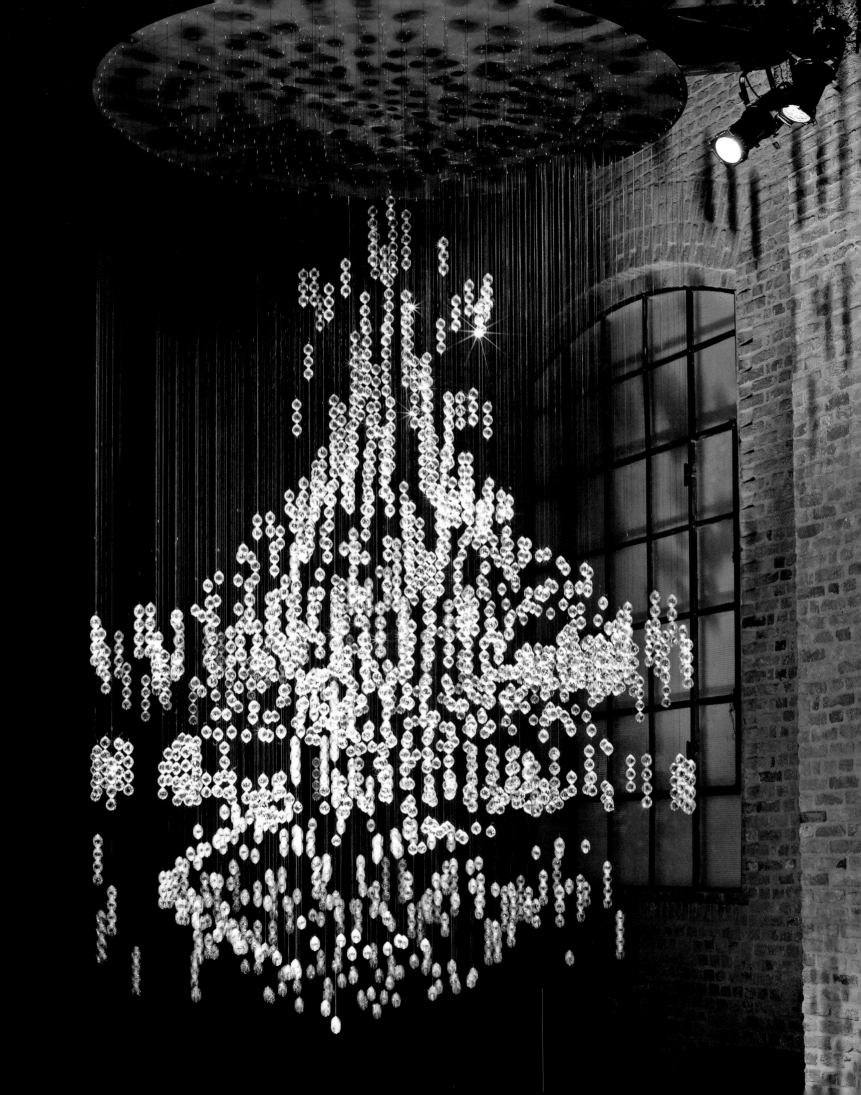

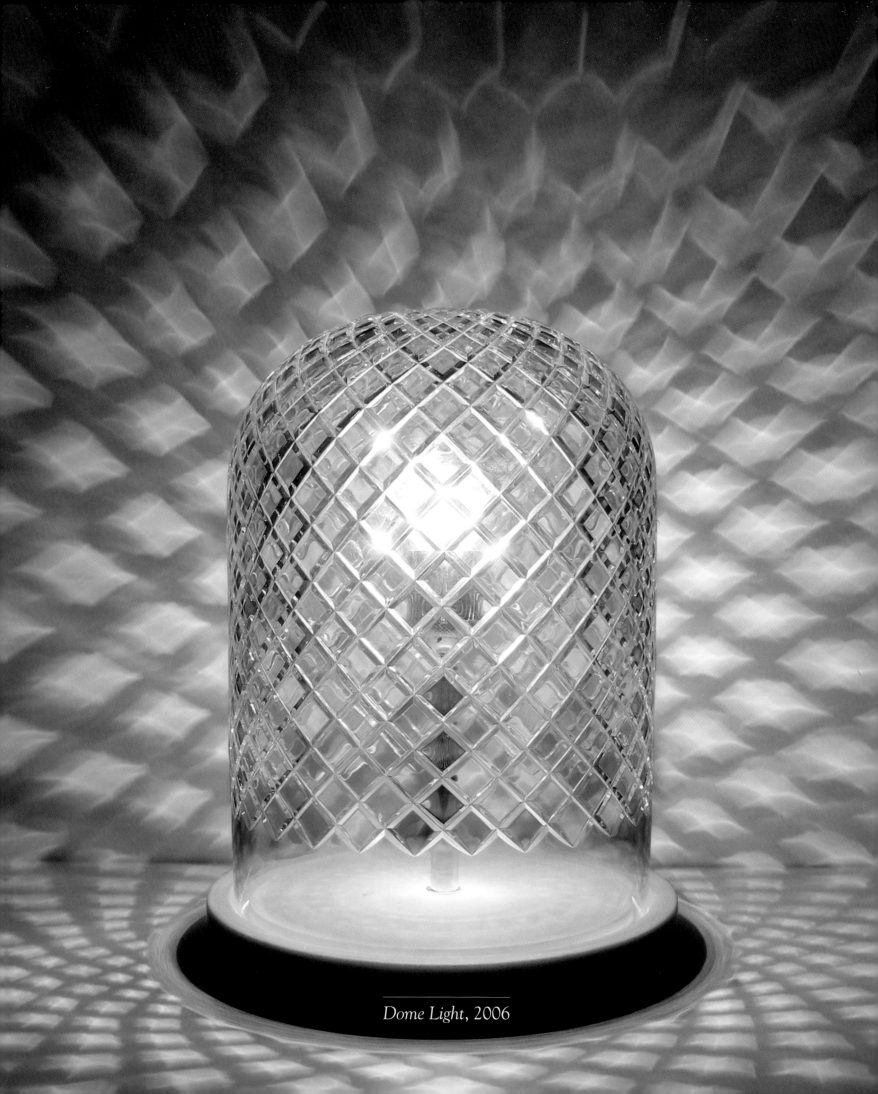

Dome Light, 2006

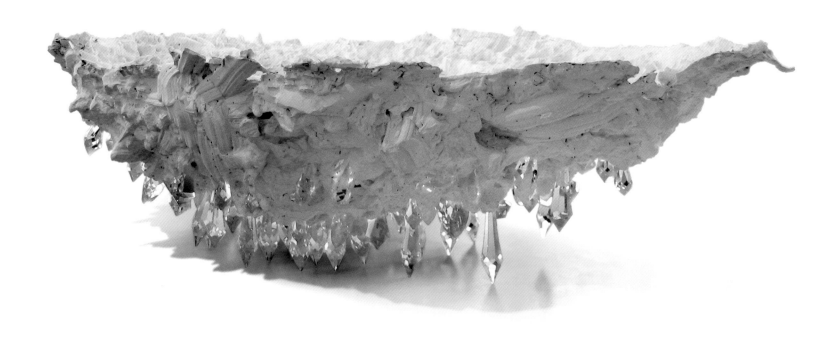

Épergne, 2009

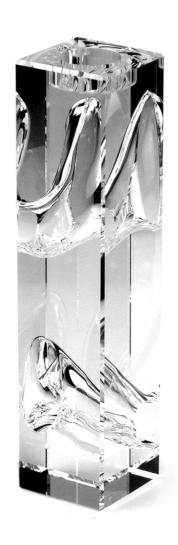
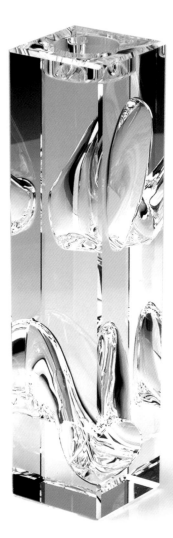

Cavern, 2008, Candleholders

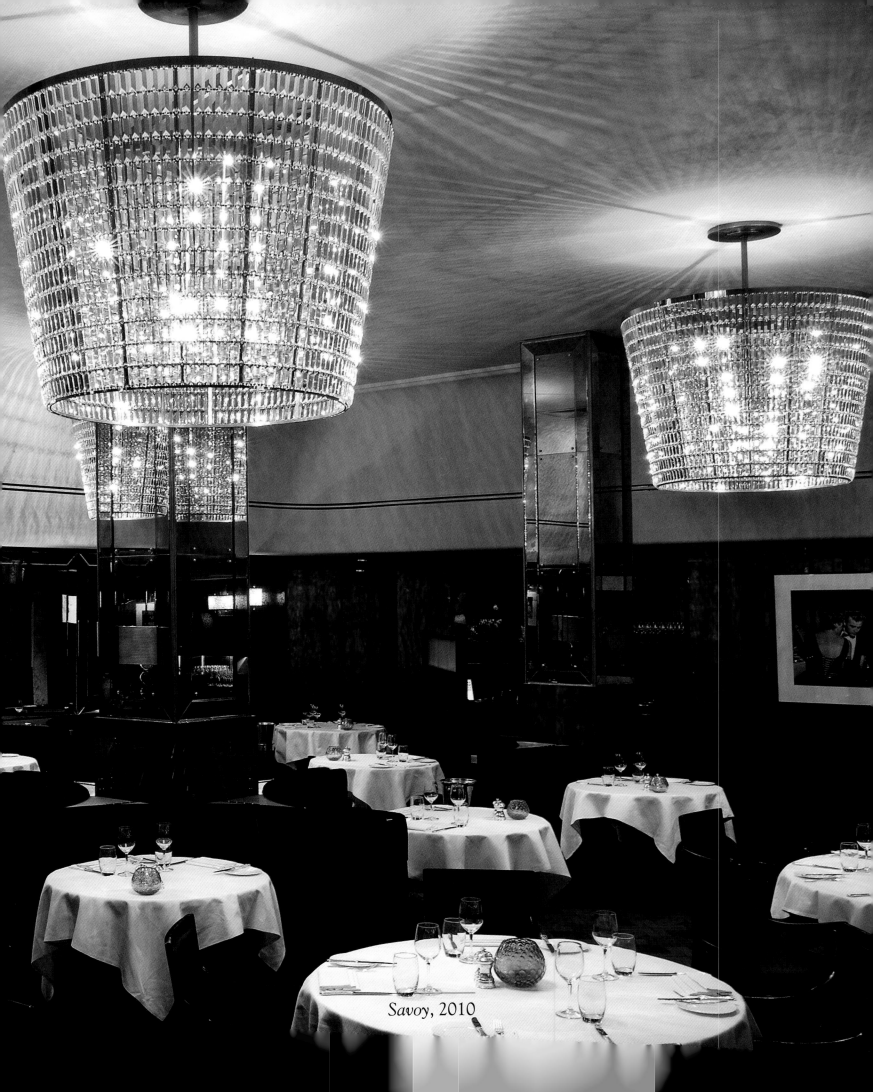
Savoy, 2010

Portrait, 2008

Fredrikson Stallard's first foray into public artwork, *Portrait* was commissioned by the iconic French champagne house Veuve Clicquot for the London Design Festival. The sculpture is made of Cor-Ten steel, popular with artists such as Richard Serra for its beautiful surface when rusted, but was inspired by a plank of wood. Ian and Patrik recall a long and frustrating weekend during which they struggled with a completely different and unsatisfactory proposal, which they dismiss as a "superfluous play with curves." In the midst of this experience (rare for them) of designers' block, their attention alighted on a plank leaning on a wall in the studio. They had a classic eureka moment: they could transmute timber, the primordial building block of architecture, into an image rather than a substance. The sculpture would be the "portrait" of a fundamental material.

Once this basic principle had been conceived, a further ingenious possibility emerged: the sculpture could visually "flip" as day turned to night, its wood grain pattern reading as negative form in the sunlight, and (thanks to internal illumination, in Veuve Clicquot yellow, of course) a glowing pattern in the evening. Particularly in its initial installation at Somerset House in London, this double identity made it into an effective beacon at all hours, a monument by sunlight and a gigantic lantern after dusk. The easily recognizable wood grain motif makes the sculpture very accessible, without pretention or conceptual difficulty. Having said this, the work does play interestingly on the idea of nature; set originally at the heart of a heaving modern metropolis, it could be read as a ghost of the forests and timber structures that once inhabited the land.

After its successful initial presentation at the London Design Festival, *Portrait* had an itinerant and distinctly uncharmed life. It was first relocated to the Wapping Project, an outdoor sculpture park in the shadow of a derelict power station. It was satisfying to see the work "surrounded by decaying urbanity," as the designers put it, but unfortunately while there a lorry drove into the work and damaged it. After repairs, it was moved again, this time to Hôtel du Marc in Reims, the former home of Madame Clicquot. En route, it fell off the back of another lorry, and had to be fixed once again. Finally, at the château, it seemed to have arrived at its final resting place. Surrounded by verdant nature instead of concrete, it took on yet another aspect. Then, two years later, a tree fell on it during a storm and destroyed it. It's a sad story, if weirdly appropriate to a sculpture born in a single moment of inspiration, which depicts materiality in the guise of absence.

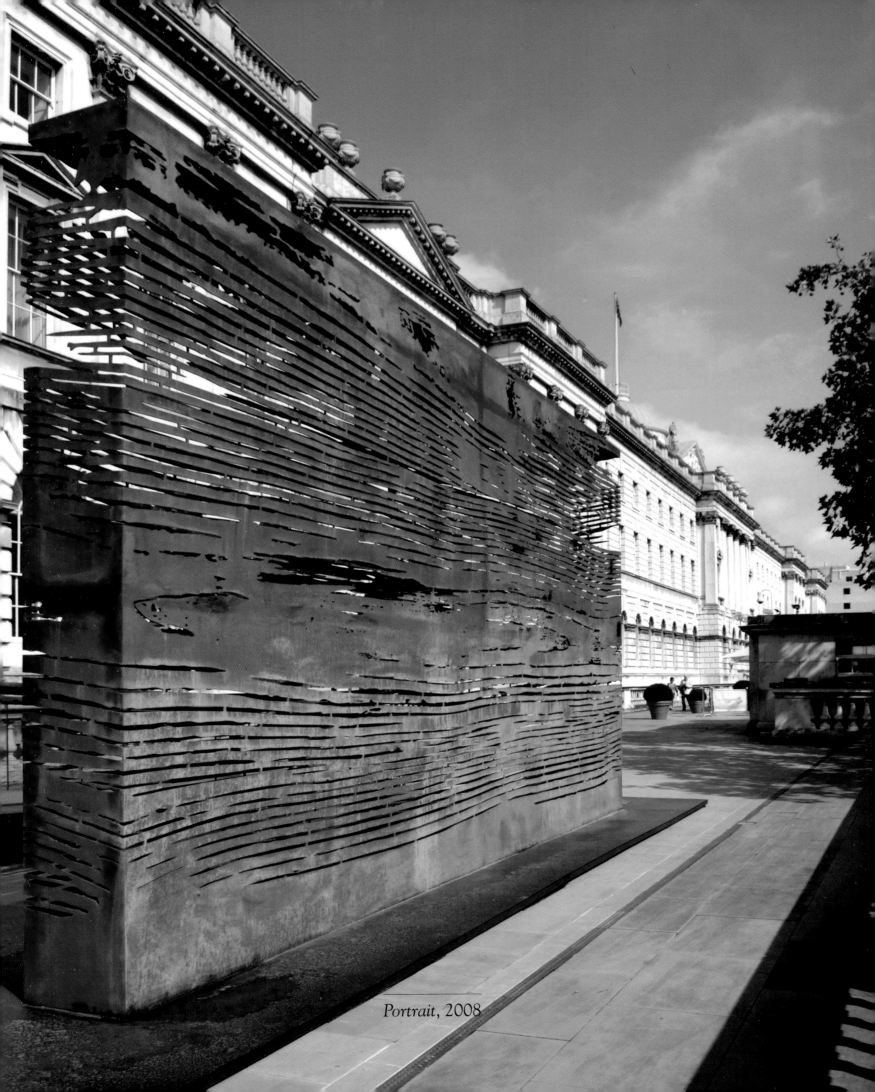

Portrait, 2008

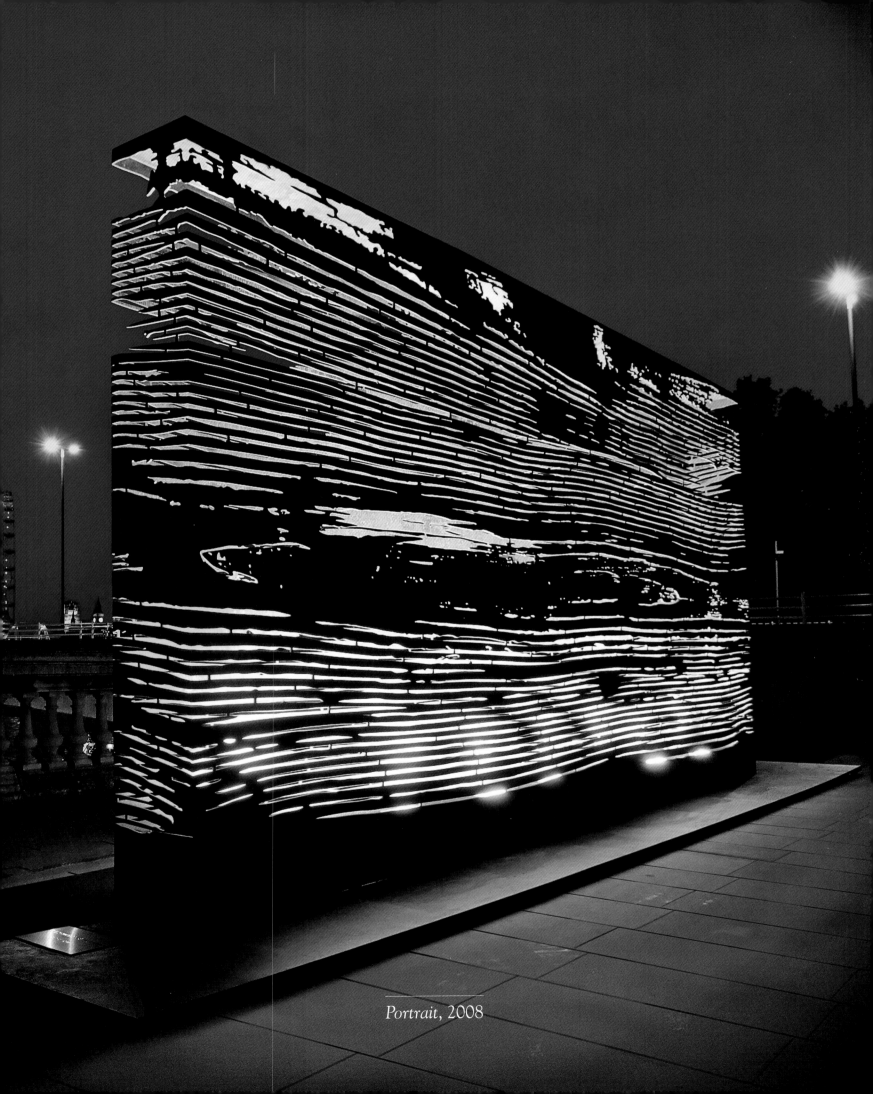

Portrait, 2008

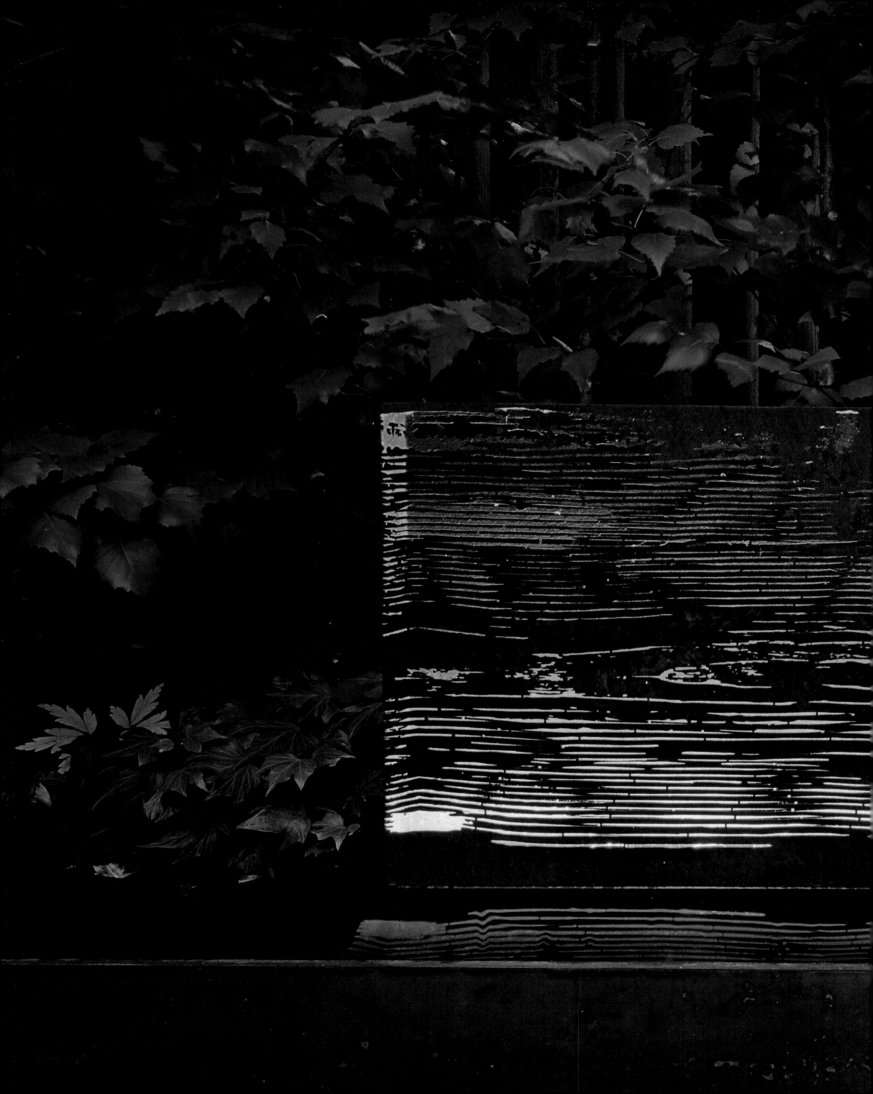

Portrait, 2008, Light

Gasoline Garden, 2009

Almost everything Fredrikson Stallard have made is easy to like. Abstract in form, evoking the wondrous qualities of materials, immaculately conceived and crafted, there is not much in their oeuvre that challenges the boundaries of good taste. *Gasoline Garden* is an exception – a reminder that they began their careers as provocateurs, and have not lost their edgier instincts. The project consists of fifteen unique vases, each of which is based on a traditional Chinese silhouette, and then sumptuously and unexpectedly decorated with the figure of a "pin up girl." The women – all of whom were played by a single extremely game model, wearing different wigs and outfits – were executed by a specialist airbrush artist, based in the UK but working in the American tradition of hot rod painting.

While it may seem an outlier in their oeuvre, *Gasoline Garden* is actually only one (though certainly the most ambitious) of many takes on the Ming vase in Fredrikson Stallard's work. Fascinated by the classicism of the form and its exuberant iconography – coiled dragons bearing their claws – they have returned to it repeatedly. One of the earliest was *Ming #2* (2006), which was stretched out horizontally, as if altered in CAD program, though it was actually handmade by artisans in China. The piece was conceived for a cross-cultural project at Contrasts Gallery in Shanghai, headed by the art dealer Pearl Lam. Though it never went into production, *Ming #2* spoke both to the idea of China and Europe reaching out to one another; an early example of the so called "new aesthetic" of our born-digital era, it presages later "stretched" design objects like Sebastian Brajkovic's *Lathe Chair* (2007) and Front's *Blow Away Vase* for MOOOI (2009).

The idea behind *Gasoline Garden* was, in one sense, just another of these transpositions. Instead of an imperial dragon, it boasts imagery that recalls Rita Hayworth on the side of a World War II bomber – like the dragon, a motif chosen to symbolize good luck and sexual prowess. (The connection was initially prompted by the fact that both the vases and the aircraft often have flames painted on them.) Ian and Patrik concede that when it comes to depicting female sensuality, there is "a very fine line" between objectification and empowerment; their hope is that viewers will find the imagery to be celebratory, a tribute to powerful femininity. Certainly, no effort was spared in glorifying the figures. Having staged a shoot in the studio, photos were then given to the airbrush painter, who "wrapped" them by eye around the circumference of the vases, like a tailor cutting a pattern. The process of rendering took about six months. The result is, as the designers aptly put it, "high octane." But then, that is true of Ming vases too; as Ian and Patrik point out, those imperial objects were the original "design art."

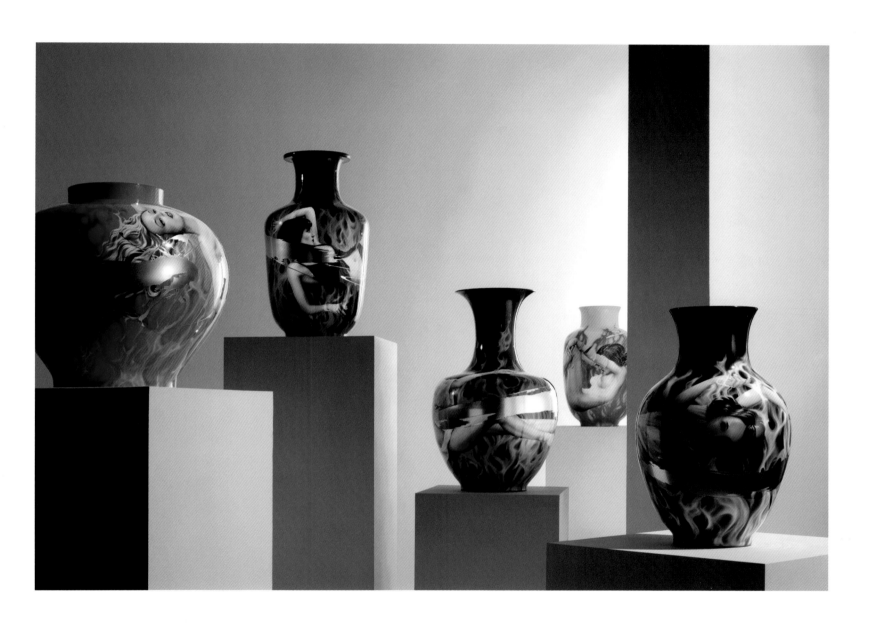

Gasoline Garden, 2009

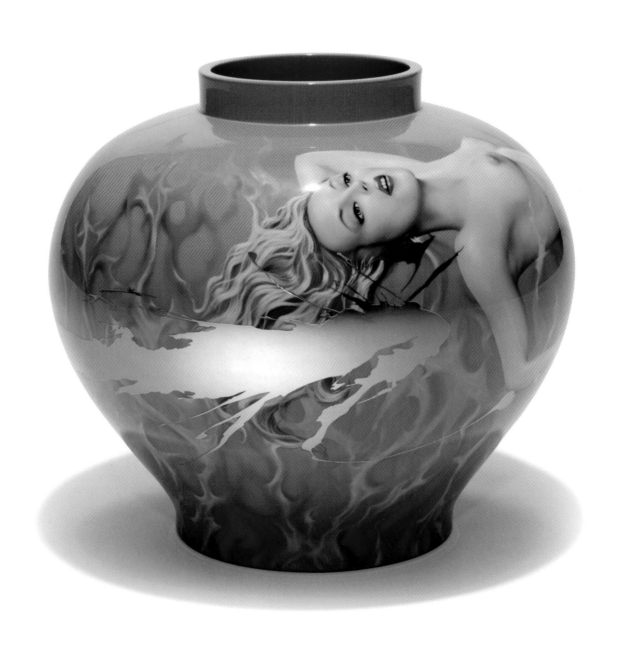

Cadillac, 2009

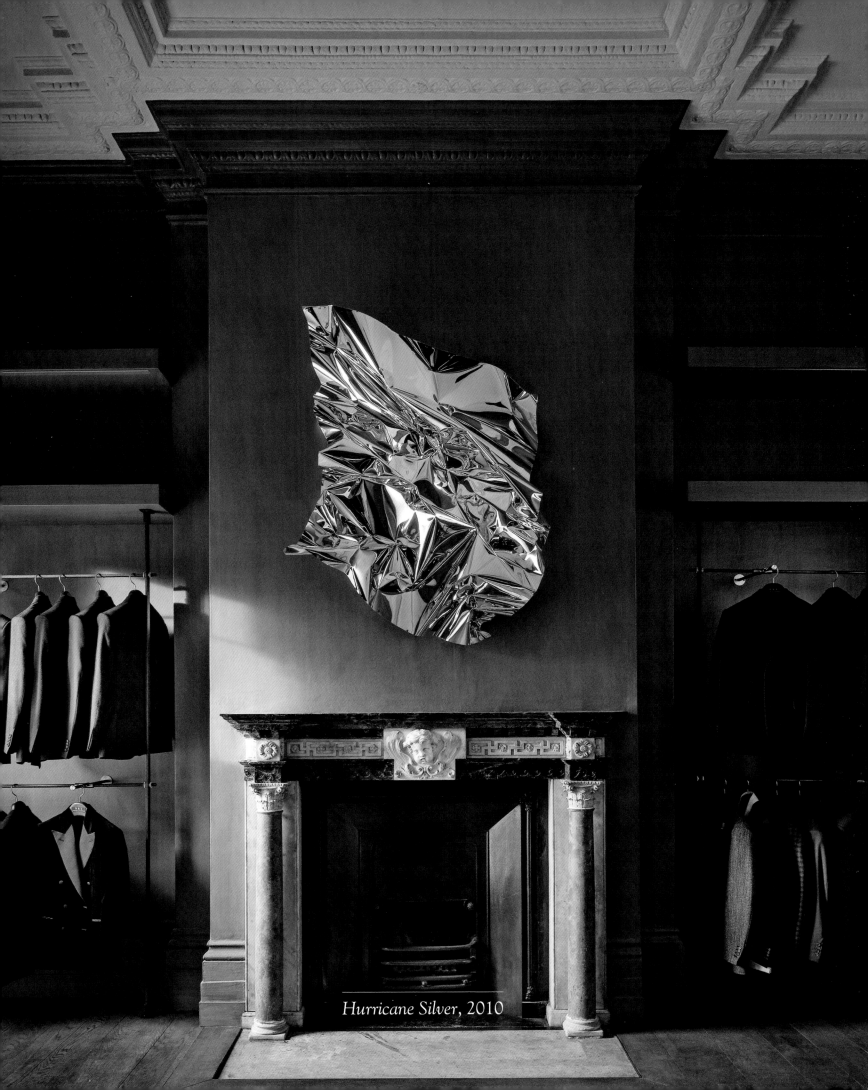

Hurricane Silver, 2010

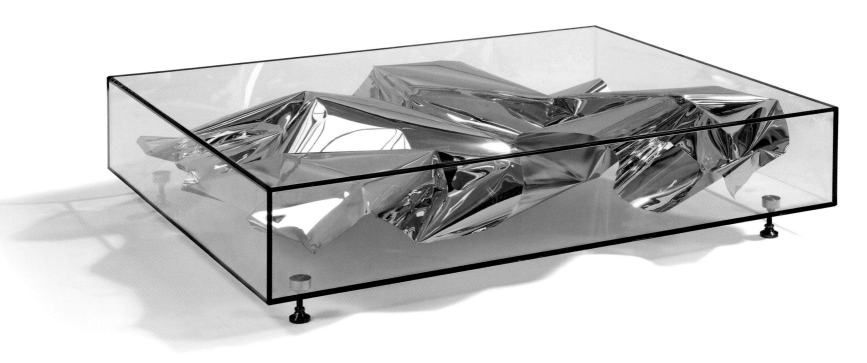

Silver Crush, 2011

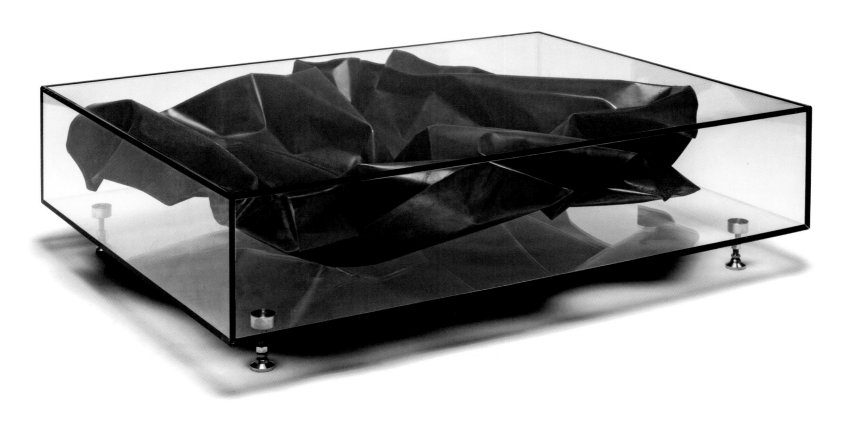

Bronze Crush, 2014

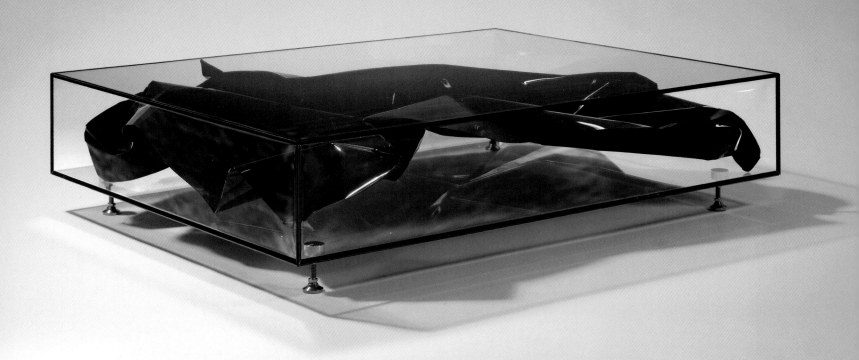

Black Crush, 2012

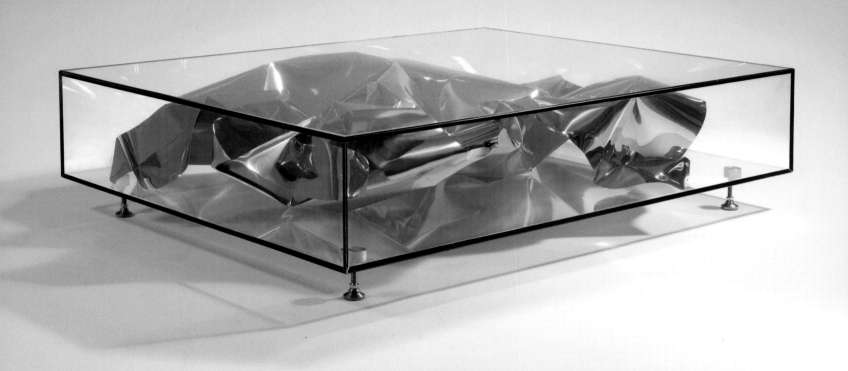

Gold Crush, 2012

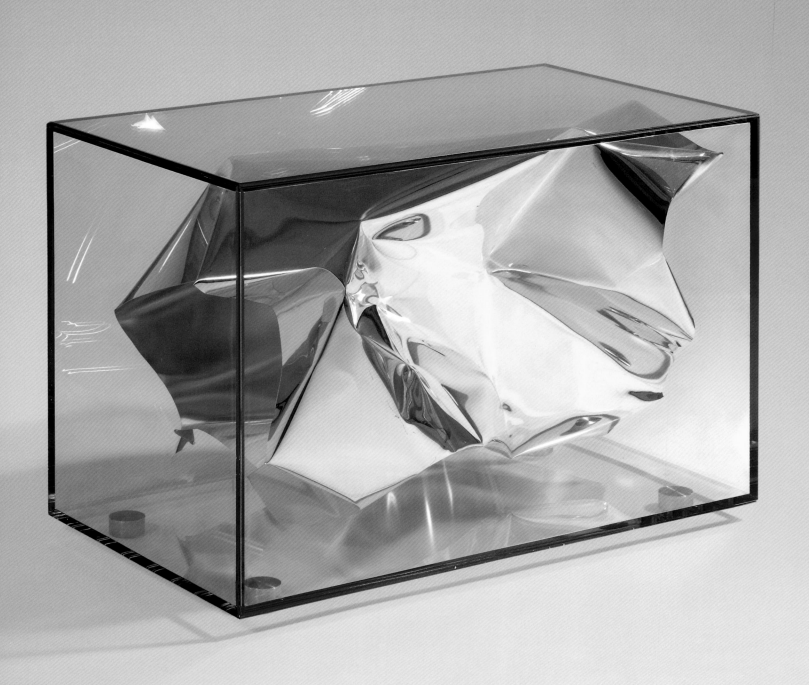

Silver Crush, 2012, Side Table

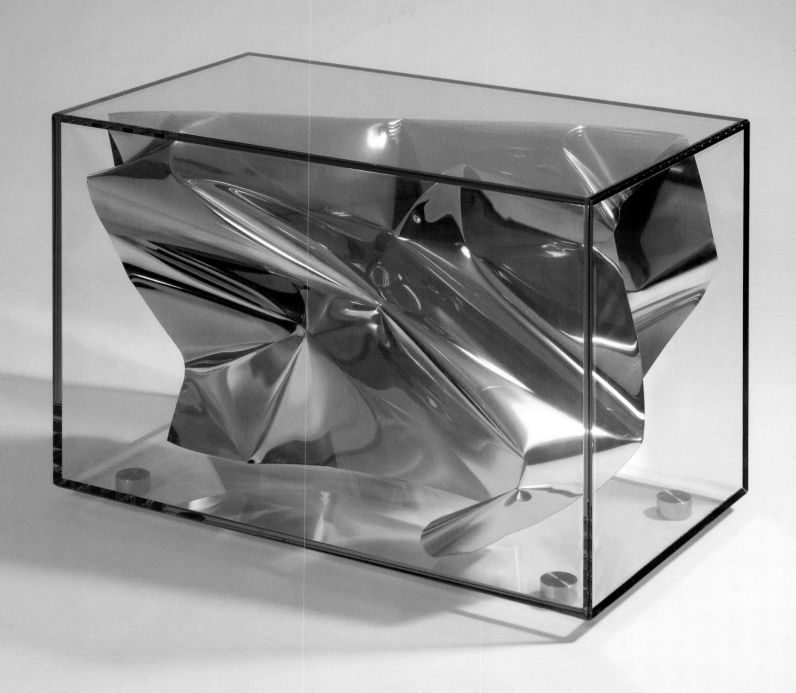

Gold Crush, 2012, Side Table

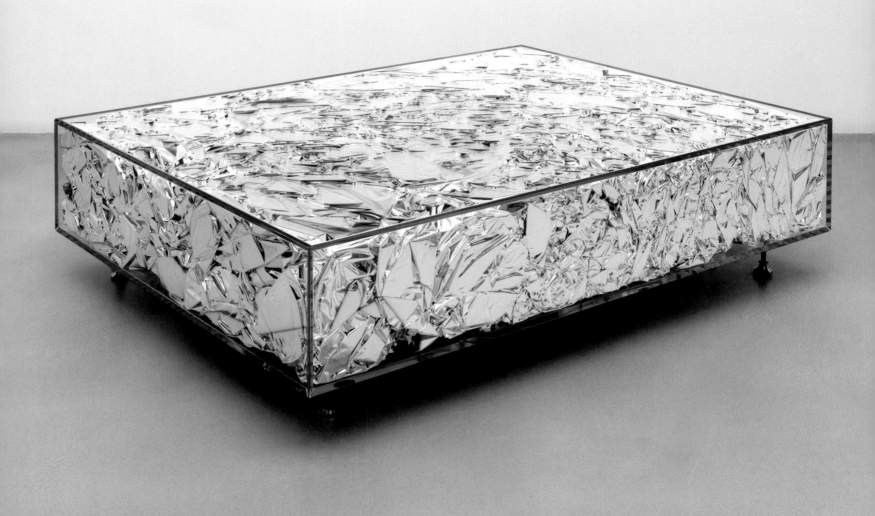

Parachute, 2015

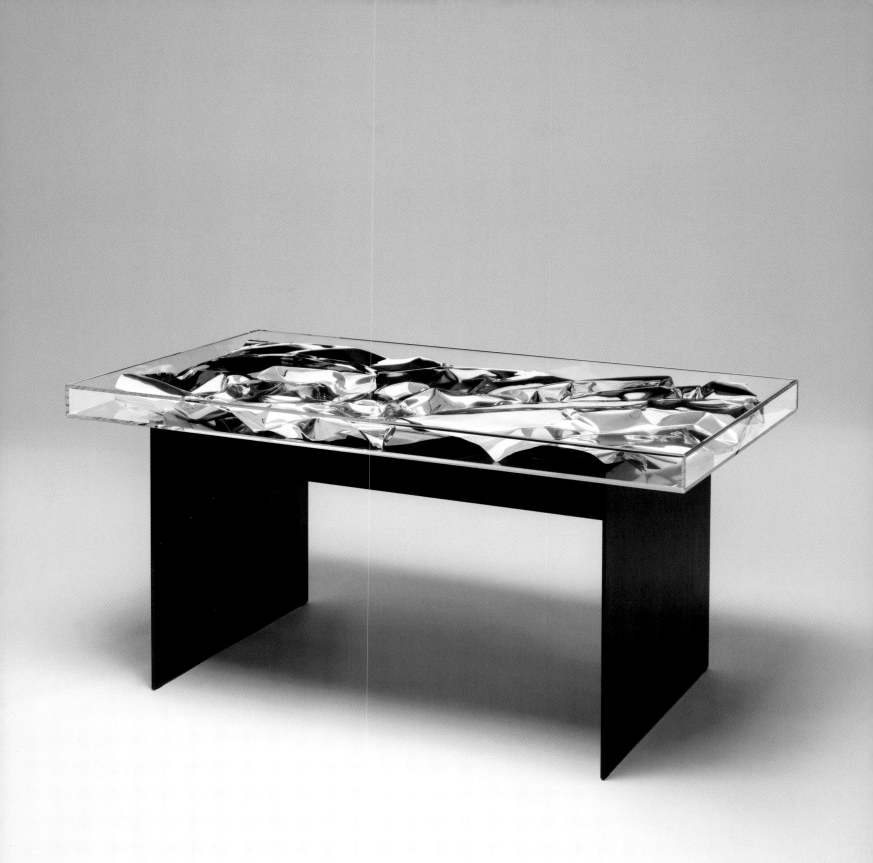

Silver Crush, 2016, Desk

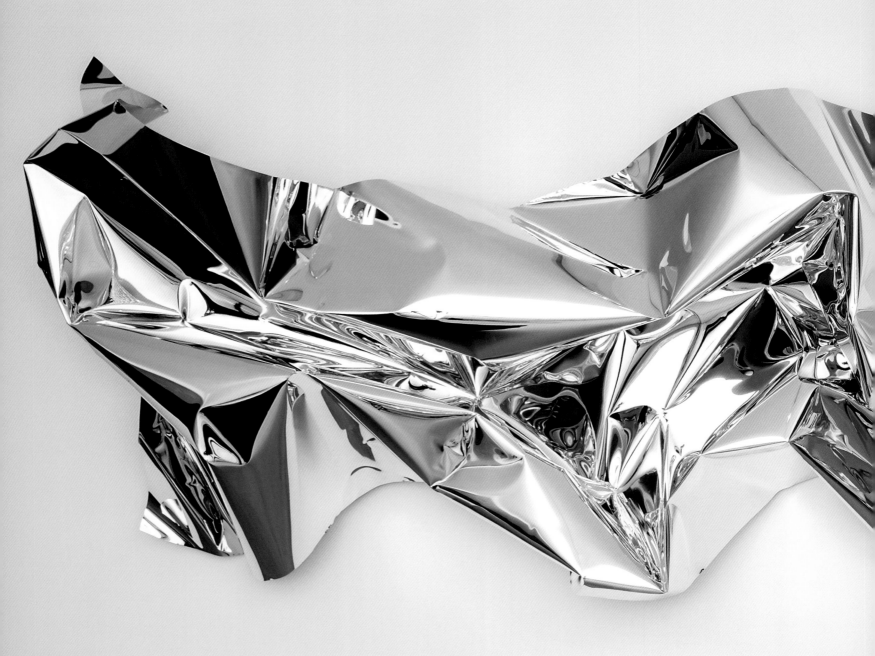

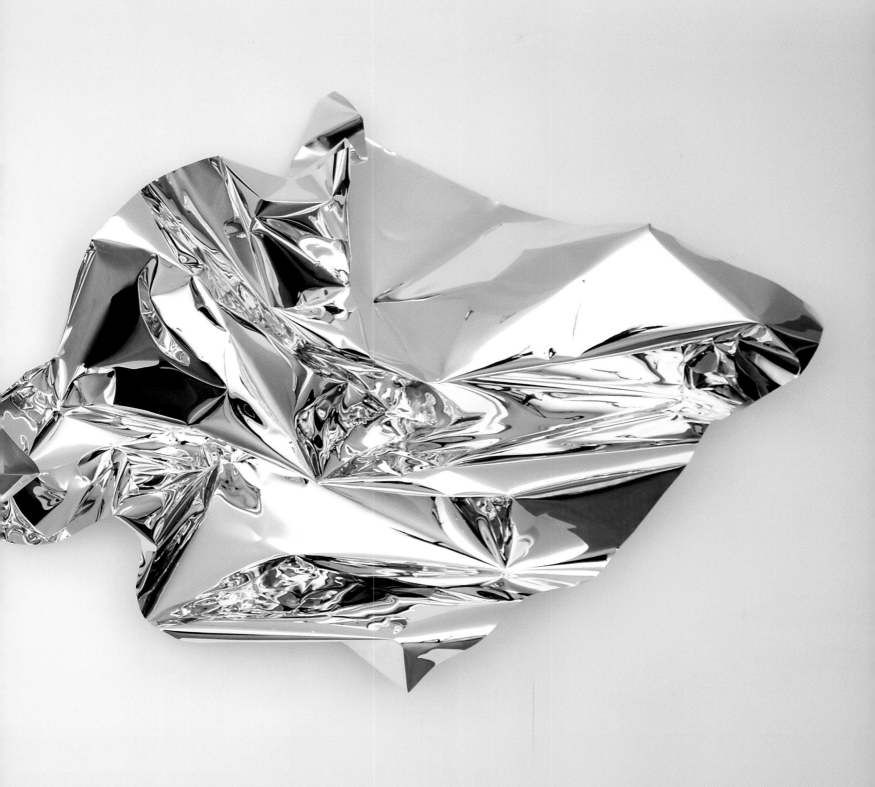

Hurricane Silver, 2010

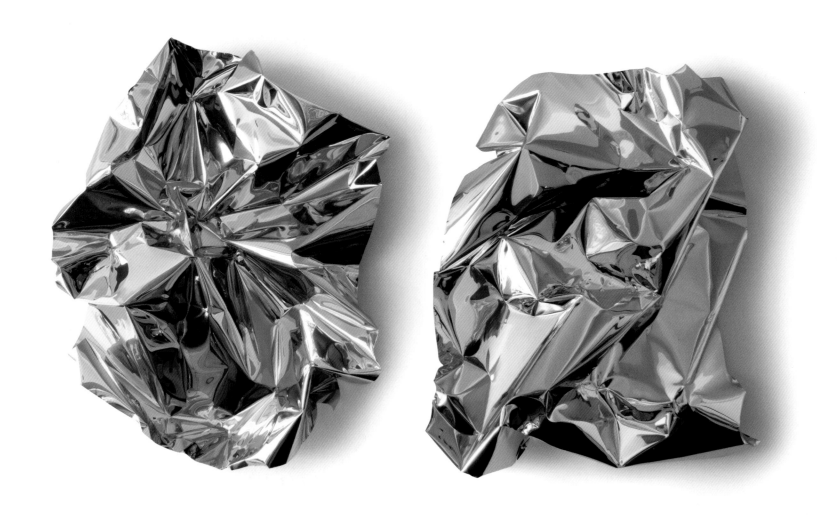

Hurricane Gold, 2010

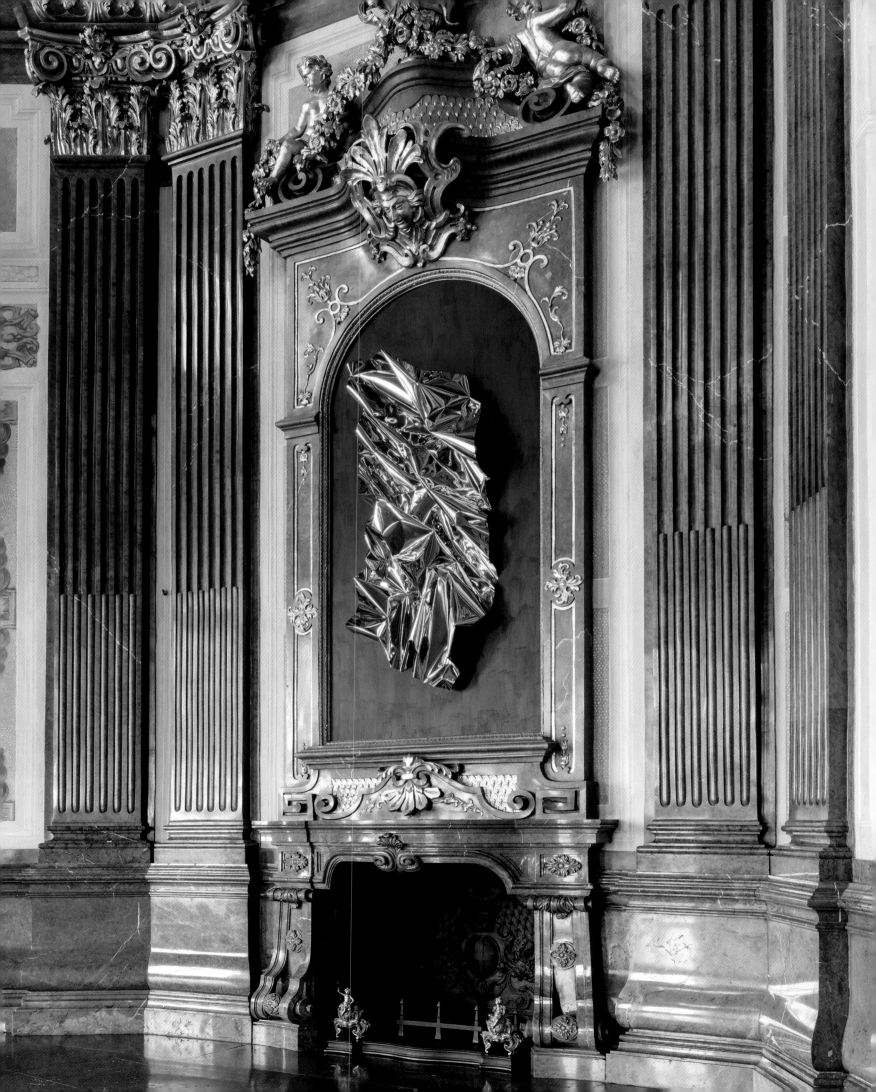

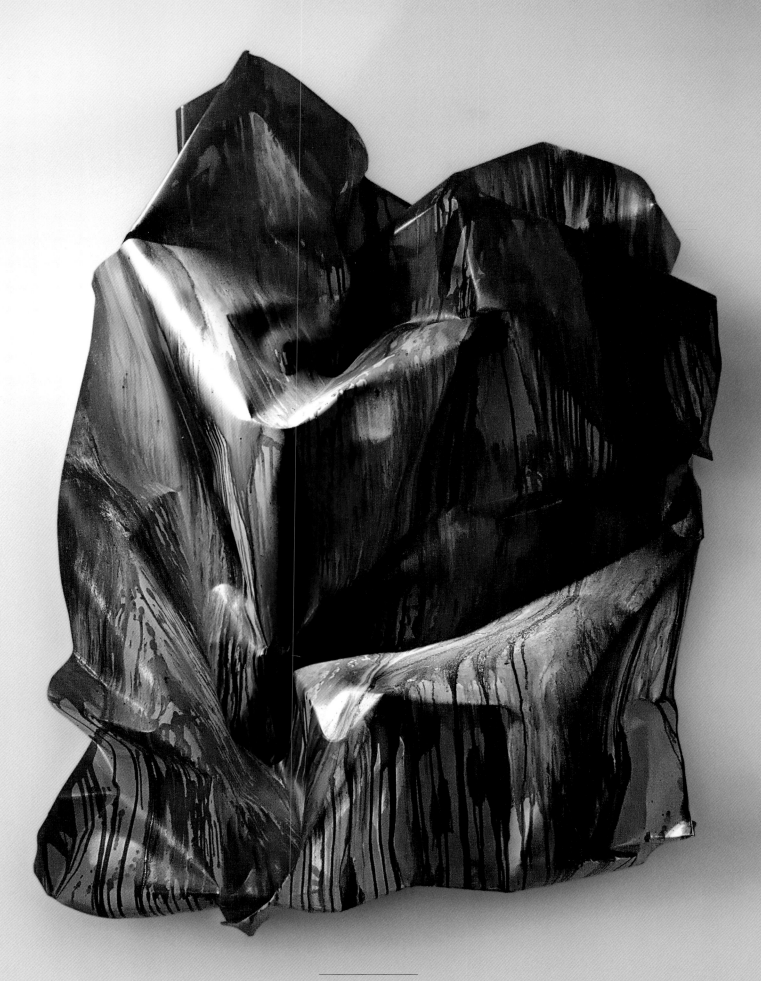

Brasilia, 2011

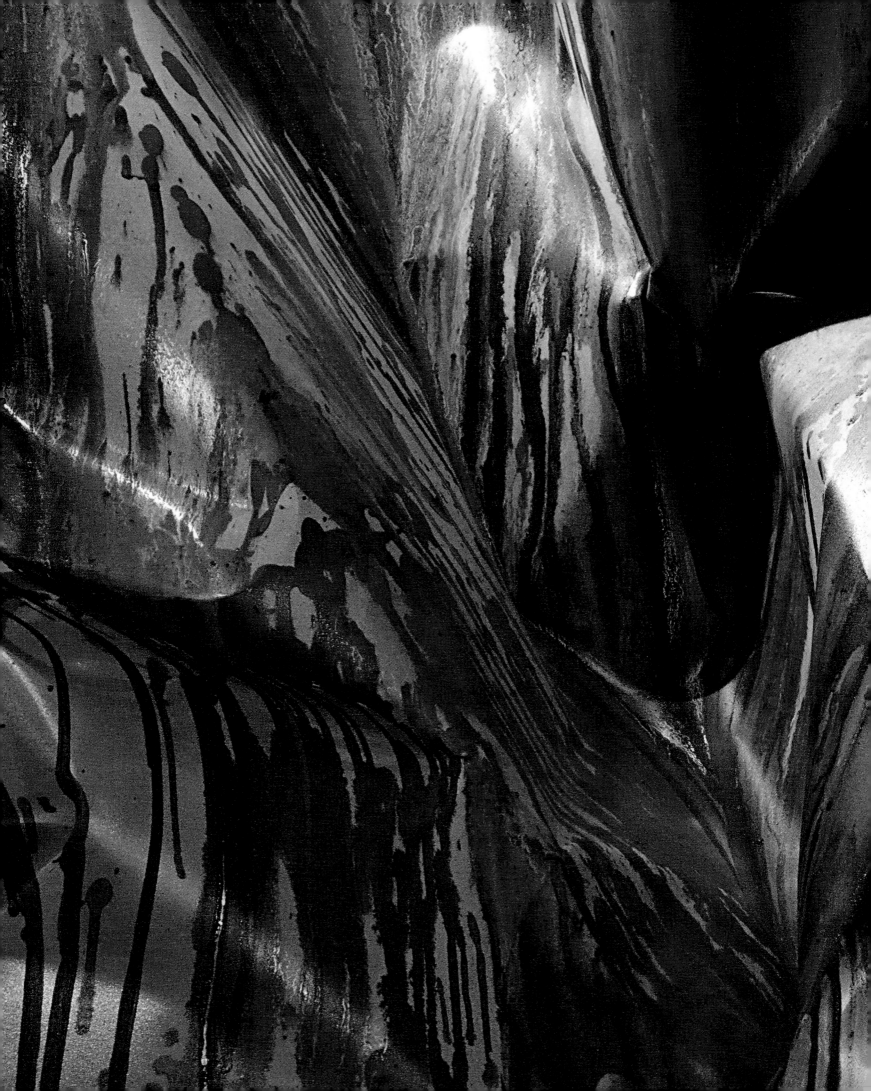

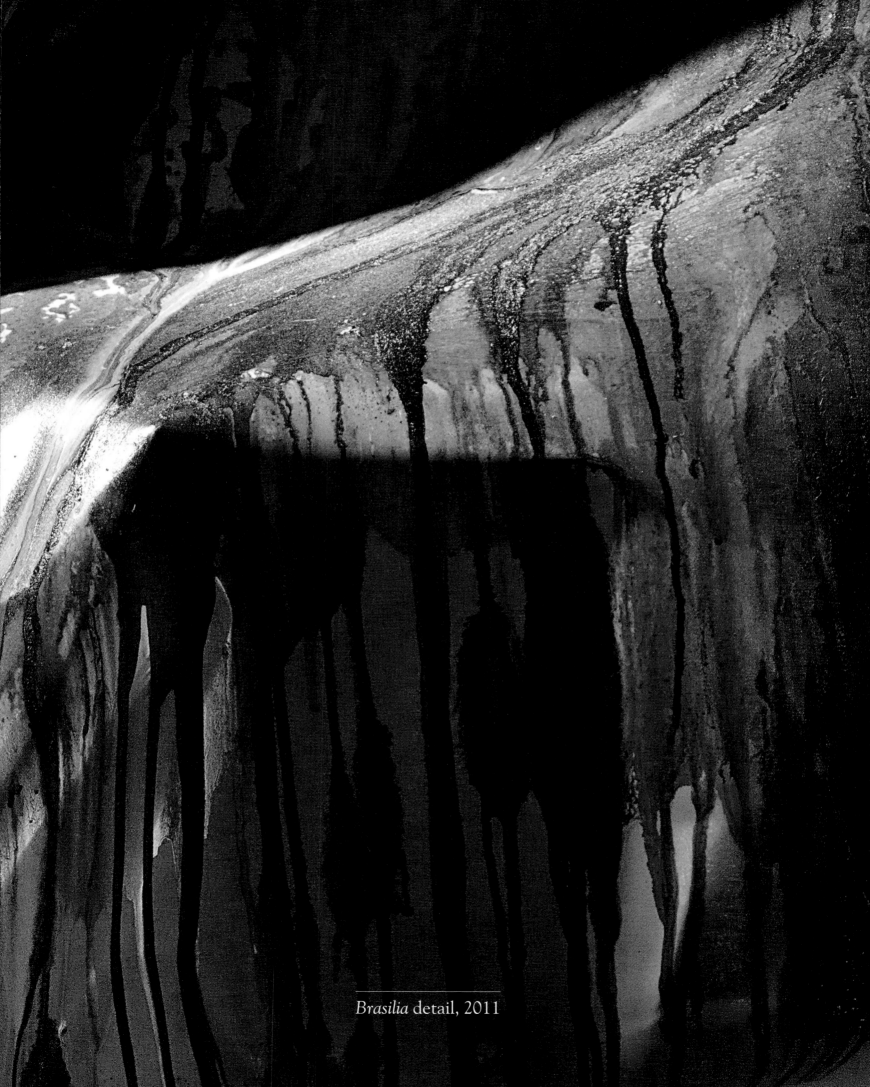

Brasilia detail, 2011

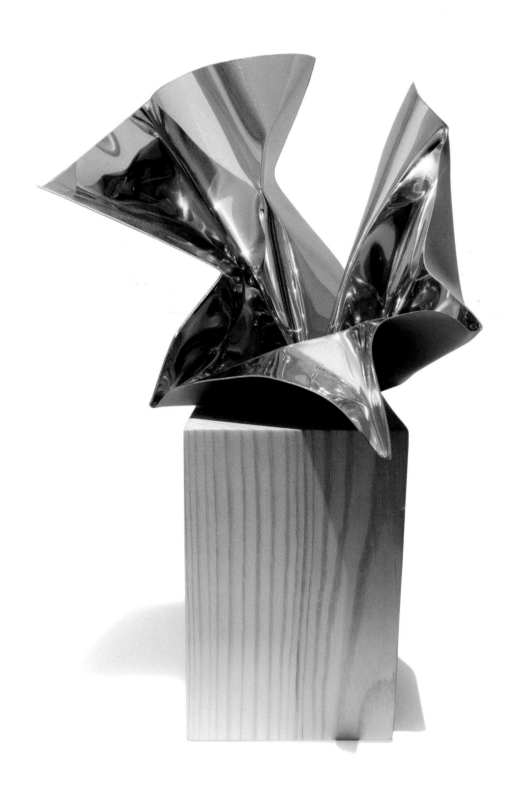

Cerulean Landscape I, 2013

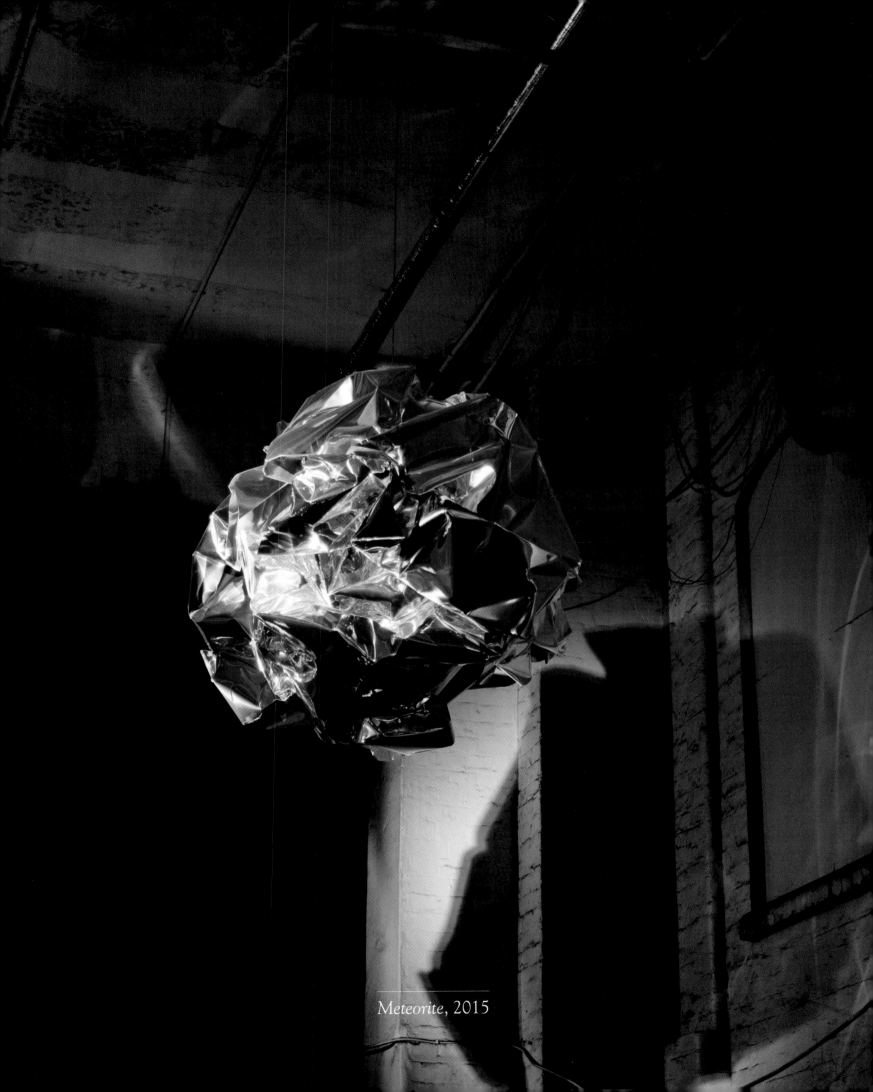

Meteorite, 2015

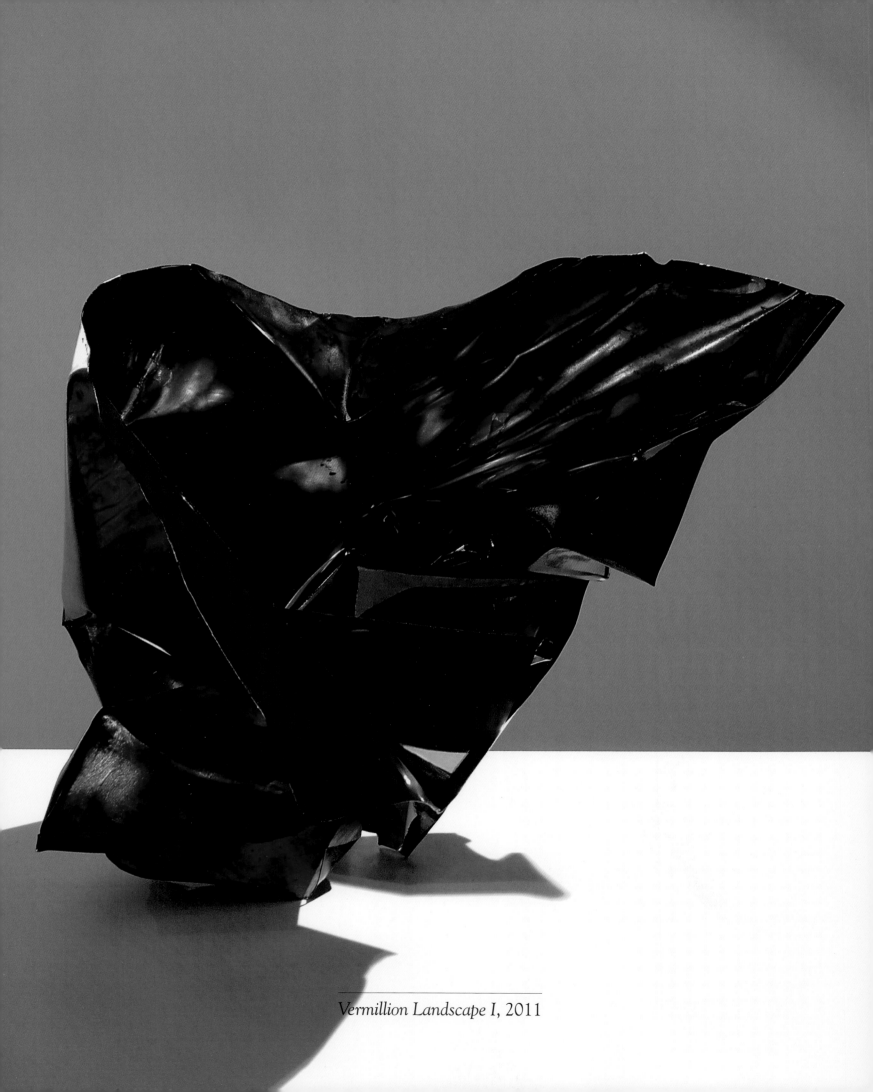

Vermillion Landscape I, 2011

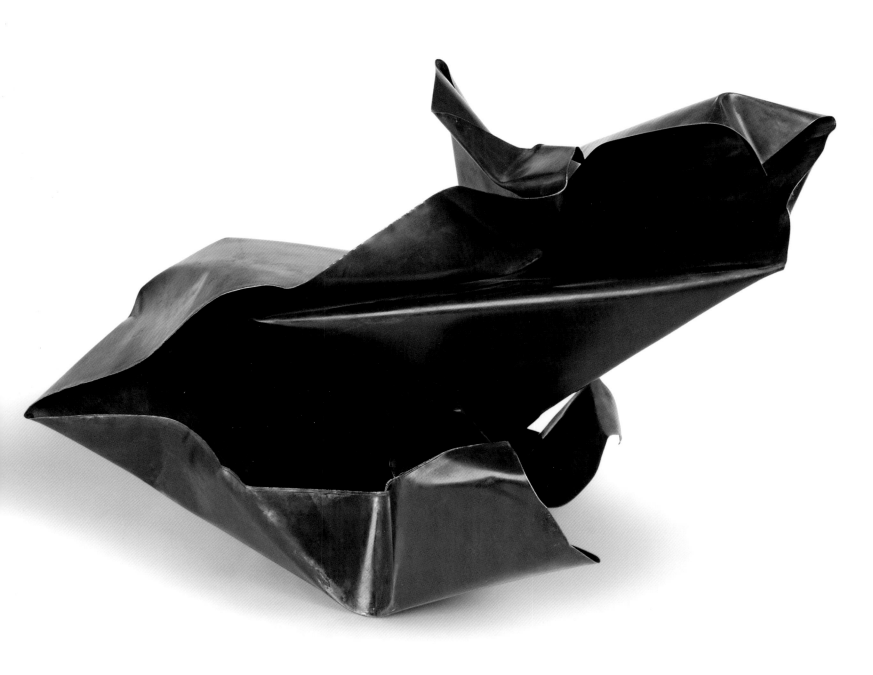

Burnt Landscape I, 2015

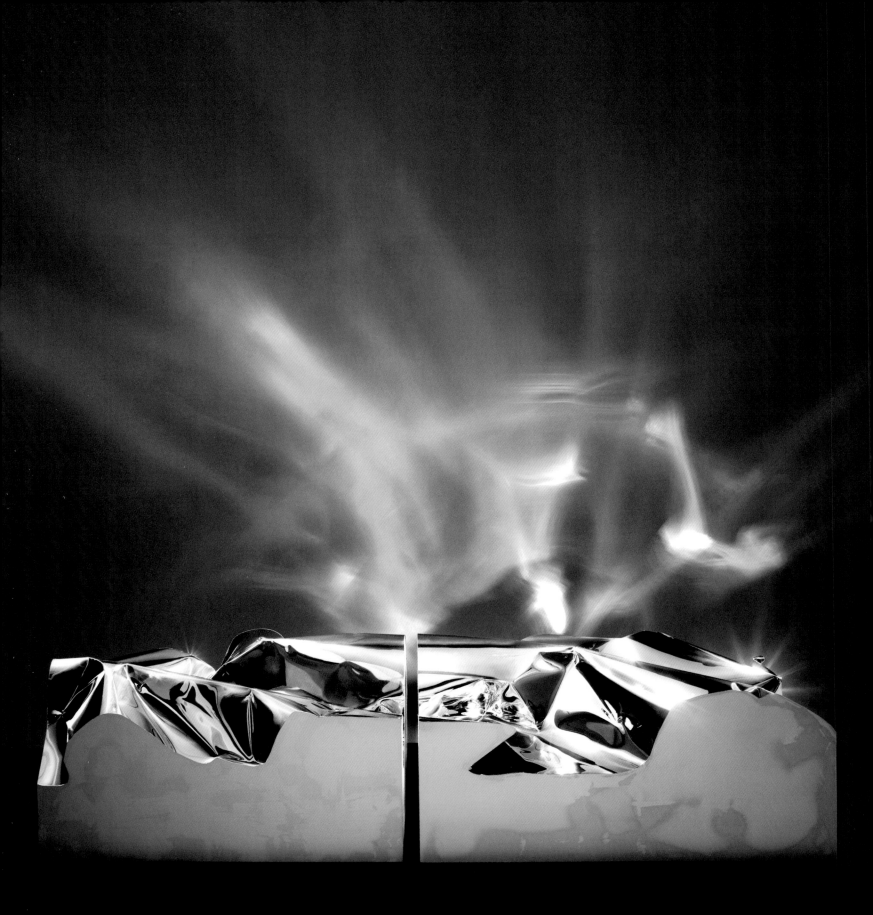

Diptych: Landscape II, 2013

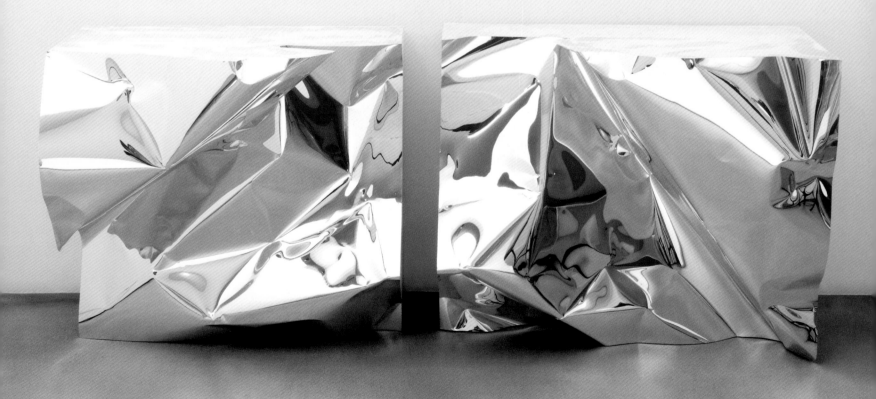

Hurricane, 2015, Console

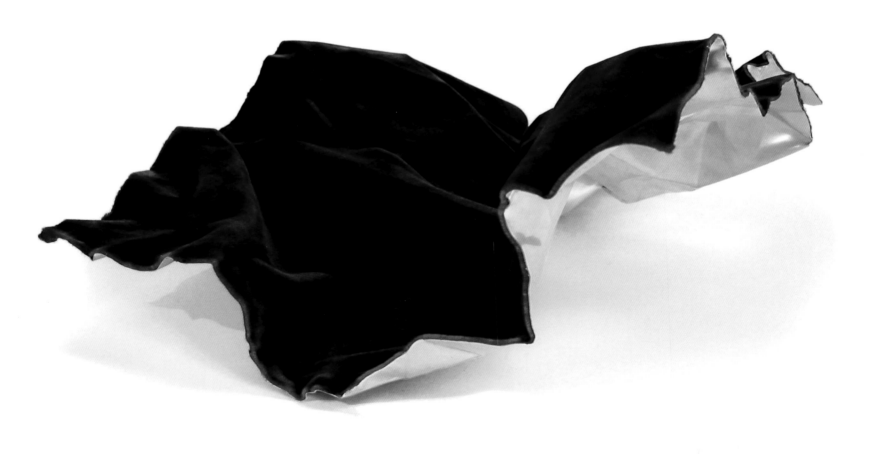

Canyon, 2010

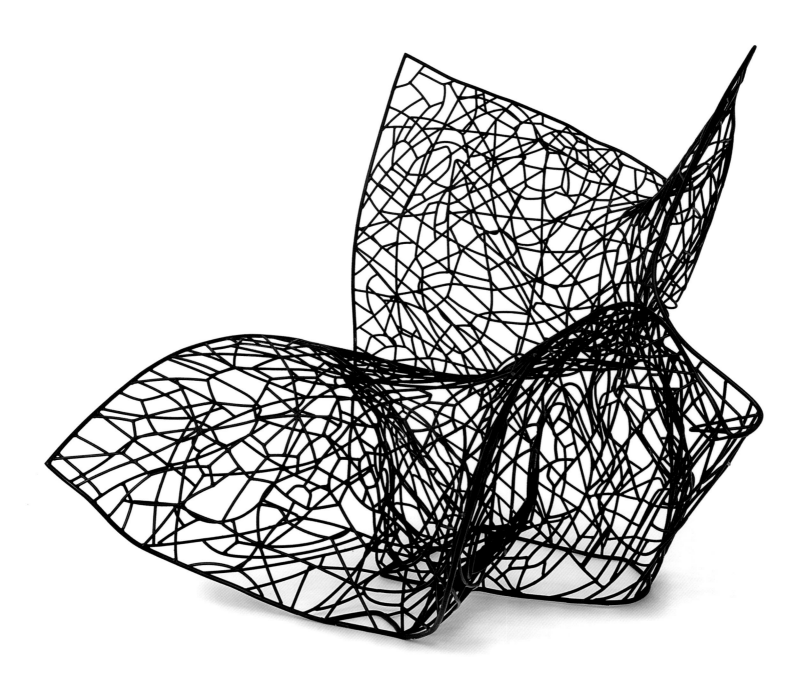

Aviary, 2012, Chair

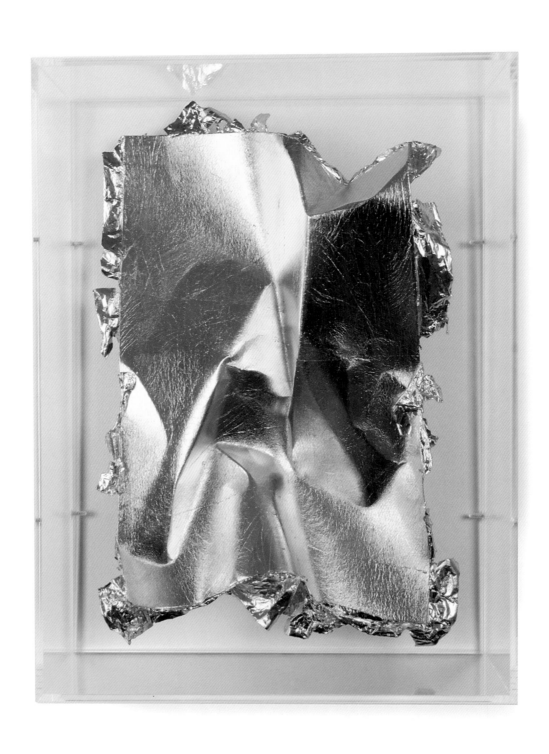

Grand Concourse Creature I, 2017

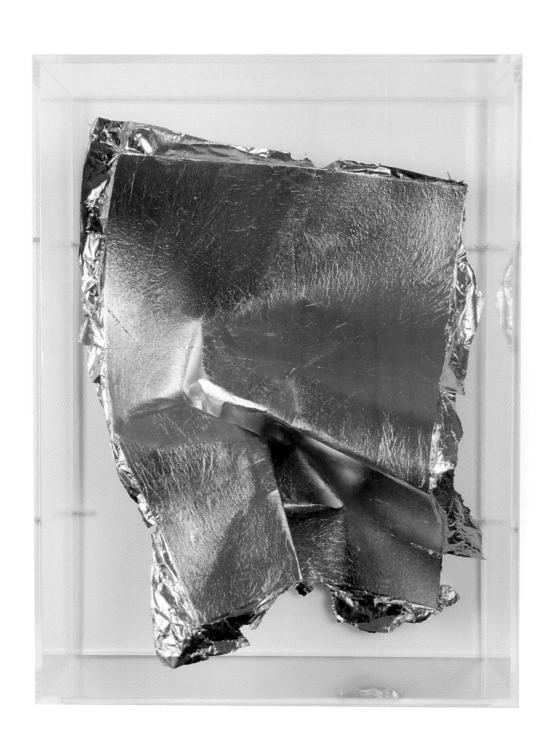

Grand Concourse Creature II, 2017

Pantheon, 2011

One way to understand a design studio is as a spinning gear, constantly connected to other gears, all of which are in motion at their own speeds: the needs of clients, both corporate and private; the schedule of the gallery; the opportunity to show in museums; the exigencies of fabrication, shipping, and a hundred other logistical details. Fredrikson Stallard spin fast. They have an extraordinarily productive studio, and generate many more ideas than can easily be fabricated and shown. In most cases, what actually sees the light of day has made it through an extensive editing process. This results in certain wrinkles in a chronological narrative like the one laid out in this book. Take the case of *Pantheon*; though it did not premier until 2012, when it was shown at David Gill Gallery alongside the *Crush* pieces, it already existed in concept sketches made several years before. It could in this sense be considered an early piece, and in this sense, a precursor to other objects that play wittily on the formats of historical furnishings.

The artists have described *Pantheon* using the purposefully oxymoronic term "baroque minimalism," a phrase that could justly be applied to many of their works. What they mean by this is that, while extremely reductive in itself, the form relates to centuries-old precedents (think of the curved mirror at the back of Jan Van Eyck's *Arnolfini Portrait*, for example) and also produces an effect of ornamental excess, by virtue of the funhouse reflections and dispersed light effects it creates. To make the works, two convex shells are milled from a solid aluminium block, contoured and cropped at the edge in such a way as to offer views into the interior when fit together. The inside is painted with a matte medium and raw pigments are then applied, producing an effect of looking into infinite colour – "no beginning and no end in there," as the artists put it.

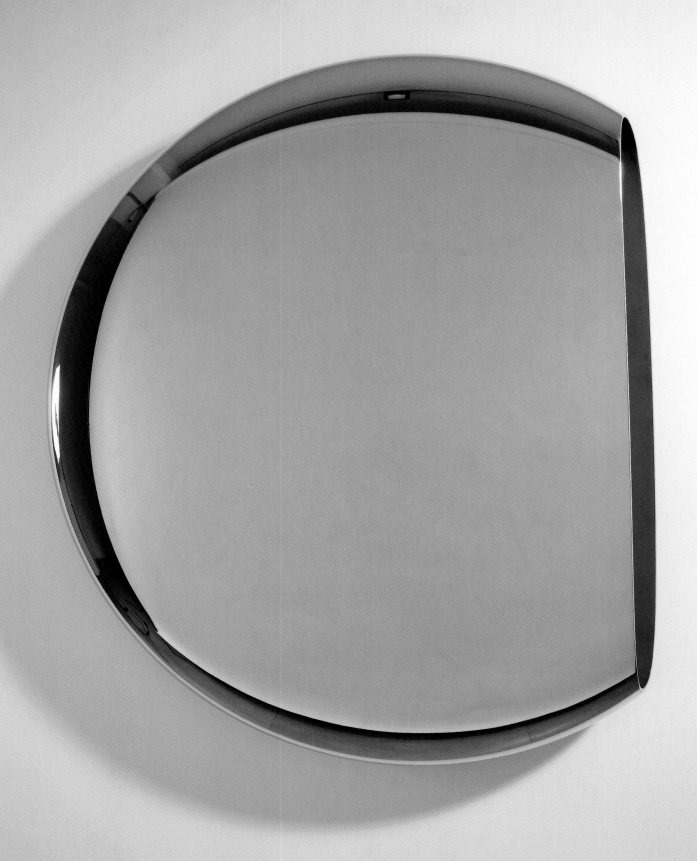

Pantheon, 2011

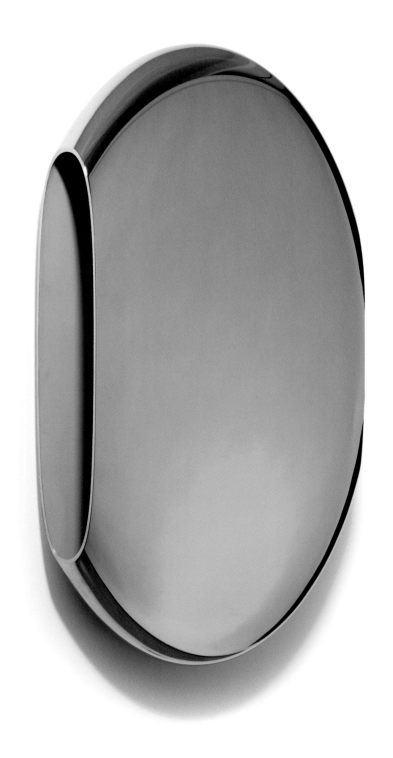

Pantheon, 2011

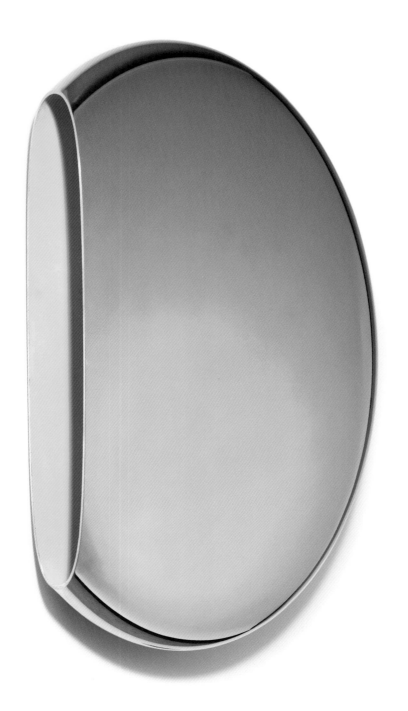

Pantheon, 2011

Bergère, 2006, *Detroit*, 2012, *Atlantic*, 2013, and *Tokyo*, 2015

One of the pieces in Fredrikson Stallard's first exhibition at David Gill was a high-backed chair, which the designers simply called *Bergère* (2006), the French term for an easy chair. In broad outlines, it conforms roughly to the shape established in the eighteenth-century and relatively unchanged since – short legs, an ample seat, and curvaceous arms. Two versions of the chair were made, one conforming to the more usual wing chair, and the other with the wings inverted, swelling downwards rather than upwards. There is a pronounced tilt to the chair's lower quarters, lending it comfort as well as a low-slung, relaxed vibe. The most unusual feature of the chair, however, is that it is built from two contrasting materials, slammed together at the midsection. The lower block of the seat is made of polyurethane (coloured hot pink, black or white), while the back and arms are fabricated, incredibly, from a single piece of stainless steel. *Bergère* marked the first time that Fredrikson Stallard worked with this material, having it hand-beaten by skilled artisans who were originally trained within the British car industry. The chair earned a certain notoriety, particularly when it was featured in the "tank" display case in front of the old Design Museum in Shad Thames.

Stainless steel would go on to be an important material for the designers, but not for some time. Unlike the thin aluminium sheet used in the *Crush* tables, stainless steel is tough

and cannot easily be worked by hand. When Fredrikson Stallard determined to work with it again, they first needed to identify a capable manufacturer and then figure out how to adapt the small aluminium prototypes they could make in the studio to finished objects. Patrik tells a great story about the first successful piece in this vein, a low oblong table dubbed *Detroit* (an allusion to its origins in auto body craft). Already there had been some discussion about the method used to shape the piece – eventually settling on the use of hydraulic pressure to form the metal. While the initial sketch had an effortless energy, the consequence of its quick making, there was a risk that the steel version would look like a rigid tablecloth – all the folds in the design present and accounted for, but without any sense of immediacy. "If it's done slowly and carefully," Patrik says, "it becomes soft and unreal." He and Ian had travelled to the factory to view the first prototype; weeks of work had gone into it, and the top was absolutely flat, and mirror-smooth. It was an impressive feat of craftsmanship but not quite what was wanted, more dead than alive. Figuring he had nothing to lose, Patrik grabbed a sledgehammer and – to the horror of the assembled artisans – whacked it once right into the table's midsection. The steel buckled slightly, the dent distending the top. Now, it was perfect.

Ever since, each *Detroit* table has had a similar blow applied to it as a finishing touch.

This makes for an interesting comparison to the *Do Hit* chair by Marijn Van Der Poll for Droog (2000), a metal cube bashed into vaguely functional shape with a heavy hammer; or the later *Extrusions* of Thomas Heatherwick (2009), in which molten hot aluminium is pushed out of a gigantic press through a die, producing a consistent cross-section but a randomized overall form. Fredrikson Stallard embrace chance in their work, too, but they always set it within a highly controlled aesthetic situation. Their subsequent steel furniture has retained this carefully calibrated unpredictability. *Atlantic* consists of two steel sheets, buckling alongside one another to create a dynamic volume. *Tokyo* is yet another riff on the *Unit* typology, as if a *Crush* table's parts – glass container and ruffled metal – had merged into one. There is also a round version of *Tokyo*, and a group entitled *Hudson* (introduced in the *Gravity* exhibition at David Gill Gallery in 2016) that includes consoles and a wall-mounted mirror.

All of these works exploit the displacement that occurs when working stainless steel – push it in here, and it pushes out over there, somewhat unpredictably, while the whole surface in between takes on a rippling contour like moonlit water. Doubtless this is a material they will continue to employ, and they say they'd love to work at even bigger scale with it.

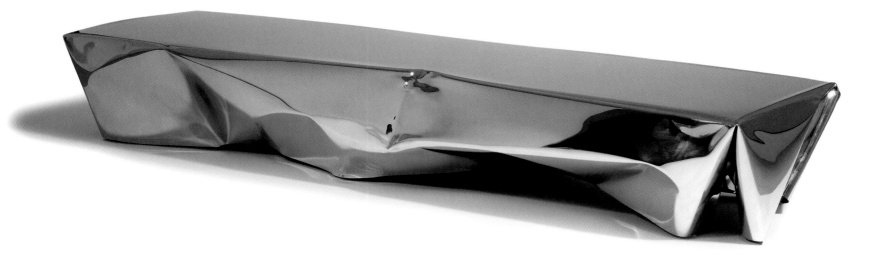

Detroit, 2012

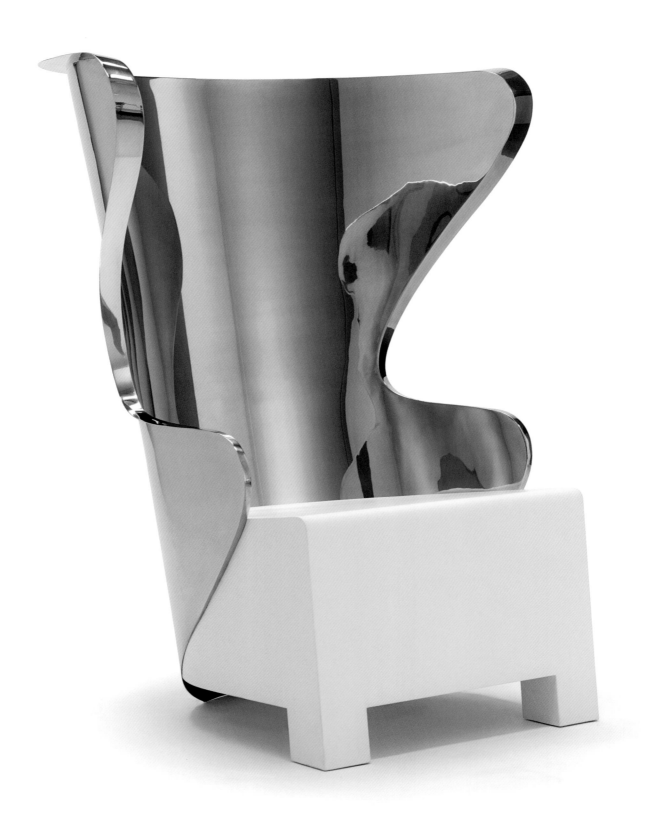

Bergère II, 2006

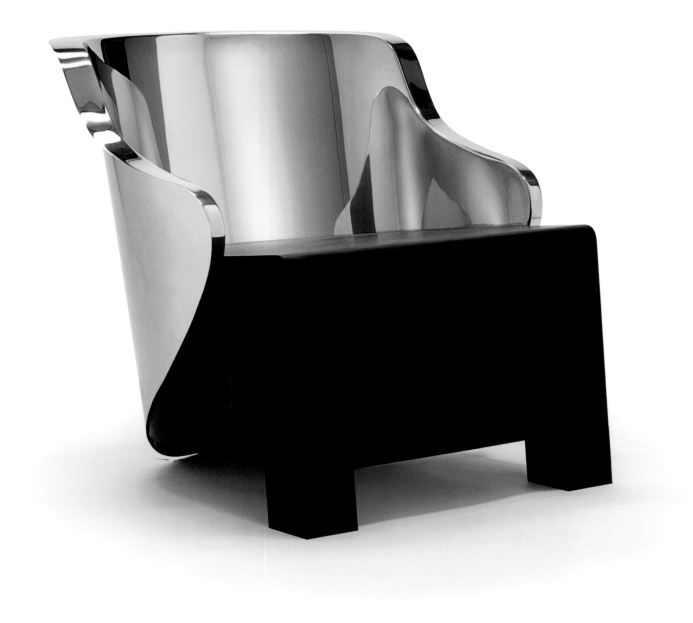

Bergère I, 2006

Atlantic II, 2013, Cabinet

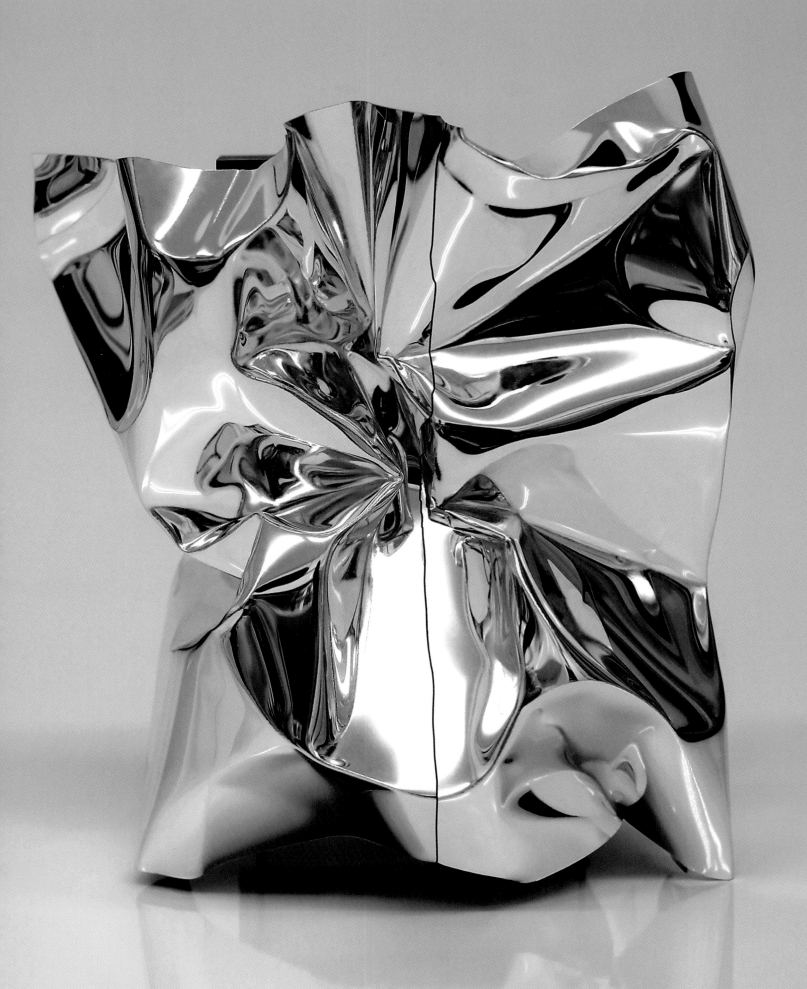

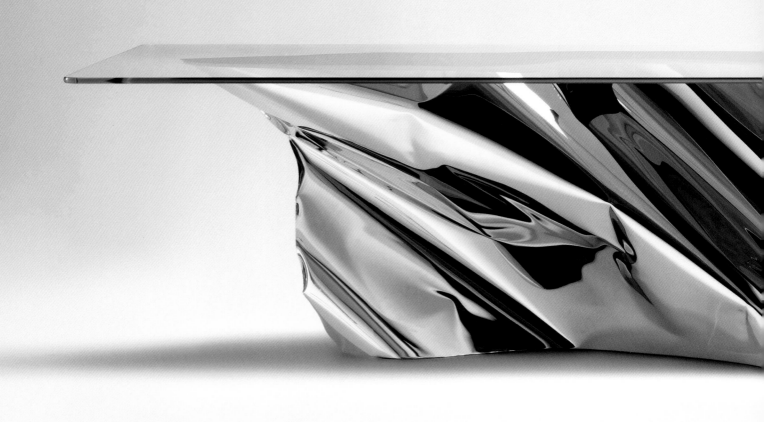

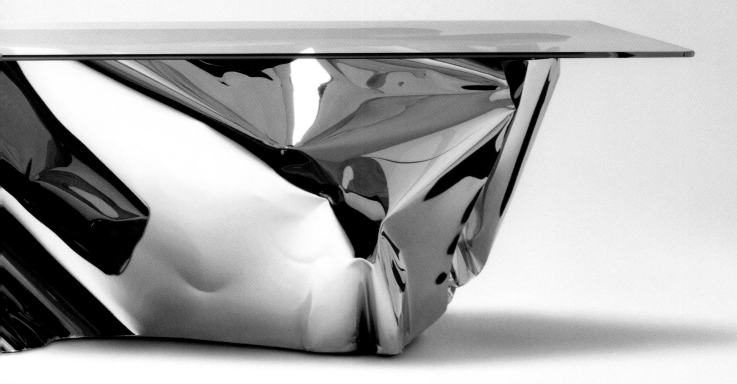

Atlantic I, 2013, Dining Table

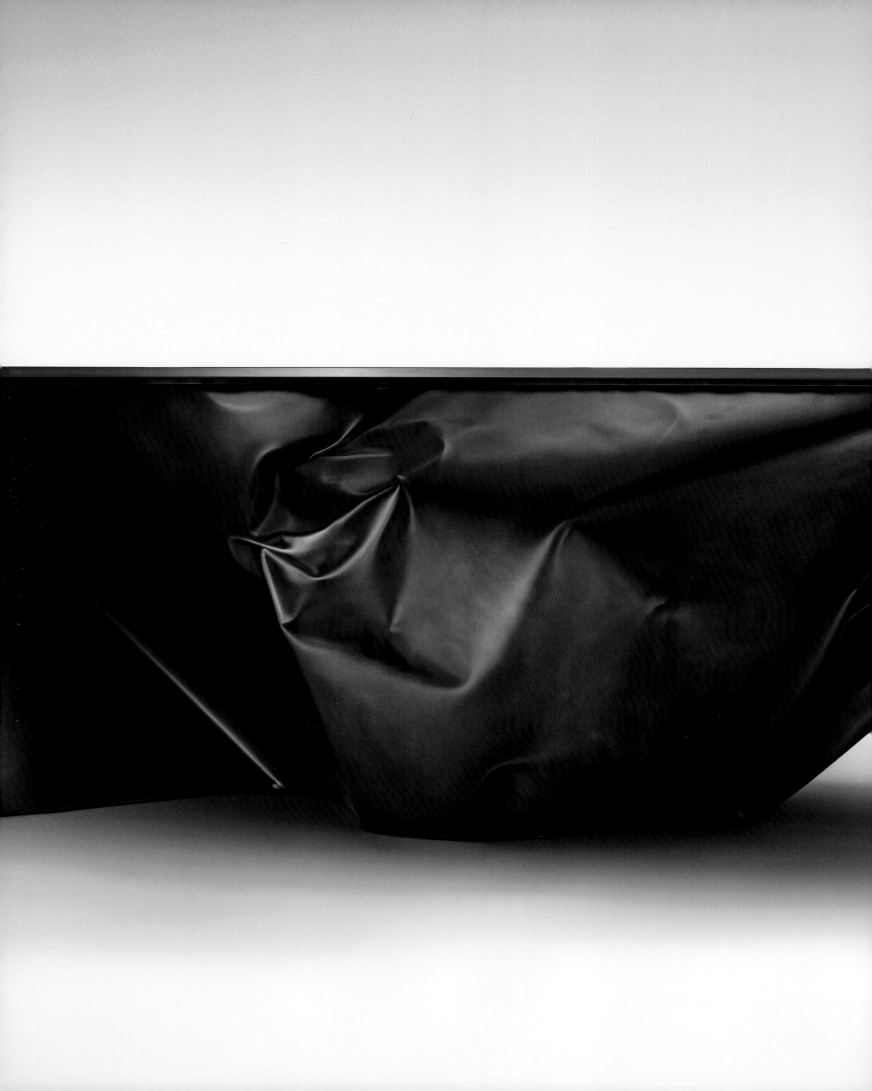

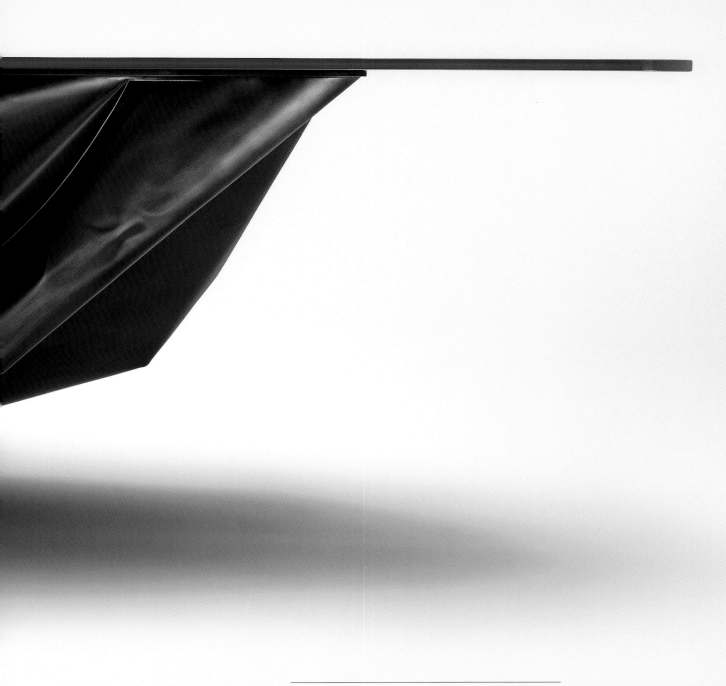

Atlantic I Bronze, 2013, Dining Table

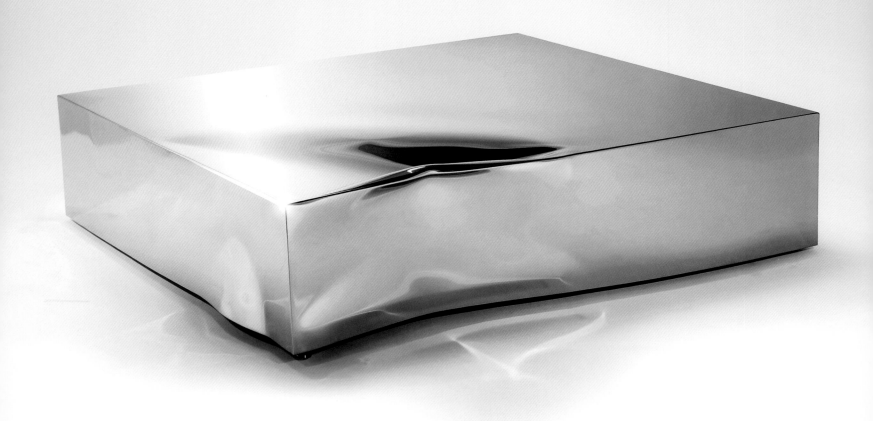

Tokyo I, 2015

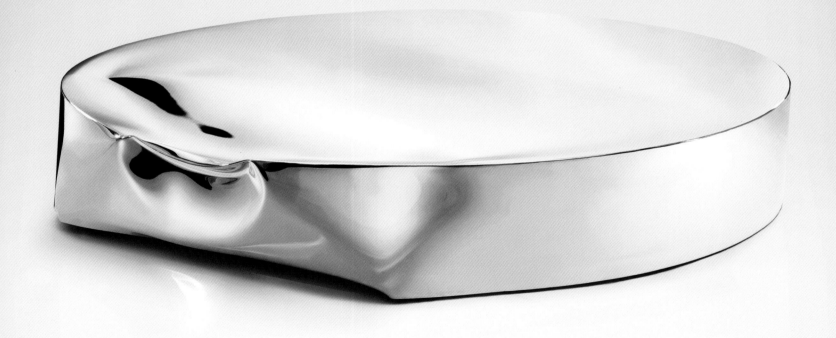

Tokyo II, 2015

Iris, 2011, and *Prologue*, 2014

One of Fredrikson Stallard's most significant tendencies is their urge to simplify. Even when making extremely involved and materially complex work, they generally try to put their finger on a key concept and use it to drive the piece forward. At an early stage in their work for Swarovski, they had a realization of this kind: every single one of the company's precisely polished crystals operates as a lens. The crystals are not primarily about form, but redirection: at a time before electricity, chandeliers maximized the illumination created by candlelight, refracting it many times over. When designing with crystals, then, it is not so much the object as its ephemeral optical effects that count. This basic insight has been the foundation for everything Fredrikson Stallard has done for the company – most explicitly in an extended series of large disk forms, rendered in different materials and contexts over a period of several years.

The human eye also has a lens, of course. When we look at a chandelier, what we are actually experiencing is the result of two optical effects, those of the fixture and those of our own visual apparatus, combining at a distance to dazzling effect. This was the animating conception of *Iris*, created for Swarovski's Crystal Palace display in Basel in 2011. While their first entry in this exhibition series, *Pandora*, had been a single object, this time round Fredrikson Stallard produced a whole suite of related works. Each of the huge lens forms was faced with a radiating pattern of crystals, while the curved backs were rendered in various materials – untreated Cor-

Ten steel, gold leaf, silver leaf, and patinated steel – each resulting in a different light effect. Another version of the design was also mounted on a tripod, echoing technical applications of lenses (telescopes, particularly) and lending the overall presentation a further degree of monumentality. No detail overlooked as usual, the power cable for the standing version was customized, covered in a hand-stitched leather sleeve, so that it would be at suitable scale with the rest of the object.

The basic eye-like format of *Iris* was resurrected at even greater scale a few years later for an outdoor display during Art Basel in Hong Kong. The site was interesting: the courtyard of the PMQ (Police Married Quarters), a former barracks set on a sloping hill in the centre of the city. This was their first public artwork in Asia, and Ian and Patrik wanted to create an image that would resonate there. So they opted for the symbol of the sun, preserving the lens reference but adding a rich gold backdrop. Like the earlier public work *Portrait*, the sculpture works at all hours. Either by daylight or by artificial illumination at night, it changes constantly with shifts in the conditions and the viewer's own position.

Like Olafur Eliasson's celebrated installation on the same theme in the Turbine Hall of Tate Modern (*The Weather Project*, 2003) Fredrikson Stallard's sculpture immediately won a rapt public following, with crowds basking in its golden light as if worshipping a secular god. Poetically entitled *Prologue* – suggestive of the dawn – the work was a synthesis of heavy industry and lightness of touch. It was fabricated of raw mild steel

and set on RSJs (rolled steel joists), materials which patinated beautifully over time, particularly where the surface was touched by curious hands. 8000 Swarovski crystals, in a mix of two topaz tints, hang within it as if by magic, simply resting on slender taut wires.

Given its name, it seems fitting that the initial presentation of *Prologue* in Hong Kong was only the beginning for the piece. "Everywhere you put it," Nadja Swarovski says, "it feels different. It adapts to its environment." It has been reincarnated several times both indoors and out, using different materials appropriate to each new location: wax-polished steel for Design Miami / Basel; galvanized steel paired with bluish transparent crystals in Shanghai. A version of the sculpture was also installed at the Belvedere Museum in Vienna, alongside an installation by Ai Weiwei; the architectural backdrop and the two bodies of work intermingled, as Nadja Swarovski puts it, "like three friends, coming together in a symbiotic way, but maintaining their own character." Two of Fredrikson Stallard's *Hurricane* mirrors were placed in the building's famous Great Marble Hall, in spots where paintings by the baroque artist Ignaz Heinitz von Heinzenthal were normally shown. The works looked remarkably at home in the historic spaces of the former palace, attesting to Ian and Patrik's affinity for eighteenth-century aesthetics and *objets d'art*. In 2016 Fredrikson Stallard developed one final iteration of the lens format, entitled *Avalon*, as part of the *Glaciarium* complete lighting collection for Swarovski.

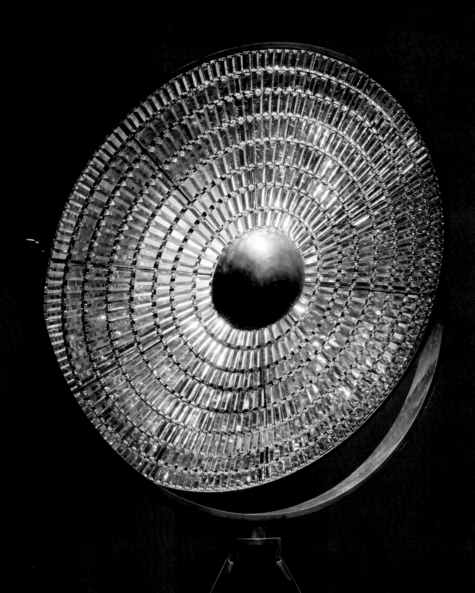

Iris Aeratus Quadrum Tripus, 2011

Iris Ferreus Vortex, 2011

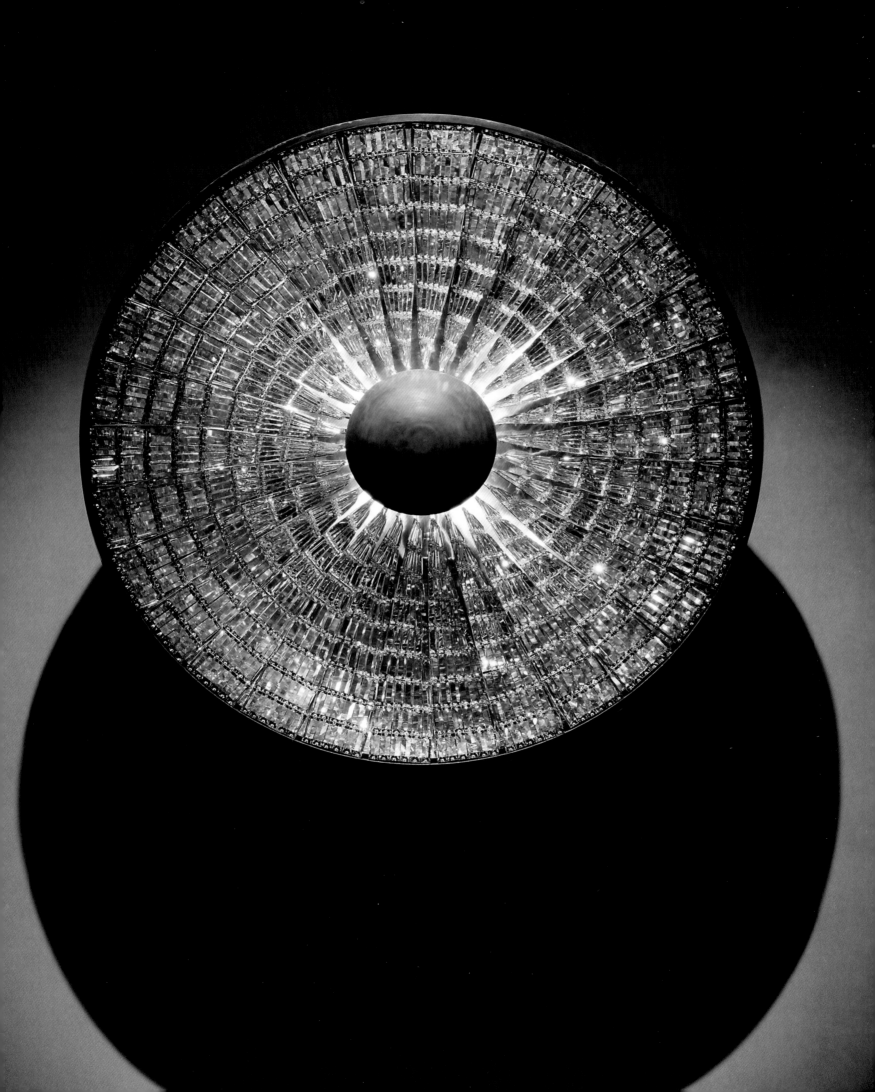

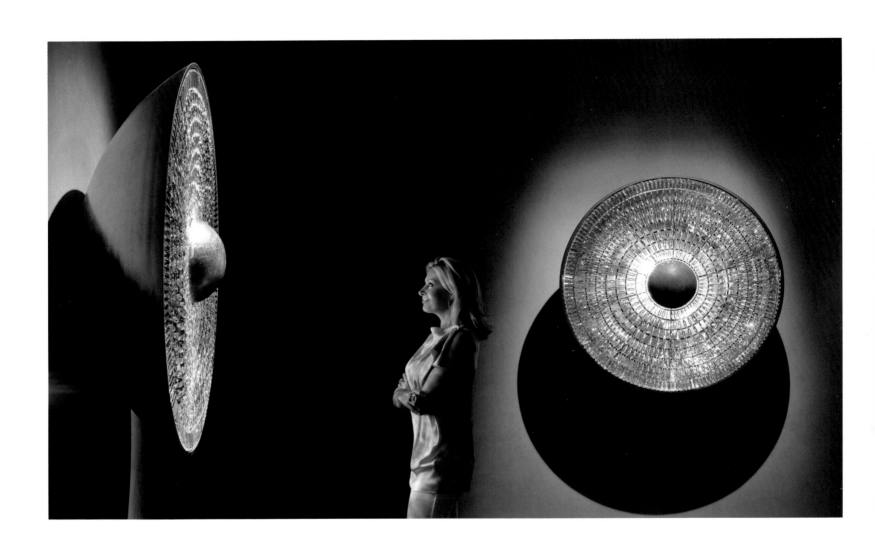

Iris Aureus Momentum, Iris Ferrugo Radiare, with Nadja Swarovski, 2011

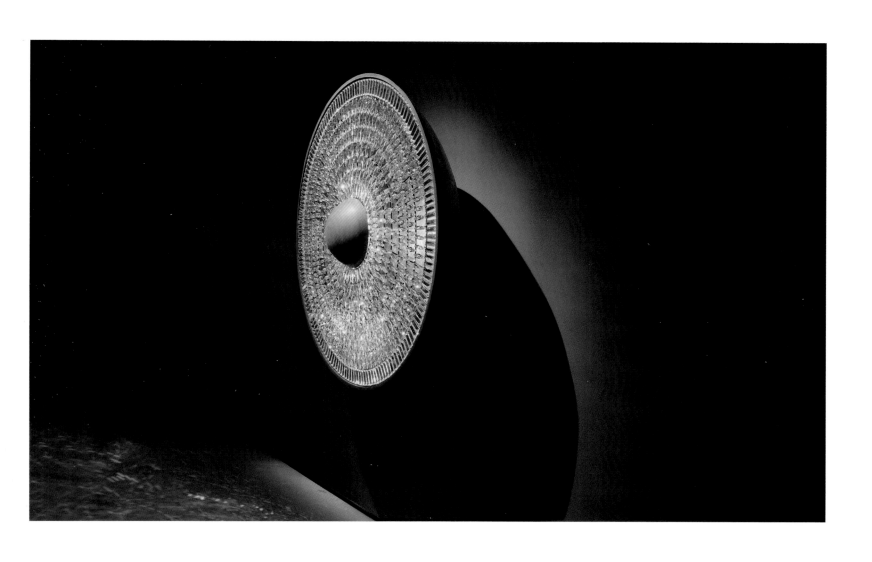

Iris Ferrugo Radiare, 2011

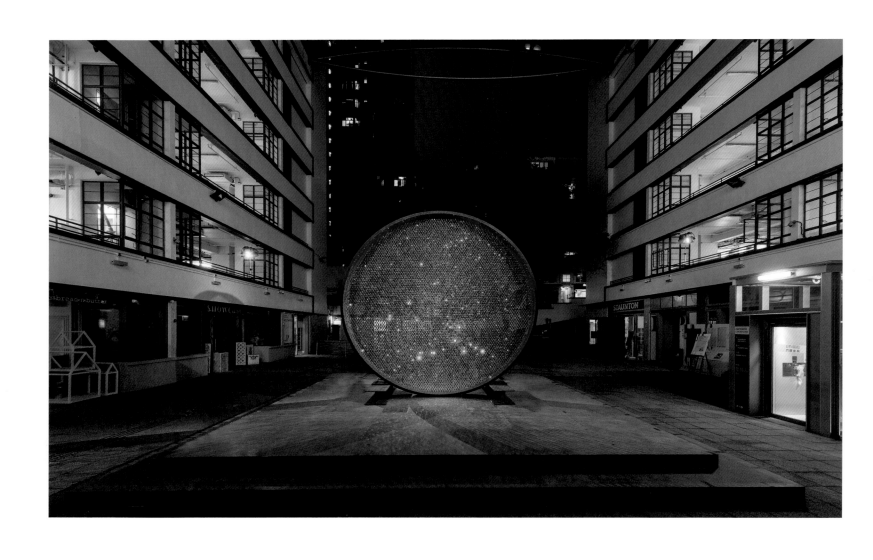

Prologue I, 2014

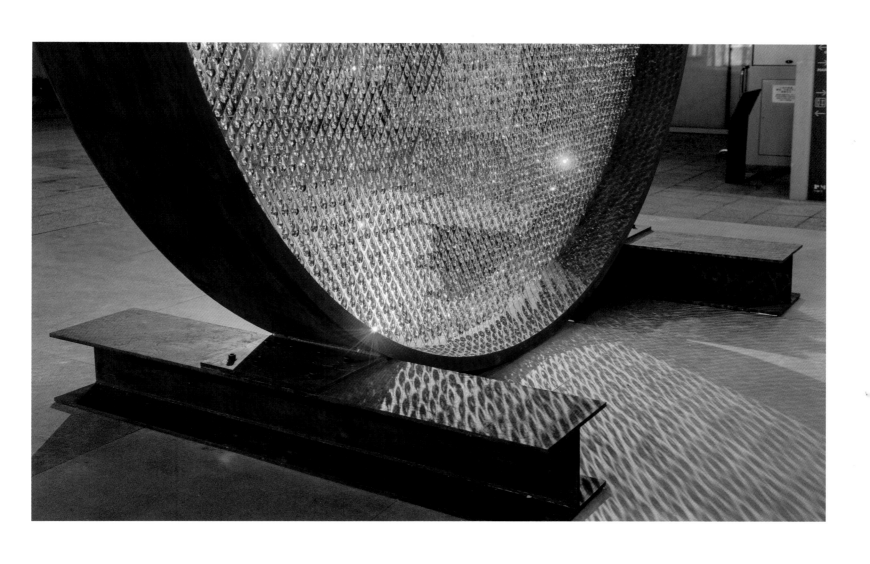

Prologue I, 2014

SWAROVSKI

Prologue

FREDRIKSON STALLARD

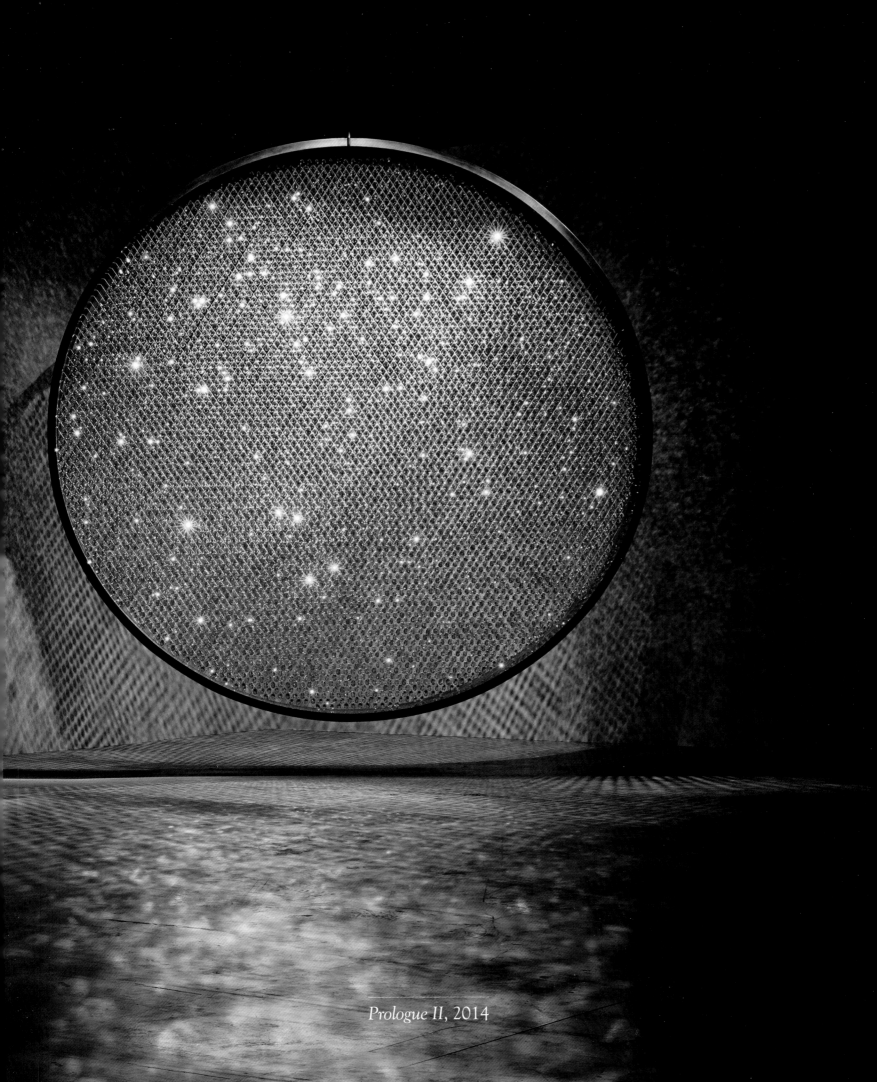

Prologue II, 2014

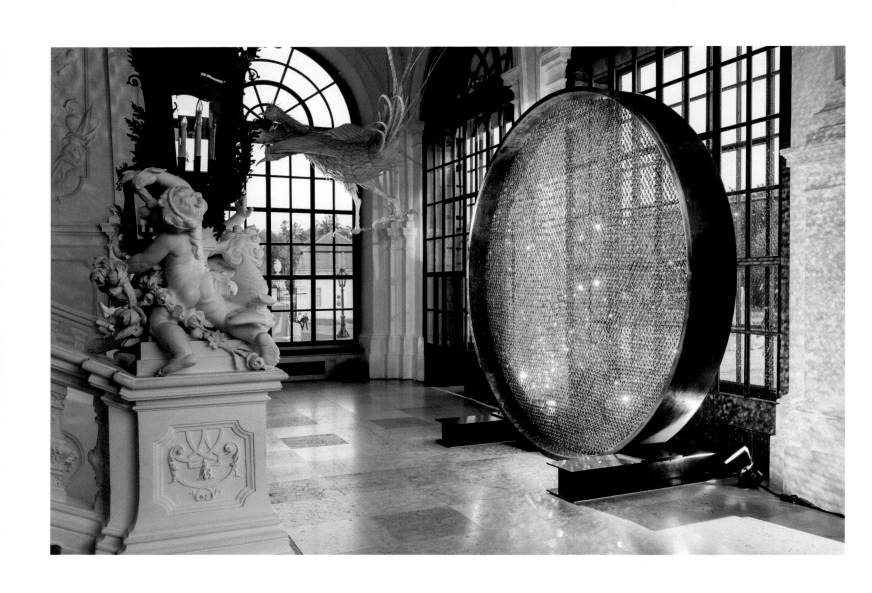

Prologue I, 2014, Belvedere Museum, Vienna

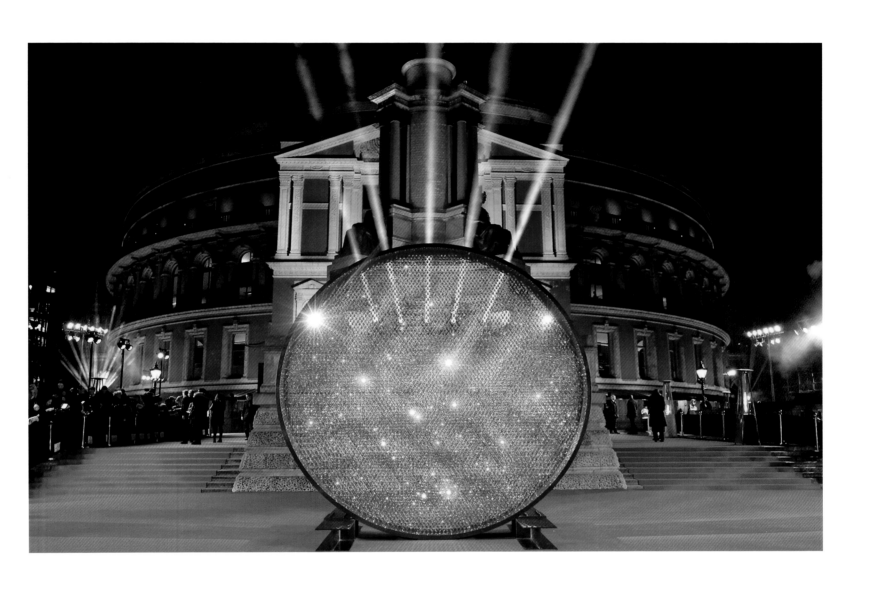

Prologue I, 2014, Royal Albert Hall, London

Hallingdal, 2012, and Brioni, 2014

Patrik has characterized the work that Fredrikson Stallard take on for corporate clients as "paid sketch time." By this, he obviously does not mean that they are unserious in responding to a brief. Rather, Patrik is pointing to the unexpectedly creative situation that happens in a commissioning process: he and Ian often find themselves reformulating vocabulary from their existing repertoire, or developing new concepts, which later end up informing their studio work. Rather than thinking of corporate commissions as a distraction from their real business, they fold these opportunities into their ongoing process of ideation.

This dynamic can be seen in a pair of contrasting commissions for the companies Kvadrat and Brioni – brands that could not be more different, despite the fact that they share a strong investment in quality textiles. The Danish firm Kvadrat is one of the leading firms carrying on the tradition of Scandinavian mid-century design; their aesthetic is democratic and modernist. Brioni, by contrast, is one of Europe's finest men's clothiers – a luxury company upholding the exacting standards of traditional Italian tailoring. Fredrikson Stallard made a kind of object-portrait of each company.

In the case of Kvadrat, they were commissioned to make a piece of furniture using the company's classic Hallingdal wool fabric, originally designed by Nanna Ditzel in 1965. Rather than go for the obvious solution

– to create the frame of a seating form, and then upholster it – they decided to make an object using nothing but the fabric. Returning to the basic format of *Table #1*, they tightly rolled a very long bolt of the textile, then secured it with a tension strap made of the same cloth. The wool, widely used in mid-century modern furnishings by the likes of Arne Jacobson, is a hard-wearing material without luxurious connotations. Fredrikson Stallard specified a beautiful cerulean blue shade of the fabric, redolent of rippling water, and set it off visually with gold plated fittings (the belt's ratchet fitting and the short feet). Despite the touch of glamour, the image of the table is nonetheless appropriate to a mass manufacturer. The extensive length of the textile, coiled and compressed, bespeaks Kvadrat's productive capacity.

The opportunity to work with Brioni came originally through the adventurous fashion director Jason Basmajian, whom Ian and Patrik had met through the philanthropist Yana Peel. The project was an unusual one: to design a new men's fragrance for the company, not just the packaging but the tint of the scent itself. They even consulted with the professional "nose" who designed the perfume. This brief indicated Brioni's level of ambition – most fashion brands simply license their name to a scent company, rather than producing every aspect of it in-house, much less bringing in outside designers to consult on every detail. Just as the fundamental issue of

the Kvadrat commission was material, in the case of Brioni it was shape: how could they translate the exquisite cuts of tailoring into an object? A breakthrough came when they saw some historic cut-glass crystal containers in the collection of the V&A. They updated this historic vocabulary, infusing it with a set of masculine cues: a scent of leather and cashmere, the colour of single malt scotch, held in a heavy glass container capped with a dark metal lid. This is a perfume bottle that one could waft under one's nose in a drawing room by the fire.

Fredrikson Stallard got a great deal out of the Brioni commission. It required them to generate a volume from compound curves, an object whose contours seem born of materiality (the flow of molten glass and metal) but in actuality are carefully drawn out, using digital tools. They would adapt this approach in other projects for Brioni, including men's jewellery, as well as a whole series of other works, from a furniture line for Driade to the Swarovski collection *Glaciarium* to a series of pigmented standing stones that are among their most recent experiments. There is obviously a big difference between each of these undertakings, an attempt to ensure that each will be appropriate to its context. Underlying this series of calibrated shifts, however, is a formal sensibility that remains consistent. If there's one thing that Fredrikson Stallard aim to do with every commission they undertake, it's to learn on the job.

Brioni Fragrance Bottle, 2014

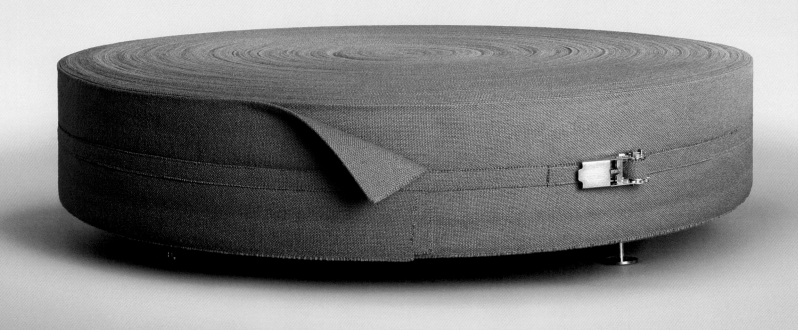

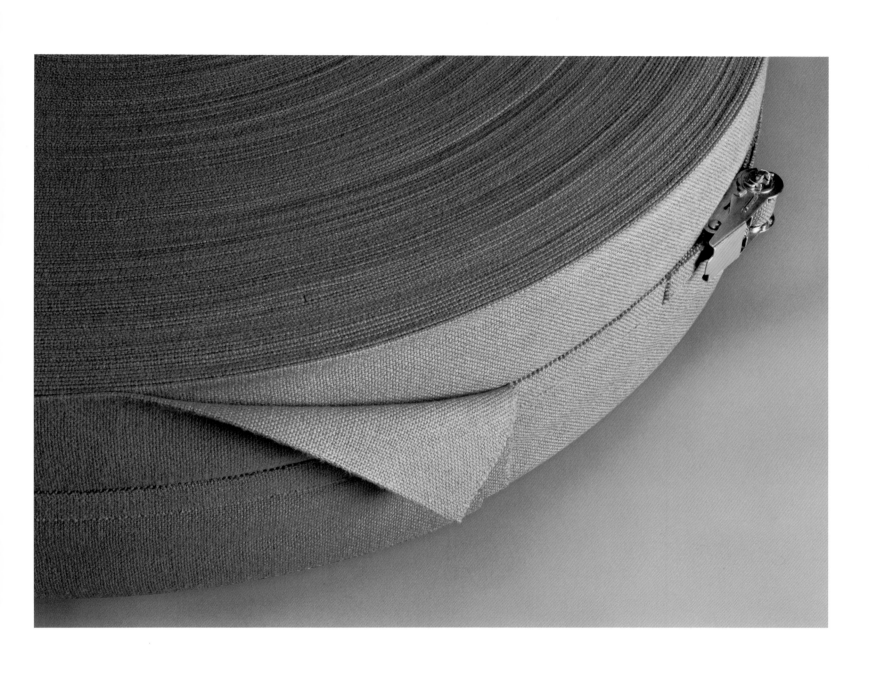

Hallingdal, 2012

Brioni Cufflinks Round, Collar Pin, 2013

Brioni Cufflinks Square, Tie Clip, 2013

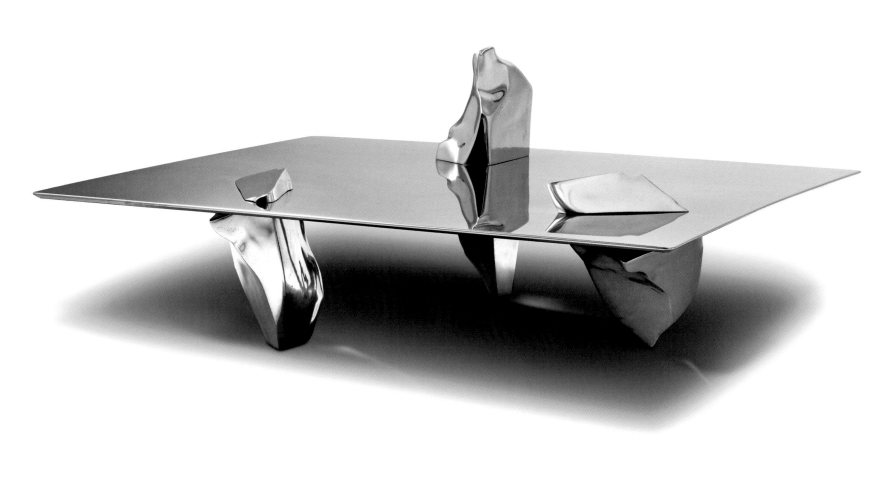

Sereno, Driade, 2014

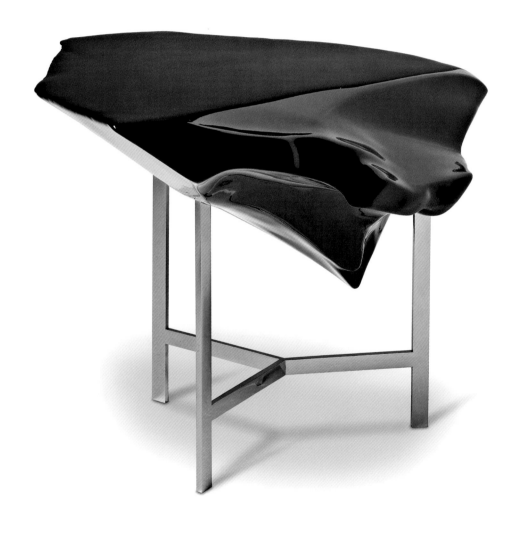

Basalt, Driade, 2014, Side Table

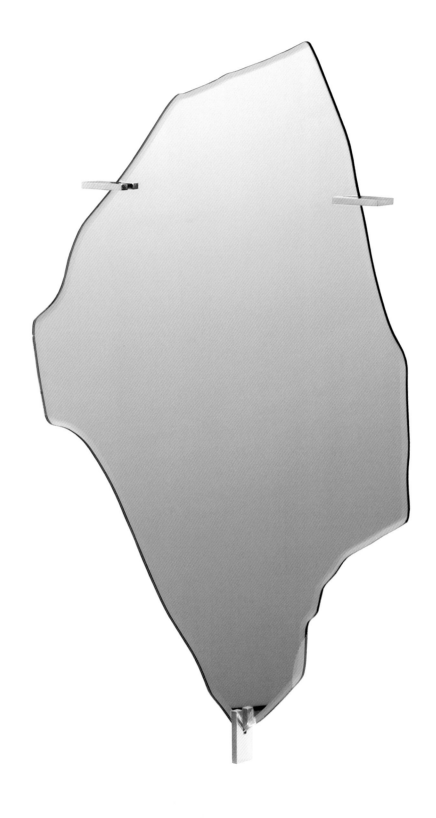

Archipelago I, Driade, 2014

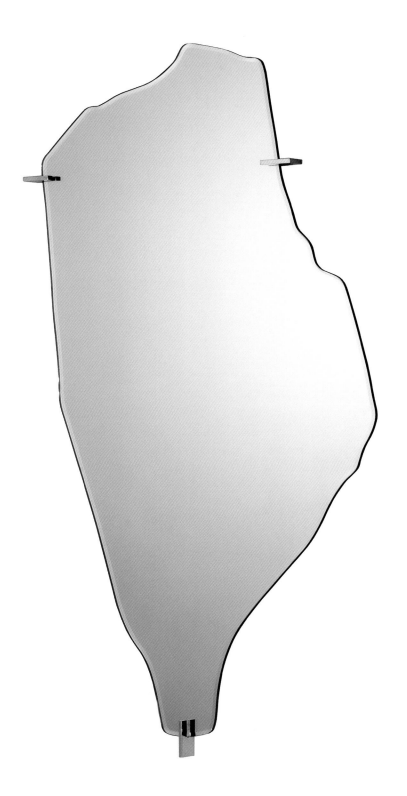

Archipelago III, Driade, 2014

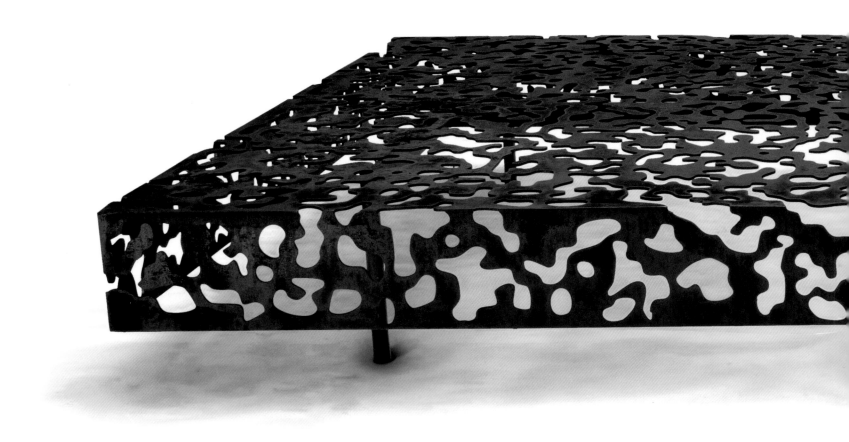

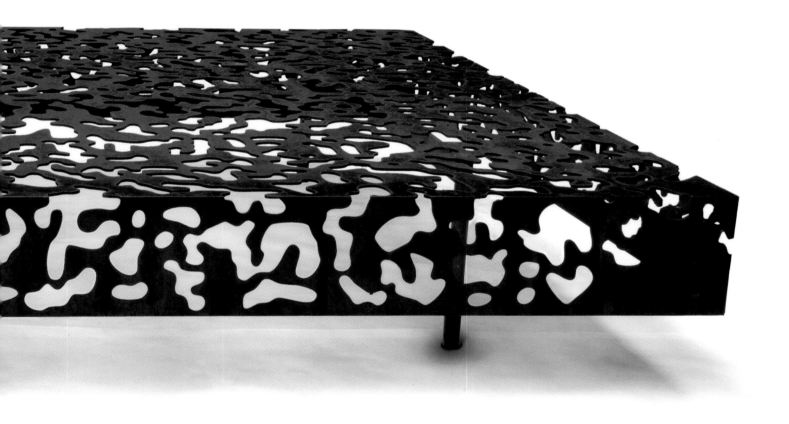

Camouflage, 2016, Daybed

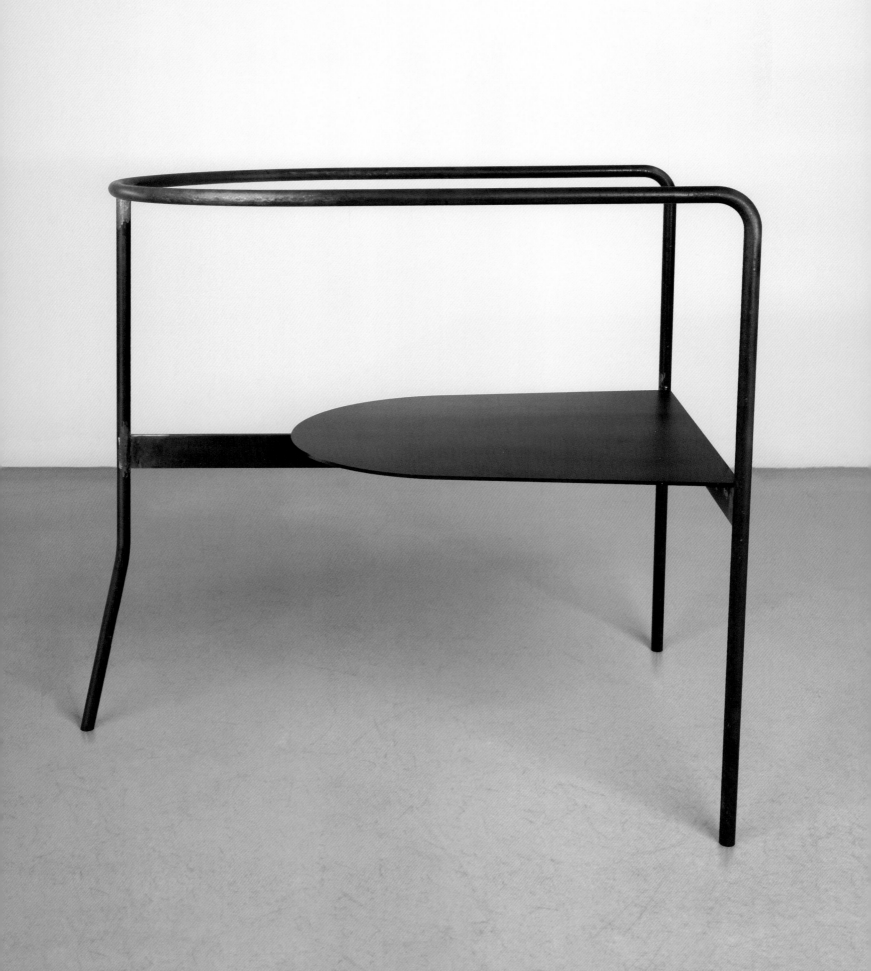

Still Waters Run Deep, 2015

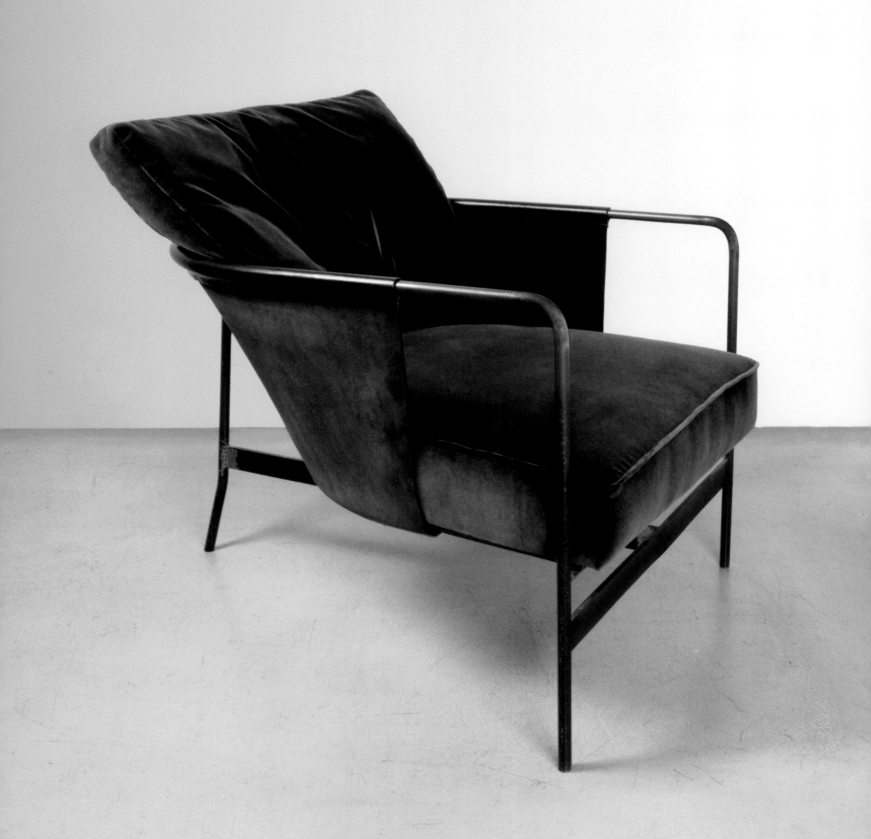

Gaucho, 2015

Avalanche, 2014, and Mirror #1, 2002

Back in 2002, when Fredrikson Stallard were just finding their artistic feet, they made an object that seemed strange even to them. It was a commercially-bought mirror – a readymade – which they backed with fabric and then struck, just once, with a nail. In an instant, a starlike pattern of cracks fissured the glass, reaching out from the site of impact to each edge. Each crack differed slightly, some just skittering along the surface, some breaking all the way through the glass. They called it *Mirror #1*. It is almost too easy to wax poetic about the premonitory quality of this early piece, in which an act of destruction is effortlessly reinvented as a means of generative composition. That alchemical transformation has recurred many times in their work since. At the time, though, Ian and Patrik did not quite realize what they had done. They liked the result enough to try and make a "production" version, cut with a waterjet, which of course totally lacked the immediacy of the original. They shelved the idea.

Twelve years later, in the wake of numerous Swarovski commissions, the *Crush* series and its offshoot the *Hurricane* mirror, and other projects involving reflectivity, they started breaking mirrors again, and quickly learned that the grace of *Mirror #1* had been serendipitous. Glass has a tendency to break in curves rather than vectors, or to splinter into many tiny pieces. It took some time to arrive at a set of procedures that would produce the desired result. Once the fragments are created, they are set, like the facets of a gemstone, into a rectilinear case, which is built of timber and lined on the inside with mirror. This compositional work is again time-consuming and complex; Patrik likens it to making an abstract painting. Once the layout is finalized, each piece is fixed in place. The shards, which are backed with a protective coat of blue paint, generate a whole microcosm of internal colour and reflection. The whole unit is then set into an overall frame of patinated steel.

Avalanche, as Fredrikson Stallard decided to call the work, is one of their most successful essays in baroque composition. As in the *Crush* tables, what appears to be the work of a moment is actually painstakingly achieved – or to put it the other way round, despite the care that has gone into its making, it seems to crystallize a single dramatic episode. Stray shards of mirror are placed in a pile at the bottom, to enhance the narrative quality; some pieces are lodged at dramatic angles, as if they too might crash to the floor. The whole thing is like something out of a work of fiction. And yet, for all the Sturm und Drang, it is entirely functional. One *Avalanche* mirror has a permanent home in Ian and Patrik's guest bathroom, where it hangs above a one-of-a-kind handbuilt clay sink, pulled and torn around its rim. It reflects the little room's malachite-pattern wallpaper in a dizzying deep green kaleidoscope. There's one larger piece in the mirror, located more or less eye height. As Ian notes, "you can do your makeup in it if you really want to."

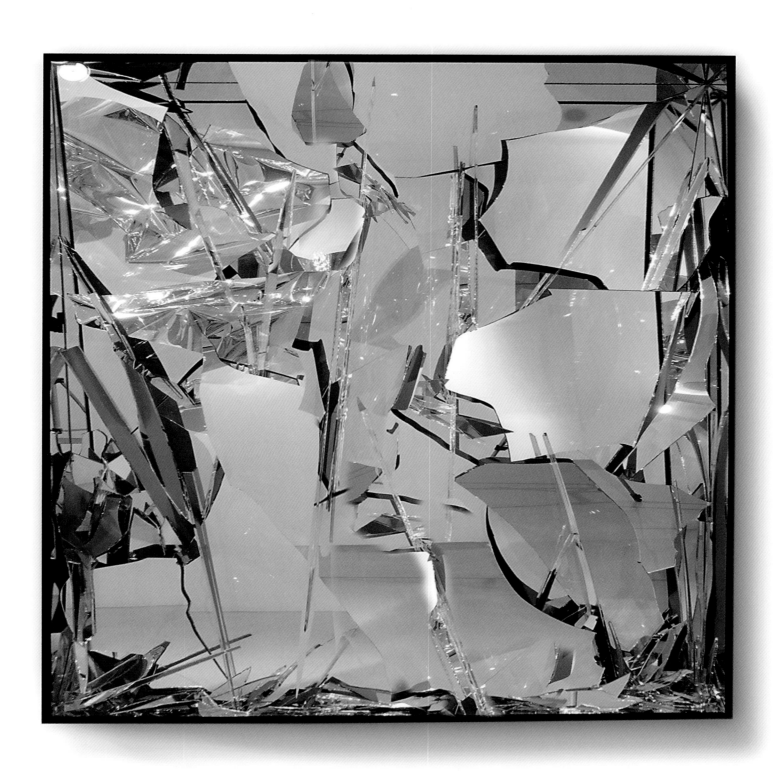

Avalanche, 2014

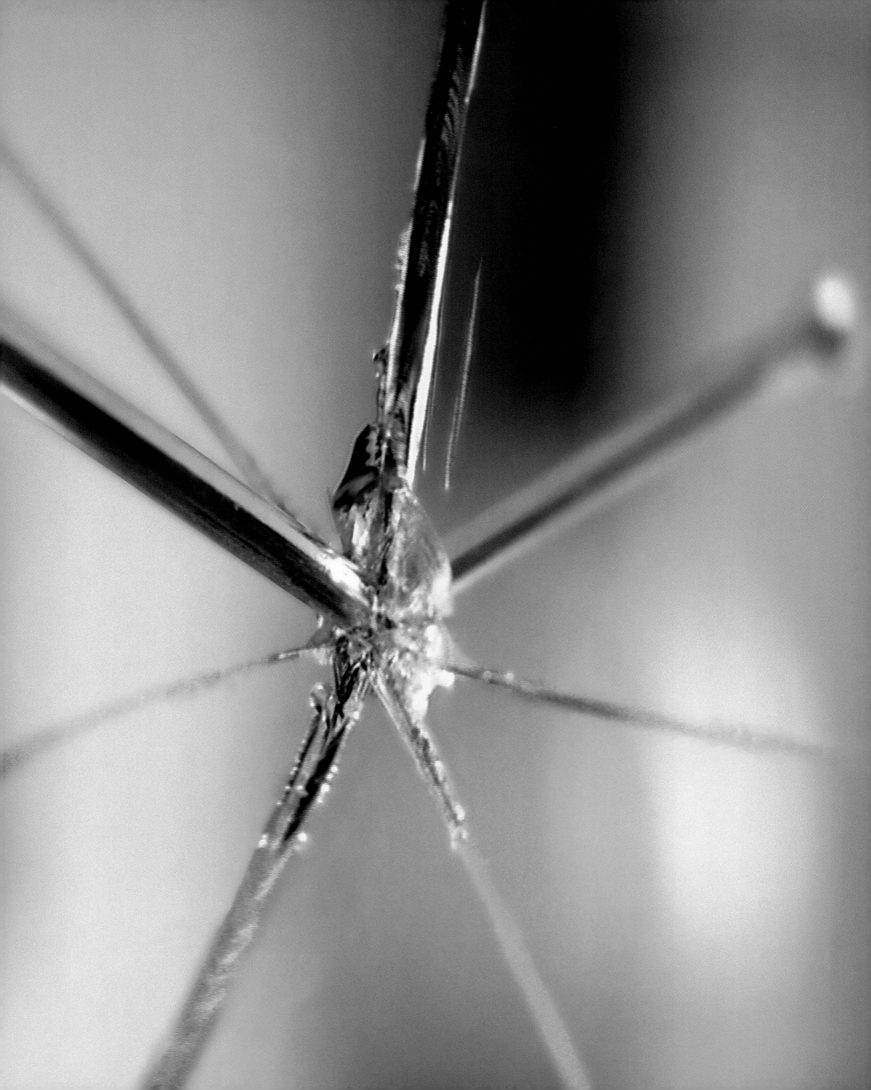

Mirror #1, 2002

Without Sin, 2012

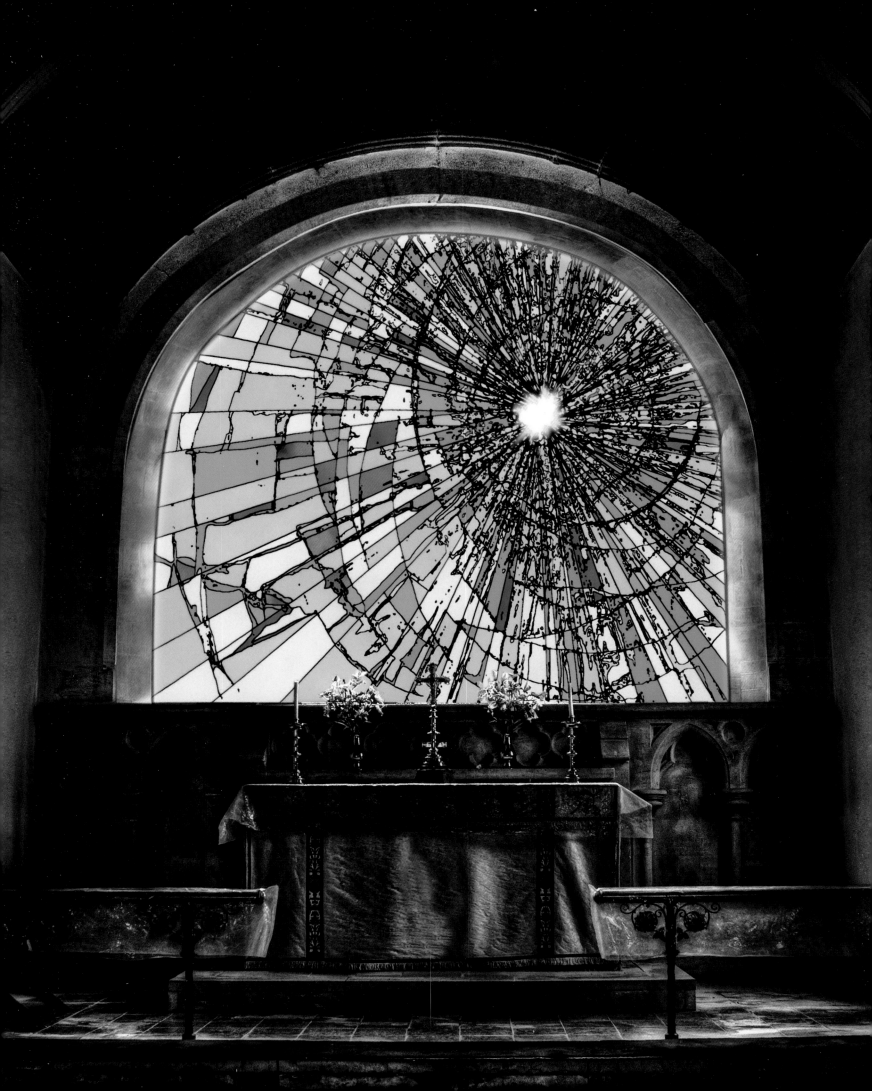

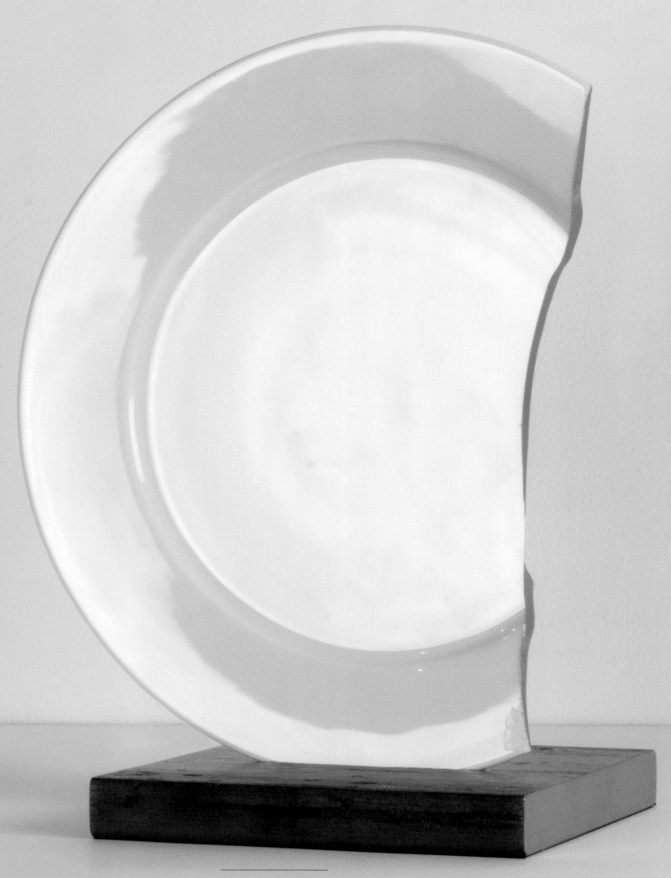

Fractus I, 2016

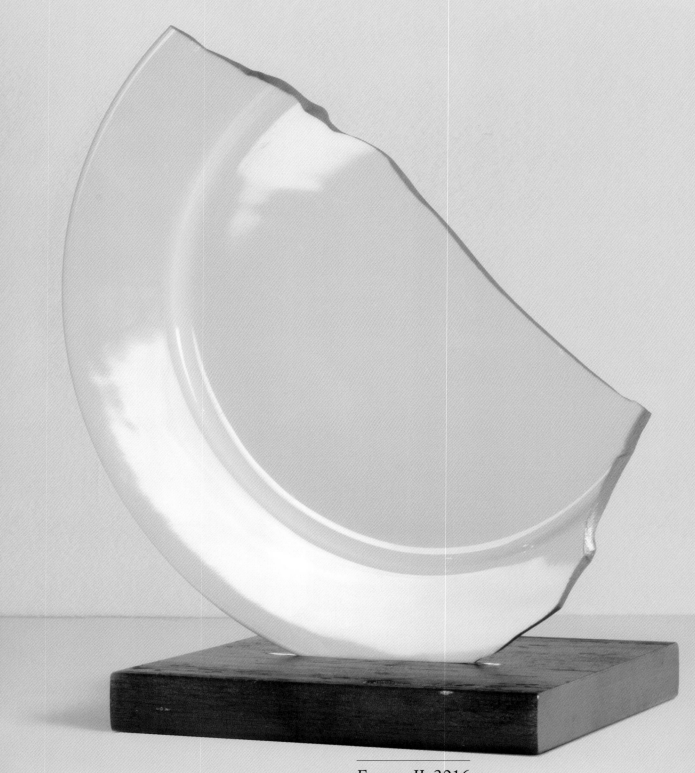

Fractus II, 2016

FREDRIKSON STALLARD

Momentum

London, September 2015

It is ten years since the inaugural show "*Gloves for an Armless Venus*" in New York where Fredrikson Stallard created their first major collection, the foundation for their signature flux of craft, industrial, contextual, sculptural and avant grade.
Fredrikson Stallard have subsequently worked internationally with some of the worlds most prestigious galleries, interior designers and architects, luxury brands from the worlds of fashion, jewellery, champagne, fragrance and film, as well as receiving numerous awards, and having their work purchased by both esteemed collectors and for permanent collections of major museums.

Working with their gallery David Gill and with other inspirational partners and patrons has facilitated Fredrikson Stallard's diverse and exciting development over the past decade. With that accumulated prowess, and for the first time since that inaugural show, Fredrikson Stallard have created a new collection of work where the design is entirely self driven by a desire to create amazing objects whose existence is derived purely from their core ideologies and vision.
The new body of works was launched under the title "Momentum" at the theatrical Fredrikson Stallard studio and HQ in Holborn, London. The works presented comprise of one off, edition and also transitory pieces designed to only last for the duration of the event, spanning across the realms of furniture, sculpture, product and print.

Momentum is a celebration of the experimental and the rigorous, the unique versus the mass produced, the importance of conceptual and creative development underlining the artists aesthetics and beliefs. But Momentum is also an anniversary of ten incredible engaging years of working with visionary patrons and craftspeople who have helped facilitate the development of true creativity into extraordinary works. Momentum acts as a personal interlude towards future destinations.

Momentum Artist Book, 2015

Parachute Gold, 2015

White Emulsion I, 2016

White Emulsion II, 2016

Species, 2015

Authors of monographs like this one are not meant to have a favourite piece. But if pressed to choose one among Fredrikson Stallard's many works, I would probably go for *Species*. It condenses many of their concerns – materiality, process, colour, directness – yet it seems not so much like a product of the studio as something pulled from deep in the earth's crust, or fallen from the heavens. It also happens that my first writing on Fredrikson Stallard coincided with the work's initial presentation. Exceptionally, this was done not at David Gill Gallery but in their own studio, which is capacious and charismatic enough that it can be used for display from time to time. The show, entitled *Momentum*, served as a capsule summary of what they had achieved to that point, and indicated where they might be going next. Fredrikson Stallard took primary responsibility for the works in the exhibition, and also made the work without any particular clientele in mind. It was like a gift that Ian and Patrik gave themselves – a moment of complete creative freedom, freed from the usual dependencies of design, and situated in its own purely expressive space.

The *Species* seating forms were the crucial lynchpin of the project. Though they recall earlier works such as the breakthrough *Pyrenees* sofa, which was made in a similar way, and a lesser-known prototype design entitled *Canyon* (2006), which has the same chasm-like contours, *Species* has a new and exciting sculptural boldness, a release from apparent functional constraint. The impression that one is looking at organic specimens – rather than the handcrafted objects they actually are – perfectly captured the spirit of the *Momentum* show, with its subtext of growth and rebirth. Even the title of the series relates to the concept of evolution: it was inspired by Charles Darwin's seminal book *Origin of Species*.

The *Species* works are made of foam that has been covered with a napped, densely textured surface. The design has been realized both in the form of handmade prototypes and CNC-milled versions; either way, the foam is set into an understructure, which lends rigidity and durability. No matter what the method, the result is sublime. It evokes ancientness and depth, in a way that Fredrikson Stallard associate with the red and black Rothko paintings in the collection of Tate Modern. Indeterminacy of scale is vital to the works. Though no bigger than a usual sofa, a *Species* chaise is impossible to gauge in a photograph: it could be a mountain or a micro-organism, a beautifully modulated single stone or a slab of marbled meat.

Ian and Patrik's bet with *Momentum* paid off. Not only did the three *Species* prototypes find homes, but David Gill ultimately found success with the related CNC-carved edition, the handmade prototype of which is in the collection of the San Francisco Museum of Modern Art. More recently, they extended the family further with a one-off, *Species III* – so dark red that it appears black – which has an internal steel structure that counterbalances the bold cantilevering of the form. The *Momentum* exhibition also served its purpose in broader terms, infusing the studio with a new energy that still seems to be propelling them today, a couple of years on. Without the development that went into *Species* it is hard to imagine *Glaciarium*, Fredrikson Stallard's most recent collection for Swarovski; and without the success of *Momentum* it is unlikely that they would have undertaken another self-generated project like the white bronze vessels of *Hybrideae*. If any younger designers are reading, there is a lesson to be drawn here: sometimes it's worth taking a risk.

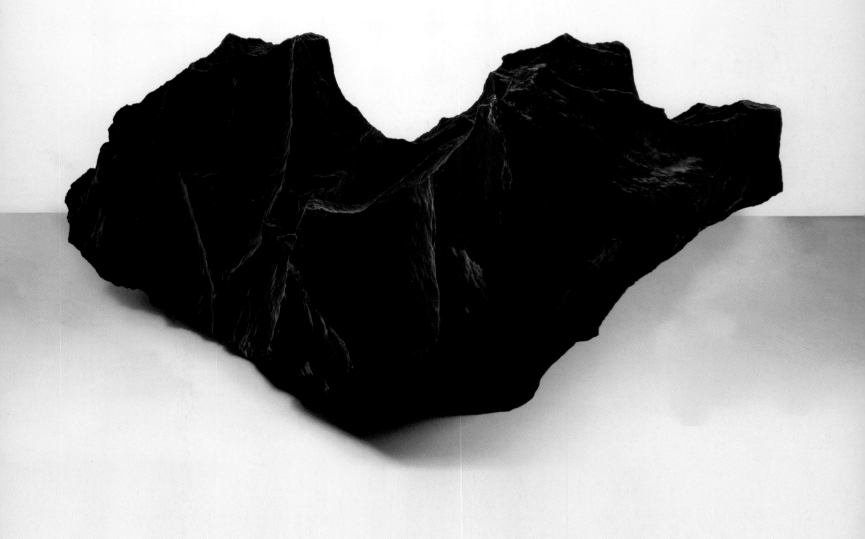

Species V, 2017

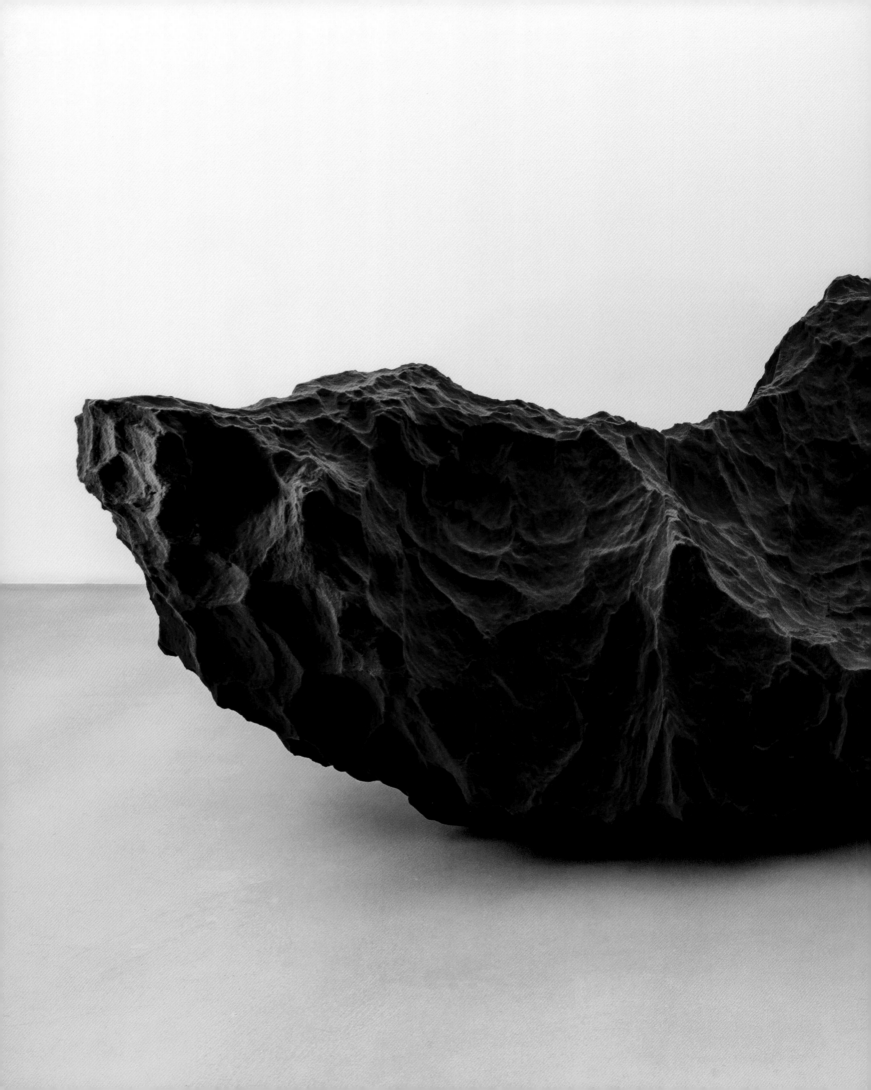

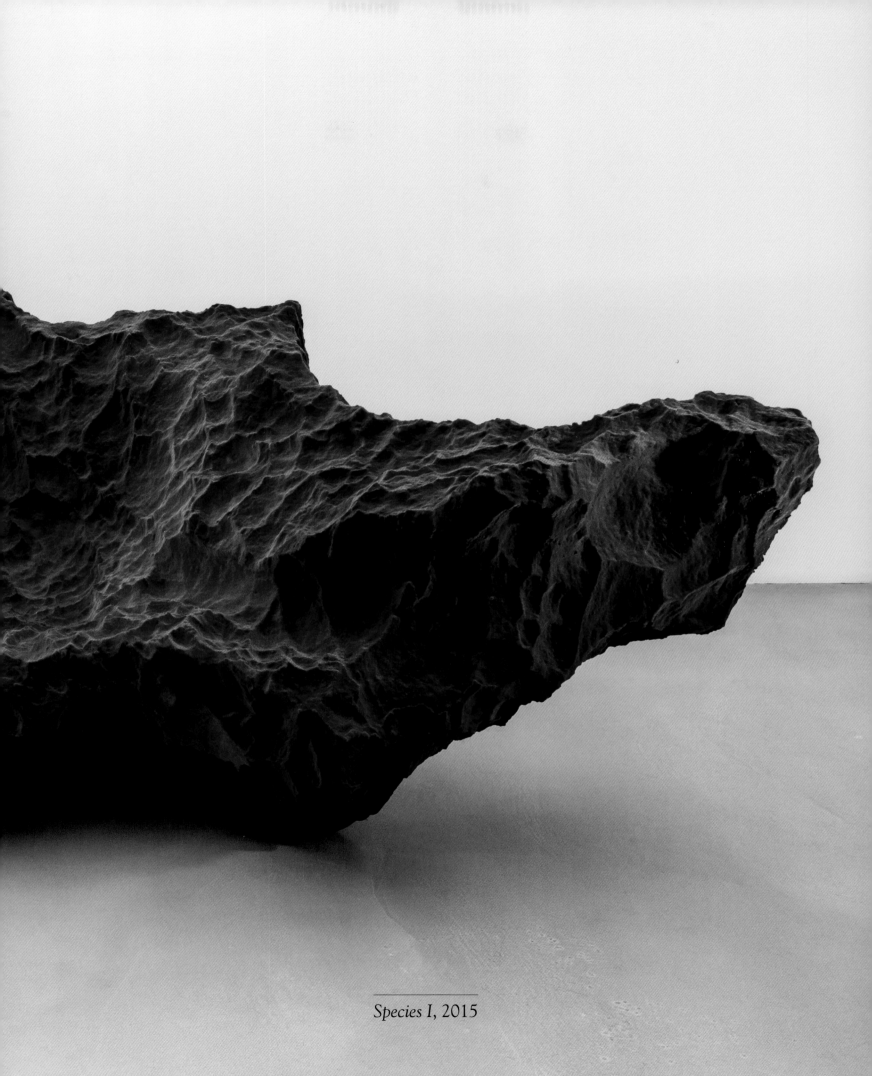

Species I, 2015

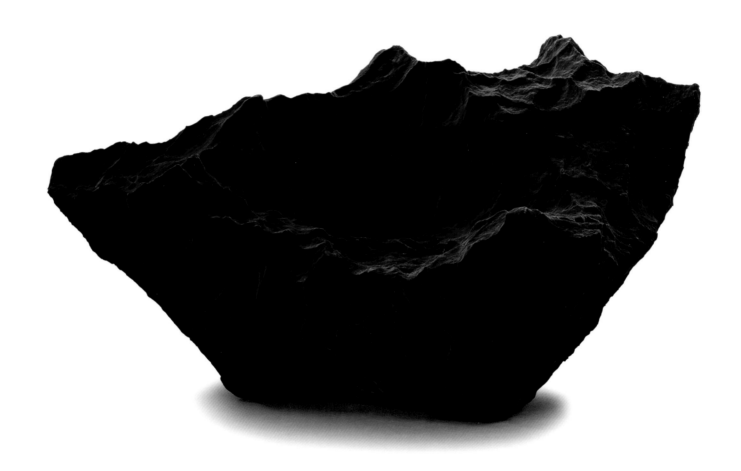

Species II, 2015

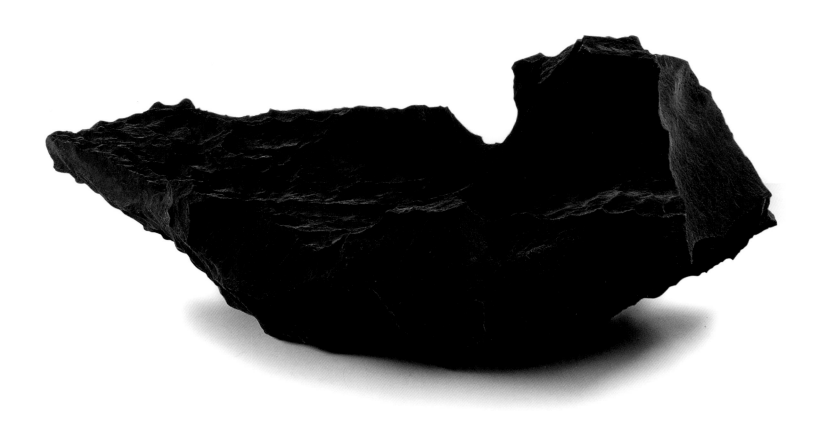

Species III, 2015

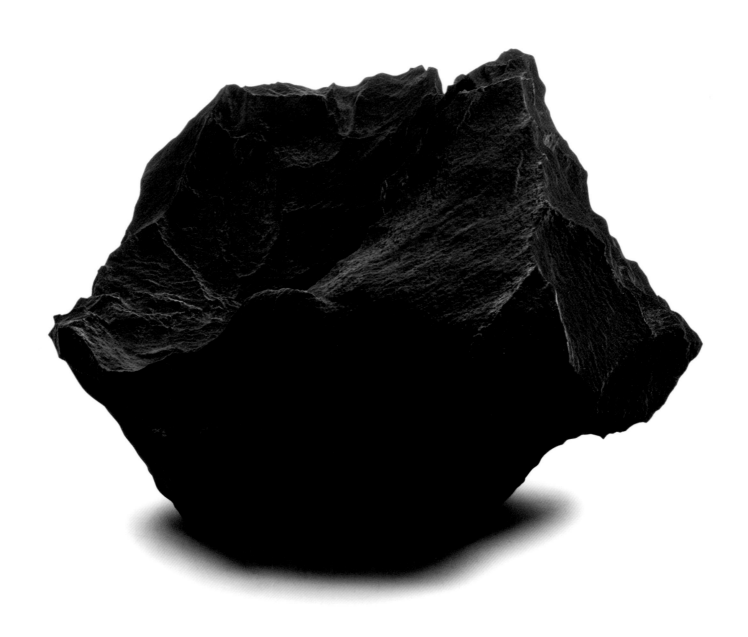

Species IV, 2017

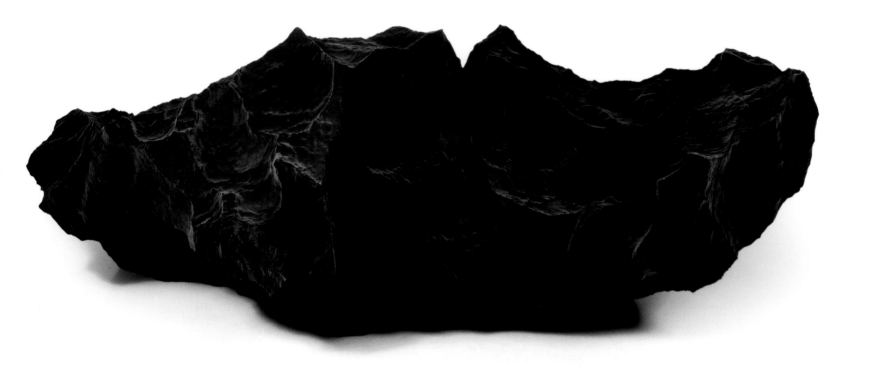

Species V, 2017

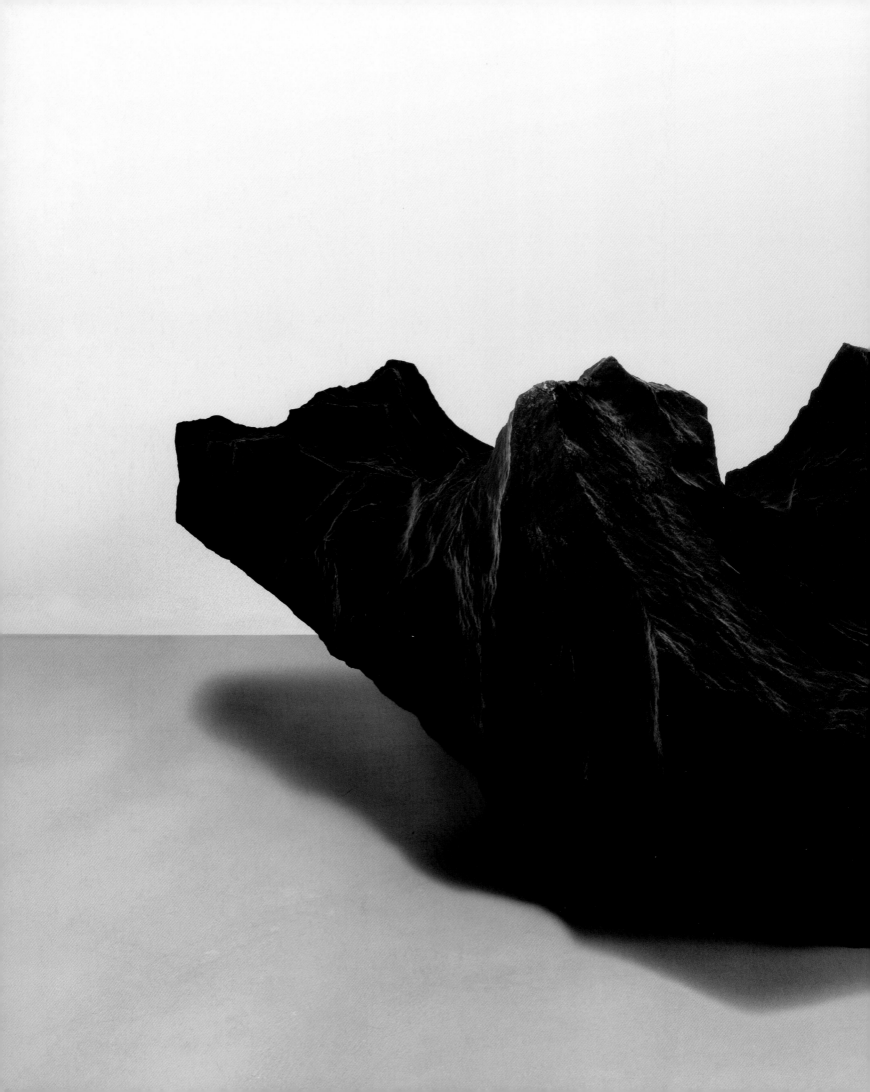

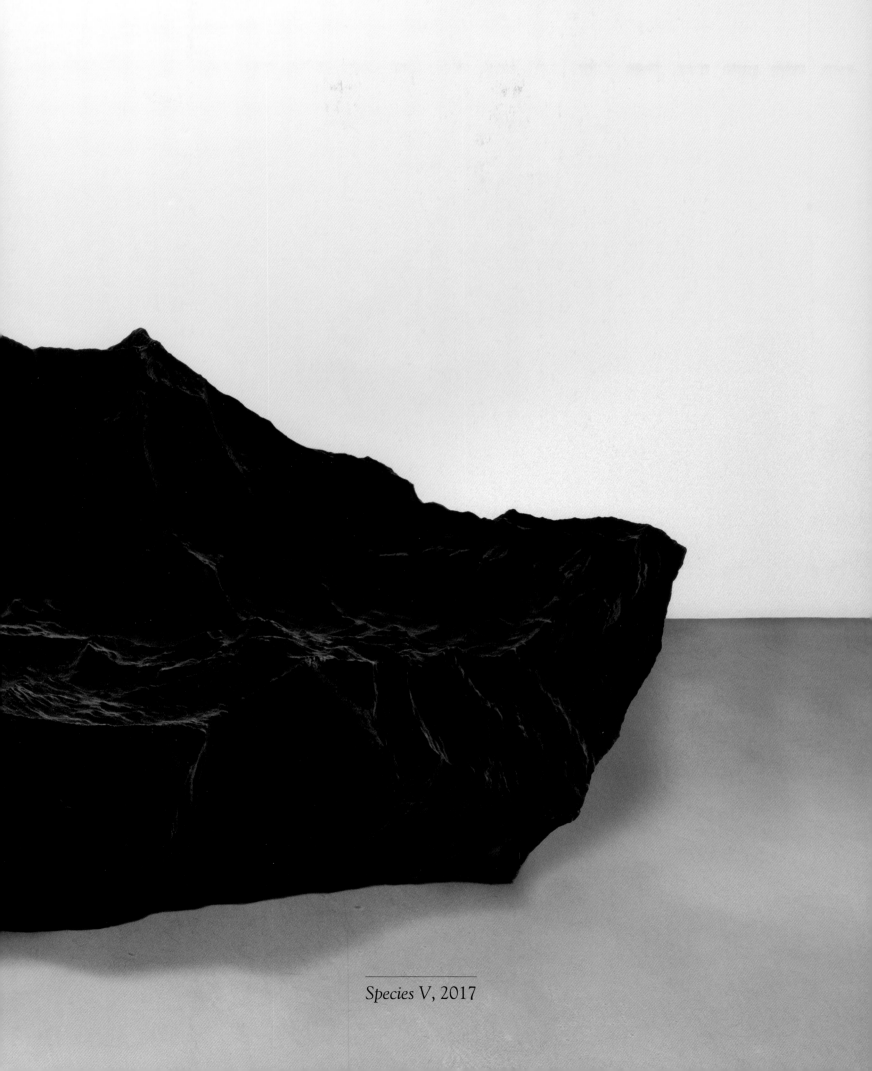

Species V, 2017

Rock #1, 2016

Rock #2, 2016

Rock #6, 2016

Rock #4, 2016

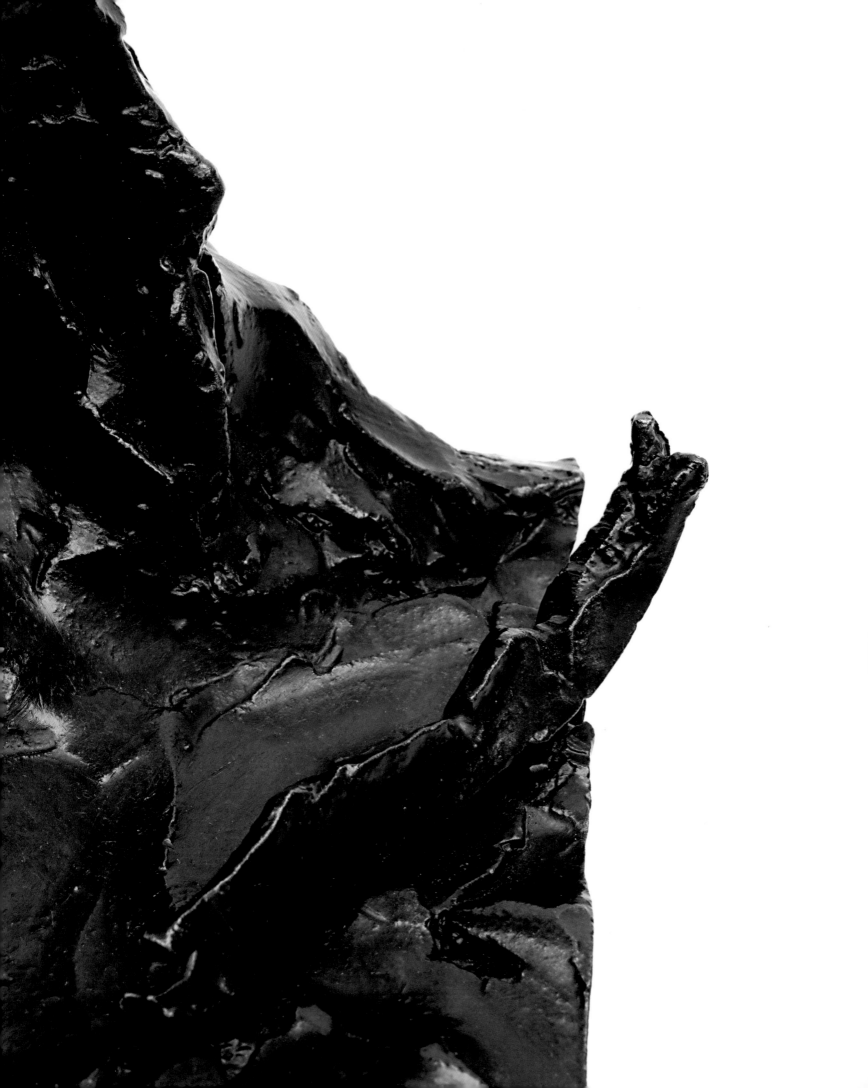

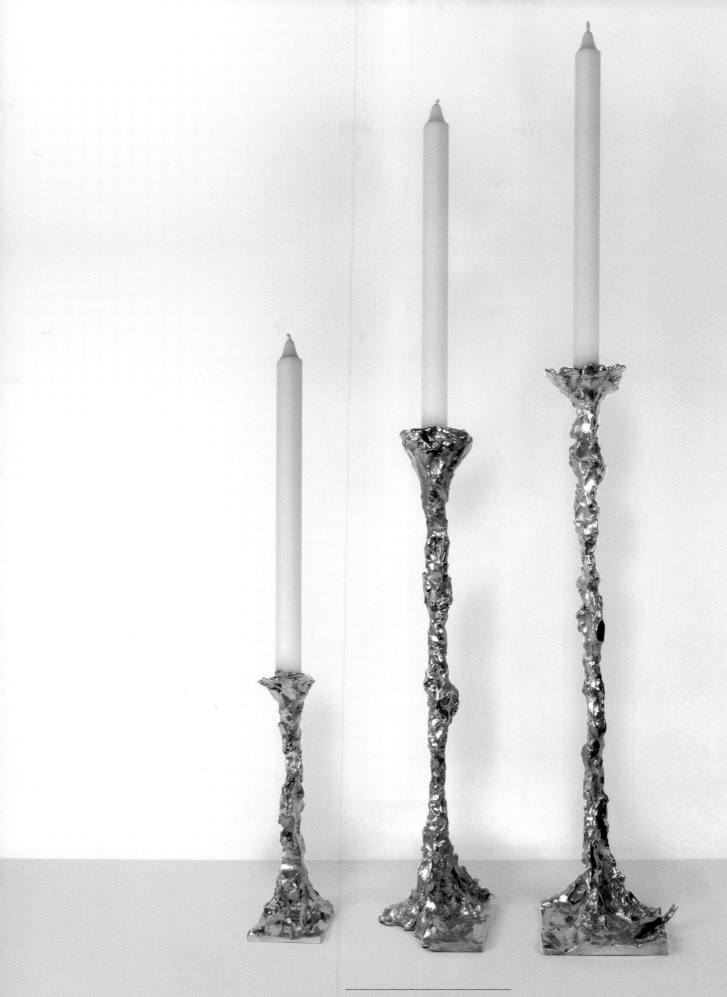

Vendôme I, II, III, 2016

Armory, 2015

Swarovski has been Fredrikson Stallard's most important corporate patron since 2007, when the kinetic *Pandora* chandelier helped establish the design studio on the international stage. In the ensuing decade, their work for the company was entirely oriented to exhibition pieces and public sculptures, like *Iris* and *Prologue*. It is a sign of the collaboration's continuing success that Swarovski eventually asked Fredrikson Stallard to begin proposing actual products – a deeper level of involvement, both technically and financially, and one that was unprecedented for both parties.

One mutual undertaking of this kind, a jewellery collection entitled *Armory*, was itself a synthetic hybrid of two previous projects in the studio. Among Swarovski's philanthropic activities is support for the British Independent Film Awards, a maverick analogue to the Oscars or the BAFTAs. In 2013, Fredrikson Stallard created an award for the ceremony, an open cage fabricated from metal rods with a single, huge Swarovski crystal inside it. Actress Emma Thompson, on receiving it, joked "thank you for this implement of torture," but in truth it is that rarest of things: a custom-designed trophy that one would display for its sculptural qualities alone.

The award's cage-like structure had roots in a still earlier project, a chair entitled *Aviary* (2012), which is unusual in the designers' oeuvre in being inspired by digital aesthetics. It is, however, a great example of Fredrikson Stallard's tendency to do things the hard way. They had been working with a model in crushed foil for a chair, thinking more or less along the lines of King Bonk. On scanning the model and translating it into 3D rendering software, they were struck by the volumetric shapes of the on-screen wireframe drawing. It was a set of shapes that "existed only in the computer's brain," as Patrik puts it. They changed course, and instead of having the chair executed in fibreglass as they had originally intended, asked a metalworker to fabricate the chair out of hundreds of individually cut and welded mild steel rods. This intricate construction was then unified with an all-over coating of thin, matte black lacquer.

The film award and *Aviary* were both successful in their own ways, but Ian and Patrik recognized that the potential of the idea was not yet exhausted. When Swarovski approached them to create a jewellery collection, they knew immediately that this was the language they wanted to use: something edgy, "rock and roll," empowering to the wearer. They also wanted to design jewellery that could appeal to any fashion-forward wearer, no matter what her age, and could be worn both day and night. The final pieces well merit the name *Armory*. They were launched at Fredrikson Stallard's London studio in a show styled by Emma Wyman, senior fashion editor at *Dazed and Confused*. The models stood on plinths, motionless as mannequins (producing double takes among the attendees) in the studio's darkened tunnel entrance. In addition to the collection itself, three wore special one-off pieces, much as haute couture gowns relate to a ready-to-wear line – a tiara, a mask and a gorget (also known as a pauldron, a shoulder piece reminiscent of an American football player's protective pads).

The models may have looked as though they were girded for combat on an ancient battlefield, but the underlying formal concept of the jewellery was still rooted in the analogue/digital hybrid that had animated the *Aviary* chair. Each of the crystals in the jewellery collection was designed by Fredrikson Stallard based on a piece of broken acrylic; the haphazard facets of the crystals, in turn, were used to generate the wire construction of the overall pieces. Despite their size, they are surprisingly wearable; the open, airy construction results in very light weight. Fredrikson Stallard had reinvented the whole idea of "gem setting." They trapped the crystal inside a cage rather than holding it in a tension setting, but in so doing, achieved the same goal that traditionally applies in fine jewellery, maximizing the amount of light passing through the stone.

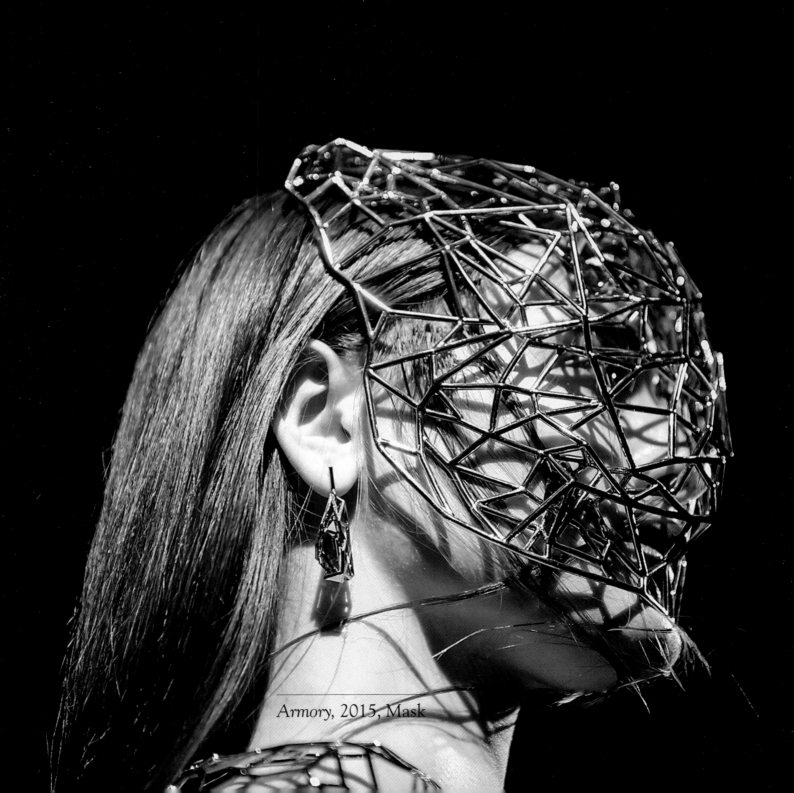

Armory, 2015, Mask

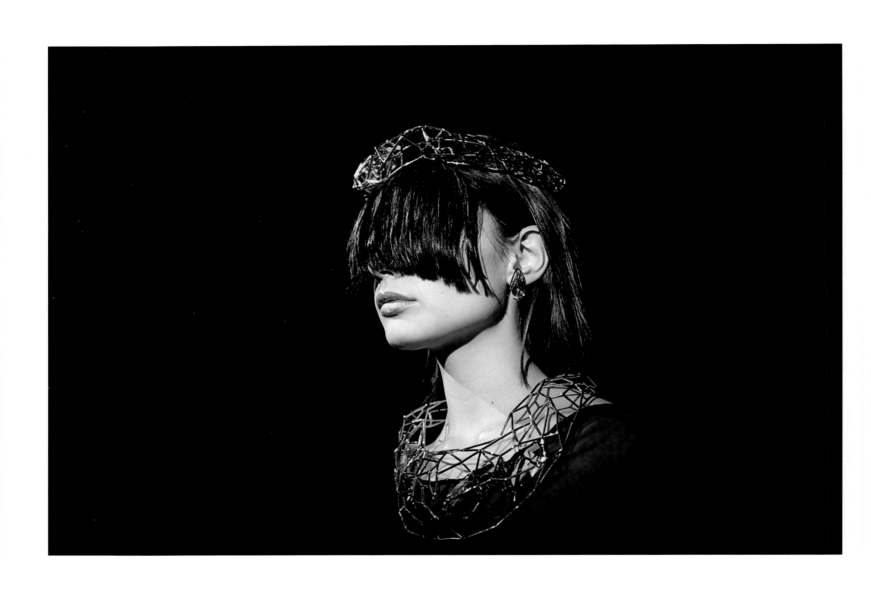

Armory, 2015, Tiara, Necklace, Earrings

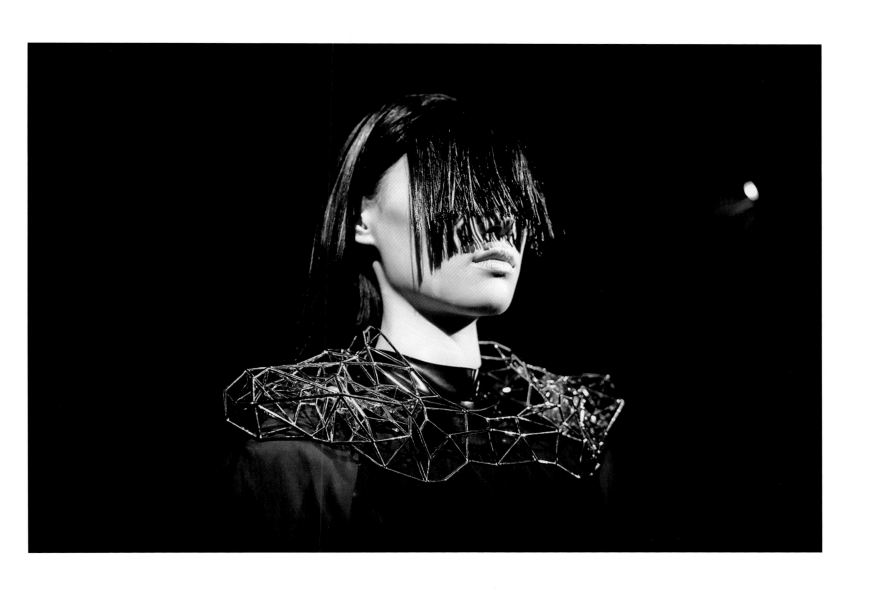

Armory, 2015, Pauldron

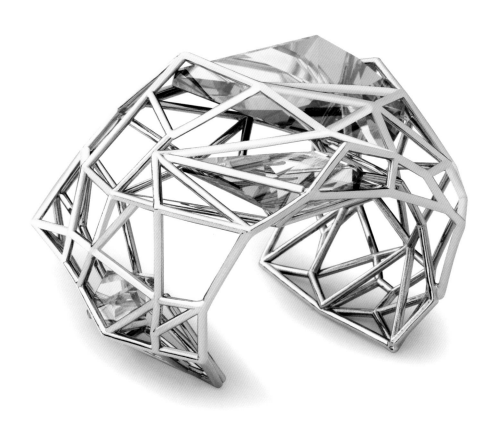

Armory, 2015, Large Gold Cuff

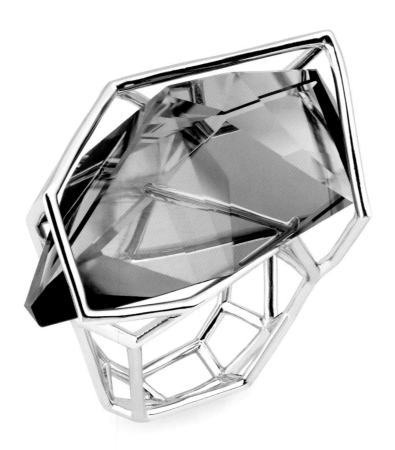

Armory, 2015, Large Silver Ring

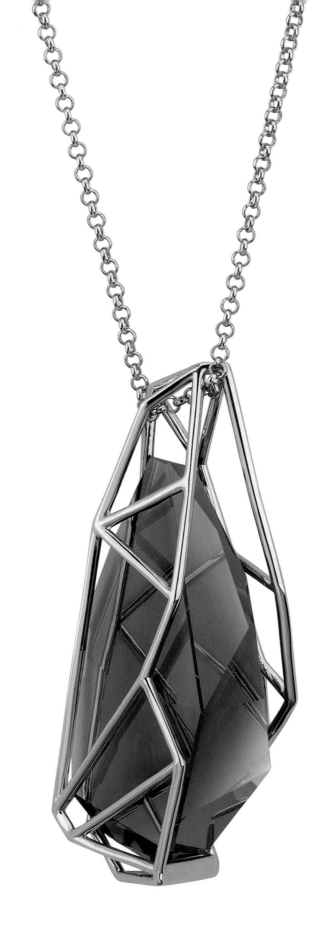

Armoy, 2015, Silver Pendant Necklace

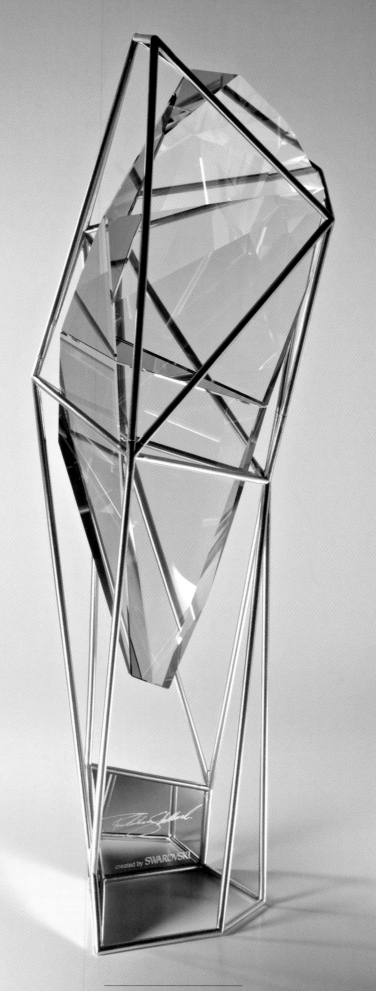

BIFA Trophy, 2013

Eden, 2014

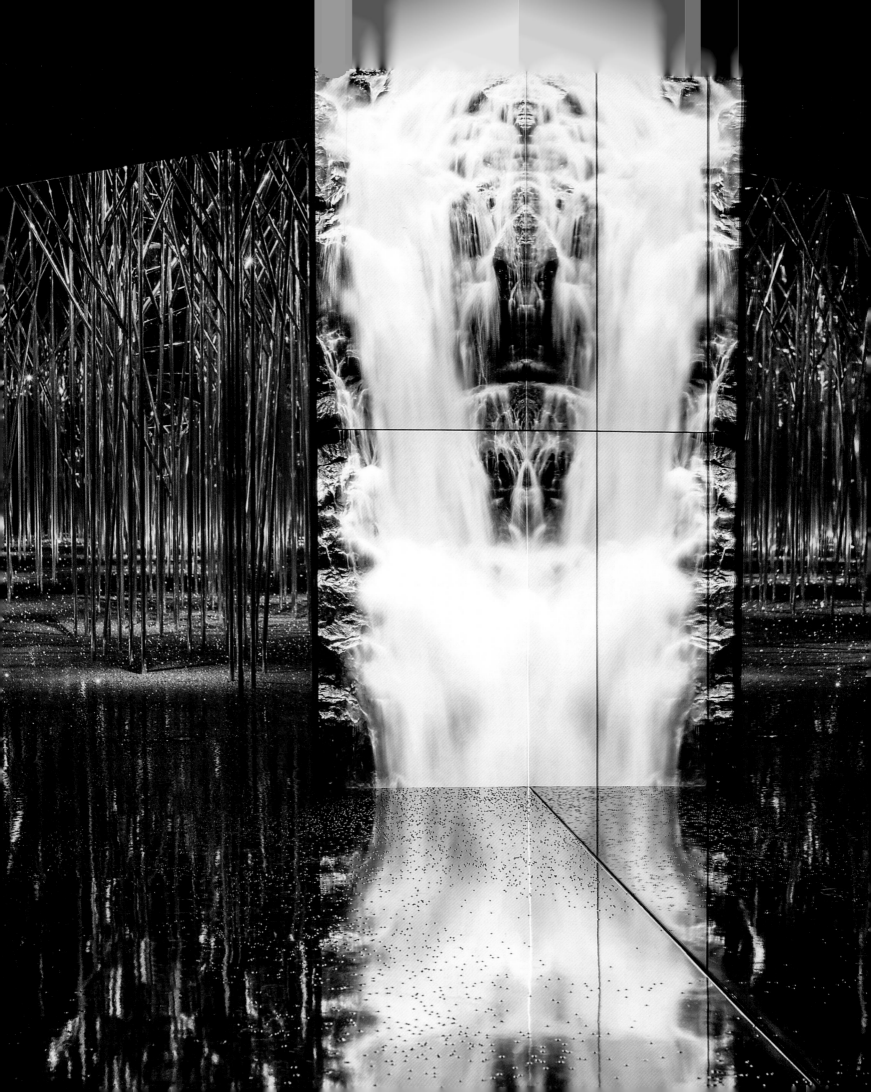

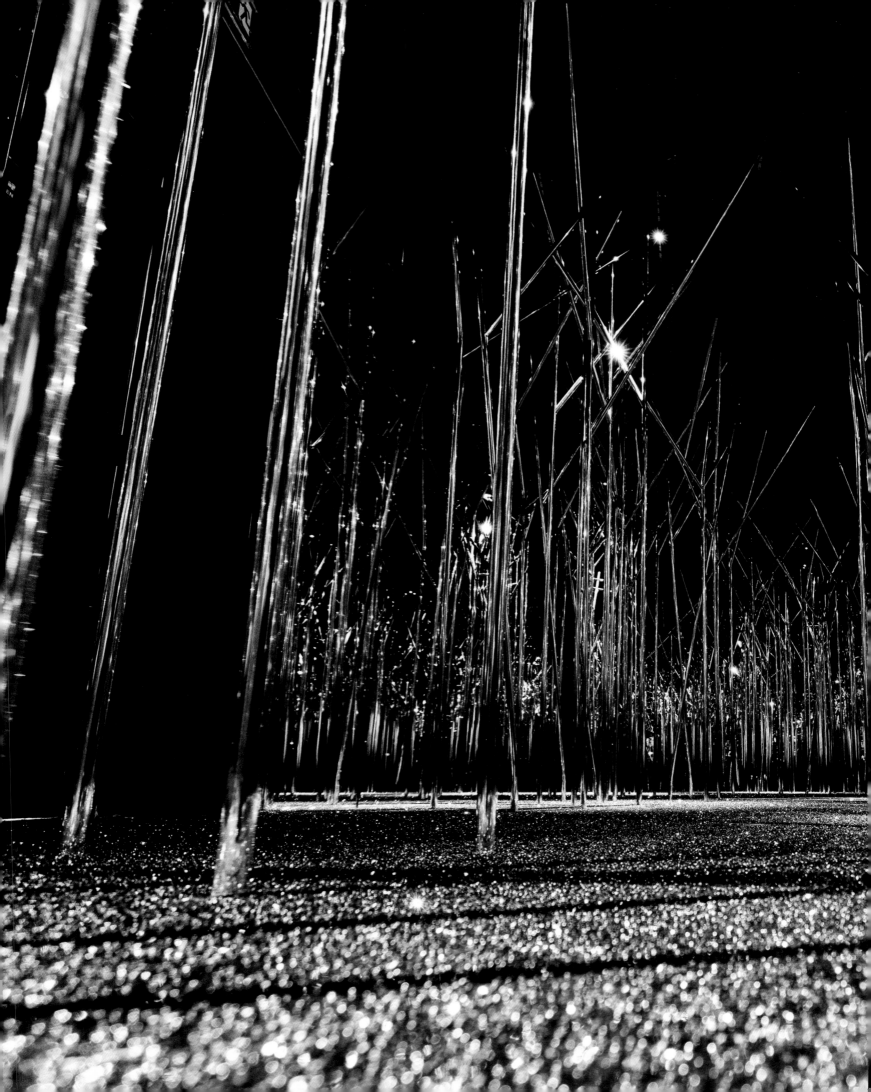

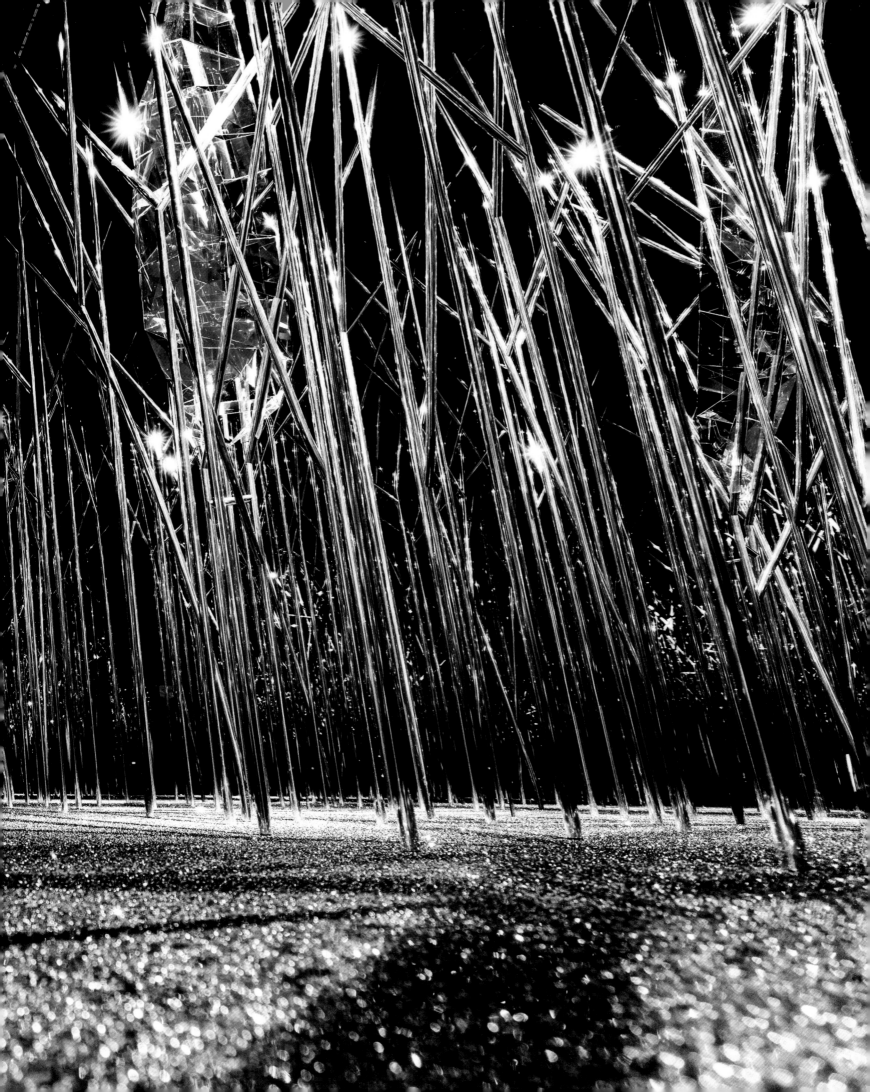

Gravity, 2016

One sign of Fredrikson Stallard's maturity as an art practice has been their increasing ability to generate critical mass around an idea, developing multiple interpretations of a line of thinking and seeing them through to completion. Perhaps no group of objects reflects this better than the works that were included in the exhibition *Gravity*, presented at David Gill Gallery in 2016. In addition to the titular piece, an acrylic table with a cantilevered form, the show included an array of other forms: examples from the *Species* series; a circular table entitled *Atlas*; accessories like firedogs and candleholders; small occasional tables or "gueridons;" new works in stainless steel, dubbed *Hudson*; and a round mirror called *Metamorphosis*.

The genesis of this group of objects came, oddly enough, from the fact that the complete edition of the *Silver Crush* table – a signature piece for the studio – had sold out. It struck Ian and Patrik that they could make a "ghost" of the object by reinventing it in ice complete with encased metal sheet; adding to the attraction of this idea was their recollection of the solid ice table that they had positioned on the sidewalk in front of their breakout show, *Gloves for an Armless Venus*. The frostily named *Polaris* was included in the studio show *Momentum*, in a constant state of melting flux, lasting exactly the length of the exhibition before disappearing. *Polaris* led to the creation of the *Gravity* table, which was the first successful realization of this concept as a permanent object.

To make it, they smashed pieces of ice with a hammer and then scanned them before the resulting fragment began to liquefy – an ephemeral moment captured in fixed form. In a parallel to the research that the studio was then conducting for the Swarovski project *Glaciarium*, they then developed a vocabulary of shapes which they cut with CNC tooling, shaping both the exterior surface and the internal "fissures." A subsequent, even freer version of the idea entitled *Antarctica* makes the affinity to *Glaciarium* still clearer.

There is nothing more magical or counter-intuitive in Fredrikson Stallard's oeuvre than this family of works. Even the modest gueridons made with the milled acrylic technique are fantastical objects, like cores pulled out of the polar ice caps; and the *Metamorphosis* mirror lives up to its name, affording the viewer a hundred fun house mirrors' worth of unstable reflections as one passes in front of it. *Atlas* is also satisfying, with its perfectly circular steel base – as in so many earlier projects (including those for Swarovski), light is captured within it, and seems all the more dynamic as a result. But there is no doubt that *Gravity* is the summit of the group. Dramatically sheared off at one side, it recalls an iceberg undercut by the passage of ocean currents. It casts a crisp rectangular shadow below, a set of fixed lines for your eyes to hold on to, but the object itself seems to deliquesce, even as it throws light around the room in a shimmering play. Monumental as it is, you keep checking it to make sure it hasn't melted away.

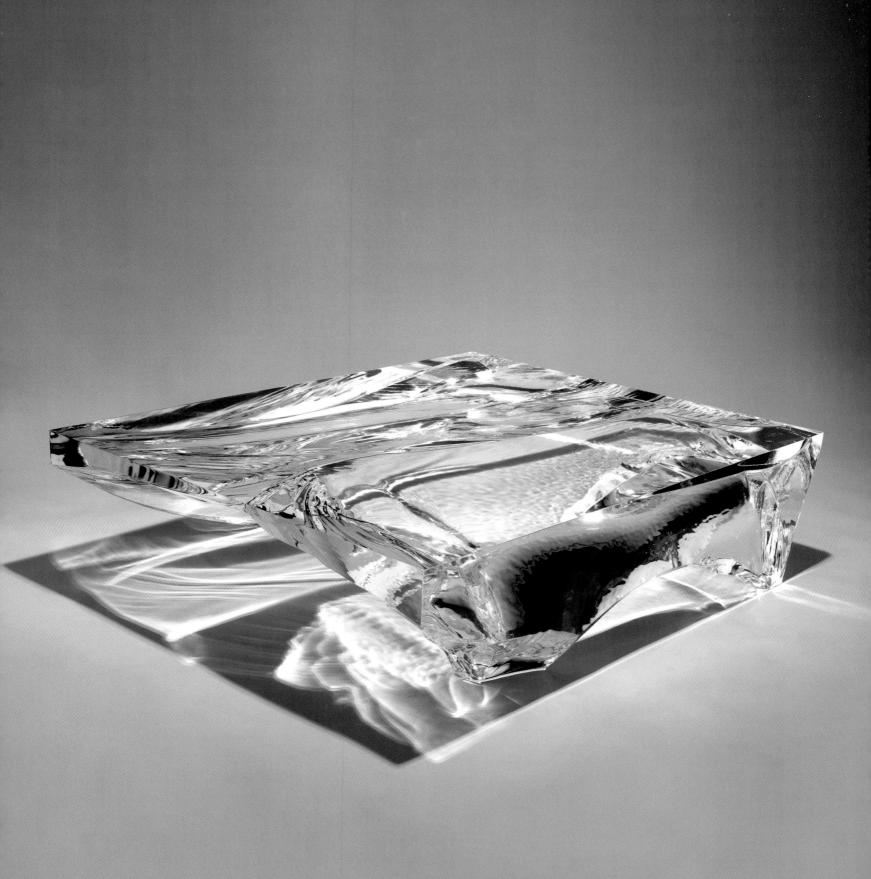

Gravity I, 2015

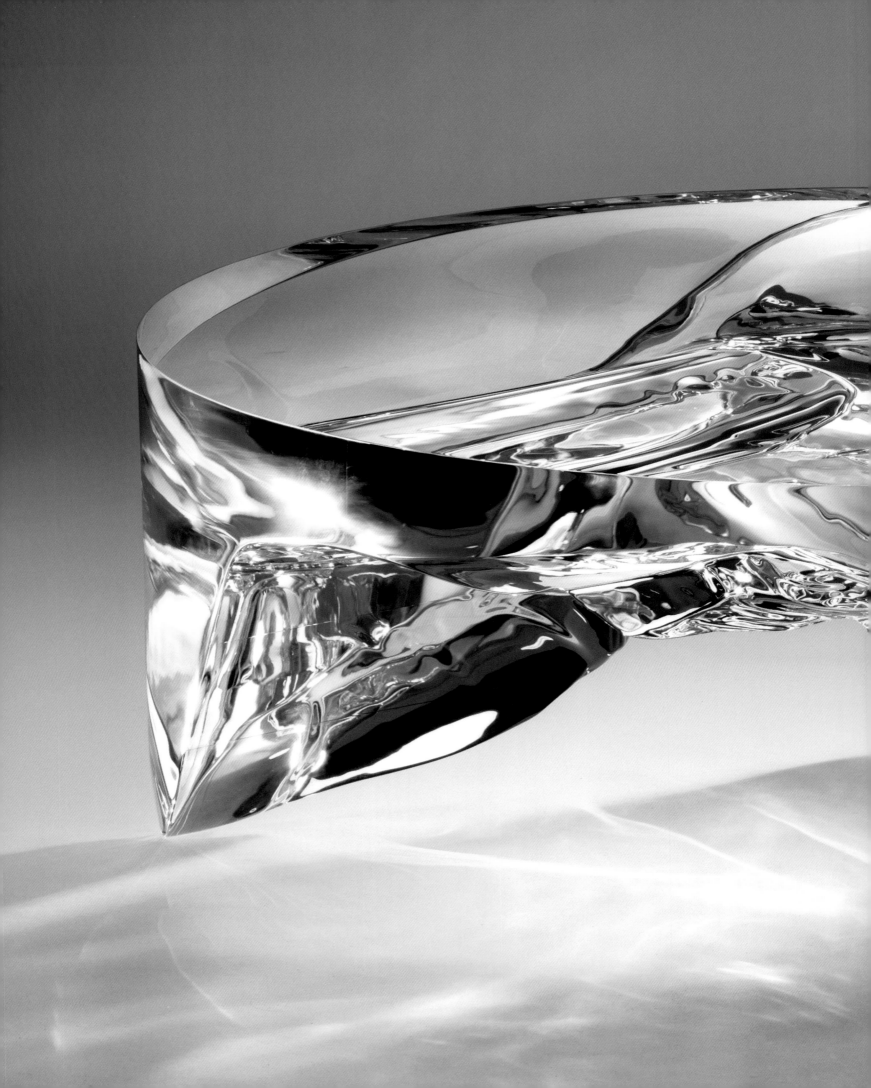

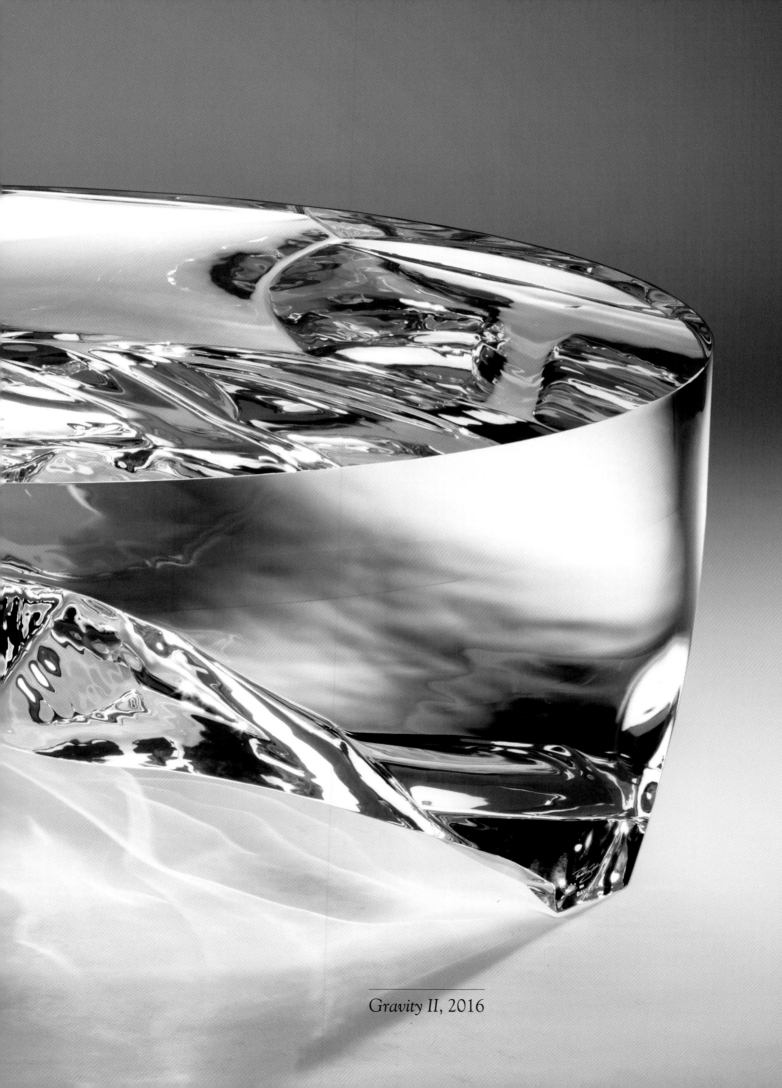

Gravity II, 2016

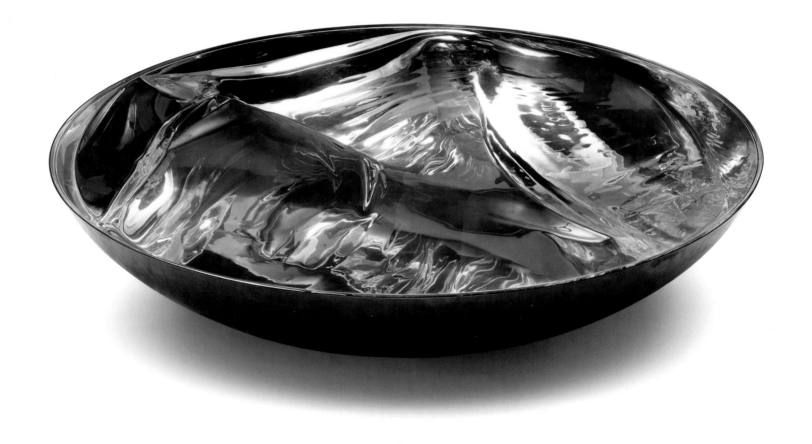

Atlas, 2016

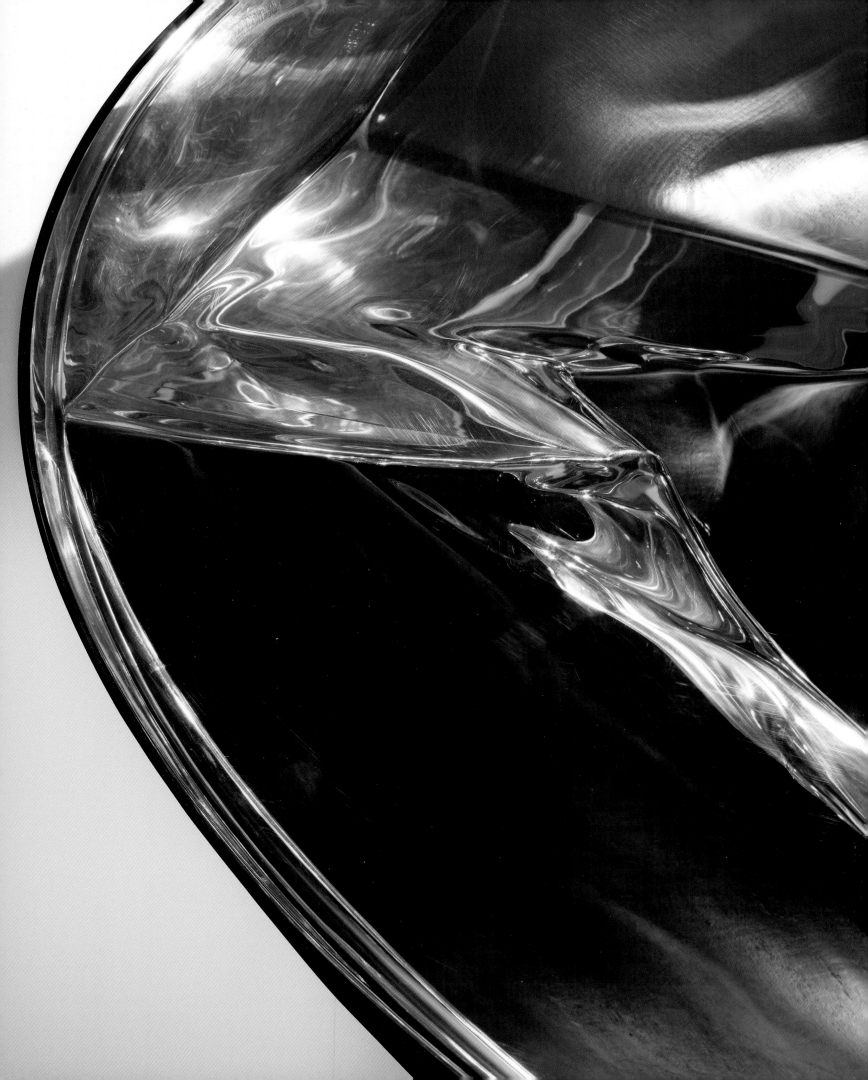

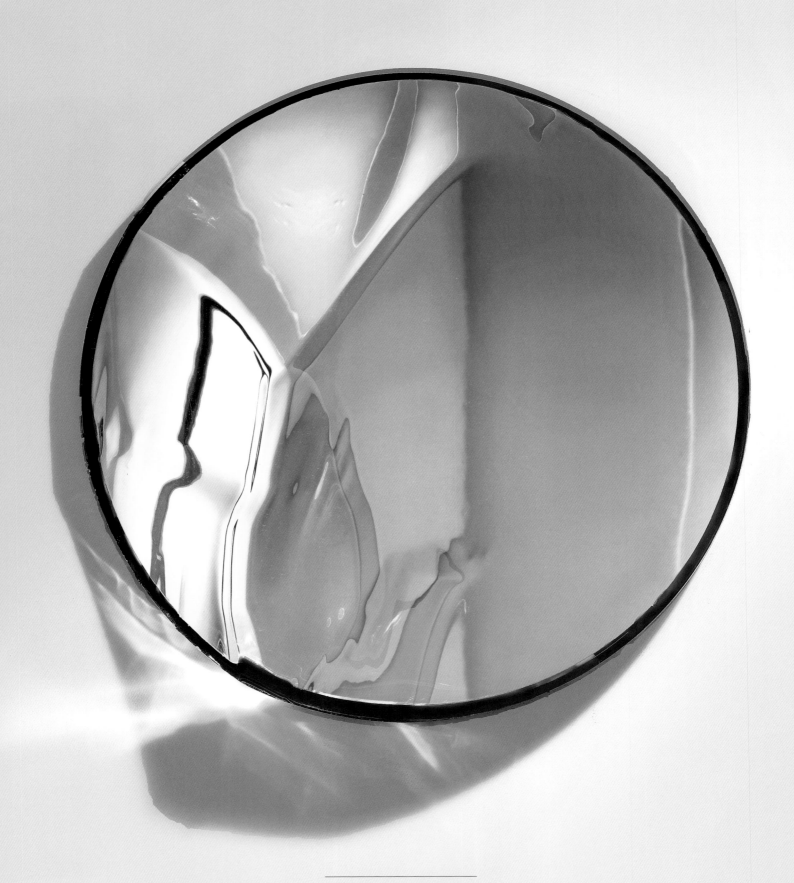

Metamorphosis, 2016

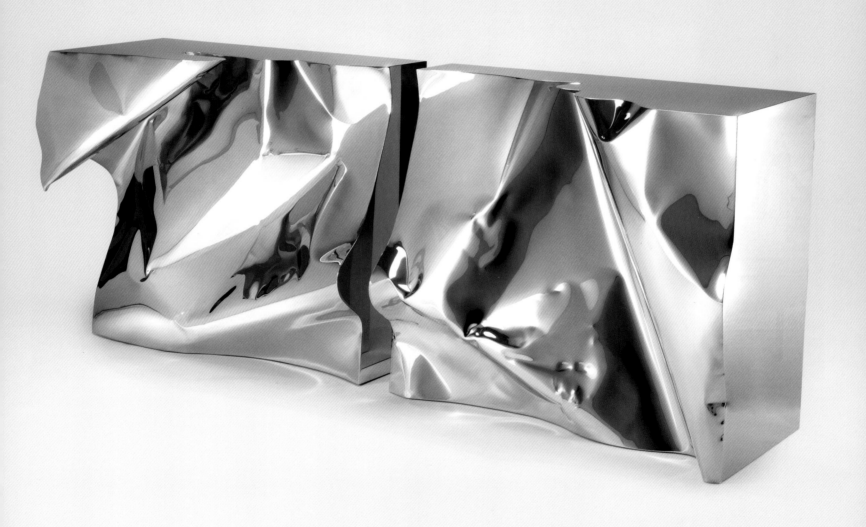

Hudson, 2016

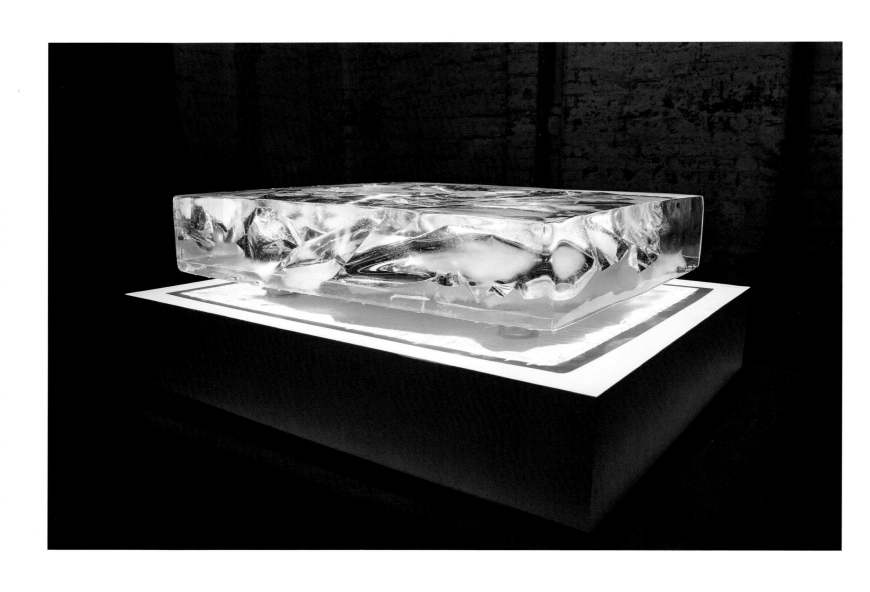

Polaris, 2015

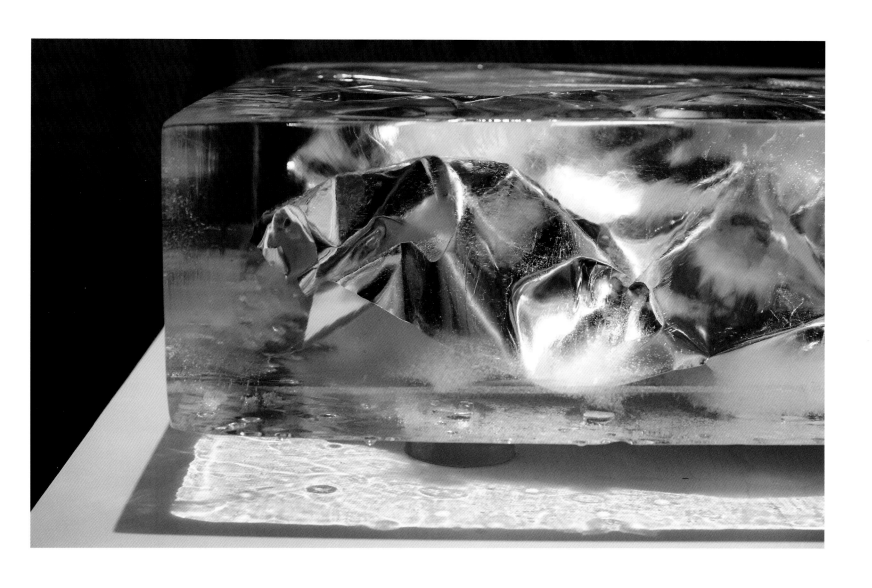

Polaris, 2015

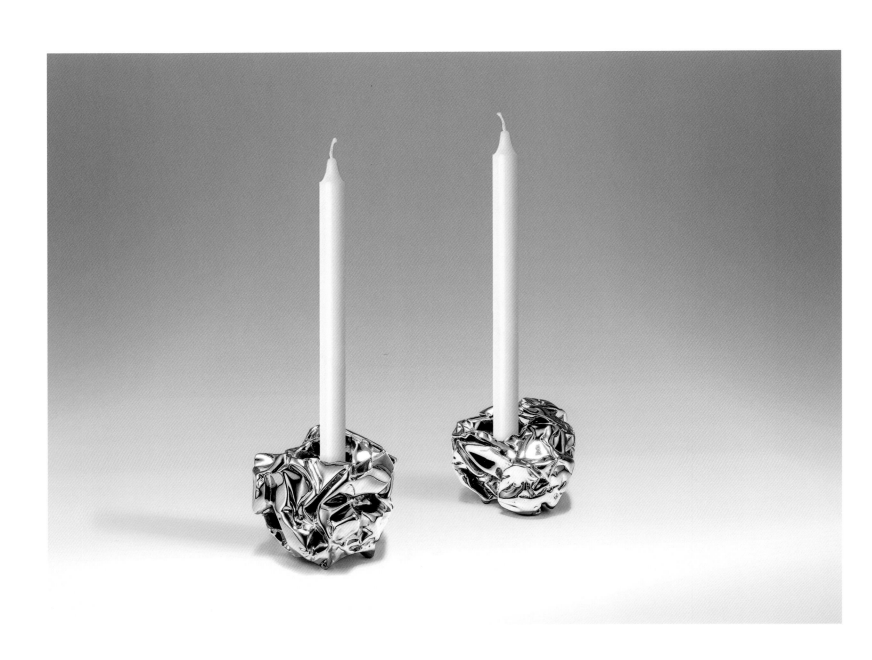

Consequences, 2016, Candleholders

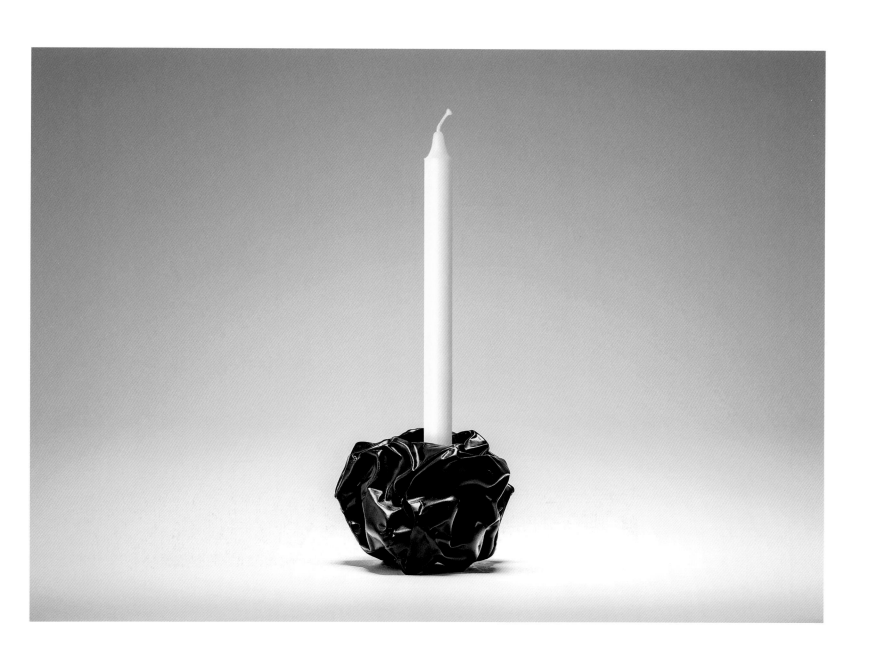

Consequences, 2016, Candleholders

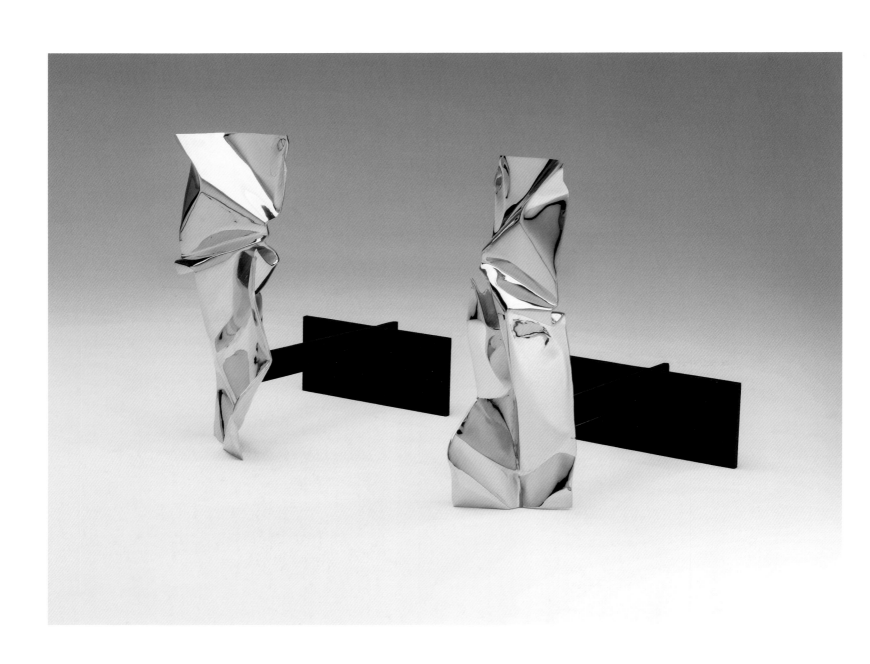

Manhattan I, 2016, Firedogs

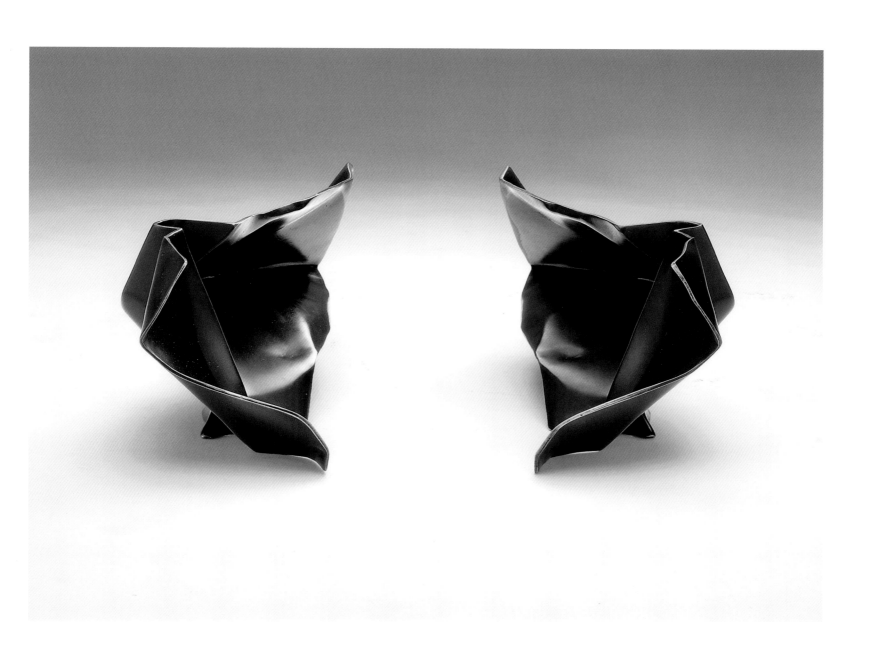

Manhattan II, 2016, Firedogs

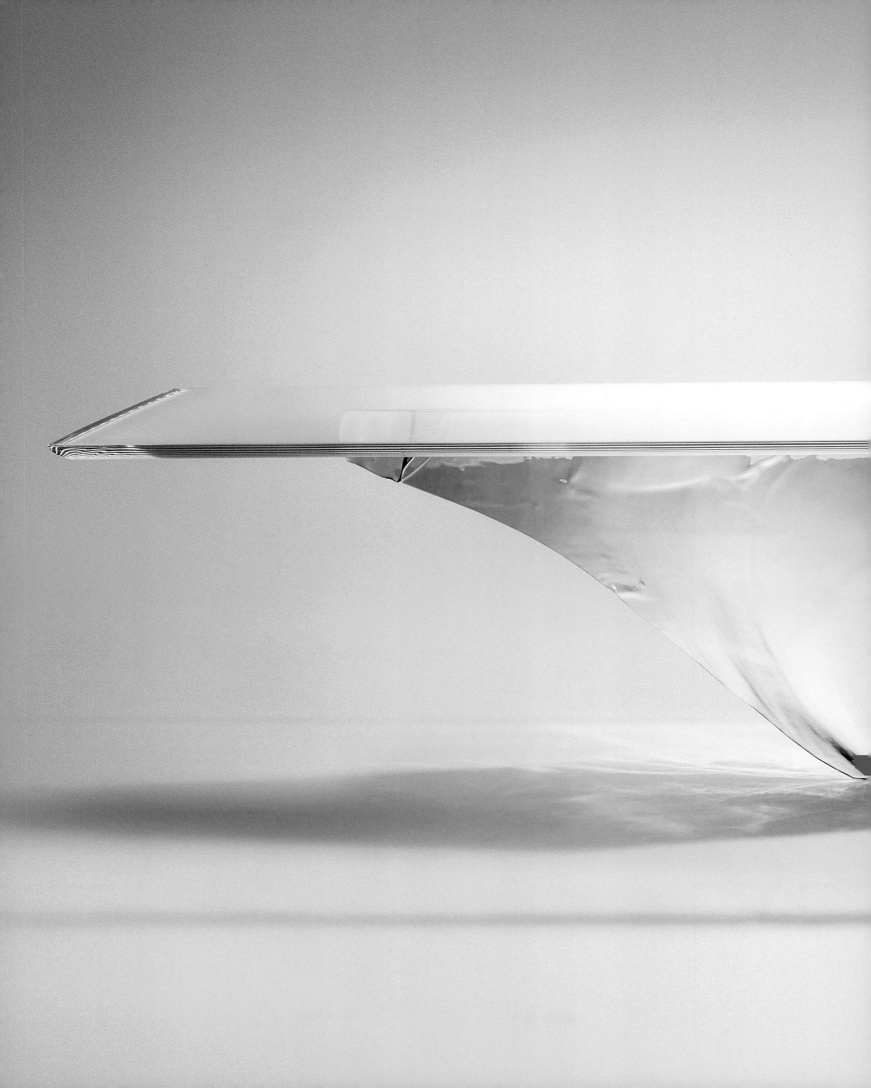

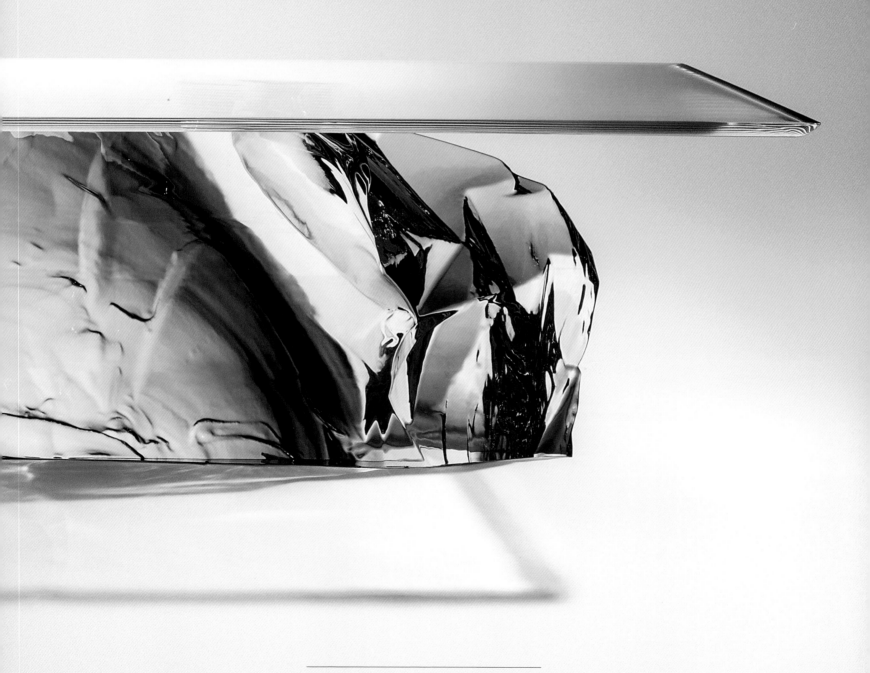

Antarctica I, 2017, Dining Table

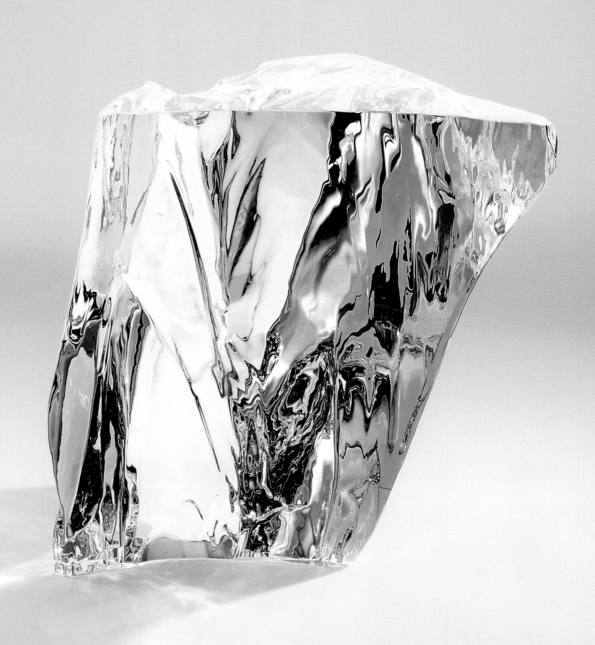

Antarctica III, 2017, Gueridon

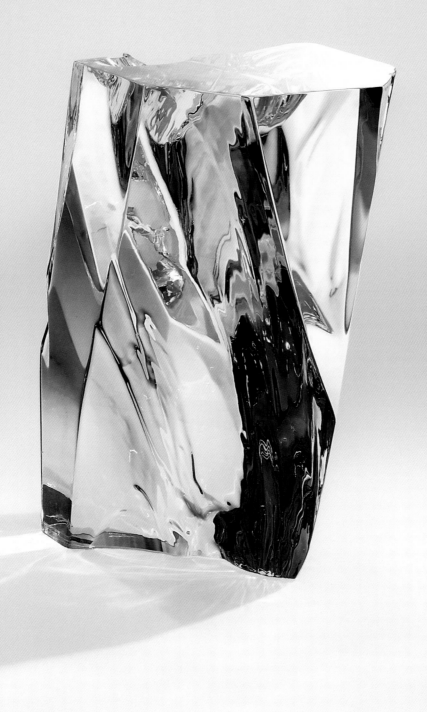

Antarctica IV, 2017, Gueridon

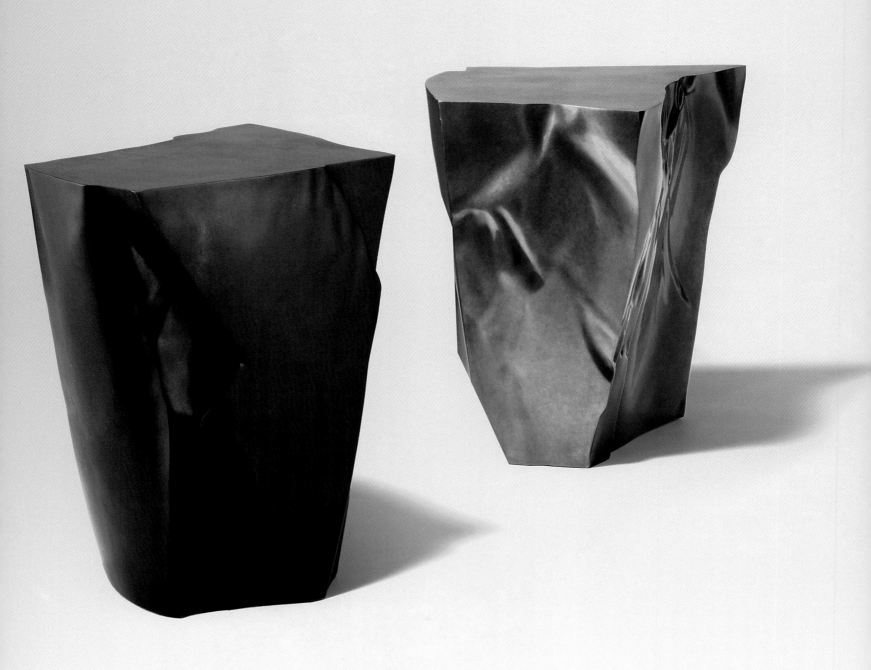

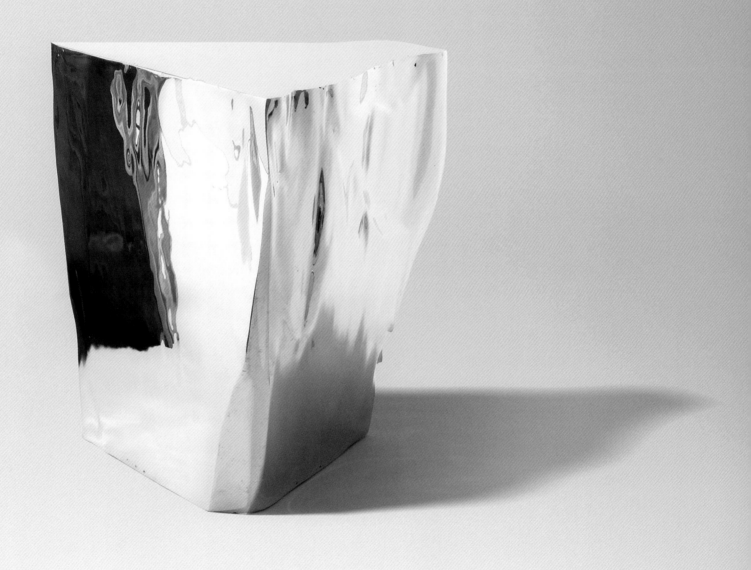

Antarctica VI, V, VII, 2017, Gueridon

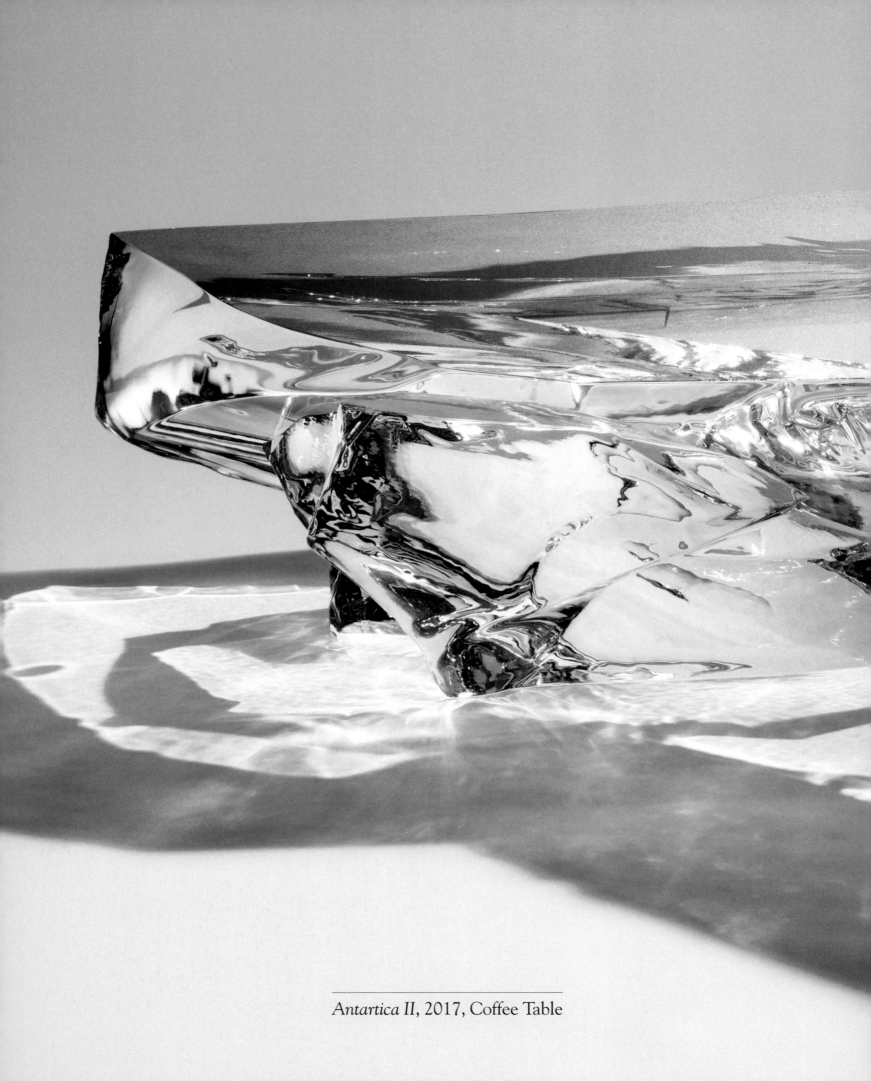

Antartica II, 2017, Coffee Table

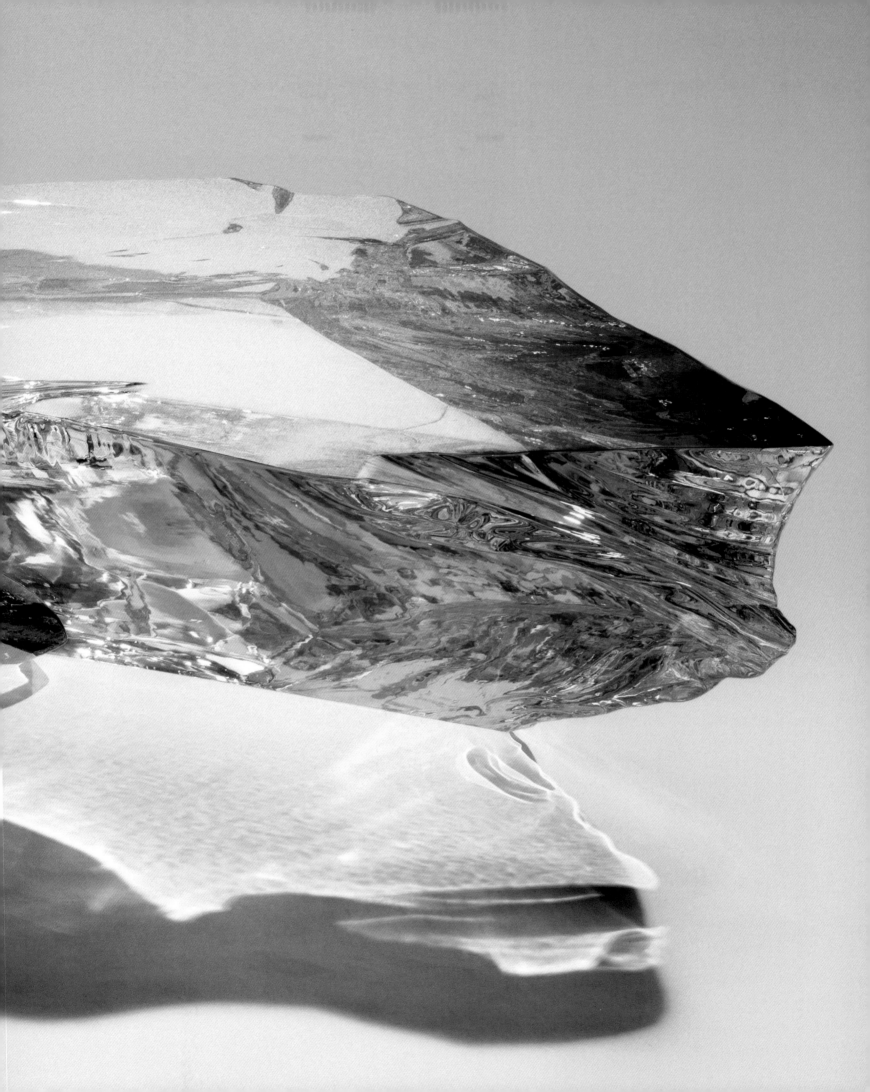

Glaciarium, 2016

Following the success of the *Armory* line of jewellery, Swarovski entrusted an even more complex and ambitious project to the studio: the development of a lighting product line, for which Fredrikson Stallard would not only design the overall shape of the fixtures, but also the actual components that would be used in them. They were effectively granted permission to experiment with the company's DNA: the forming and polishing techniques that Daniel Swarovski had established over a century before, a proprietary technology that remains a closely guarded secret. The company had extended this opportunity to other designers – among them Andrée Putman, Gianni Versace, and Giorgio Armani – but always in the domain of fashion and jewellery.

Cognizant of the significance of this assignment, Ian and Patrik travelled to the company's headquarters in to observe the manufacturing process up close. They were particularly fascinated by the kiln where the glass is formed, which "becomes lined with a sea of solidified crystals, which the workers have to remove from the walls by hand," they say. "The bits they chisel out are just rocks, but the surfaces are really beautiful, because the crystal is behaving in the way it wants to behave." This was enough to get them started on a concept for the crystal components, which would preserve this sense of raw matter in its moment of formation.

Of course, there was much more to it than that. The forms that Fredrikson Stallard conceived are not just random chips and chunks, but highly considered forms, designed using CAD. Some resemble prisms, while others look like primordial versions of fancy gem cuts. Nadja Swarovski emphasizes how different this is from the company's usual approach, which involves "hard core geometry, to maximize the amount of refraction coming from each stone." In the case of the *Glaciarium* crystals, there is instead "an entirely irregular shape, which produces a free play of light within." All of the components, however, share a common vocabulary. They evoke the natural qualities of the crystal as a material, the way that it splinters into shards, and the ripples that articulate its surface. The language of surfaces that Fredrikson Stallard developed does refer to the results of random hammering, the smashed up bits of the kiln room, but it has been optimized and controlled through the use of 3D modelling software. Each component crystal sits at an ideal point of hybridity between the inchoate forms of the raw material, and the classic cut stone that one might find in a Swarovski necklace.

As unique as the crystals were, they were primarily meant as building blocks. Other artists and designers will be able to use them, and Fredrikson Stallard showed something of the possibilities in making four *Glaciarium* chandeliers. As in the *Armory* jewellery collection, the eccentric forms of the components are set off by rigorously geometrical metal – as Nadja Swarovski puts it, the housings "bring the law and order back in." Two of the chandeliers are strictly linear, the other two perfectly circular, recalling earlier works like *Iris* and *Prologue*. As in previous works by the designers for Swarovski, the components can face different ways, and also shiver and shimmer with a passing breeze or movement, bringing life to the play of refraction. In the case of *Avalon*, arguably the pièce de résistance in the collection, the crystals seem almost to float in space, as the chromed struts of the fixture disappear in the dazzling light.

The *Glaciarium* collection also attests to the strategic skills that Fredrikson Stallard brought to the project: their ability to anticipate a company's needs in a practical, as well as an aesthetic, sense. Not only has the project resulted in a new "quarry" of components for Swarovski's future use, but as the chandelier designs show, the crystals are extremely flexible. *Avalon* and its sibling *Paradisium* are showstopper centrepieces, most suitable for grand rooms, while *Superline* and *Voltaire* could be used as accents or to light an irregular modern space. Most important of all is the conceit of the whole undertaking: that Swarovski's historic roots and essential techniques contain the potential for design that chimes perfectly with contemporary sensibilities.

Glaciarium Component Prism, 2016

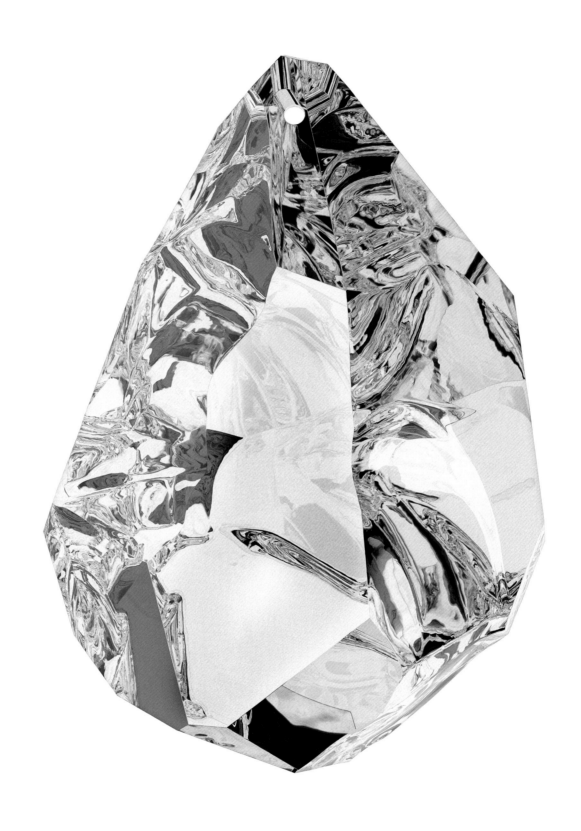

Glaciarium Component Pear, 2016

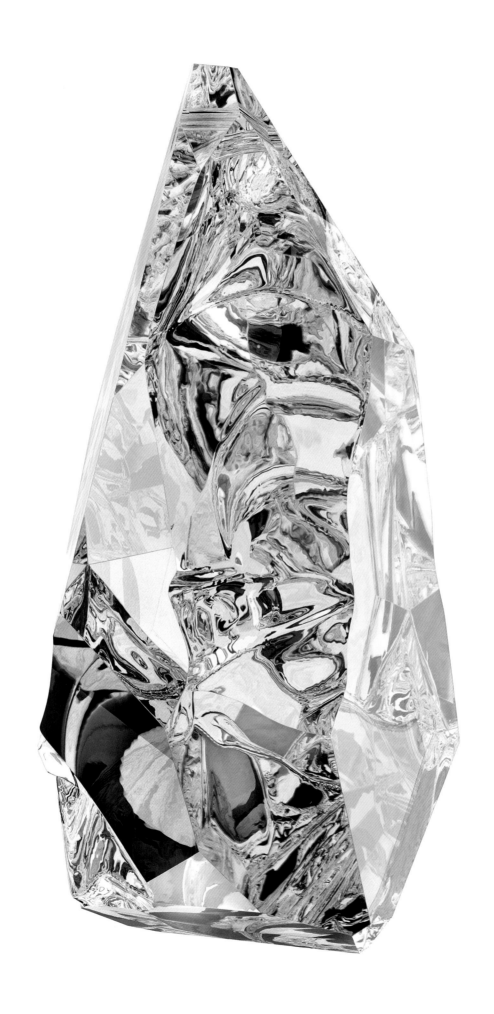

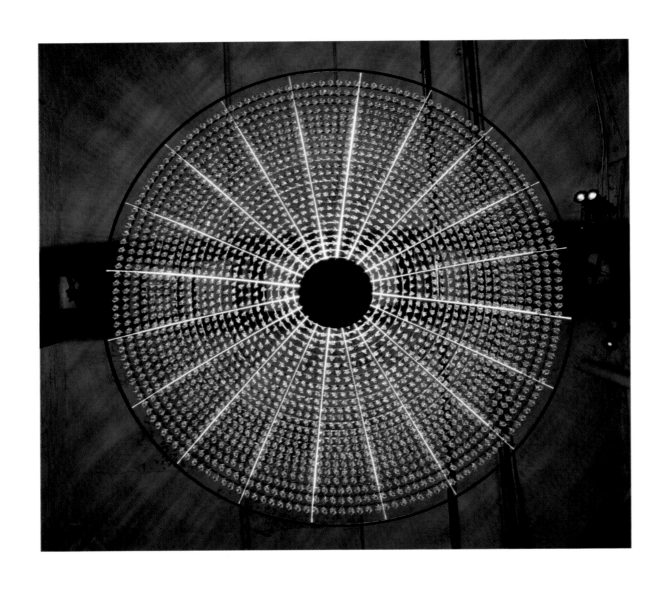

Avalon, 2016

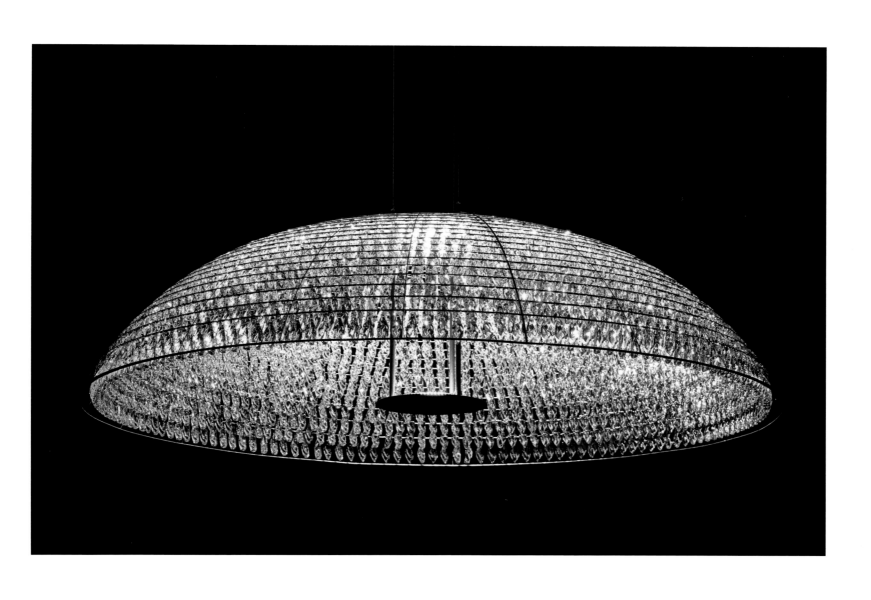

Avalon, 2016

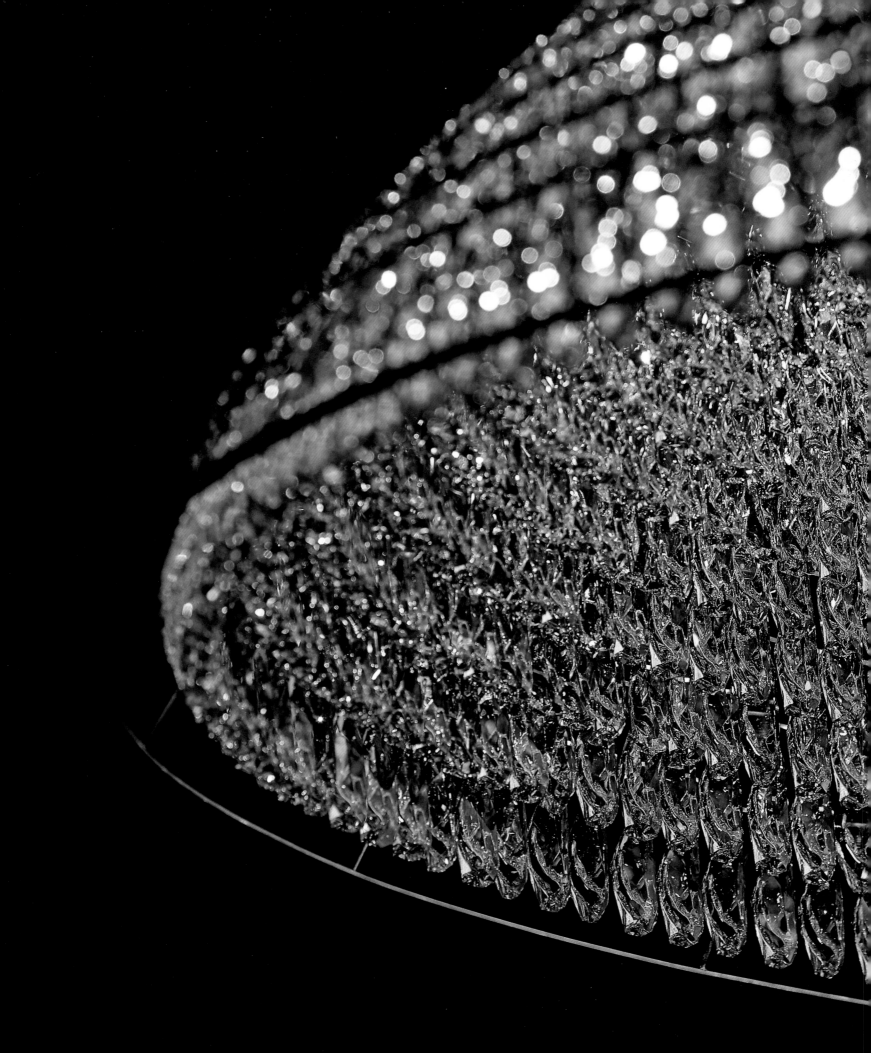

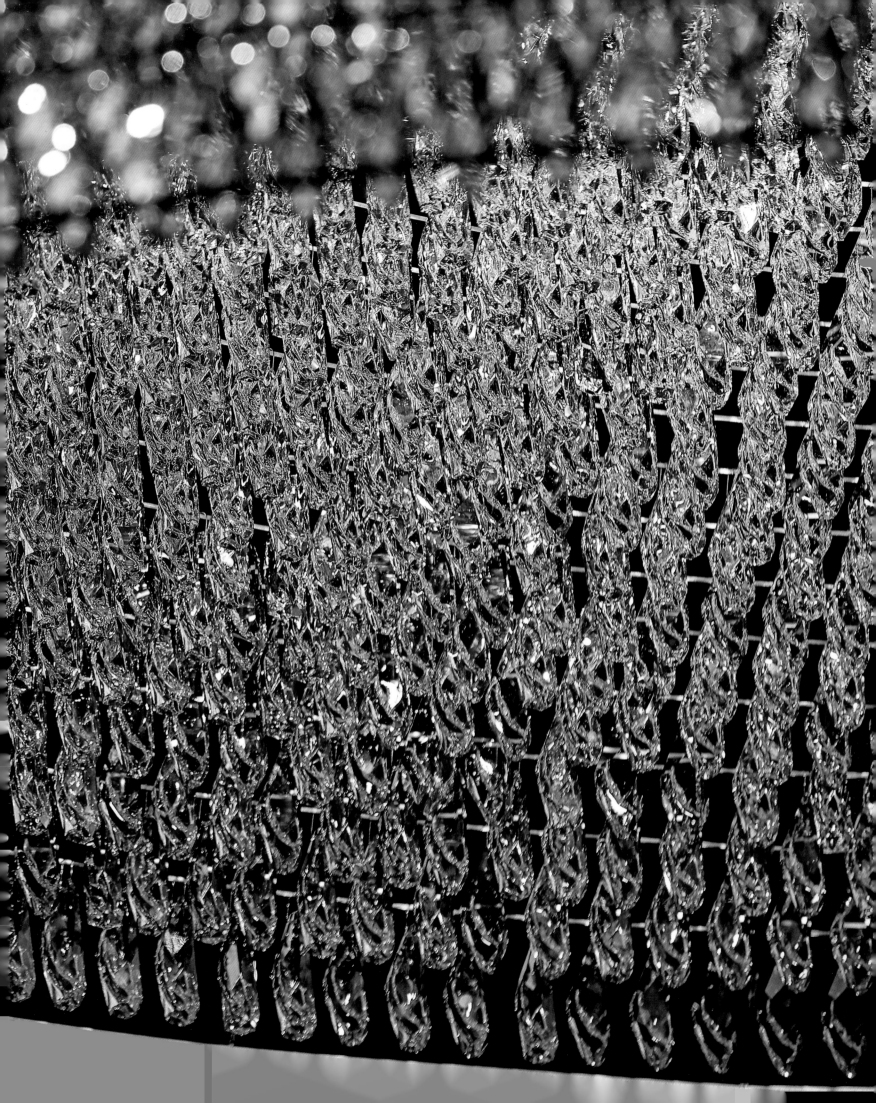

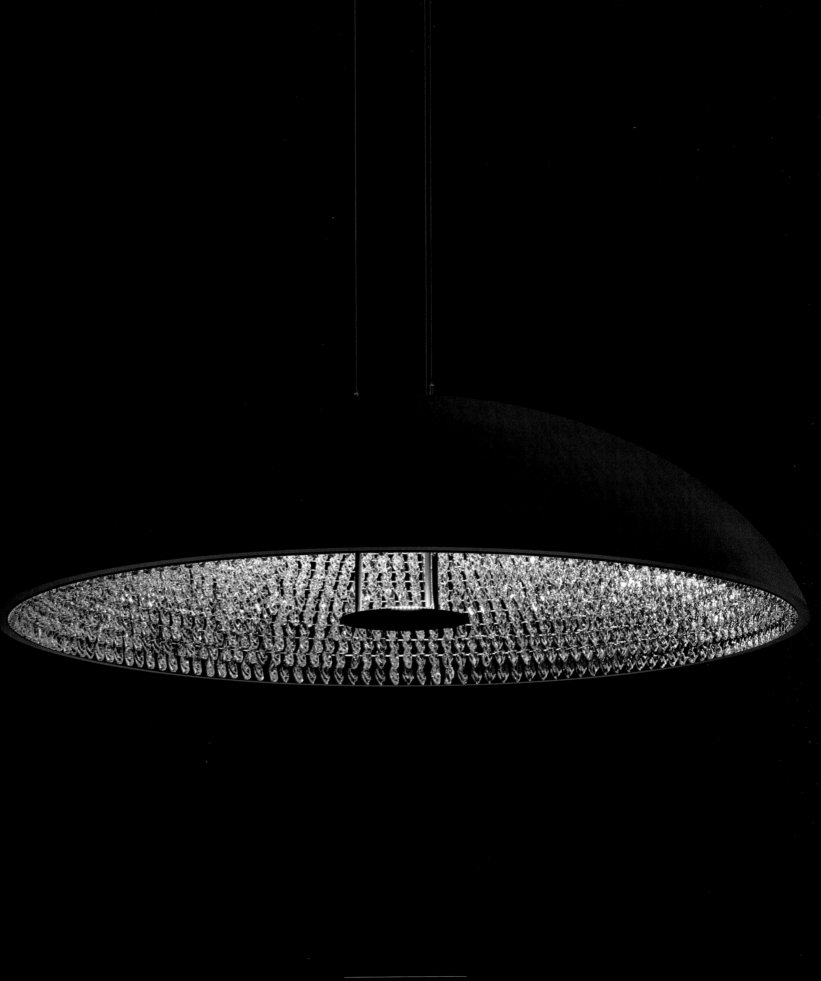

Paradisium, 2016

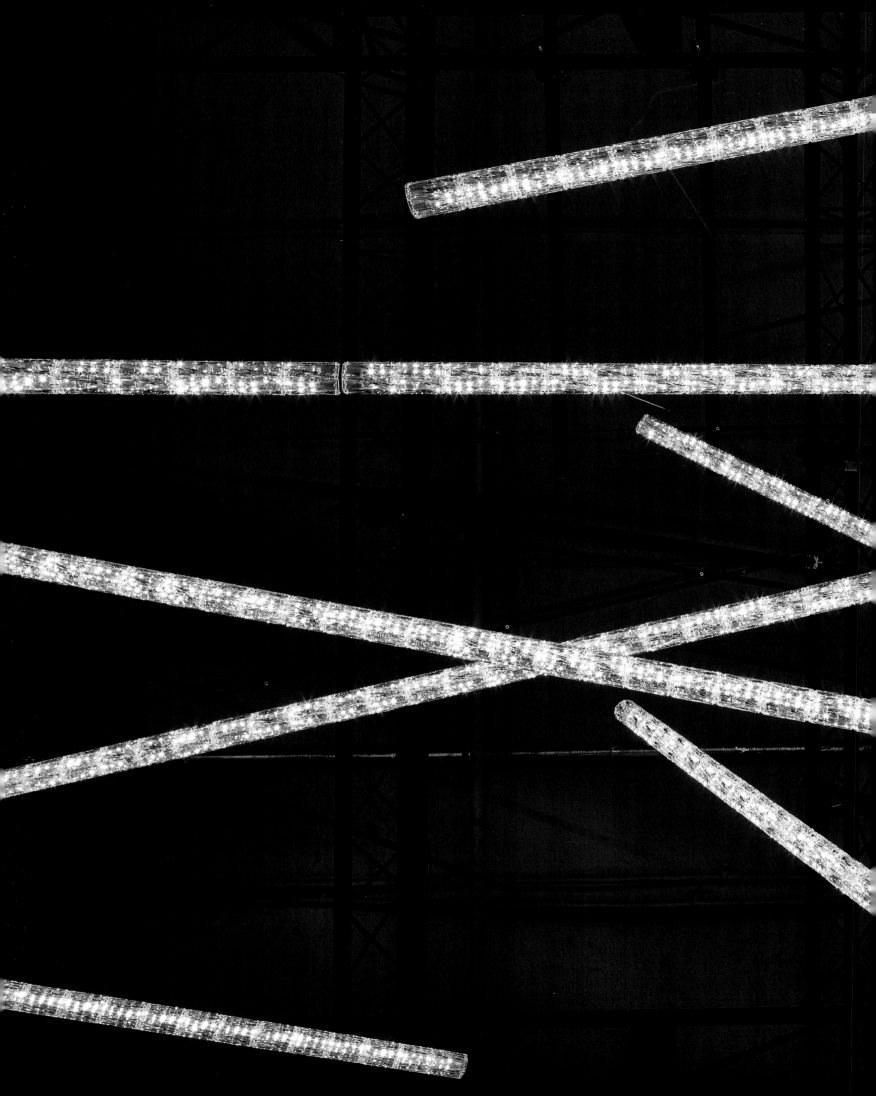

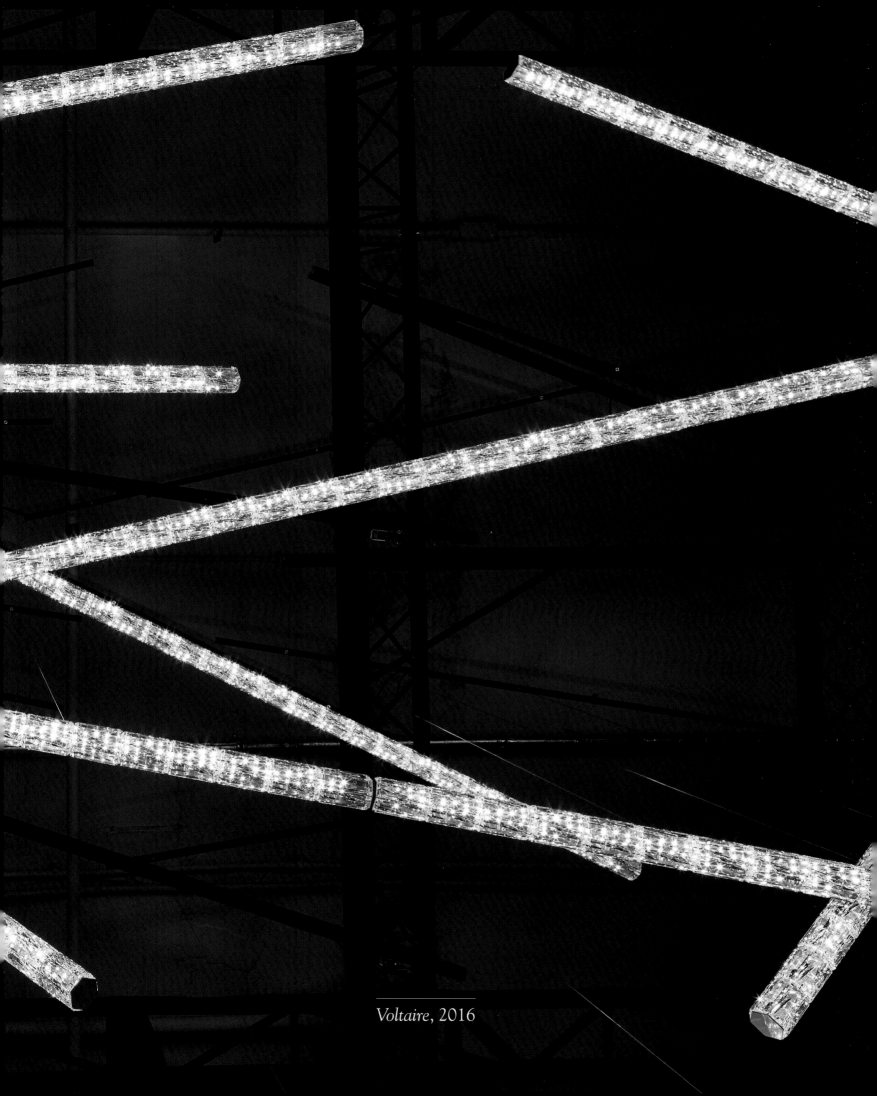

Voltaire, 2016

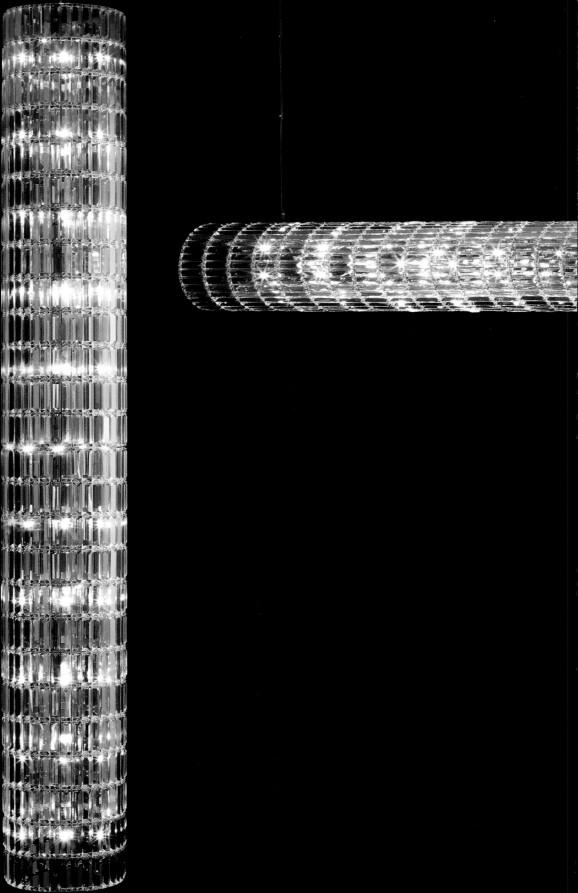

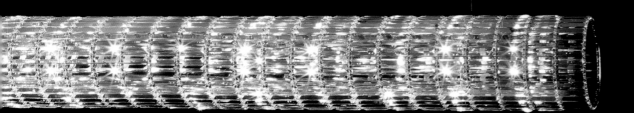

Cannon, 2014

Glaciarium, 2016, Candleholders

Glaciarium, 2016, Orchid Vase

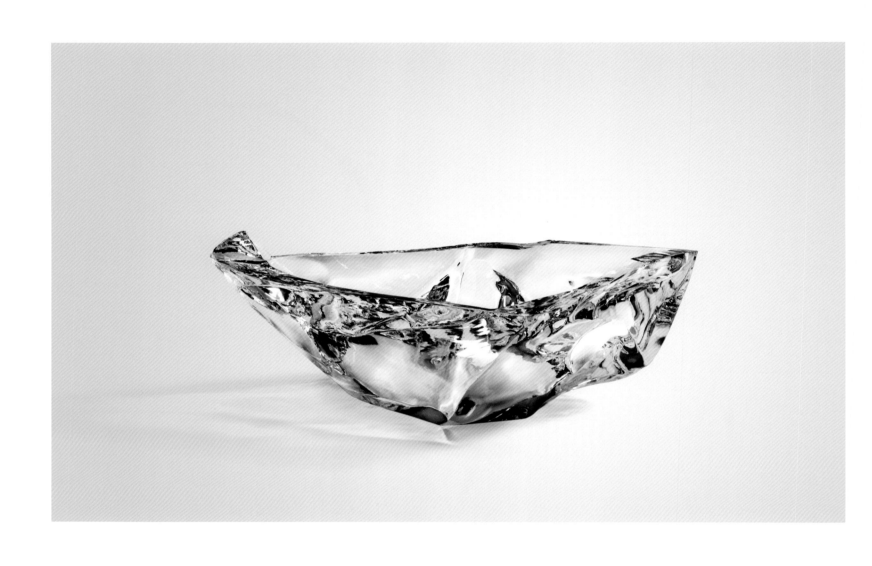

Glaciarium, 2016, Large Bowl

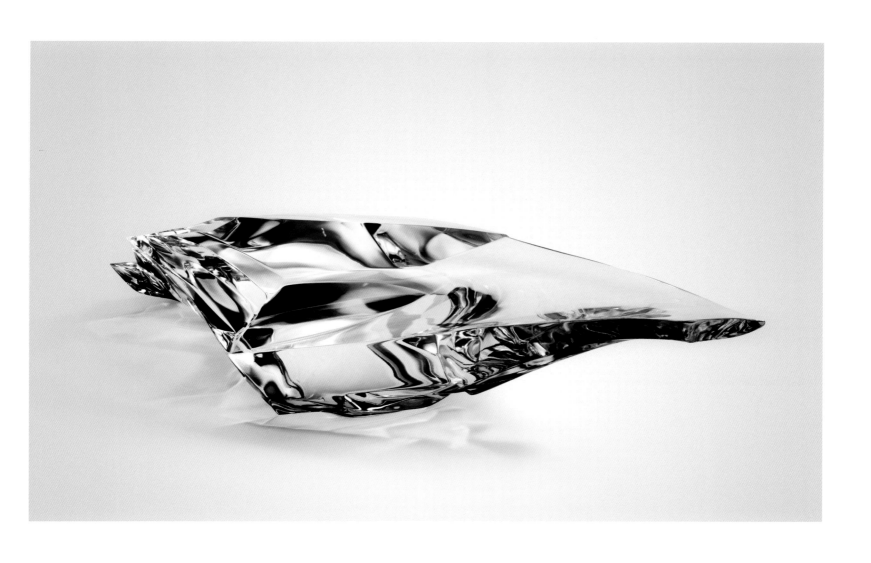

Glaciarium, 2016, Centrepiece

Hybrideae, 2017, and Kingdom, 2006

When a designer begins as a studio potter, you can expect a lasting imprint. This is certainly true of Ian Stallard, whose years of ceramic training resurface periodically. Not only have he and Patrik continually returned to the vessel form in their work together, but the specific materiality of clay has also remained important to their practice, as has the instinctive logic of a potter, which runs deep in art and culture. After all, as Ian jokes, it's "the second oldest profession."

The primary encounter with clay is a theme explored in numerous Fredrikson Stallard projects. One, particularly delightful for the unexpectedness of its conceit, is a chess set in which each piece is cast from a quickly squeezed bit of clay. Well aware of the conventionality of the forms involved – bishop, knight, rook, and the rest – and the long history of design variations that have been tried, Ian and Patrik adopted a totally abstract language. While the relative heights and basic proportions do recall a traditional set, each work is also a freestanding little sculpture, though the serial repetition of the pawns and the doubling of the other pieces also assert the nature of the artifacts as casts. When in use, the player reprises the gesture by which each of the objects was made, placing their fingertips just where the designers' had been.

A further series of works in clay, which again rely on the immediacy of the medium, have brought to fruition an equally arresting and ambitious body of work under the mock-botanical name *Hybrideae*.

The collection consists of seven unique pieces, each about a meter high, and one smaller, serially produced version, the size of a small planter or wine cooler. Each form, like the chess pieces, is based on the slightest of gestures: Ian sticks his finger into a little lump of terracotta. Or lots of little lumps – in one sitting late at night, glass of wine beside him, he made a couple hundred, of which a handful were selected as sufficiently interesting to enlarge. These were scanned into a computer and then rendered in hard foam using a CNC cutting tool. A silicon mould was then taken, which was in turn used to make a wax positive, with the same surface and contours as the foam model. From there on out it is traditional lost-wax casting, done at a traditional foundry. The positive is sprayed with ceramic, which is fired and then used to cast the final object.

For those keeping track, that's seven iterations altogether: the original terra cotta, virtual render, positive foam model, negative silicon mould, positive wax model, negative ceramic mould, and the work itself, in white bronze. As in the artist Urs Fischer's sculpture series *Big Clay*, which employs a similar process at even greater scale, there is a humorous and self-effacing quality to the finished objects. Ian's fingerprint is blown up many times its original size, and also intermingled with the figurative "print" of the CNC cutter, which leaves a tidal pattern of tool paths across the surface.

As with the *Momentum* show of 2015, *Hybrideae* was completely financed by Ian and Patrik and was presented at their studio. And like the showcase for the Swarovski *Armory* jewellery that was held in the space, they created a cross-disciplinary, immersive environment. A key collaborator was the composer Rosey Chan, who sourced the talented cellist Gerald Peregrine from Ireland, and improvised electronic music to accompany him as he played motifs drawn from Bach. One of the pieces, located strategically at the end of the studio tunnel, was planted with a 4 metre high camellia tree in full bloom, a few white petals scattering on the floor below. The luxurious setting seemed appropriate to the shining metal objects, but it was worth lingering over their surfaces, which are torn and lumpen in their fine detail. The *Hybrideae* vessels are meant for outdoor use, and over time they will acquire a patina of grime and green, throwing the surface into a contrast of highlight and shadow. Ideally, they will also be filled with dirt and plant life – the stuff from which clay is formed underground, brought full circle.

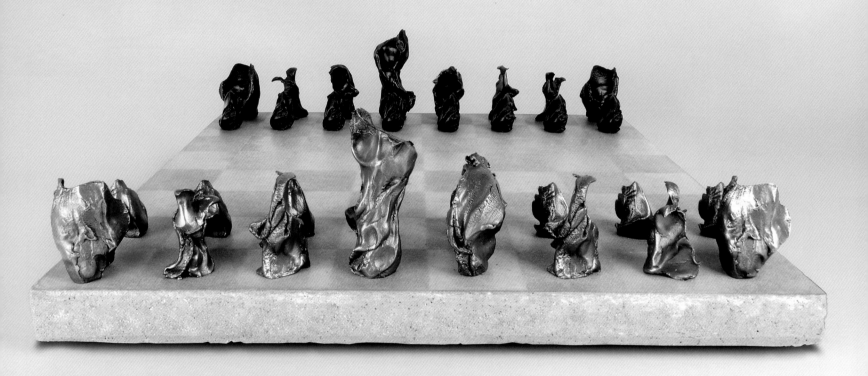

Kingdom, 2006

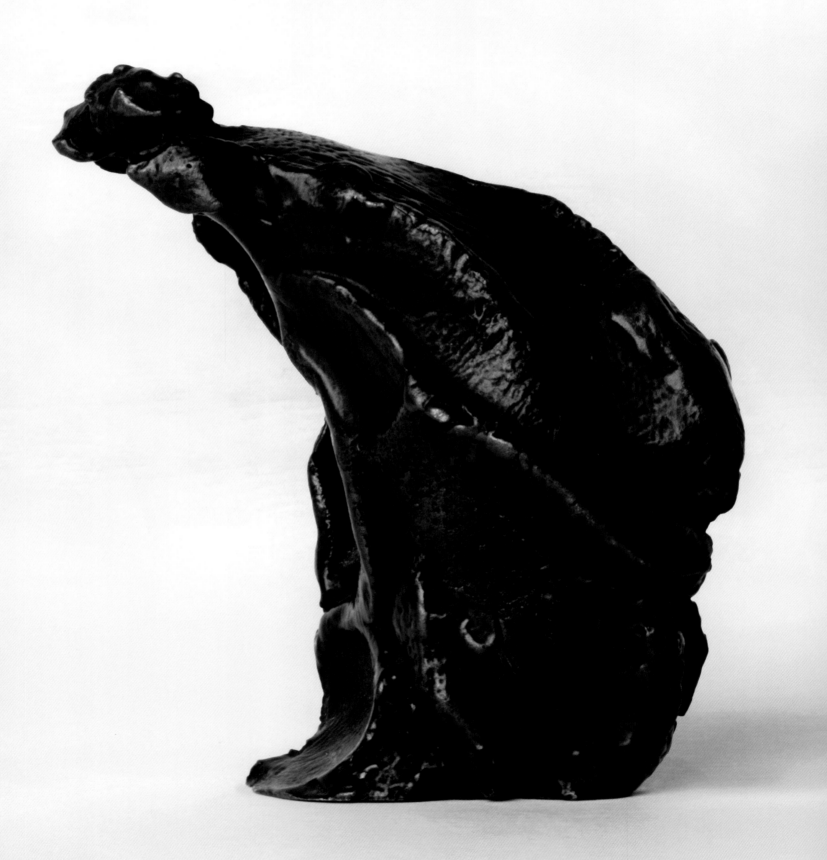

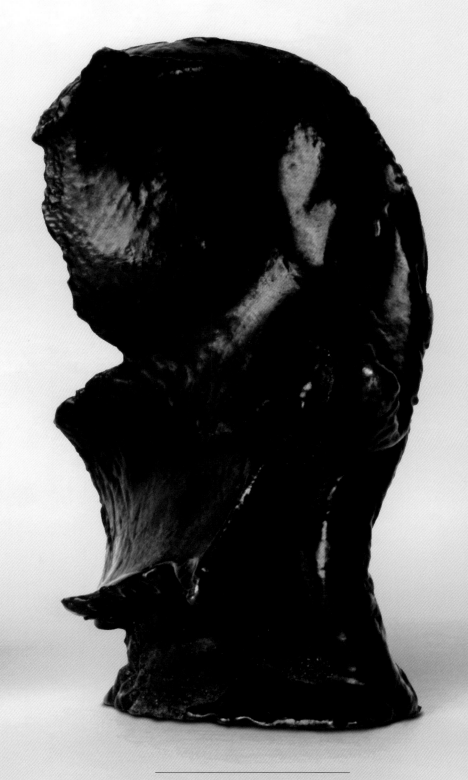

Queen, Knight Pieces, 2006

Hybrideae II, 2016

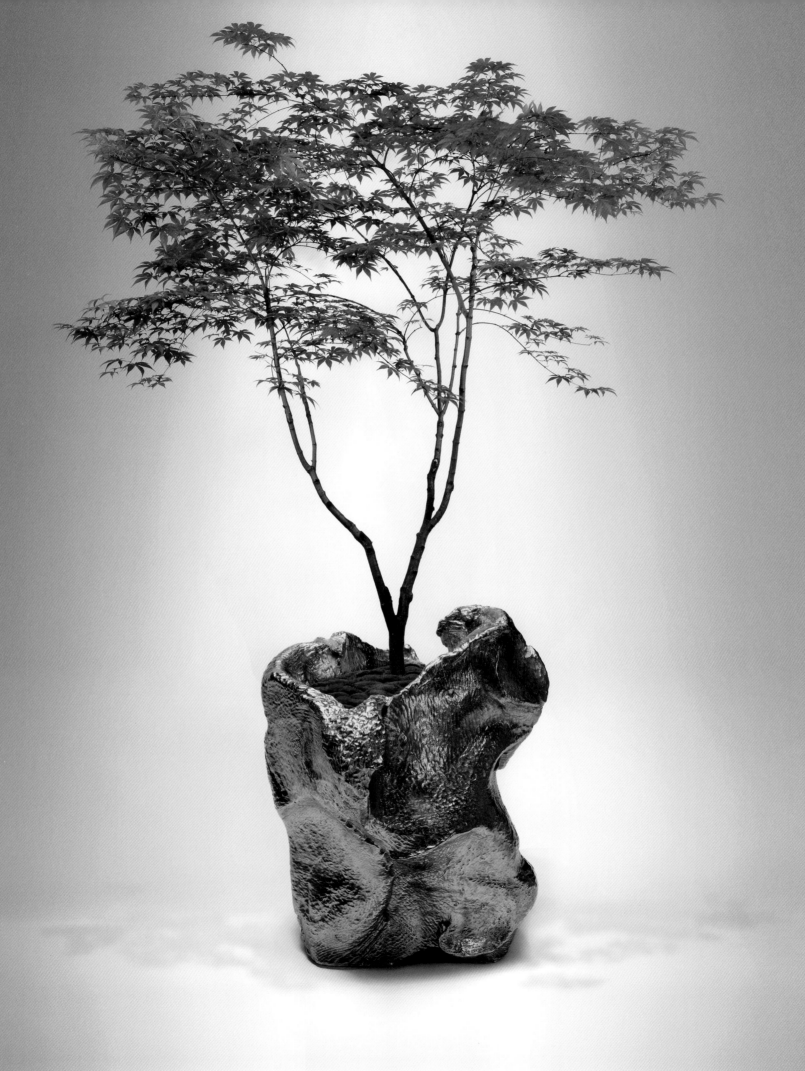

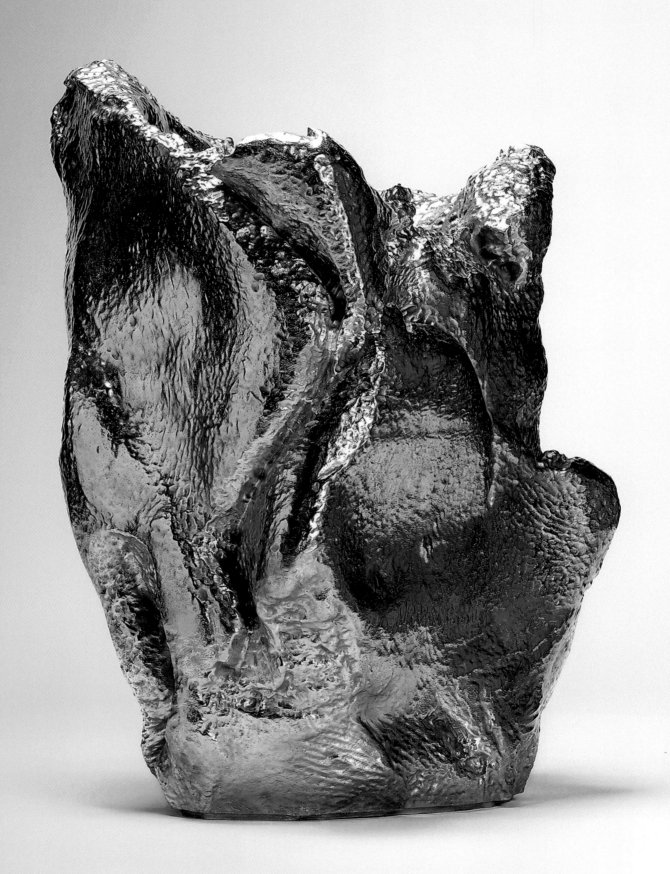

Hybrideae I, 2017

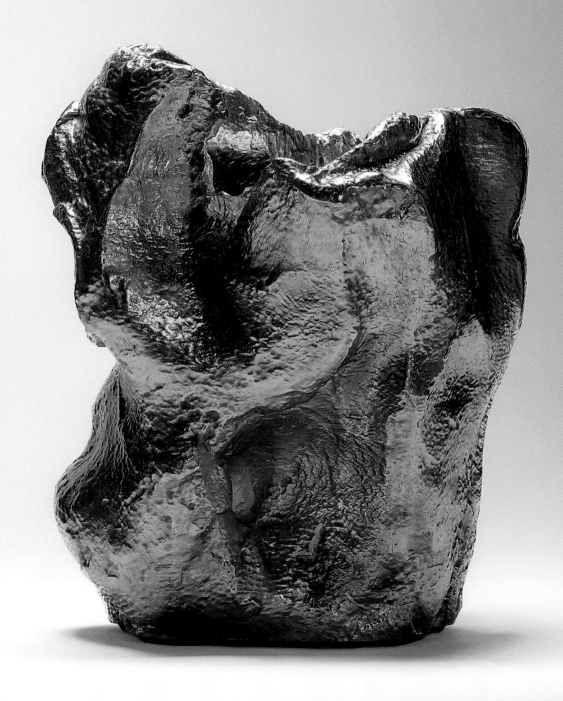

Hybrideae II, 2017

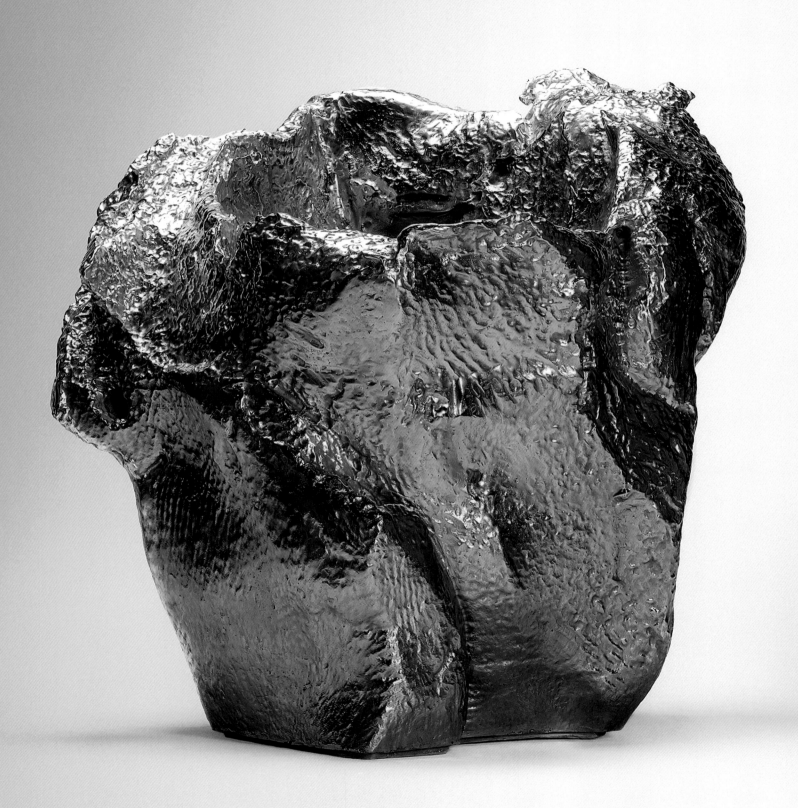

Hybrideae VII, 2017

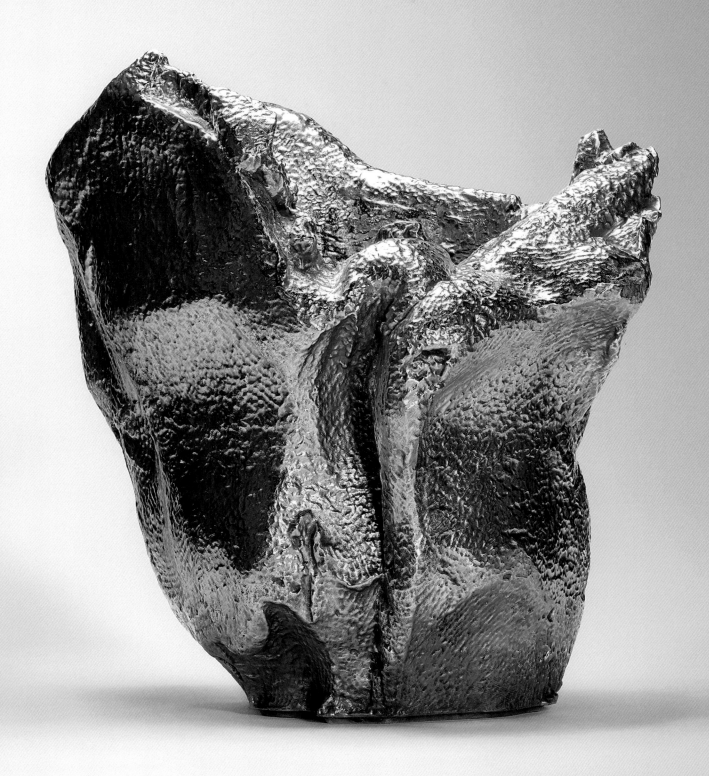

Hybrideae IV, 2017

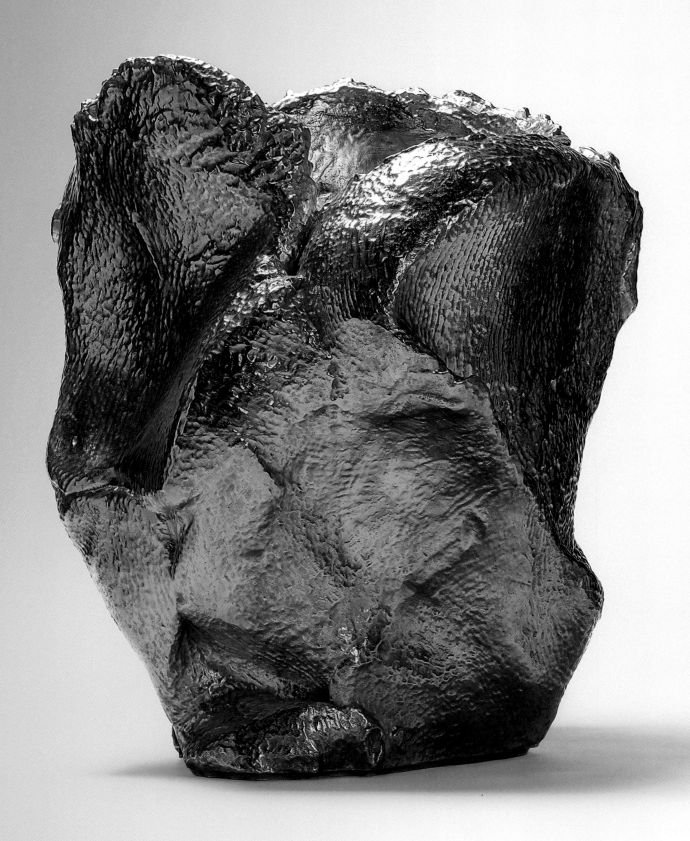

Hybrideae V, 2017

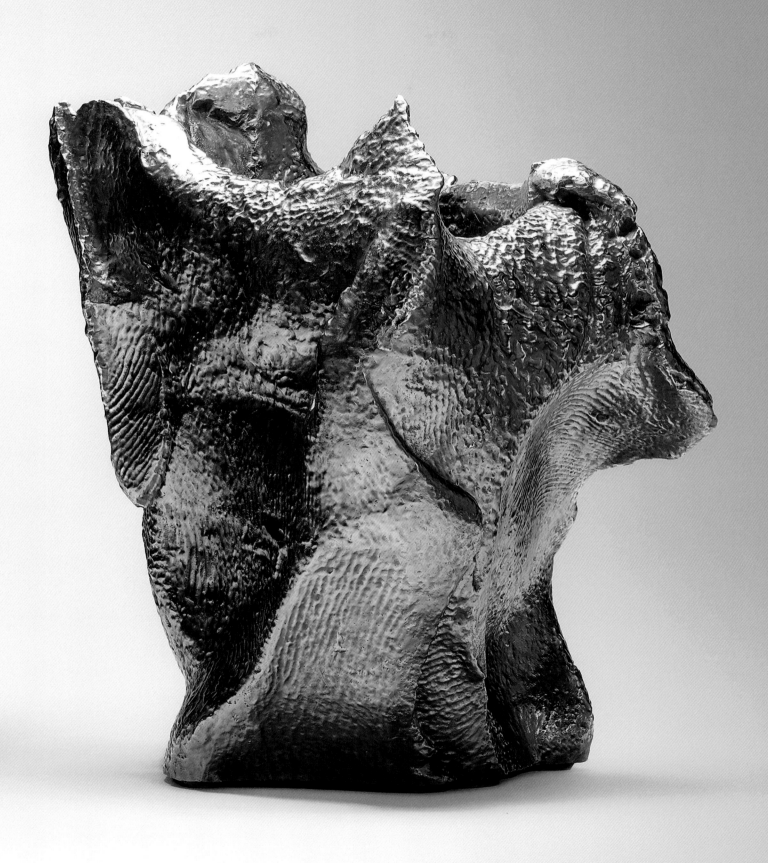

Hybrideae VI, 2017

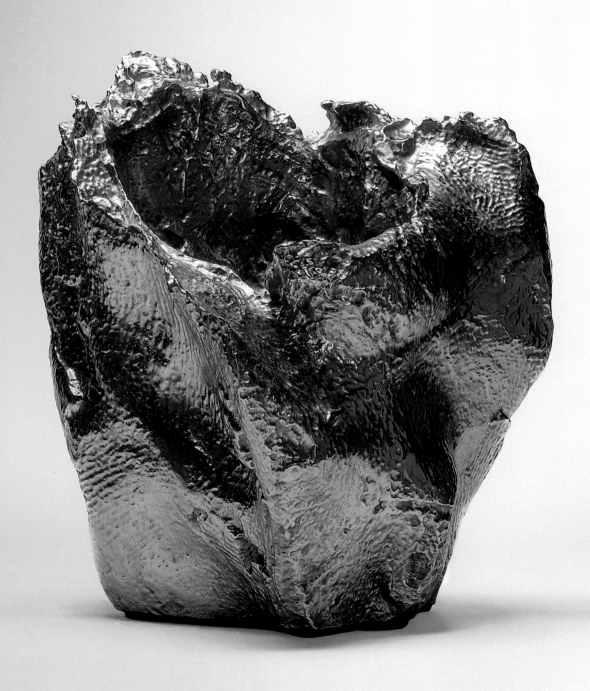

Hybrideae III, 2017

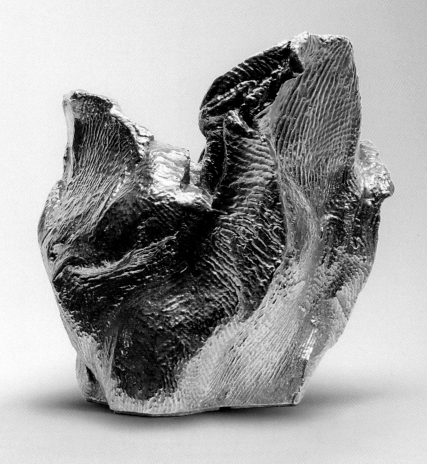

Hybrideae VIII, 2017

Scriptus, 2017, and *Bibliothèque*, 2017

Fredrikson Stallard's work has gotten more sculptural in the past few years, and it can be tempting to conclude that function is of correspondingly less interest to them. This would be a mistake. They always consider how an object will fare in use, not just how it looks on a gallery floor or a magazine page. Whether they decide to prioritize functionality or not is another question, but *Bibliothèque* is a good example of a piece in which the concept is premised on utility. It derived from their observation that many contemporary bookshelves look great when empty, but once actually filled with contents, disappear as compositions. Conversely, other contemporary bookshelves are not that useful, because of their curves or tilted angles. The *locus classicus* here would be Ettore Sottsass's *Carlton* room divider, perhaps the single most well-known furniture design of the 1980s. When asked about its impractically short, angled shelves, Sottsass reputedly commented, "what's the point? Your books will fall over anyway."

While taking nothing away from wilfully impractical designs like the *Carlton*, Ian and Patrik wanted to make shelves that would actually do good service while looking fantastic. They began simply by drawing a series of lines with an ink pen. The contour of these marks, with their wavering hand-scribed quality, was used as the basis for the lower edge of each of the bookcase's shelves. The upper surface is completely flat, and therefore perfectly functional. Though fabricated in steel, the results look for all the world like elongated slabs of slate, or indeed as if they had been drawn in midair by some East Asian *literatus*, a horizontal scroll painting unfurled on the wall. In a high-concept variation on the modularity that we all know thanks to Ikea, the *Bibliothèque* can be ordered in any number of panels, with the stroke-like shelves arranged on them as desired. The calligraphic lines cannot be read in any literal sense; but as an example of Fredrikson Stallard's design approach, they speak volumes.

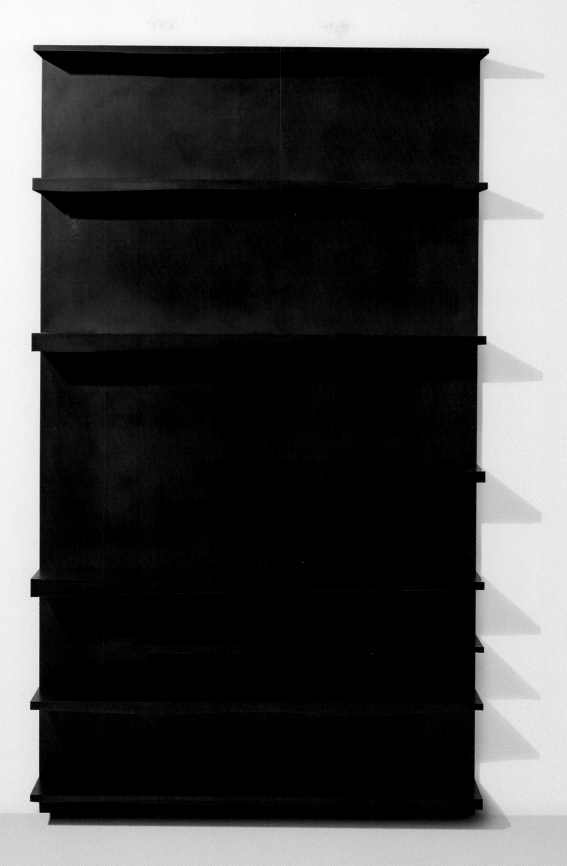

Bibliothèque, 2017

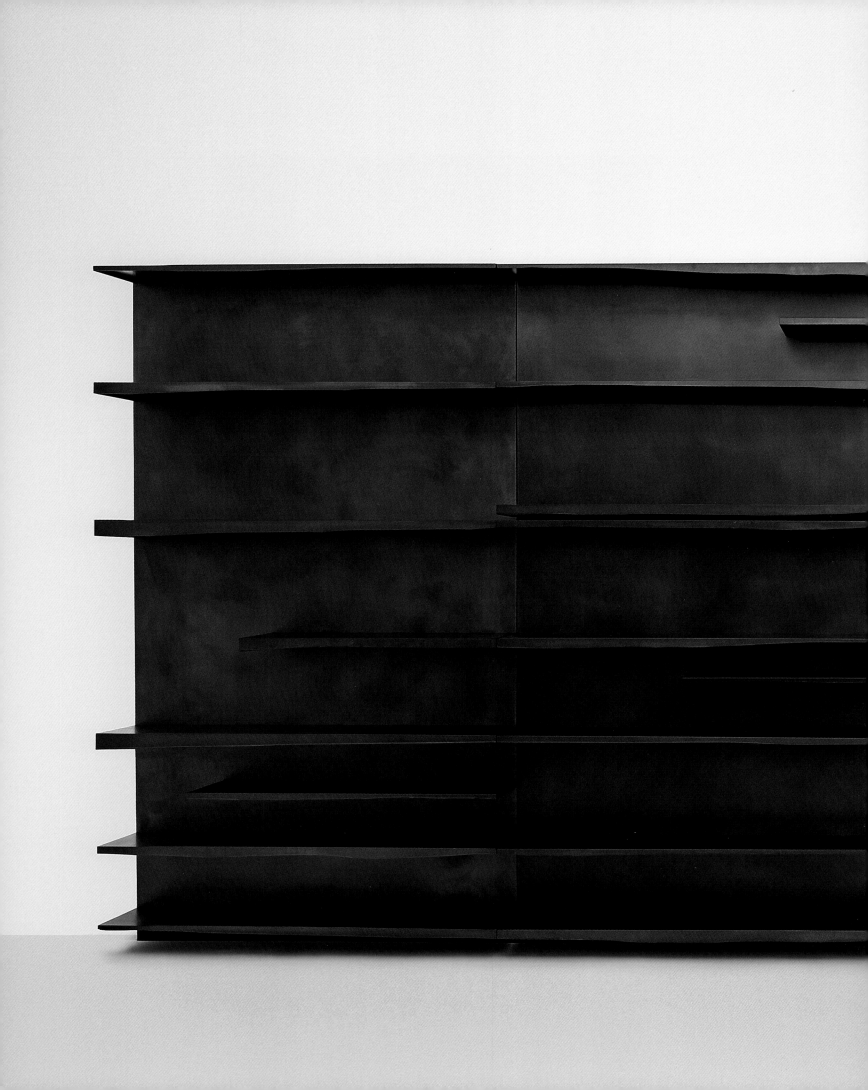

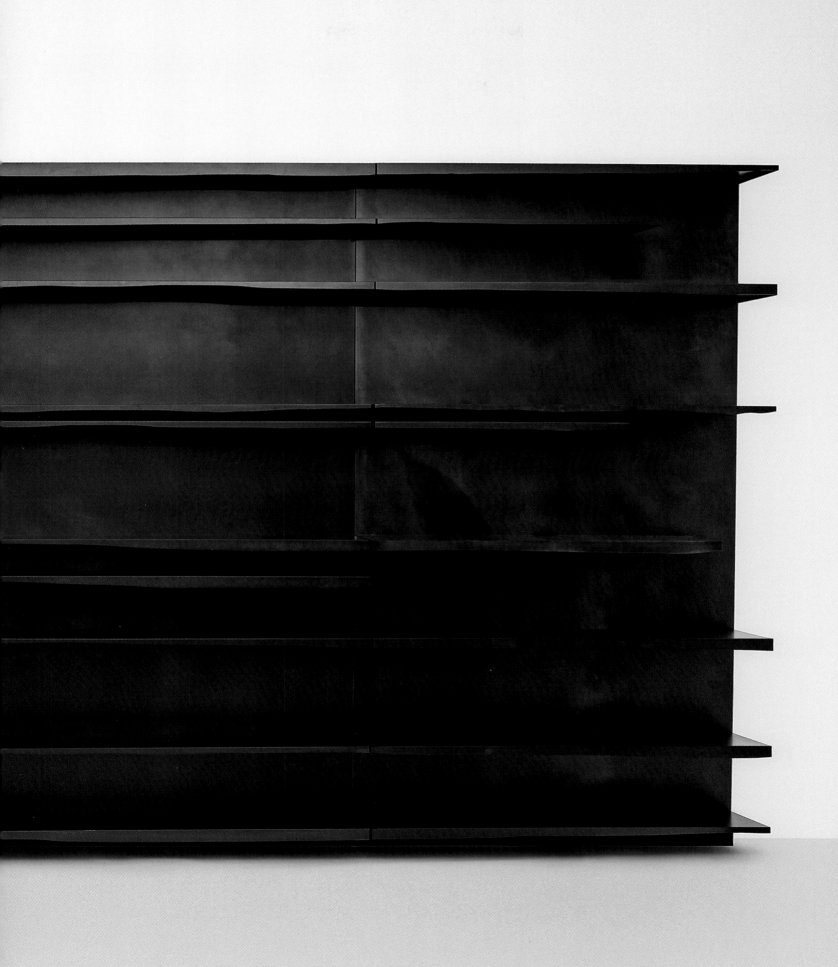

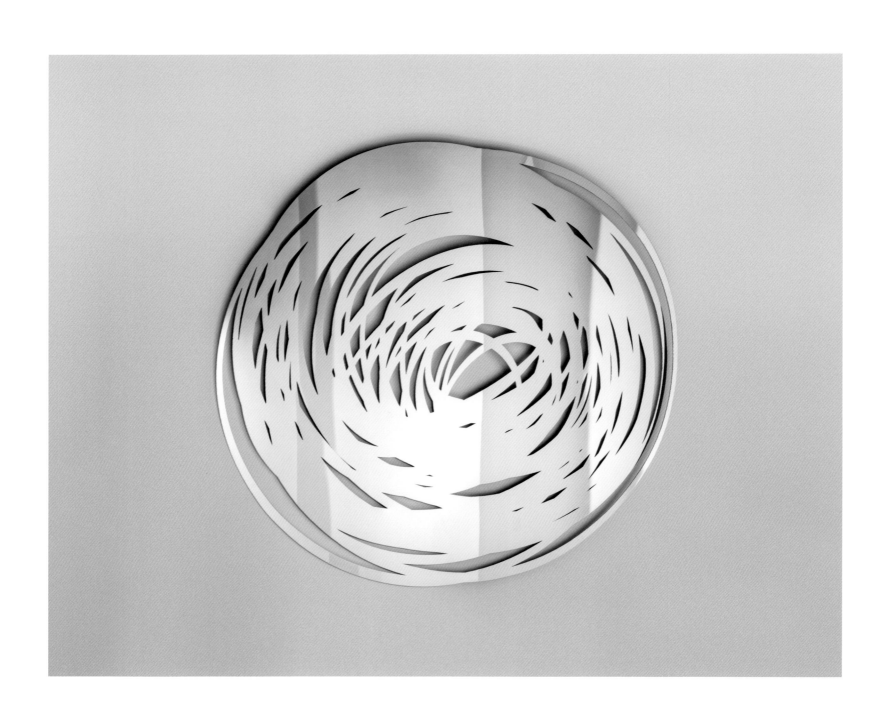

Scriptus 1, 2017, Mirror

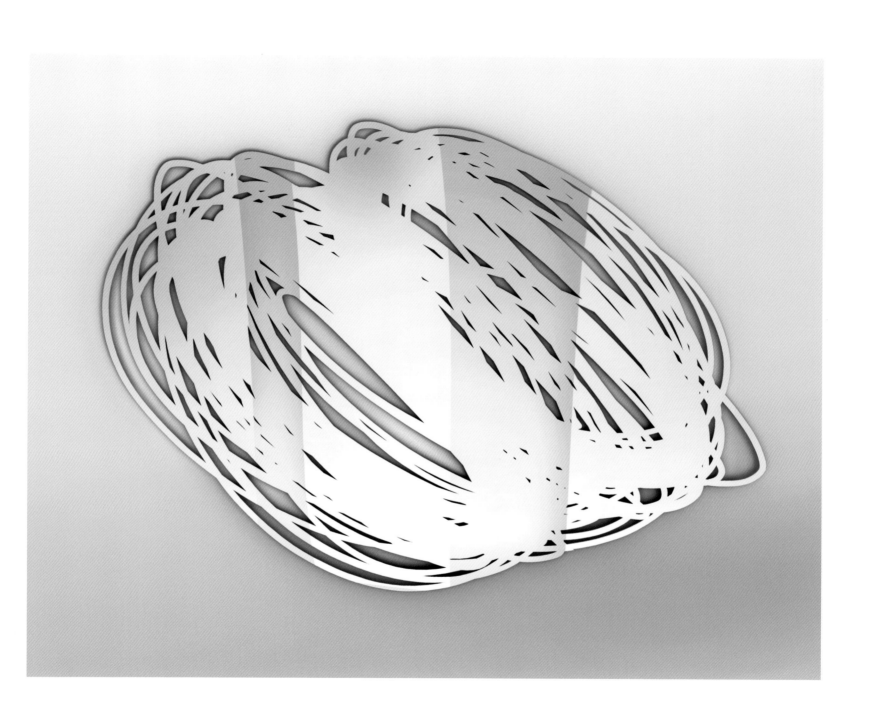

Scriptus I1, 2017, Mirror

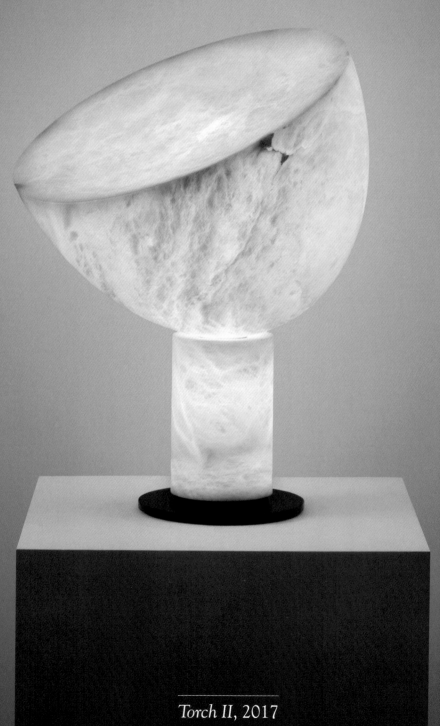

Torch II, 2017

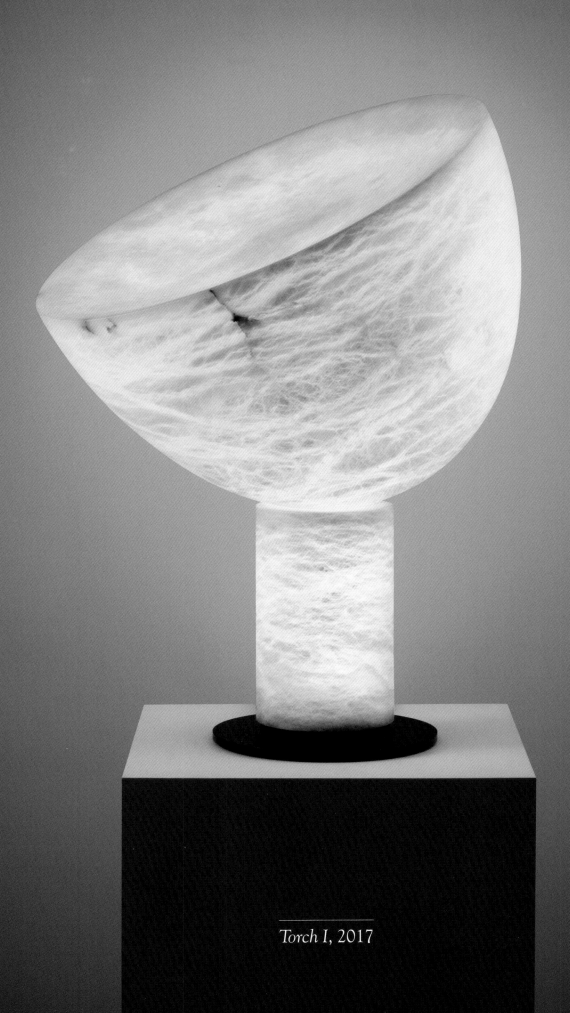

Torch I, 2017

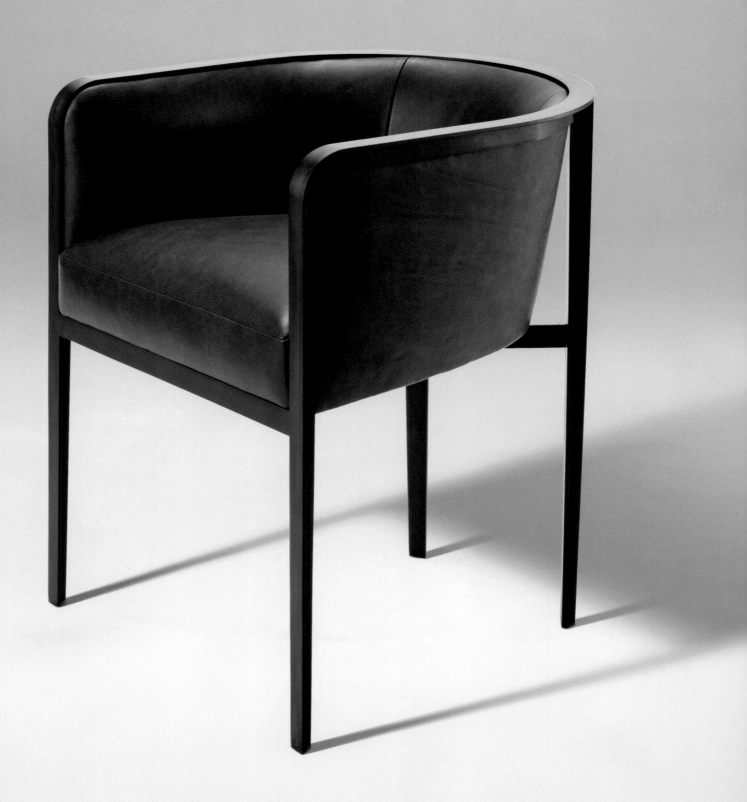

Element IV, 2017

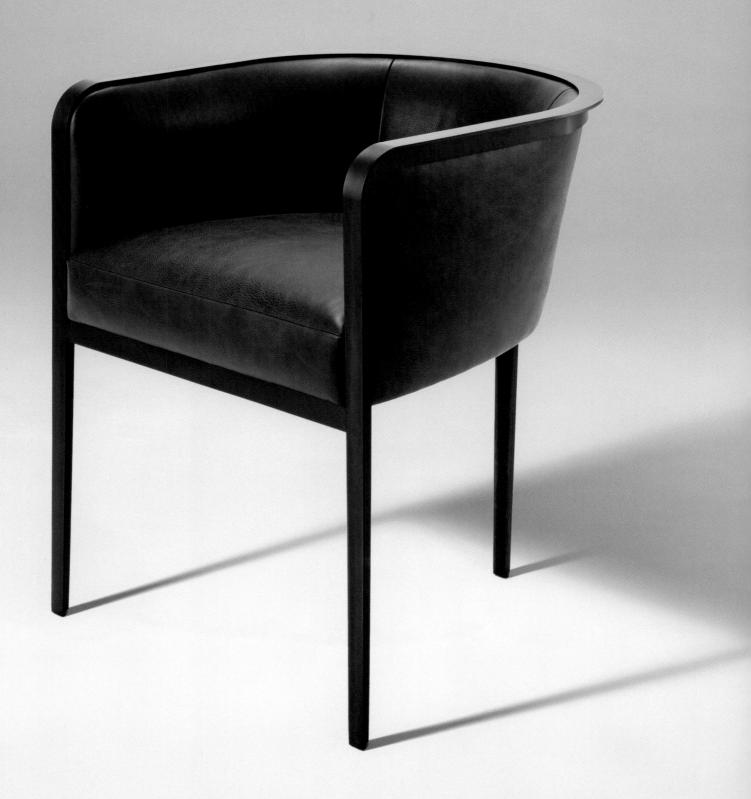

Element III, 2017

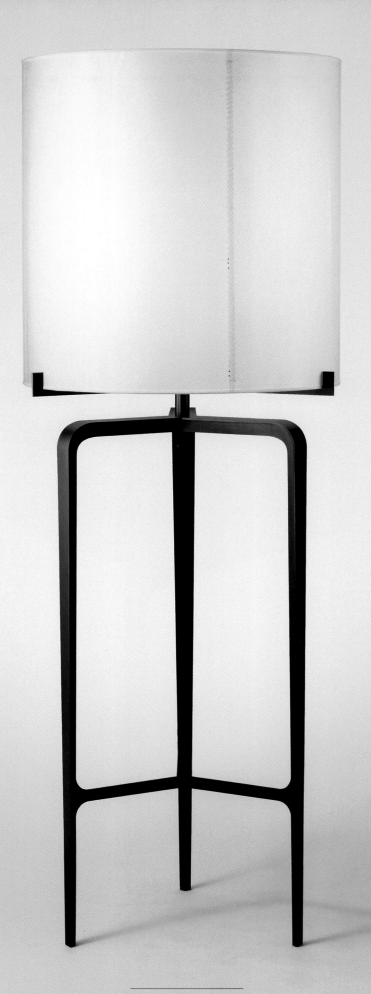

Element I, 2017

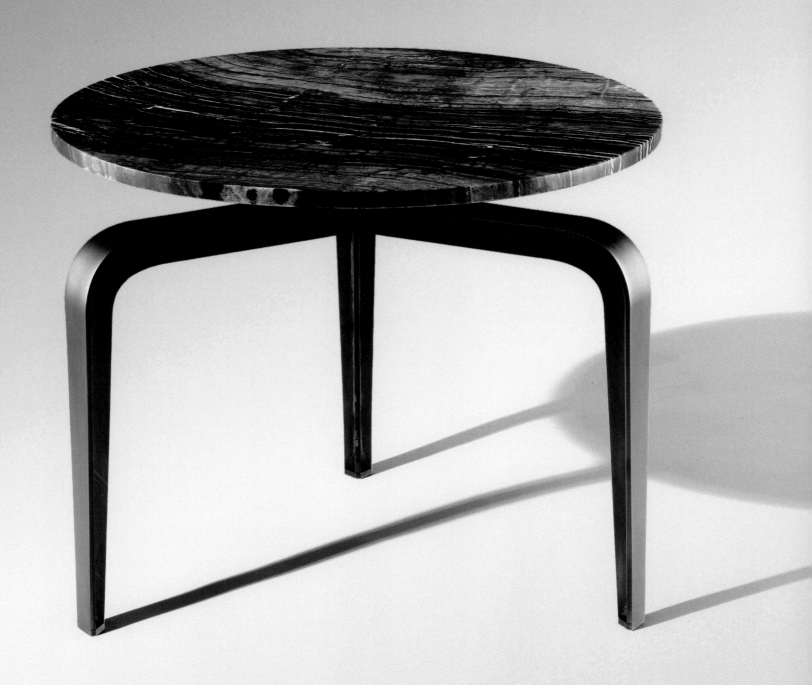

Element II, 2017

Reformation, 2017

Talk to Fredrikson Stallard for any length of time, and you will detect what they long for is the purity of gesture that can happen in painting and sculpture. Over the years, their practice, as various as it is, has always been premised on materialism. When one seeks the origins of any of their recent work, one finds not a clean and clear sketch for a cabinet, table or chair, but rather slabs and chunks and piles of material, animated principally by the unbridled pleasure of experimentation, made without any particular end in mind.

Their newest collection is – like all of their mature work – an ideal synthesis of two countervailing impulses: the drive to design and create, juxtaposing itself with an equally powerful interest in pure sculptural expression. *Reformation* is made through an assemblage technique in which bits of corrugated cardboard are folded and crushed into blocks, used as the basis for silicon molds, which in turn are employed to make bronze casts. Varying types of patination are then applied, with some objects left matte black and others given a painterly contrast of ground color and highlights. One can locate several art historical references in the project, another common phenomenon in their work: it can be located in the trajectory that begins in Cubist and Dada collage, and then continues through the work of Rauschenberg, César, and John Chamberlain, down to present-day artists like Georg Baselitz and Franz West. In all of these cases, worthless detritus is gathered and then compressed, either against the picture plane or within the sculptural volume. The character of the composition is determined by the density and variety of the collaged elements, and also the "cuts" between each element and at the edge of the aggregated mass.

In *Reformation*, these variables are all at work and can be seen in an unmediated state. The cardboard itself is neutral in affect. It lacks the content of the stray scraps of newspaper or packaging that one encounters in a collage by Kurt Schwitters or Hannah Höch, or even the specificity of automotive fenders and body panels in a Chamberlain. Precisely because of this blankness, the way that Ian and Patrik have manipulated the material makes a dramatic difference in the mood of each piece. Within the collection one can find playful scattering and brooding density, sheen and weight, delicacy and brutalism. In the tables, the edges (and therefore the interior structure of the cardboard) are revealed, providing a further language of articulation.

And yet, despite the glorious profusion of effects in the *Reformation* pieces, there is an underlying uniformity of purpose. Trash becomes treasure, street pickings transformed into enviable décor. Ingeniously, the deep folds in the card, when rendered into bronze, resemble the veining found in stones such as marble – a perfect example of the way that Fredrikson Stallard seize un-noticed potential for beauty and realize it through material transposition. The pieces are indeed meant to be functional. Depending on the intended use, the tabletops are either massed together in thick sheaves, or left blade-thin. The cabinets crack open down the middle, like ribcages in an operating theatre, to reveal shelved interiors. Patrik and Ian have said that they would love at least one or two of the works to be completely non-functional: slabs of beguiling materiality hung on the wall, like thick paintings. At the time of writing, they were pondering whether to do this. Maybe it will happen, maybe not. Either way, one thing is sure. They will continue to experiment. "The most important thing," they say, "is to keep making."

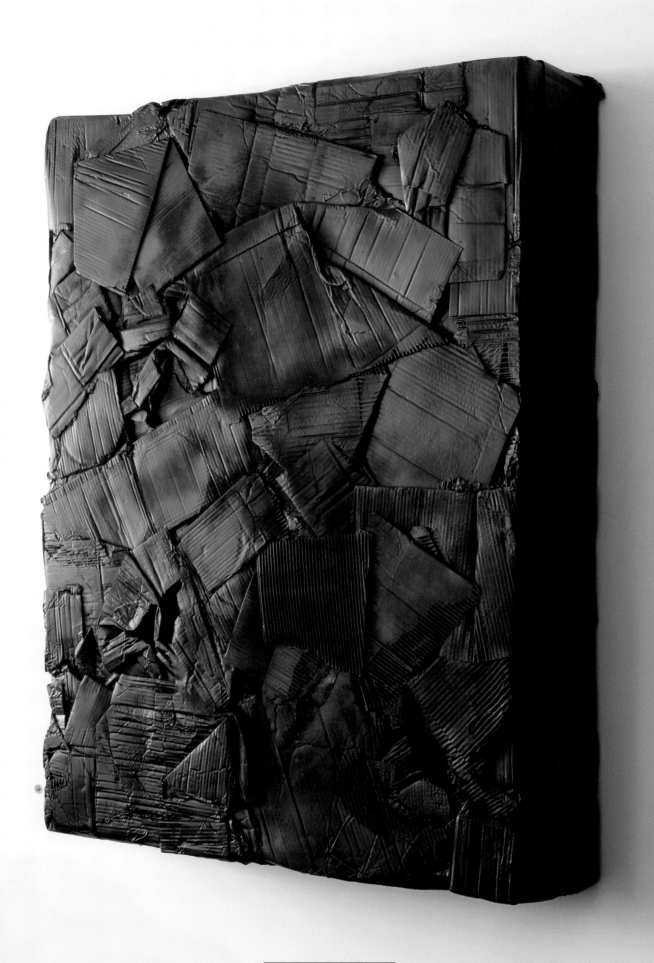

Reformation, 2017

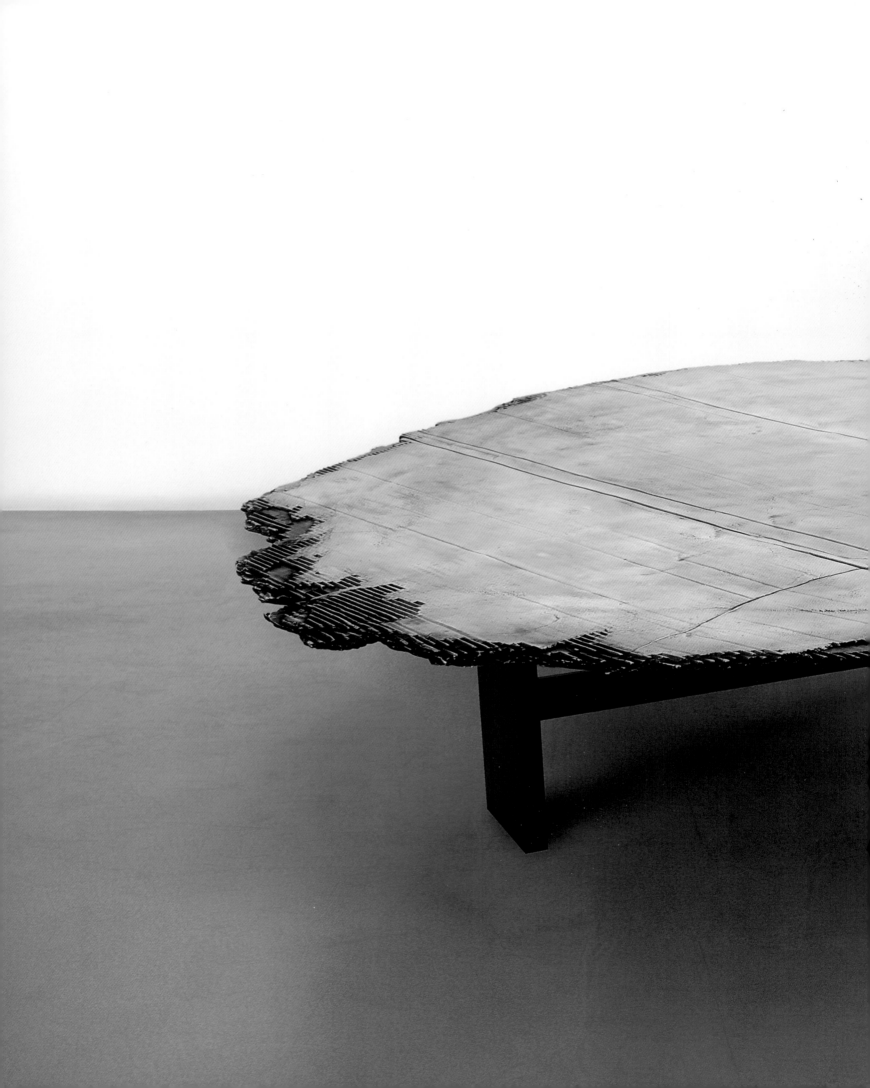

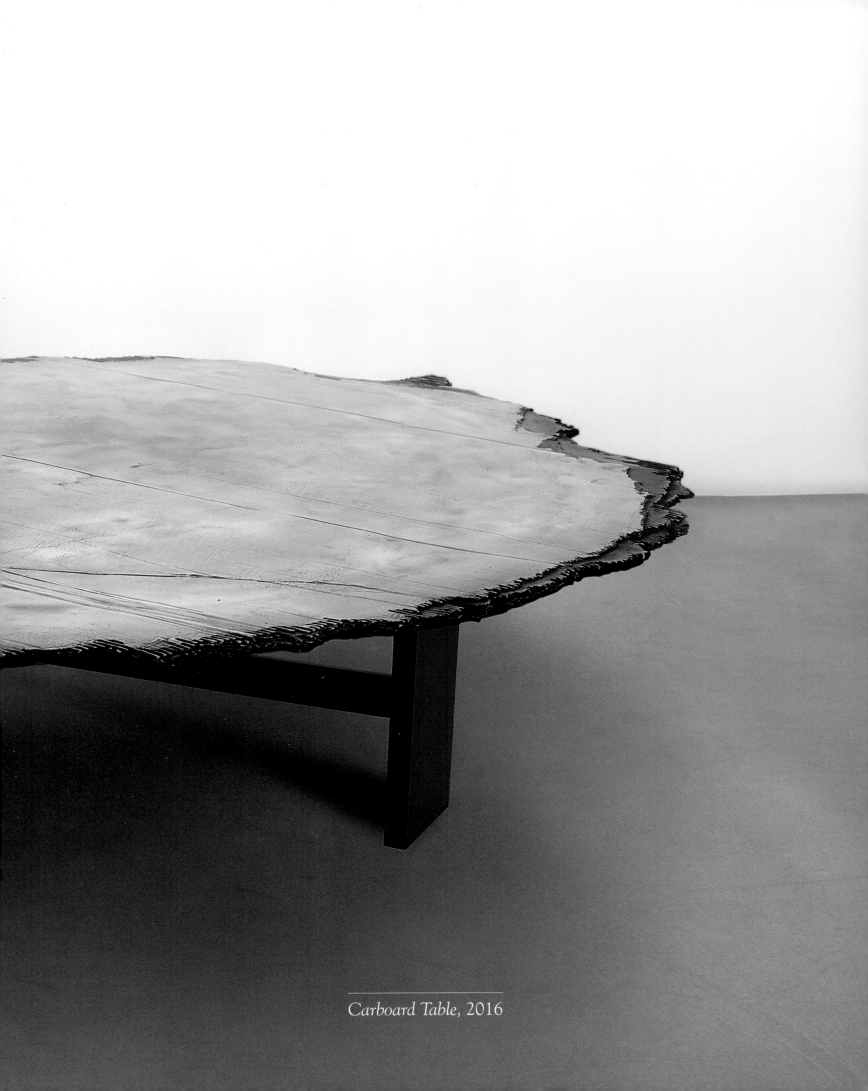

Carboard Table, 2016

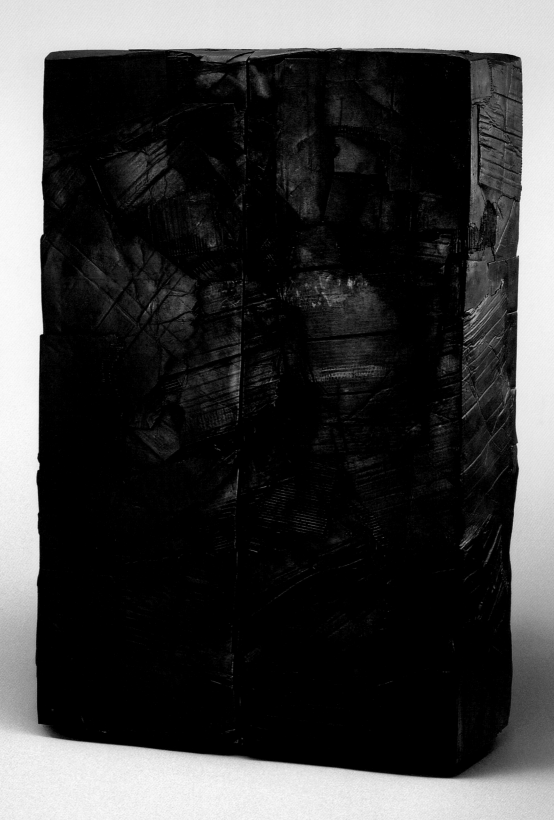

Reformation, 2017

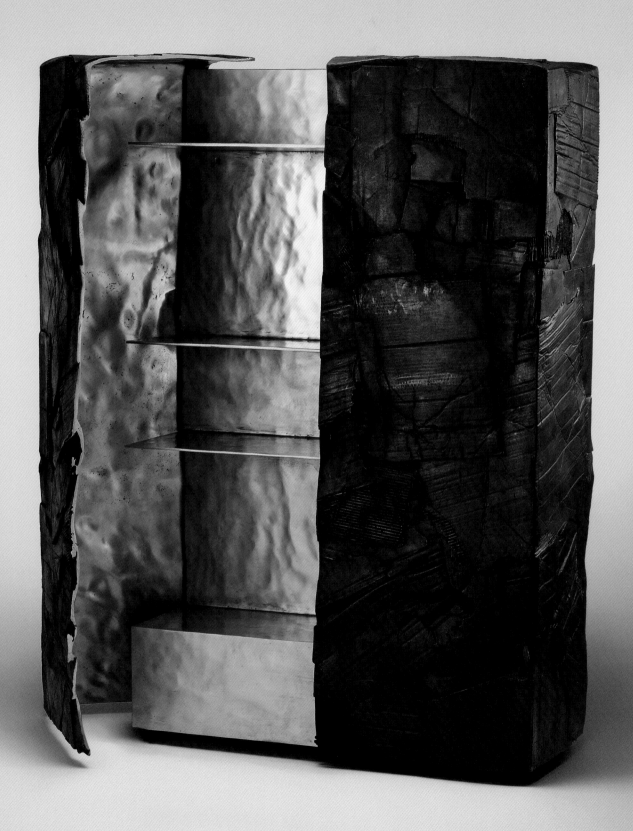

Reformation, 2017

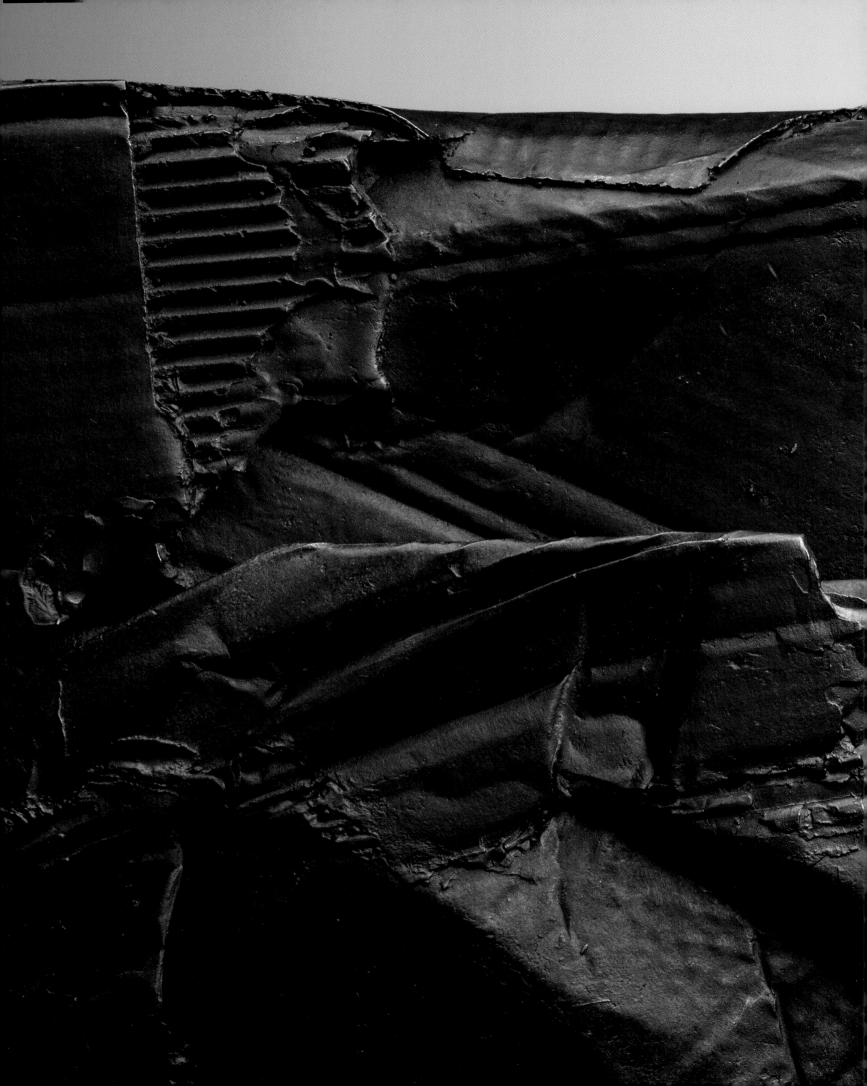

A Unique World

Caroline Roux

One of my favourite works by Patrik Fredrikson and Ian Stallard isn't in this book. It is a one-off, three-part chandelier that was made for a private apartment in Tribeca, New York. It hangs above a 10 foot long dining table, and is stealthily, invisibly installed into a custom-designed beech ceiling, the hundreds of wire-strung crystal that make up its three swollen forms dispensing delicate points of light. It is by turns both evanescent and present, a pale and subtle thing by day and a dazzle of drama by night.

The chandelier has many of the properties associated with decorative arts from centuries past: it is exquisitely crafted in expensive materials, it is elaborate in its scale, it speaks of status and taste. And yet there is something in its graphic formality and its insinuation into the very architecture of the space it occupies that distances it from the pure glitter and glee of a fabulous piece of décor. It is commanding, not fancy. It is integral and yet mutable, changing depending on the time of day.

I mention it because, although it seems unfair to talk about the one design by Fredrikson Stallard that readers of this book will not get to see, it is a perfectly emblematic piece. Apart from the fact, it must be said, that the pair are more inclined by far to create their own objects than work to commission.

The *Tribeca* chandelier contains the values that underpin so much of their work: the use of the singular material; the transformative quality that their objects exert upon the space in which they are placed; and the ease with which they can turn their attention to the floor, or the ceiling, or finally the wall as the point from which a work can grow.

Fredrikson Stallard, for all that they have a background in craft, design and art direction, or maybe because of it, work well outside the boundaries that these terms suggest. Crushed metal, carved foam, finely sculpted acrylic, or cardboard torn and cast in bronze — the physicality is right there, but beyond such materiality is a bold, sensuous, performative presence that is harder to define. Along with a forceful spatial impact, there is an equally strong emotional one, too.

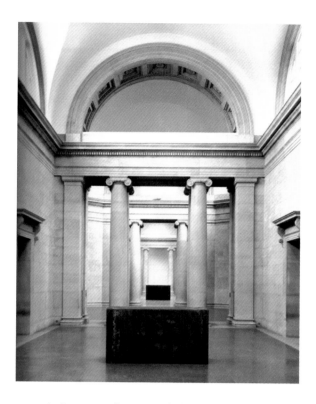

A *Species* sofa can redefine a generous room in the way that Richard Serra's big rectangular blocks of forged steel suddenly made sense of the Tate's Duveen galleries many years ago. That space had been closed, and refurbished, and when it re-opened — all clean and clear — Serra's artworks created a focus and a route through it, bringing a new idea of scale and approachability to what had often seemed like a long and lonely hallway. Air moved differently and timed slowed down as you approached the Serra sculpture.

A Fredrikson Stallard *Hurricane* mirror — a fiercely folded sheet of liquid-looking water-polished aluminium — throws light around a room in unexpected, ever-changing ways while equally absorbing and re-editing the surroundings. I've seen the one they have in their own apartment change from pink to green in just a passing hour, and the reflections in it becoming no less puzzling or compelling in the same period.

It's not that Fredrikson Stallard don't design furniture. They do. Their work manifests itself as tables and lights and chairs and vases. But its function often feels like a by-product of a far more interesting game played out through the language and expectations of materials.

Table#1, for example, is made of wood, as so many tables are. But their wood comes in the form

of painstakingly dried and polished logs lashed together with tension cable. There's a fetishistic squeeze to the whole thing, like the compression of a corset. A candle and candlestick is cast entirely in wax, to create an object that is destined ultimately to disappear upon usage – a tale of luxury, or simply loss?

They are far from the only designers to imbue their work with narrative, but they are among the least concerned with function and the most concerned with effect. They don't want to shock, but run along a spectrum from confusion to perturbation. One minute you're comfortable with their work and then it begins to mutate and discombobulate. That glass box that you thought was a table is a painting. How did that happen?

Ian and Patrik are concerned with space and performance and the result is a repertoire of objects that become increasingly hard to define over time. Space, because they seek continually to redefine it – think of the red urethane puddle of *The Lovers Rug* – and performance because that's fundamental to their process. Metal is manipulated, cardboard is torn, foam is tied up with string. Creation for them is a physical pursuit. They are particularly admiring of the work of Paul McCarthy, an artist who privileged performance, particularly earlier in his career, as a form of production. Though I'd guess the transgression strikes a chord too. They have one of McCarthy's blingingly gold 2m high inflatable butt plugs in their studio.

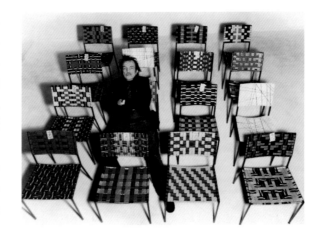

Franz West, *Chairs*

Grand Finale by Hofesh Shechter Company, 2017

Performance by Rosey Chan and Gerald Peregrine at *Hybrideae* vernissage, Fredrikson Stallard HQ, London, 2017

When they were both students at St Martin's School of Art in the mid-1990s, the design of furniture and artefacts for daily use ran on a continuum from the artistic to the industrial. There was Philippe Starck mass-producing objects that were meant to be comical or absurd but ultimately useful, their real power lying in their potential to romance us or entertain us. There was the concision of Jasper Morrison, with restraint taken to a beautiful extreme. Fredrikson Stallard instead emerged to produce vases that grew hair and sofas that could only be carved by hand and sat on by 5 people though mostly facing different directions.

At the same time, artists like Jorge Pardo, Franz West and Tobias Rehberger were taking the language of the domestic world and making it say something different. West questioned the physicality, tactility and meaning of the furniture we take for granted every day, recreating it in brilliant African textiles. Pardo used the tropes of design to play with colour, form and materials.

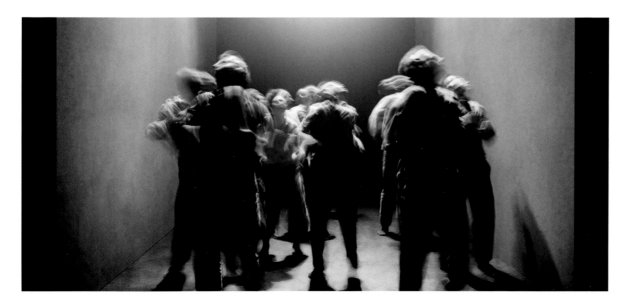

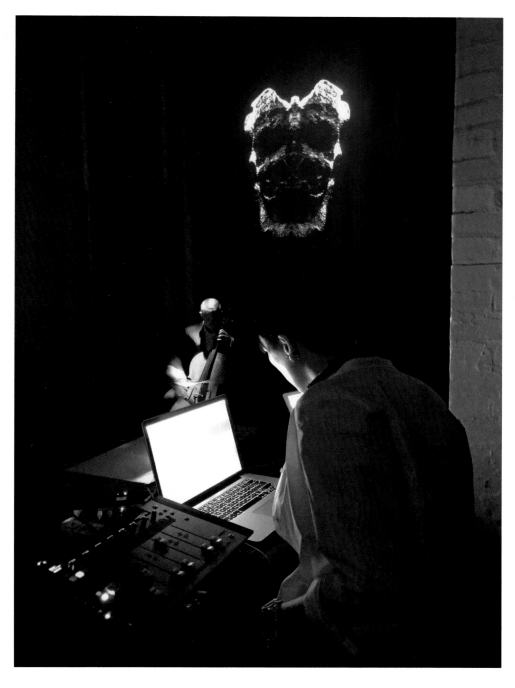

energy, music leads to a level of emotion and imagination that we crave and strive for."

The space Fredrikson Stallard now occupy is an individual and indefinable one, that plays equally with the material and the emotional, mingling the values of design and art to create something outside of definition. The work is too uncomfortable and non-conformist to bring them into the world of luxury, where aspiration hangs on the recognisable rather than the rare. And its unavailability for plagiarism keeps them even further from the pack. A series of recent pieces – huge bronze planters called *Hybrideae* – are derived from small hand-worked pieces of clay, which are then digitally scanned and blown up a thousand times. The thumb prints that have been left in the clay are translated into elaborate striations in the final bronze artefact.

The importance of working with the most antiquated, analogue form of making – manipulating clay – and then using the most contemporary digital technology available is, for them, an important part of the story.

When they launched *Hybrideae* in their studio space in 2017, they did so with an atmospheric event that reflected the analogue/digital way in which it had been developed. They used the cavernous access passage to their studio – once an 18th century street, now roofed over – to stage an event. There the cellist Gerald Peregrine performed his own interpretation of Bach's Cello suites from the 1720s, when the road was first built and Fredrikson Stallard's atelier was itself a bronze foundry. He then moved into the 21st century with a new duet by the pianist and electronic composer Rosey Chan. On a 6 metre high backdrop, a digital animation ebbed and flowed of one of the *Hybrideae* pieces revolving and splitting Rorschach-like, to create a never-ending series of forms that could be read in as many ways as one of those famous ink blots. It was astounding and beautiful.

Afterwards I looked anew at those expanded human thumbprints in the bronze. Nothing could be more unique, and entirely appropriate outcome in the on-going incomparable mission of Fredrikson Stallard.

The space between art and design was being filled, or at least contested. Fredrikson Stallard were, perhaps inadvertently, approaching it from the other side.

They have said they find design fairs dull and art fairs exciting, which hardly comes as a surprise. One is the realm of finite functional solutions and the other of ideas and endless possibilities. While their own scale is domestic, their inspiration is more the mashed metals of John Chamberlain, or the physical and psychological subversions of the choreographer Hofesh Shechter. "If we go and see his work," they say of Shechter, "It creates a whole new dynamic in our thinking – the combination of movement, light,

Appendix

Biography

Patrik Fredrikson
Born in Sweden, 1968. Lives and works in London since 1995
Trained at Central Saint Martins College, London

Ian Stallard
Born in United Kingdom, 1973. Lives and works in London since 1993
Trained at Central Saint Martins College, London

Awards and Nominations
2018
Design of the Year Award, *Wallpaper**, February, 2018
2016
Designer of the Year, Nomination by Design Museum London, November, 2016
2014
Best Trophy, *Azure Magazine*, February, 2014
2010
Red Dot Design Award, Hyde Chair for Bernhardt Design, November, 2010
2009
British Design of the Year Award, *Elle Decoration*, December, 2009
Courvoisier Design Award, *Wallpaper**, September, 2009
2007
Designer of The Year Award, *Wallpaper**, November, 2007
2006
The Furniture Design Fellowship, The Arts Foundation, December, 2006
2004
Designer of The Year, *Elle Decoration*, November, 2011
Product of The Year, *Wallpaper**, November, 2011
1998
Best Young Designer, Ung Svensk Form, Young Swedish Design, September, 1998
1997
Photography, Alfred Dunhill, August, 1997

Collections
2016
Design Museum, London, Species II, September, 2016
San Francisco Museum of Modern Art, San Francisco, Species II, March, 2016
2013
Kvadrat Collection, Copenhagen, Hallingdal Table, January, 2013
2011
Victoria & Albert Museum, London, Pyrenees Sofa, January, 2011
Victoria & Albert Museum, London, Table#1, January, 2011
2009
Veuve Clicquot Collection, Reims, Portrait, January, 2009
Museum of Art & Design, New York, Pandora, January, 2009
2005
French National Art Collection, Paris, Ming#1, January, 2005

Exhibitions

Solo Exhibitions
2017
Intuitive Gestures, David Gill Galleries, London, September 2017
Elements, Collective Design Fair, New York, May, 2017
Glaciarium, Salone del Mobile, Milan, April, 2017
Hybrideae Vernissage, Fredrikson Stallard HQ, London, March, 2017
2016
Fredrikson Stallard and Heinitz von Heinzenthal, Belvedere Museum, Vienna, September, 2016
Glaciarium, Fredrikson Stallard HQ, London, September, 2016
Summer Party, Fredrikson Stallard HQ, London, July, 2016
Fluido, Machado-Muñoz Gallery, Madrid, May, 2016
Gravity, David Gill Gallery, London, March, 2016
2015
Momentum, Fredrikson Stallard HQ, London Design Festival, London, September, 2015
Prologue, Swarovski, Design Shanghai, Shanghai, March, 2015
2014
Prologue, Swarovski, Design Miami Basel, Basel, June, 2014
Prologue, Swarovski, Art Basel Hong Kong, Hong Kong, May, 2014
2012
Crush, David Gill Gallery, London, September, 2012
2011
Iris, Swarovski, Design Miami Basel, Basel, June, 2011
2010
Fredrikson Stallard, O A Gallery, Madrid, February, 2010
2009
Gasoline Garden, David Gill Galleries, London, November, 2009
Swarovski Crystal Palace, Cannes Yacht Show, Cannes, September, 2009
2008
Portrait, Somerset House, London, September, 2008
King Bonk, David Gill Galleries, London, September, 2008
2007
Design Art London Lounge, London, October, 2007
Furniture, David Gill Gallery, London, May, 2007
Fredrikson Stallard Tank, The Design Museum, London, January, 2007
2005
Gloves for an Armless Venus, Tribeca Grand, New York, May, 2005
2004
Fredrikson Stallard, Citizen: Citizen, New York, May, 2004

Group Exhibitions
2018
Masterpiece, London, June, 2018
Nomad, Villa La Vigie, Monaco, April, 2018
Nomad, St. Moritz, Switzerland, February, 2018
Fogg Art Fair, San Francisco, California, January, 2018
2017
Dubai Design Week, Dubai, United Arab Emirates, November, 2017
Joy of Living, Maggies Charity Auction, London, September 2017
Masterpiece, London, June, 2017
Sur/face, Museum Angewandte Kunst, Frankfurt, Germany, June, 2017
Contemporary Art Auction, Sotheby's, London, June, 2017
Glaciarium, Salone del Mobile, Milan, April, 2017
Intersection, Machado-Muñoz, Madrid, April, 2017
Design Days, Design District, Dubai, March, 2017
ARC, Machado-Muñoz, Madrid, February, 2017
Craftsmanship Alone is not Enough, Central Saint Martins, London, January, 2017
Fogg Art Fair, San Francisco, California, January, 2017

2016
Beazley Design of the Year, Design Museum, London, September, 2016
Atelier Swarovski Home, Salone del Mobile, Milan, April, 2016
Driade, Salone del Mobile, Milan, April, 2016
2015
Salon, David Gill Gallery, New York, November, 2015
Driade Stand, Salone Del Mobile, Milan, April, 2015
Design Oracles, Centre National des Arts Plastiques, Paris, April, 2015
2014
Chandeliers, David Gill Galleries, London, September, 2014
Gathering, Design Museum Holon, Israel, July, 2014
Handmade, Salone Del Mobile, Milan, April, 2014
Handmade, Design Shanghai, Shanghai, March, 2014
2013
Handmade, Design Miami, Miami, December, 2013
Handmade, Harrods, London, October, 2013
Pad, London, October, 2013
Design Days Dubai, Design District, Dubai, March, 2013
Atelier Swarovski, Somerset House, London, February, 2013
Brioni Presentation, Palazzo Serbelloni, Milan, January, 2013
2012
Swarovski Design Exhibition, Times Art Gallery, Beijing, November, 2012
Pavillion of Art & Design, London, October, 2012
Digital Crystal, The Design Museum, London, September, 2012
Kvadrat Hallingdal 65, Salone del Mobile, Milan, April, 2012
Driade, Salone del Mobile, Milan, April, 2012
British Design 1948-2012, Victoria & Albert Museum, London, March, 2012
The Big Egg Hunt, Green Park, London, March, 2012
Arco, Madrid, February, 2012
2011
The House of the Nobleman, London, October, 2011
Pavilion of Art & Design, London, October, 2011
Beijing International Design Triennial, Beijing, October, 2011
Victoria & Albert Museum, London, September, 2011
Design Miami Basel, David Gill Galleries, Basel, June, 2011
Swarovski Lighting, Euroluce, Milan, April, 2011
2010
Savoy Hotel, Launch of Fredrikson Stallard Chandeliers for the Savoy Grill, London, November, 2010
David Gill Galleries, Frieze Art Fair, London, October, 2010
Bernhardt Global Edition, London, September, 2010
Design Miami Basel, Basel, June, 2010
Design City Luxembourg, Musée d'Art Moderne, Luxembourg, April, 2010
2009
Telling Tales, Victoria & Albert Museum, London, July, 2009
Bernhardt Global Edition, Icff, New York, May, 2009
Bernhardt Global Edition, Milan, April, 2009
Swarovski, Euroluce, Milan, April, 2009
Swarovski Crystal Palace, Maison et Objet, Paris, January, 2009
2008
Turning of the Season, The Wapping Project, London, November, 2008
Design Art London, London, October, 2008
Swarovski Crystal Palace, Milan, April, 2008
Swarovski Unbridaled, London, April, 2008
Unbridaled, Hotel De La Monnaie, Paris, January, 2008
2007
Design Miami, Miami, December, 2007
Designer's Universe, Grand Palais, Paris, October, 2007
Design Art London, National Gallery, London, October, 2007
Swarovski Crystal Palace, London, September, 2007
Play with Tools, Galerie, Paris, June, 2007
Design Miami Basel, Basel, June, 2007
Swarovski Crystal Palace, Milan, April, 2007

Form Vip Room, Olympia, London, March, 2007
P Design Gallery, Denver, Colorado, January, 2007
2006
St.Etienne Bienalle, St. Etienne, December, 2006
Moma, Citizen Citizen, San Francisco, December, 2006
Art Basel Design Miami, Miami, December, 2006
Nasher Sculpture Center, Dallas, November, 2006
Contrasts and Contradictions, Contrasts Gallery, Shanghai, September, 2006
In Production, London Design Festival, London, September, 2006
Designers Block, Frankfurt, August, 2006
Peel Gallery, Citizen Citizen, Houston, Texas, July, 2006
The Apartment Loves..., Citizen Citizen, New York, June, 2006
Icff, Citizen Citizen, New York, May, 2006
Thorsten Van Elten, Superstudio Più, Milan, April, 2006
Showroom Launch, Citizen Citizen, San Francisco, February, 2006
2005
Truly British, Harrods, London, September, 2005
Upstairs in the Woodlands, Truman Brewery, London, September, 2005
Fredrikson Stallard and Alexander Taylor, Citizen Citizen, New York, May, 2005
The Apartment Builds an Apartment, The Apartment, New York, May, 2005
The Conran Shop, New York, May, 2005
Rossana Orlandi, Milan, March, 2005
Martin Bouche & the Collection, Maison et Objet, Paris, January, 2005
2004
The Great Eastern Hotel, London, December, 2004
Firmitas Utilitas Venustas, Factio, London, September, 2004
Designed in Sweden, Museum of London, London, September, 2004
Print, Mint, London, September, 2004
Fredrikson Stallard, 100% Design, London, September, 2004
The Great Indoors / Inspired Living, Spring Gallery, New York, April, 2004
Incognito, Riverside Gallery, Reading, March, 2004
Life Symphony, Felissimo Gallery, New York, March, 2004
2003
Fredrikson Stallard, 100% Design, London, September, 2003
2002
Top Drawer, London, September, 2002
2001
Top Drawer, London, September, 2001
2000
Pot Valliant, London, September, 2000
Top Drawer, London, September, 2000
1999
Carte Blance, Mission Gallery, London, October, 1999
Top Drawer, London, September, 1999
Miscellany of Objects II, Mission Gallery, London, September, 1999
Ung Svensk Form, Designers Block, London, September, 1999
Young Swedish Design, Best Scandinavian Design, Sweden, February, 1999
1998
Exploring Design, Form Design Centre, Malmo, Sweden, September, 1998
Miscellany of Objects I, Mission Gallery, London, September, 1998
Out of Darkness, Mission Gallery, London, August, 1998
New Designers, London, June, 1998
1997
Patrik Fredrikson, Anteprima '97, Germany, September, 1997
Leicester City Gallery, Leicester, September, 1997
Directions '97, Lethaby Gallery, London, September, 1997
1996
Directions '96, Lethaby Gallery, London, September, 1996
1994
Kraftwerk, Ponnert Gallery, Malmo, Sweden, April, 1994

Bibliography

Books
2015
Sven Ehmann, *The Chamber of Curiosity*, Berlin: Gestalten, 2015
2014
Tim McKeough, Carolyne Roehm and Caroline Weber, *Robert Couturier: Designing Paradises*, New York: Rizzoli, 2014
2013
Lesley Jackson, *Modern British Furniture: Design Since 1945*, London: V&A Publishing, 2013
2012
Gareth Williams, *21 designers for twenty-first century Britain*, London: V&A Publishing, 2012
2011
Fiona Bate, Rebecca Silus, *Lux: Lamps & Lights*, Berlin: Gestalten, 2011
Fiona Baker, *Modern Furniture Classics: From 1900 to Now*. London: Carlton Books, 2011
2010
Libby Sellers, *Why, What, How: Collecting Design in a Contemporary Market*. London: HSBC Private Bank, 2010
2009
Robert Klanten, *Hair'em Scare'em*, Berlin: Gestalten, 2009
Chantal Michetti-Prod'Hom, *Nature En Kit*, Lausanne: Mudac, 2009
Robert Klanten, *Once Upon a Chair*, Berlin: Gestalten, 2009
Gareth Williams, *Telling Tales: Fantasy and Fear in Contemporary Design*, London: V&A Publishing, 2009
David Linley, Charles Cator, Helen Chislett, *Star Pieces: The Enduring Beauty of Spectacular Furniture*, London: Thames & Hudson, 2009
Sophie Lovell, *Limited Edition: Prototypes, One-Offs and Design Art Furniture*, Boston: Birkhaeuser, 2009
2008
Sebastian Hackenschmidt, *Formlose Möbel*, Ostfildern: Hatje Cantz, 2008
2006
Marcus Fairs, *Twenty-first Century Design: New Design Icons, from Mass Market to Avant-garde*, London: Carlton Books, 2006
Gareth Williams, *The Furniture Machine: Furniture Since 1990*, London: VetA Publications, 2006
Jennifer Hudson, *1000 New Designs and Where to Find Them*, London: Laurence & King, 2006
2005
Cara Brewer, *Experimental Eco -> Design*, Crans-Près-Célign: RotoVision, 2005
2004
Tom Dixon, *The international Design Yearbook 2004*, New York: Abbeville Press, 2004
2001
Max Fraser, *Design UK*, London: Conran, 2001
Exhibition Catalogues
2010
The Art of Light and Crystal, Wattens: Swarovski Crystal Palace, 2010, p. 77-83, 196-198. Exhibition
2006
Le Livre, Saint-Étienne: Biennale Internationale Design, 2006, p. 70. Exhibition
Citizen Patrol, New York: International Contemporary Furniture Fair, 2006. Exhibition
2004
Designed in Sweden, London: Museum of London, 2004. Exhibition

Selected Articles
2018
Farley, Paul, "Clerkenwell Design Week Cements International Status," *Furniture News*, Jun 13, 2018. Web.
Thomas, Kristofer, "CDW Presents," *Sleeper*, May / June, 2018: 162

Catchpole, Lewis, "Mandarin Oriental Hyde Park Completes Multi-Million Pound Refurb," *Hotel Owner*, May 29, 2018. Web
Jabarti, Somayya, "Mandarin Oriental Hyde Park, London Finishes Restoration," *Saudi Gazette*, May 29, 2018. Web
O'Neil, Heather, "Mandarin Oriental Hyde Park, London Completes its Multi-Million Pound Restoration," *Hospitality & Catering News*, May 29, 2018. Web
Burnett Kate, "Must See," *Studio.daily*, May 22, 2018: Cover, 2
Rauter, Maria, "Zwischen Schön & Gut (Between Beautiful & Good)," *Tirolerin*, 29 (May, 2018): 188 -190
Schuster, Angela, "Nomad Monaco Offers a Stylish Diversion from All that Sun-Soaked Luxury," *Robb Report*, April 26, 2018. Web
Hoggard, Liz, "Culture capital: Serpentine Galleries' CEO Yana Peel reveals her top London design destinations," *Evening Standard: Homes & Property*, April 03, 2018. Web
Wallpaper* Lifestyle, "Fragrance bottles: a decade of design innovation," *Wallpaper**, March 21, 2018. Web
Unterthurner, Barbara, "Gutes Design ist faires Design (Good design is fair design)," *Tiroler Tageszeitung*, March 21, 2018: 15
Niedermair, Brigitte, "Moving Parts," *Wallpaper**, March, 2018: 164,169, 174
Thynn, Emma, "Atelier Swarovski: A Sparkling Success Story," *Vanity Fair*, February 09, 2018. Web
Niedermair, Brigitte, "We play fast and loose with form and transparency for S/S 2018." *Wallpaper**, February 08, 2018. Web
Frearson, Amy, "Eight winter-themed furniture designs on show at inaugural Nomad St Moritz," *Dezeen*, February 08, 2018. Web
Bertoli, Rosa, "Best Deep Seascape," *Wallpaper**, February, 2018: 52-53
Keh, Pei-Ru. "Design, art and San Francisco soul unite at the fifth edition of FOG." *Wallpaper**, January 16, 2018. Web
2017
Sunshine, Becky, "Creative dispatches: highlights from Dubai Design Week 2017," *Wallpaper**, December 07, 2017. Web
Wrathal, Claire, "Objects of Desire," *Boat International*, 378 (December, 2017): 67
Parsons, Elly, "Crystal palace: Swarovski adds dreamy new 'chambers of wonder' to its Austria HQ," *Wallpaper**, November 30, 2017. Web
Vogue Living. "Everything you need to know from Dubai Design Week," *Vogue Australia*, November 21, 2017. Web
Jardine, Julia, "Find out what is going on at Dubai Design Week," *Arab News*, November 15, 2017. Web
Keh, Pei-Ru, "The Salon Art + Design New York: the Wallpaper* highlights," *Wallpaper**, November 13, 2017. Web
Trade Arabia, "Dubai Design Week opens with larger, diverse programme," *Trade Arabia*, November 13, 2017. Web
Assomull, Sujata, "Downtown Design to dazzle with new additions, local talent," *Khaleej Times*, November 13, 2017. Web
Zaki, Yousra, "Your ultimate guide to Dubai Design Week 2017," *Gulf News*, November 12, 2017. Web
Kothari, Rue, "From shopping to snacking: Everything you need to know about Dubai Design Week," *Emirates Woman*, November 09, 2017. Web
Blouin Artinfo, "Fredrikson Stallard's Futuristic Designs at David Gill Gallery, London," *Blouin Artinfo*, November 09, 2017. Web
Thomas, Kristofer, "Design for All Ages," *Sleeper*, 75, November, 2017: 182
Imanova, Aidan, "Fredrikson Stallard to Present Sun-inspired Installation for Swarovski during Dubai Design Week," *Design Mena*, October 30, 2017. Web
Browne, Alix, "The Anti-Bling Movement Takes Salone del Mobil," *W Magazine*, October 18, 2017: 54

Spears, Tim, "Downtown Design Unites Over 150 High End, Global and Regional Brands," *Designboom*, October 17, 2017. Web

White, Natalie, "Swarovski to Exhibit Large Outdoor Installation at Dubai Design Week," *Senatus*, October 17, 2017. Web

Bodiam, Michael, "Bunker Down," *Wallpaper**, October, 2017: 190

Mandarin Oriental, "The Mandarin Oriental in Knightsbridge Unveils New Makeover," *Luxury London*, October 09, 2017. Web

Wallpaper* Art, "From Matisse to Mapplethorpe, Step this way for the St James' Art and Design Walk," *Wallpaper**, October 06, 2017. Web

Shirskaya, Marina, "Exhibition of Intuitive Gestures in David Gill Gallery," *Architectural Digest Russia*, October 02, 2017. Web

Deacon, Sam, "Fredrikson Stallard Intuitive Gestures Exhibition Launch," *Cellar Maison*, September 29, 2017. Web

Ohad, Dr. Daniella, "Collectible Contemporary Design II: Fredrikson Stallard, the Rock Stars of the Collectible Design World," *Cobo Social*, September 14, 2017. Web

Morris, Ali, "Grand Gestures: Fredrikson Stallard's Latest Work Makes a Bold Statement," *Wallpaper**, September 12, 2017. Web

Long, Carola, "Goldie Looking Chains: the Hot New Jewellery Collaboration," *Financial Times*, September 08, 2017. Web

Thompson, Henrietta, "Joy of Living: art and design stars create artworks for anonymous Maggie's charity auction," *The Telegraph*, September 04, 2017. Web

Blouin Artinfo, "'Intuitive Gestures' by Fredrikson Stallard at David Gill Gallery, London," *Blouin Artinfo*, September 01, 2017. Web

Parsons, Elly, "Paper mates: Max Fraser taps creative luminaries for a charity auction with a twist," September 01, 2017. Web

Mason, Brook, "Fredrikson Stallard Make Waves with a New David Gill Gallery Show," *Architectural Digest*, September 01, 2017. Web

Chambers, Tony, "The People," *Es Magazine*, September 01, 2017: 39

Roux, Caroline, "Let there be Light," *Salt*, 15 (September, 2017): 78-79, 86-89, 103

Taylor, Chris, "Q&A: Crystal-clear Life Lessons from Nadja Swarovski," *Reuters*, August 22, 2017. Web

Ryder, Bethan, "Walpole's Secrets of Success: How to Launch a Luxury Brand," *The Telegraph*, August 18, 2017. Web

Bettens, Walter, "Productivity: Patrik Fredrikson & Ian Stallard," *Damn° Magazine*, July 10, 2017. Web

Hopkinson, Ryan, "Space," *Wallpaper**, July, 2017: 210-213, 215

De Andrade, Artur, "Mostras Paralelas (Parallel Shows)," *Casa Vogue Brazil*, June, 2017

Escribano, Gloria, "Fredrikson Stallard. Artesanía de vanguardia (Fredrikson Stallard. State-of-the-Art Crafts)," *Room Diseño*, May 26, 2017. Web

Baumgardner, Julie, "Green thumbs: Collective Design Fair 2017 takes a bucolic bent," *Wallpaper**, May 12, 2017. Web

Howarth, Dan, "Six of the best showcases from New York's Collective Design fair 2017," *Dezeen*, May 04, 2017. Web

Meier, Allison, "Participatory Stool Making, Reclaimed Materials, and More at Collective Design Fair," *Hyperallergic*, May 03, 2017. Web

Morris, Ali, "Master Cast," *Wallpaper**, May, 2017: 79

Phillips, Ian, "A High-style Family Retreat in the Mountains of Lebanon," *Architectural Digest*, April 10, 2017. Web

Speros, Will, "Mandarin Oriental Hyde Park, London Reveals First Phase of Redesign," *Hospitality Design*, April 10, 2017. Web

Ryder, Bethan, "Illuminating new lighting trends at Milan design week," *The Telegraph*, April 01, 2017. Web

De Biasi, Frank, "A Refined Affair," *House Beautiful*, April, 2017: 112 – 121

Barreneche, Raul, "High Impact," *Galerie*, 4 (March, 2017): 76

Lutyens, Dominic, "Light Motifs," *Financial Times*, March 31, 2017. Web

Trocmê, Suzanne, "Desert Storm: Dubai Hosts Two International Design and Art Fairs," *Wallpaper**, March 22, 2017. Web

Priest, Matthew, "5 Top Picks from Design Days Dubai 2017," *Esquire Middle East*, March 14, 2017. Web

Sarup, Pratyush, "Design Days Dubai 2017: What not to Miss," *Gulf News*, March 12, 2017. Web

Tsang, Jacqueline, "Gieves & Hawkes Opens Private Tailoring Store at the Mandarin Oriental in Hong Kong," *Style Magazine*, February 28, 2017. Web

Battaglia Engelbert, Giovanna, "Inside Giovanna Battaglia's Downtown Abbey Getaway," *W Magazine*, February 18, 2017. Web

Thompson, Anna Walker, "Light Magic: Glacial Beauty," *Salt*, 14 (February, 2017): 108

Burman, Sujata, "The Beazly Designs of the Year Winners Revealed at the Design Museum," *Wallpaper**, January 26, 2017. Web

Scelsi, Rosario, "Atelier Swarovski Home at Maison & Object Paris 2017," *Deluxe Blog*, January 23, 2017. Web.

Crichton-Miller, Emma, "Going with the Flow," *Financial Times: How to Spend it*, January, 2017: 46-51

2016

Krasny, Jill, "Velvet's Plush Renaissance," *Financial Times: How to Spend it*, December 29, 2016. Web

Fernandez, Jennifer, "44 of the Best Living Rooms of 2016," *Architectural Digest*, December 22, 2016. Web

Sissons, Jemima, "Burning Love: Hygge and the Art of Building a Fire," *Financial Times: How to Spend it*, December 13, 2016. Web

Quick, Harriet, "The Final Cut," *Salt*, 13 (December, 2016): 84

Madlener, Adrian, "Winter Forms," *TLmag*, 26 (December, 2016): 221

Sherman, Lauren, "The Fashion Awards Goes Global," *Business of Fashion*, December 06, 2016. Web

Cocksedge, Mark, "Colección de Lámparas de Fredrikson Stallard para Swarovski (Fredrikson Stallard Lamp Collection for Swarovski)," *90+10*, December 01, 2016. Web

Hoh, Rebecca, "In Good Company: Fredrikson Stallard," *Studio*, November, 2016. Web

Ascani, Danilo, "I Designer Patrik Fredrikson e Ian Stallard (The Designers Patrik Fredrikson and Ian Stallard)," *Marie Claire*, November 04, 2016. Web

Cocksedge, Mark, "Reflection, Refraction, Reborn," *Darc*, 18 (November 2016): 86-89

Rezende, Aline Lara, "Undoing Modernism," *Damn° Magazine*, 58 (November 2016): 42-46

Dallorso, Elena, "Nell'anno del topo (In the Year of the Rat)," *Architectural Digest*, 424 (October 2016): 210-213

Aouf, Rima Sabina, "Sun-like Disc of 8,000 Swarovski Crystals Installed at Baroque Viennese Palace," *Dezeen*, October 04, 2016. Web

Schaur-Wünsch, Teresa, "Es Geht um Kraft und Energie (It's About Power and Energy)," *Die Presse*, September 30, 2016. Web

Lewis, Tessa, "Second Nature," *Swarovski*, September 22, 2016. Web

Azzarello, Nina, "Fredrikson Stallard's 'Glaciarium' Collections for Swarovski Shine at London Design Festival," *Designboom*, September 22, 2016. Web

Thompson, Henrietta, "London Design Festival Preview," *The Telegraph*, September 15, 2016. Web

Burman, Sujata, "Cutting Edge: Fredrikson Stallard to Launch Bespoke Swarovski Crystal Collection at LDF," *Wallpaper**, August 26, 2016. Web

Heap, Tim, "{Perspective} Fredrikson Stallard," *Winq*, September 2016: 158-159

ориентиры имя, "Меланхолики (Melancholic)," *Interior + Design*, September 2016: 14-16

Azzarello, Nina, "Fredrikson Stallard Presents Fluido at Madrid's Machado – Muñoz Gallery," *Designboom*, July 02 2016. Web

Velasco, Laura, "Entrar en Materia (Enter into the Matter)," *Architectural Digest*, June 15, 2016. Web

Librero, Angela, "No Busque esto en su Tienda Habitual (You Cannot Find This in Your Local Store)," *Icon*, 28 (June, 2016): 111

Chandler, Barbara, "Camouflage Collection, Chairs Are Getting Taller," *London Evening Standard*, May 11, 2016: 22

Boisi, Antonella, "Fredrikson Stallard, in the Presence of Ones Dreams," *Interni*, 5 (May, 2016): 48-53

Fredrikson Stallard, "Species," *Wild*, 28 (May, 2016): 96-97

Neira, Juliana, "Fredrikson Stallard Designs an All-Year-Round Outdoor Collection for Driade," *Designboom*, April 24, 2016. Web

Steltzner, Holger, "Camouflage," *Frankfurter Allgemeine*, April 24, 2016: Front Page

Menkes, Suzy, "#CNILux Stephen Webster: Goldstruck," *Vogue*, April 19, 2016. Web

Fredrikson Stallard, "Kunstvolle Knautschzone (An Artful Crumple Zone)," *Places of Spirit*, April, 2016: 92-93

Fredrikson Stallard, "Inspiration: Fredrikson Stallard," *Arkitexture*, March 25, 2016. Web

Strong, Narender, "Gravity by Fredrikson Stallard," *TLMag*, March 17, 2016. Web

Morris, Ali, "Analogue and Digital Processes Collide in Fredrikson Stallard's David Gill Showcase," *Wallpaper**, March 10, 2016. Web

Ryder, Bethan, "In Conversation: Fredrikson Stallard," *The Telegraph*, March 09, 2016. Web

Swengley, Nicole, "Fredrikson Stallard at David Gill Gallery," *Financial Times: How to Spend it*, March 09, 2016. Web

Senda, Shuhei, "Fredrikson Stallard Presents Gravity at London's David Gill Gallery," *Designboom*, March 05, 2016. Web

Chandler, Barbara, "March Design Events: Gravity by Fredrikson Stallard at David Gill Gallery," *Evening Standard: Homes & Property*, March 03, 2016. Web

Fraser-Cavassoni, Natasha, "Conversation Pieces, Around the World," *Salt*, 12 (March, 2016): 78-79, 102-103

Wallis, Stephen, "Material Guys," *Architectural Digest*, March, 2016: 34

Tobin, Emily, "Seriously Creative," *House & Garden*, March, 2016: 33

Perkovic, Jana, "Fredrikson Stallard's New Collection 'Gravity' to Premiere at David Gill Gallery," *BlouinArtinfo*, February 26, 2016. Web

Storms, Sarah, "A Connecticut Boathouse Gets an Elegant European-Inspired Makeover," *Architectural Digest*, February 04, 2016. Web

U.S, "Big Bang Theory," *Architectural Digest*, February, 2016: 40

David Gill Gallery, "Gemütlicher Brocken" (Cozy Boulders), *Architektur & Wohnen*, February 01, 2016: 12-13

Lerche, Jelka, "Steinweich (Soft Stone)," *Lufthansa Exclusive*, 1 (January, 2016): 12

Fredrikson Stallard, "Species," *JJ.*, 126 (January, 2016): 58-59

2015

Ryan, Robert, O'Kelly, Emma, "Worlds Apart, Let there be Light," *Salt*, 11 (December, 2015): 66-71, 83-87

David Gill Gallery, "Beam me up, Scotty!" *Quality*, 48/49 (December, 2015): 16-17

Rajvanshi, Tanvi, "10 of Bazaar's Favourite Pieces from Atelier Swarovski," *Harper's Bazaar Singapore*, December 17, 2015. Web

Chien, Jovier, "Design as Art," *Architectural Digest*, December, 2015: Feature

Wilson, Nathalie, "Antennae," *The World of Interiors*, November, 2015: 18-19

Chambers, Tony, "Wallpaper* Power 200: The World's Top Design Names and Influencers," *Wallpaper**, October 12, 2015. Web

Stratford, Oli, "Momentum by Fredrikson Stallard," *Disegno*, October 01, 2015. Web

Bertou, Rosa, "Velvet Love," *Wallpaper**, October, 2015: 85

Coirier, Lise, "Momentum by Fredrikson Stallard: Fairytales for Grown-Ups," *TLMag*, September 30, 2015. Web

Thompson, Henrietta, "Fredrikson Stallard's Momentum," *The Telegraph*, September 24, 2015. Web

Senda, Shuhei, "Fredrikson Stallard sets the Momentum at London Design Festival," *Designboom*, September 23, 2015. Web

Doyle, Jessica, "A Design Guide To... Islington And Clerkenwell," *House & Garden*, September 15, 2015. Web

Cremascoli, Olivia, "I Nuovi Mondi di Cristallo a Wattens (The New Crystal Worlds in Wattens)," *Interni*, 9 (September, 2015): 99-101

Swengley, Nicole, "Fredrikson Stallard: Momentum," *Financial Times: How to Spend it*, September 20, 2015. Web

Chan, TF, "Spin the Bottle," *Wallpaper**, June 25, 2015. Web

Shaw, Catherine, "Crystal Set," *Wallpaper**, May 18, 2015. Web

Lorelle, Véronique, "Design of the Times," *The Guardian*, May 15, 2015. Web

Moore, Emma, Thawley, Dan, "Message in a Bottle," *Wallpaper**, May, 2015

Shaw, Catherine, "Prologue Shanghai," *South China Morning Post*, April 10, 2015: C8

Ng, Jerri, "Prologue," *Modern Lady*, April 06, 2015

Wangyue, Tong, "Having Designs on Innovation and Creativity," *Shanghai Daily*, April 05, 2015: 10

Nort, Nathalie, "What to See at Contemporary Design Hall of Design Shanghai…," *Ideat*, 1 (April, 2015): 232

Fredrikson Stallard, "Design in Context," *Trends Magazine*, Vol. 3 No. 1 (April, 2015): 9-16

Bloomfield, Ruth, "Master Class," *Sunday Times*, March 03, 2015: 12

Crowther, Melissa, "Shanghai Sparkle," *The Clerkenwell Post*, 24 (March, 2015): 6

Fraser, Virginia, "Lessons in Layout," *House & Garden*, (March, 2015): Cover, 94-100

Fraser, Virginia, "Prologue," *Vision*, 148 (March, 2015): Events

Bertoli, Rosa, "Driade Takes Us Back to the Future," *Wallpaper**, January 15, 2015. Web

Italia-Dhanu, Ronitaa, "Statement Addition," *Trends Magazine*, Vol. 2 No. 8. (January, 2015)

Bloomfield, Ruth, "A Designing Duo's Daring Décor," *The Wall Street Journal*, January 09, 2015: M5

McCabe, Lucy, "Design News," *Belle*, January, 2015: 40

2014

Heffernan, Amy, "Nobel Art," *Wallpaper**, December, 2014: 186-187

Madlener, Adrian, "A Gentle Man," *TLMag*, 22 (December, 2014): 152-153

White, Belinda, "Inside Gieves & Hawkes Renovated No.1 Savile Row Flagship," *The Telegraph*, November 25, 2014. Web

Grinnell, Sunhee, "Who is the Brioni Man?" *Vanity Fair*, November 12, 2014. Web

Calascibetta, Alessandro, "Fragranza Brioni (Fragrance Bironi)," *Corrierre della Sera*, November 12, 2014. Web

Tinson, Teddy, "Message in a Bottle," *Interview*, November 03, 2014. Web

Rachlin, Natalia, "Looking After No.1," *Wallpaper**, November, 2014: 80-84

Jaguar Design, "The Handmade Issue," *Wallpaper**, August, 2014: Cover, 176-177

Grassie, Richard, "What Gieves?" *Financial Times: How to Spend it*, July 05, 2014: 10-12

Harris, James, "Prologue by Fredrikson Stallard," *Archiloci*, June 18, 2014. Web

Loverini, Carlotta, "Design Miami + Art Unlimited 2014," *Vogue*, June 17, 2014. Web

Shulman, Alexandra, "Prologue," *Vogue*, June 17, 2014. Web

Cilento, Jeanne-Marie, "Design Miami/ Basel 2014: Prologue by Fredrikson Stallard," *Design and Art Magazine*, June 18, 2014. Web

Harris, James, "Fredrikson Stallard for Swarovski," *Wall Street International*, June 17, 2014. Web

Bauknecht, Sandra, "At Design Miami/ Basel with Swarovski," *Sandra's Closet*, June 17, 2014. Web

Le Fort, Marie, "Un Goût de Design Miami / Basel (A taste of Design Miami / Basel)," *Les Echos*, June 13, 2014. Web

Bertoli, Rosa, "Wallpaper* Workshop," *Wallpaper**, June 12, 2014. Web

Chan, Areon, "The Power of Design is Crystal Clear," *Young Post*, June 04, 2014: 2

Bettens, Walter, "Prologue, Fredrikson Stallard for Swarovski," *Damn° Magazine*, June 04, 2014. Web

Lui, Esther, "Fredrikson Stallard Profile," *Magazine P*, 4 (June, 2014): 76-79

Arcila, Greta, "Sereno," *Glocal Magazine*, June, 2014: 128

Chung, Amy, "Art Basel Hong Kong Visitors Rise," *Women's Wear Daily*, May 19, 2014. Web

Azzarello, Nina, "Fredrikson Stallard Suspends 8,000 Golden Swarovski Crystals in a Luminous Ring," *Designboom*, May 17, 2014. Web

Gayen, Mary, "Fredrikson Stallard Work Dazzles at PMQ in Hong Kong," *BlouinArtinfo*, May 16, 2014. Web

Kolesnikov-Jessop, Sonia, "A Legacy Shines Through," *Art Info*, May 15, 2014: 10

Harilela, Divia, "Creatively Inclined Find a Home at PMQ," *South China Morning Post*, May 14, 2014. Web

Joanilho, Marcal, "Sparkling for Art Basel," *The Standard Hong Kong*, May 14, 2014

Shaw, Catherine, "Design Duo Fredrikson Stallard Dazzle Hong Kong with a New Installation for Swarovski," *Wallpaper**, May 13, 2014. Web

Visual Arts News Desk, "Swarovski Presents Prologue, by Fredrikson Stallard for Art Basel in Hong Kong," *Broadway World*, May 13, 2014. Web

Pao, Ming, "Prologue," *Ming Pao*, May 22, 2014: D6

Rich, Sarah, "Big, Bright and Sparkly," *48 Hour Magazine*, May, 2014: 12

Perilli, Vanessa, "Driade al Salone del Mobile 2014," *Marie Clare Italy*, April 06, 2014. Web

Redazione Abitare, "Fredrikson Stallard per Driade," *Abitare*, March 07, 2014. Web

David Gill Gallery, "Farfalle d'acciaio," *Architectural Digest Italy*, 394 (March, 2014): 48

Anniss, Elisa, "The Cut," *Salt*, 8 (March, 2014): 14-15

Trendspot, "Fornemmelse Forås," *Bo Bedre Magazine*, 3 (March, 2014): 50-51

Osborne, Catherine, "5 Winning Trophy Designs," *Azure*, February 28, 2014. Web

2013

Daily Mail Reporter, "BIFA Trophy," *Daily Mail Online*, December 08, 2013. Web

Barraclough, Leo, "You Like Us? You Really Like Us?" *Variety Magazine*, December 03, 2013: 66

Evans, Greg, "FILM3SIXTY, Moët BIFA Awards Issue," *The Guardian*, December, 2013: Back cover

Hesedenz, Katharina, "Metall Motivation," *Vogue Germany*, November 11, 2013: 172

Jaguar Design, "Diptych: Landscape II," *Wallpaper**, October 16, 2013. Web (video)

Donninelli, Barbara, "Bright and Beautiful," *Salt*, 7 (September, 2013)

Sands, Sarah, "Go Rouge," *Es Magazine*, May 24, 2013: 16

Aude de La Conté, "Art et Design," *Architectural Digest*, May, 2013: 144-153

Felicetti, Cinzia, "Materiali," *Marie Claire Italy*, March, 2013: 138-139

Cheung, Angelica, "Party Style," *Vogue China*, 120 (January, 2013): 91, 359

Eastern, Yoel, "Pandora," *Calcalist Lifestyle*, January, 2013: 18

2012

Wright, Jean, "Right Now," *Belle*, December, 2012: 41

Wiles, Will, "Design Erotica," *Disegno*, 7 (December, 2012): 37, 86-87

Grand, Katie, "The Cut," *Salt*, 5 (December, 2012): 13

Chambers, Tony, "Don't Put your Feet on the Coffee Table," *Wallpaper**, December, 2012: 189

Cooper, Harriet, "Style Council," *BA First Life*, November 2012: 5,13

Extravagance Network, "The Swarovski Transboundary 2013 New Spring and Summer," *China Luxe*, November 06, 2012. Web

Keh, Pei-Ru, "Brioni Art & Design, Curated by Francis Sultana, London," *Wallpaper**, October 09, 2012. Web

Matton, Livia, "New Talent," *Elle Décor Italy*, 9 (September, 2012): 48-50

Brown, Mark, "It's Crystal Clear," *The Guardian*, September 03, 2012. Web

Beatrice, Hanna Nova, "Gränslöst Snyggt," *Plaza*, July, 2012 : 84-91

Chandler, Barbara, "At Milan," *Evening Standard*, May 02, 2012: 10-11

Caggiano, Stefano, "Chic & Choc," *Interni*, 5 (May, 2012): 82-85

Beatrice, Hanna Nova, "Expats," *Form*, April, 2012: 60-61

Prodger, Micheal, "All Seeing," *Salt*, 4 (March, 2012): 38-39

Love, Emma, "Hot List," *Elle Decoration*, November, 2012: 117

Abrahams, Charlotte, "True Covetables," *Financial Times*, November 17, 2012: 52-56

2011

Fredrikson Stallard, "Pyrenees Sofa by Fredrikson Stallard," *Furniture Fashion*, July 18, 2011. Web

Lanks, Belinda, "Eight Designs that will soon Become Classics, Chosen by the V&A," *Fast Co Design*, June 28, 2011. Web

Etherington, Rose, "Iris by Fredrikson Stallard for Swarovski Crystal Palace," *Dezeen*, June 16, 2011. Web

Burrichter, Felix, "Asked & Answered," *New York Times: T Magazine*, June 13, 2011. Web

Skeggs, Toby, "Cutting-edge Furniture Donation for Design Museum," *The Art Newspaper*, June 15, 2011: Front Page

Le Fort, Marie, "Art Streets of London," *Ideat*, April, 2011: 237-240

Fredrikson Stallard, "Fredrikson Stallard, Design as Alchemy," *Lancia Trend Visions*, March 03, 2011. Web

2010

Murray, Tony, "Art-nership," *Gafenco*, May, 2010: 70-75

Otero, Brenda, "El Poder de un Florero Peludo (The Power of a Hairy Vase)," *El Pais*, January 25, 2010. Web

Tett, Gillian, "Decade of Diversification," *Financial Times*, January 16, 2010: 6

Fredrikson Stallard, "Mitt 2020 (My 2020)," *Plaza*, January, 2010: 63-64

2009

Mitsios, Apostolos, "Hôtel Particulier du Marc and Fredrikson Stallard," *Yatzer*, November 11, 2009. Web

Roux, Caroline, "Tea Time with Two of the Design World's Future Household Names," *Pin-Up*, 7 (November, 2009): 56-64

Labougle, Ricardo, "Artists in Residence," *The World of Interiors*, November, 2009: 68-77

Roux, Caroline, "Breaking the Mould," *Financial Times: Superior Interiors*, October, 2009: 33-35

Swengley, Nicole, "Youthful Inspiration," *Financial Times*, October, 2009: 19

Roo, Prognya, "The British Design Awards 2009," *Elle Decoration*, October, 2009: 107, 112

McLeod, Lyndsay Milne, "Candy Store," *Wallpaper**, May, 2009: 6-7, 232-239

Abrahams, Tim, "Turning the Season," *Blueprint*, 276 (March, 2009): 78-82

Koskinen, Harri, "London Fredrikson Stallard," *Iittala Create Magazine*, March, 2009: 112-126

2008

Blankenship, Tamra, "Londres Surexpose Son ADN Design," *Soon*, December, 2008: 140-143

Margalejo, Isabel, "High Tec," *Architectural Digest Spain*, December, 2008: 62-66

Roo, Prognya, "The Hottest… Seat About Town," *Elle Decoration*, December, 2008: 67

O'Flaherty, Mark, "Off the Wall," *Quintessentially*, November, 2008: 40-42

Morris, Andy, "Art House," *GQ*, October, 2008: 65

Roo, Prognya, "Sale of the Century!" *Elle Decoration*, October, 2008: 49

Barneby, Vanessa, "Dark Age," *Vogue*, October, 2008: 36

Hughes, Penny, "The Art of the Matter," *Id Fx*, October, 2008: 36-40

David Gill Galleries, "Floor Power," *Wallpaper**, October, 2008: 160-162

Willis, Alasdhair, "Les Anglais contre-attaquent," *Architectural Digest France*, 77 (September, 2008): 82-86

Swengley, Nicole, "Double Vision," *Financial Times*, August 23, 2008: House & Home

Oshemkova, Ekaterina, "Fredrikson Stallard: The Non British Avant Garde," *Canoh*, August, 2008: 82-86

Gregory, Olivia, "Odd Ones Out," *House & Garden*, July, 2008: 31-34

Thompson, Henrietta, "Double Vision: Fredrikson Stallard in Profile," *Design Week*, 23 (June, 2008): Cover, 13

Fredrikson Stallard, "Antennae Roundup," *The World of Interiors*, May, 2008: 23

Taraska, Julie, "Two of a Kind," *Metropolitan Home*, May, 2008: 60-62

Swengley, Nicole, "We Began with a Cold Water Tap and Two Rats," *Financial Times: Weekend*, April 12, 2008: House & Home

Barneby, Venessa, "Runway to Room," *Vogue*, April, 2008: 119

Compton, Nick, "The Numbers Game," *Wallpaper**, April, 2008: 157-160

Chew, Leon, "Ten to Watch," *Art + Auction*, April, 2008: 144-145

Fredrikson Stallard, "Epergné," *Unbridaled*, February, 2008: 14-15

2007

Grandjean, Emmanuel, "Le Design au Pays des Merveilles (Design in Wonderland)," *Edel Weiss*, December, 2007: 186

Roux, Caroline, "Interview Fredrikson Stallard," *Blueprint*, 260 (November, 2007): 100-104

Lorinz, Trish, "Swarovski – Pandora," *Elle Decoration*, November, 2007: British Design Awards

Franklin, Kate, "Design Notebook," *Viewpoint*, 21 (November, 2007): 144-160

Van Der Post, Lucia, "Between Art and Design Lies an Ocean's Difference in Terms of the Prices That Pieces Command," *The Times Magazine*, October 06, 2007: 79

Pearmain, Max, "Through Strife and Glory and Back Again," *Arena Homme +*, October, 2007: 60

Bagner, Alex, "Spin-ball Wizard," *Wallpaer**, October, 2007: 122-124, 366-367

Gibson, Grant, "Up Front," *Crafts Magazine*, 208 (September, 2007): 6

Keith, Michele, "Top Fall Trends," *New York Living Magazine*, September, 2007: 51

Pa ków, Lidia, "Oferta Strach (Offer Fear)," *Wysokie Obcasy*, 436 (September, 2007): 34-38

Beatrice, Hanna Nova, "Monokroma Mästare," *Plaza*, August, 2007: 83-86

Bates, Anna, "A Mountain-shaped Sofa," *Icon*, 49 (July, 2007): 53

Fredrikson Stallard, "What's this got to do with the New

Volvo S40?" *Liv*, July, 2007: Cover, News S40

Farrar-Hockley, Henry, "Blood Brothers," *Esquire*, June, 2007: 26

Fredrikson Stallard, "Fredrikson Stallard Feature," *Game Land Russia*, Vol. 6 No. 62 (June, 2007): 56-57

Sherwood, Tim, "News," *Icon*, 48 (June, 2007): 75

Hughes, Ben, "C18 Cover Story," *Modern Weekly Lifestyle*, May 21, 2007: Cover, 4

LCD, "One to Watch," *Artkrush*, 58 (May, 2007). Web

Byng, Hatta, "Insider News," *House & Garden*, May, 2007: 106

Englmann, Claudia, "Crossover," *Vogue Germany*, May, 2007: 150-152

Dalton, Jenny, "My How They've Grown," *Financial Times: How to Spend it*, May, 2007: 18-22

Mocchetti, Ettore, "Fantasie in Rosa (Fantasies in Pink)," *Architectural Digest Italia*, 312 (May, 2007): 180

Chung, Karen, "Elastic Brand," *Wallpaper**, May, 2007: 79-80

Hunter, Will, "Designer Profile – Fredrikson Stallard," *Architectural Journal*, 9-11 (May, 2007): 4, 9, 11

Traldi, Laura, "Frammenti d'Autore (Auteur's Fragments)," *Interni*, 39 (April, 2007): 116-117

Gura, Judith, "Pedal to the Metal," *Art + Auction*, April, 2007: 140-145

Hoggard, Liz, "Fredrikson Stallard on Forty Naked Johnny Depps," *Crafts Magazine*, 205 (March, 2007): 23-29, 92-93

Catalano, Patrizia, "Novità al Salone (News from The Show)," *Flair*, March, 2007: 37

Tremblay, Céline, "Fredrikson Stallard, Semeurs de Palabres," *Plaisir de Vivre*, February, 2007: 38-46

2006

Long, Kieran, "I am in Shanghai," *Icon*, 42 (December, 2006): 88-94

Blockstrom, Joakim, "Inspired Buys Modern Glamour," *Elle Decoration*, December, 2006: Easy Entertaining

Bates, Anna, "Design is Evil," *Icon*, 41 (November, 2006): 116-122

Trocmê, Suzanne, "Kings of Cool," *Architectural Digest Germany*, November, 2006: 111-112

Vogue Living, "Go with the Flow," *Vogue*, October, 2006: 263

Mohandesi, Salar, "Design Notebook," *Viewpoint*, 20 (October, 2006): 153-162

Mohandesi, Salar, "Must Have Designers Fredrikson Stallard," *Viewpoint*, October, Antenna, 2006

Hogg, Clare Dwyer, "Interiors Notes Animal Magic," *The Independent Magazine*, October 21, 2006: 71

Bradford, Amy, "From Catwalk to Couch," *Elle Decoration*, October, 2006: 47

Abrahams, Charlotte, "Space," *The Guardian Weekend*, September 30, 2006: 79

Fairs, Marcus, "The Design Issue, Interiors Special," *The Observer Magazine*, September 10, 2006: 3, 37

Hudson Jennifer, "Design Identikit," *Azure*, September, 2006: 76-77

Byng, Hatta, "Fredrikson Stallard at The Apartment," *House & Garden*, July 11, 2006: 15

Bobová, Zuzana, "British Design," *Atrium SK*, July, 2006: 16-19

Degen, Thomas, "New on the Scene," *WWD Scoop*, June 1, 2006: 68

Ipsum Planet, "Fredrikson Stallard," *Neo2*, 58 (June, 2006): 84

Warner, Chloe Redmond, "The Lowdown…" *Lucky Magazine*, June, 2006: 214

Wild, Lorraine, "Material Culture," *Western Interiors and Design*, 3rd Anniversary Issue (May, 2006): 45

Millar, Annie, "Space," *Wallpaper**, May, 2006: 200-203

Sardar, Zahid, "Display of Technical Wit at New York's Furniture Fair," *San Francisco Chronicle: Home & Garden*, May 31, 2006: G4

Latinsky, Michal, "Milujeme Hoblík/ Pílku," *Interior SK*, May, 2006: 64-65

Fairs, Marcus, "What Comes After Modernism?" *Icon*, 35 (May, 2006): 56-57, 60

Picture, Bill, "Consumption Junction," *BPM*, May, 2006: 34

Weichmann, Kai, "The Gourmet Guzzler," *Viewpoint*, 19 (April, 2006): 114-115

Long, Kieran, "I Earn Nothing," *Icon*, 34 (April, 2006): 56-59

Gregory, Olivia, "Insider Shopping," *House & Garden*, April, 2006: 69-70

McFadden, Susan, "What's New," *California Homes*, April, 2006: 35

Lutyens, Dominic, "Sharp Edges," *Art Review*, April, 2006: 68-69

Fredrikson Stallard, "Taken Away as Evidence," *Spaces*, 16 (March, 2006): 31, 40-41

Wiltshire, Alex, "Patrik Fredrikson has Won," *Icon*, 33 (March, 2006): 38

Wolff, Zoë, "Citizen: Citizen," *Eat.Shop.Brooklyn…*, March, 2006: 29

Romm, Jessica, "The Good China," *Domino*, March, 2006: 54

Poinas, Vincent, "Style Clinique," *Citizen K*, March, 2006: 198

Kelly, Peter, "Publicity is its own Reward," *Blueprint*, 240 (March, 2006): 82

Reardon, Ben, "New Forms for Faith," *I.D.*, March, 2006: 11

Harris, Chloé, "8 Fresh Picks to Buy, Borrow or Steal," *California Home + Design*, March, 2006: 60

Lutyens, Dominic, "Sharp Edges," *Art Review*, April, 2006: 68-69

Iva, Dee, "Gothic Glamour," *Wedding Day*, February, 2006: 55

Hirst, Arlene, "Take Note," *Metropolitan Home*, February, 2006: 18

Valdés, Elena, "Todo al Rojo," *Casa Basic*, February, 2006: 20-21

Jones, Rachel, "The Year of Living Dangerously," *The Telegraph Magazine*, January 14, 2006: 68-69

Choudhry, Talib, "High Gloss," *Sunday Times*, January 22, 2006: 55

Fredrikson Stallard, "With this New Crop of Designers, Value is not Only Questioned, but is Questioned by Being Extravagantly Applied," *Spoon*, January, 2006: 90

Lalinsky, Michal, "Lovecky Revír," *Atrium*, January, 2006: 106

2005

Waldron, Glenn, "Coathook #1," *I.D.*, December, 2005: 43-44

Needleman, Deborah, "Gothic Touches," *Domino*, December, 2005: 27

D'Argenzio, Rosie, "Winter's Gift Noir," *California Homes*, December, 2005: 30-31

Uusinarkaus, Julie, "Black Dreams," *Pàp*, 17 (November, 2005):44-46

Chan, Ana, "World Citizens," *VMan*, November, 2005: 124-125

Khemsurov, Monica, "Dual Citizenship," *Surface*, November, 2005: 73

Roux, Caroline, "Against Nature," *Spoon*, September, 2005: 53-55

Ленгле, Анна, "Миф и Авангард" (Myth and Avantgarde), Ле, 17 (September, 2005): Cover, 50-51

Y.S., "Fredrikson Stallard," *Intramuros*, 120 (September, 2005): 65, 128

Feldman, Melissa, "Dazzling Candlesticks," *House & Garden*, September, 2005: Domestic Bliss

King, Natasha Louise, "Black Matters," *34 Magazine*, September, 2005: 47-65

Sherwood, Tim, "Gloves for an Armless Venus," *Icon*, 26 (August, 2005): 58

Wolff, Zoë, "New York Showroom," *Dove*, August 17, 2005: 118 -119

Druckman, Charlotte, "London Bridge," *Food & Wine*, June 27, 2005: 32

Treffinger, Stephen, "Waiting Till Sunset to Seek a New Dawn," *New York Times*, May 19, 2005: House & Home

Ogundehin, Michelle, "Coat Stands," *Elle Decoration*, May, 2005: 34

Raymond, Martin, "Where the Art is," *Viewpoint*, April, 2005: 169-170

Young, Xavier, "Shelf Life," *Sunday Times*, March 6, 2005: 51

Goad, Juliana, "Hooked on you," *Living etc*, March, 2005: 120

Vikkelsoe, Sebastian, "Bolt Vase," *All Access*, March, 2005: 71

Choudhry, Talib, "Floor Show," *The Sunday Times*, February 13, 2005: 15

Flynn, Jennifer, "The Chers," *Home Furnishings Now*, February, 2005: Trends

Bell, Gabriel, "Let them Eat Cake," *City*, February, 2005: 126

Azhon, Miri, "Trends – Hangers," *Biyan Vediur*, February, 2005: 22

Fredrikson, Patrik, "Brennbar Design," *Elle Interiør Norway*, January, 2005: 4

Langmead, Jeremy, "Design Awards 2004," *Wallpaper**, January, 2005: 46-47

Jones, Rachel, "Unfinished Symphony," *Telegraph Magazine*, January 29, 2005: 70

Beatrice, Hanna Nova, "Nattens Våning," *Residence*, January, 2005: 68-75

Baillie, Claudia, "Green Glam," *Living etc*, January, 2005: 23

Briscoe, Adrian, "Porcelain Lights," *Elle Decoration*, January, 2005: 33

2004

Nolan, Clare, "On the Where Track," *You Magazine*, December 19, 2004: 50

Long, Kieran, "This Roomful of Steel," *Icon*, 18 (December, 2004): 30-31

Jacobs, Kate, "Night Fever," *Elle Decoration*, December, 2004: 44, 108-113

Wolff, Zoë, "Know and Tell," *Details*, December, 2004: 62

Thomas, Rupert, "Shortlist," *The World of Interiors*, December, 2004: 57

Martin, Inger, "Nya Numret ute nu!" *Elle Interiör*, December, 2004: 57

Wolff, Zoë, "The W Luxe Shopping Guide," *W Magazine*, November, 2004: 11-12

Cockpit Arts, "Installation at the Great Eastern Hotel," *Time Out London*, November 24, 2004: 52

Seudile, Zahid, "Silverado Quarters," *San Francisco Chronicle Magazine*, November 27, 2004: 26-27

Fredrikson Stallard, "Ian Stallard and Patrik Fredrikson: Modern Gothic," *The Sunday Times: Style*, November 14, 2004: 77

Davies, Sophie, "En Naturlig Kille," *Elle Interiör*, 9 (November, 2004): 57

Richardson, Vicky, "Ipsio Factio," *Blueprint*, 225 (November, 2004): 99

Fredrikson, Patrik, "Melt Down," *Vivre*, October, 2004

Ogundehin, Michelle, "Dragon Vase," *Elle Decoration*, October, 2004: 128-129

La Vie-Le Monde, "De l'Usine au Musée," *Télérama*, October 30, 2004: Cover

Wolff, Zoë, "Home & Garden," *New York: Fall Shopping Guide*, September, 2004: 115

Kelly, Peter, "Designed in Sweden," *Blueprint*, 223 (September, 2004): 133

Emerson Studios, "Firmatus, Utillitas, Venustas," *AA News*, September, 2004. Web

Royal, Luís, "Dragon Vase," *Oindependente*, August 27, 2004: 16

Treffinger, Stephen, "Bringing the World Together, One Table at a Time," *The New York Times*, July 29, 2004: Currents

Treffinger, Stephen, "Bringing the World Together, One Table at a Time," *The New York Times: on the Web*, July 29, 2004. Web

Wolff, Zoë, "Choice," *Idanda*, July 20, 2004. Web

Sugi, Rima, "Best Bets," *New York Magazine*, July 12, 2004: 7

Wolff, Zoë, "English Channel," *Time Out New York*, June 24, 2004: 48

Sugi, Rima, "London Calling," *New York Magazine*, June 14, 2004: 109

Aranda-Alvarado, Belén, "Wicked," *The Washington Post*, June 06, 2004: 10

Stallard, Ian. "Guide to Creative London," *Time Out London*, June, 2004: 20

Sugi, Rima, "London Calling," *New York Metro*, June, 2004. Web

Wolff, Zoë, "False Fronts," *Time Out New York*, June 03, 2004: 48

Micolau, Silvia, "The Laid Table," *B-Guided*, 20 (June, 2004): 143-152

Donninelli, Barbara, "Tea Ceremony," *The World of Interiors*, May 2004: 15, 117

Wolff, Zoë, "UK Company Opens in NYC," *Riba USA*, May, 2004. Web

Royal, Luís, "#1 e #2," *Oindependente*, May 21, 2004: 12

Köpställen Sidan, "Skurkors," *Elle Trädgård*, May, 2004: 41

Carr, Margaretha, "Uppvindar," *Elle Interiör*, May, 2004: 145

Blanchett, Cate, "Vogue Living," *Vogue*, April, 2004: 297

Koster, Amanda, "New Talent," *Elle Decoration*, April, 2004: 37, 130-131

Stallard, Ian, "Infusion of Modern Technology," *Traditional Home*, March, 2004: 30

Blanchett, Cate, "Vogue Living," *Vogue*, March, 2004: 357

Pithwa, Sudhir, "Insider: Decorator's Notebook," *House & Garden*, March, 2004: 24

Fredrikson, Patrik, "Coat Hook #1," *Find a Property*, March, 2004. Web

Beatrice, Hanna Nova, "Utmärkt Brittisk Form" (Excellent British Form), *Bon*, 16 (March, 2004): 127-129

Talang, Ny, "Vågad Design," *Bazaar*, 37 (February, 2004)

Fredrikson, Patrik, "Natural Design," *Mooch*, February, 2004. Web

Baillie, Claudia, "Erotic Adventures," *Living etc*, February, 2004: 23

Stallard, Ian, "Graphic Crockery," *Kitchen Culture*, 4 (February, 2004): 17

Ohlsson-Leijon, Karin, "Nyheter Kring design & Prylar," *Elle Interiör*, February, 2004. Web HomePage

Nolgren, Sandra, "Notiser," *Rum*, 1 (January, 2004): 34

Fredrikson, Patrik, "100% Design," *I.D.*, January, 2004: 43-44

Fredrikson Stallard, "New and Notable," *I.D. Online*, January, 2004. Web

Davies, Sophie, "Superfly," *Elle Decoration*, January, 2004: 31, 54, 56

Thompson, Henrietta, "Go Fly a Kite," *Blueprint*, 215 (January, 2004): 9, 71

2003

Davies, Tristan, "Living Review," *The Sunday Review*, December 21, 2003: 33, 47

Koster, Amanda, "Shadow Play," *Elle Decoration*, December, 2003: 29, 78-79

Lee, Emma, "Art of Darkness," *You Magazine*, November 30, 2003: 70-71

Rattray, Fiona, "9 Candles Burning," *The Independent Magazine*, November 22, 2003: 31

Rattray, Fiona, "Design for Living," *The Sunday Review*, November 02, 2003: 5

Rattray, Fiona, "Up and Coming," *The Independent Magazine*, October, 2003: 60-62

Norton, Poppy, "Ten of the Best Candle Sticks," *The Guardian Weekend*, September 13, 2003: 77

Hill, Albert, "In House News," *Wallpaper**, March, 2003: 223

Windsor, John, "Follow the Golden Ripples," *The Observer*, January 05, 2003: 12

1999

Sherwood, James, "Branching Out," *Scene*, December, 1999: 130

Alton, Roger, "The Digital Gold Rush," *The Observer Magazine*, August 01, 1999: Life

Courtney, Yvonne, "She's got to have it," *Marie Claire*, April, 1999: 39

Sherwood, James, "The Future's White," *Scene*, March, 1999: 132-136

1998

Ross, Alan, "Going with a Bang," *The London Magazine*, November, 1998: 7

Procter, Jane, "After the Goldsmith," *Tatler*, May, 1998: 171

1997

Relph-Knight, Lynda, "Barking Mad," *Design Week*, February 07, 1997: 5

1996

Wiklund, Anna, "Sovrumsdrömmar" (Bedroom Dreams), *Sköna Hem*, January, 1996: 77

Artist Publications

2017

Intuitive Gestures, David Gill Galleries, London, September 2017

Hybrideae, London: Fredrikson Stallard, 2017. Newspaper, Black & White. Edition 150

2015

Momentum, London: Fredrikson Stallard, 2015. Artist Book, Colour. Edition 350

Index
All photographs are copyright Fredrikson Stallard,
unless otherwise indicated

List of the works

1992
Car Stereo Tea Set, 1992

1996
Big Bag, 1996
Love Box, 1996

1997
For the Love of, 1997
Sleeping Beauty, 1997

1998
2-Light, 1998
4-Light, 1998
Luna Light, 1998
Vector Light, 1998

2000
Cufflink, 2000

2001
Coat Hook #1, 2001
Keyring, 2001
Studio Candles, 2001
Studio Splendidus Vase, 2001
Studio Bowls, 2001
Table #1, 2001
Table #2, 2001

2002
Atlas Tableware, 2002
Brush #1, 2002
Candle #1, 2002
Cartouche Tableware, 2002
Clothes Brush, 2002
Hofterup Tableware, 2002
Mirror #1, 2002
Nativity, 2002
Scaffold Tableware, 2002
Studio Titanic Vase, 2002

2003
Cable Vase, 2003
Down Light, 2003
Dragon Vase, 2003
Dragon Vase with Falcon, 2003
Incognito, 2003
Kite, 2003
Soho Tableware, 2003
Table #5, 2003
Uplight, 2003
Urban Tableware, 2003
Void Wall Light, 2003

2004
Bolt Vase, 2004
Dead Vase, 2004
Diptych, 2004
Light #1, 2004
Ming #1, 2004
Monochrome, 2004
Oil Unit, 2004
Rug #1, 2004
System #1, 2004
Villosus, 2004
White Feather, 2004

2005
The Lovers, 2005
Unit #4 Ice, 2005

2006
Bergère I, 2006
Bergère II, 2006
Chandelier #1, 2006
Dome Light, 2006
Kingdom, 2006
Ming #2, 2006
Orchideae Mirror, 2006

2007
Aluminium Series, 2007
Bird Box, 2007
Ghost Unit, 2007
Pandora, 2007
Plaster Table, 2007
Pyrenees, 2007
Rubber Table, 2007
Rubber Side Table, 2007
Tarkett, 2007

2008
Cavern Bench, 2008
Cavern Candle Holder, 2008
Cavern Light, 2008
Cavern Table, 2008
King Bonk, 2008
King Bonk Footstool, 2008
Portrait, 2008
Portrait Light, 2008

2009
Acid Queen, 2009
Aviator 1, 2009
Aviator 2, 2009
Blue Feather, 2009
Cadillac, 2009
Daytona, 2009
Épergne, 2009
Firebird, 2009
Fossil Table, 2009
Hyde Lounge Chair, 2009
Liberty 1, 2009
Liberty 2, 2009
Monochrome Blue, 2009
Phantom, 2009
Phoenix, 2009
Pink Corvette, 2009
Pink Feather, 2009
Silver Spirit 1, 2009
Silver Spirit 2, 2009
Thunderbird, 2009
Tribeca Chandelier, 2009

2010
Billboard, 2010
Canyon, 2010
Hurricane Gold, 2010
Hurricane Silver, 2010
Moscow, 2010
Orchideae CorTen, 2010
Orchideae I, 2010
Orchideae II, 2010
Orchideae III, 2010
Orchideae IV, 2010
Orchideae V, 2010
Orchideae VI, 2010
Savoy, 2010
Waterfall, 2010

2011
Brasilia, 2011
Iris Aeratus Momentum, 2011
Iris Aeratus Quadrum, 2011
Iris Aeratus Quadrum Tripus, 2011
Iris Aeratus Radiare, 2011
Iris Aeratus Vortex, 2011
Iris Aeratus Vortex Tripus, 2011
Iris Argenteum Momentum, 2011
Iris Argenteum Quadrum, 2011
Iris Argenteum Radiare, 2011
Iris Argenteum Vortex, 2011
Iris Ferreus Momentum, 2011
Iris Ferreus Momentum Tripus, 2011
Iris Ferreus Quadrum, 2011
Iris Ferreus Radiare, 2011
Iris Ferreus Radiare Tripus, 2011

Iris Ferreus Vortex, 2011
Iris Ferrugo Momentum, 2011
Iris Ferrugo Quadrum, 2011
Iris Ferrugo Radiare, 2011
Iris Ferrugo Vortex, 2011
Orchideae Paintings, 2011
Orchideae Print #1, 2011
Orchideae Print #2, 2011
Orchideae Print #3, 2011
Pantheon, 2011
Rimini Sofa, 2011
Rimini Sunbed, 2011
Rimini Table, 2011
Silver Crush, 2011
Soft Panton, 2011
Vermillion Landscape I, 2011
White Feather Side Table, 2011

2012
Aviary Chair, 2012
Black Crush, 2012
Detroit, 2012
Fabergé Egg, 2012
Gold Crush, 2012
Gold Crush Side Table, 2012
Hallingdal, 2012
Silver Crush Side Table, 2012
Without Sin, 2012

2013
Atlantic I, 2013
Atlantic II Cabinet, 2013
BIFA Trophy, 2013
Brioni Collar Pins, 2013
Brioni Cufflinks Round, 2013
Brioni Cufflinks Square, 2013
Brioni Tie Clips, 2013
Cerulean Landscape I, 2013
Diptych: Landscape II, 2013
Space Flowers, 2013

2014
Archipelago I, 2014
Archipelago II, 2014
Archipelago III, 2014
Avalanche, 2014
Basalt Dining Table, 2014
Basalt Side Table, 2014
Brioni Fragrance Bottle, 2014
Bronze Crush, 2014
Cannon, 2014
Eden, 2014
Les Visionnaires, 2014
Prologue I, 2014
Prologue II, 2014
Sereno, 2014

2015
Armory Earrings, 2015
Armory Large Gold Cuff, 2015
Armory Large Silver Ring, 2015
Armory Mask, 2015
Armory Necklace, 2015
Armory Pauldron, 2015
Armory Silver Pendant Necklace, 2015
Armory Tiara, 2015
Burnt Landscape I, 2015
Cast Consequences, 2015
Crush Consequences, 2015
Gravity I, 2015
Gaucho, 2015
Hurricane Console, 2015
Meteorite, 2015
Momentum Artist Book, 2015
Palais De Tokyo, 2015
Parachute, 2015
Parachute Gold, 2015

Polaris, 2015
Prologue III, 2015
Rock Oil Lamp, 2015
Species I, 2015
Species II, 2015
Still Waters Run Deep, 2015
Tokyo I, 2015

2016
Atlas, 2016
Avalon, 2016
Camouflage Daybed, 2016
Camouflage High Back Chair, 2016
Camouflage Low Back Chair, 2016
Camouflage Small Table/Stool, 2016
Cardboard Table, 2016
Consequence Candleholders, 2016
Ferrum, 2016
Glaciarium Candlestick Holders, 2016
Glaciarium Centrepiece, 2016
Glaciarium Large Bowl, 2016
Glaciarium Small Bowl, 2016
Glaciarium Vase, 2016
Glaciarium Night Light, 2016
Glaciarium Orchid Vase, 2016
Gravity Gueridon, 2016
Gravity II, 2016
Helios, 2016
Hudson, 2016
Hybrideae I, 2016
Hybrideae II, 2016
Hybrideae II, 2016
Hybrideae III, 2016
Hybrideae IV, 2016
Hybrideae V, 2016
Hybrideae VI, 2016
Hybrideae VII, 2016
Hyrbideae VIII, 2016
Manhattan I Firedogs, 2016
Manhattan II Firedogs, 2016
Metamorphosis, 2016
Paradisium, 2016
Rock, 2016
Rock #1, 2016
Rock #2, 2016
Rock #3, 2016
Rock #4, 2016
Rock #6, 2016
Rock #9, 2016
Rock #11, 2016
Scribble Bench, 2016
Scribble Chair, 2016
Silver Crush Desk, 2016
Species III, 2016
Superline, 2016
Vendôme I, 2016
Vendôme II, 2016
Vendôme III, 2016
Vitrine #1, 2016
Vitrine Triptych, 2016
Voltaire, 2016
White Emulsion I, 2016
White Emulsion II, 2016

2017
Antarctica I Dining Table, 2017
Antarctica II Coffee Table, 2017
Antarctica III Gueridon, 2017
Antarctica IV Gueridon, 2017
Antarctica V Gueridon, 2017
Antarctica VI Gueridon, 2017
Antarctica VII Gueridon, 2017
Bibliothèque, 2017
Element I, 2017
Element II, 2017
Element III, 2017

Element IV, 2017
Fractus I, 2017
Fractus II, 2017
Fractus III, 2017
Glaciarium Component Pear 50mm, 2017
Glaciarium Component Pear 89mm, 2017
Glaciarium Component Prism Frame 1 Hole, 2017
Glaciarium Strands, 2017
Grand Concourse Creatures, 2017
Reformation, 2017
Scriptus I, 2017
Scriptus II, 2017
Scriptus III, 2017
Species IV, 2017
Species V, 2017
Tokyo II, 2017
Torch I, 2017
Torch II, 2017

2018
A Virtue – Possibly Truth, Temperance or Justice, 2018
Judith with the Head of Holofernes, 2018
Narcissus, 2018
The Dying Achilles, 2018
The Rape of the Sabines, 2018